Arts, Inc.

The publisher gratefully acknowledges the generous contribution to this book provided by the Richard and Harriett Gold Endowment Fund in Arts and Humanities of the University of California Press Foundation.

Arts, Inc.

HOW GREED AND NEGLECT
HAVE DESTROYED OUR
CULTURAL RIGHTS

BILL IVEY

UNIVERSITY OF CALIFORNIA PRESS
Berkeley Los Angeles London

University of California Press, one of the most distinguished university presses in the United States, enriches lives around the world by advancing scholarship in the humanities, social sciences, and natural sciences. Its activities are supported by the UC Press Foundation and by philanthropic contributions from individuals and institutions. For more information, visit www.ucpress.edu.

University of California Press
Berkeley and Los Angeles, California

University of California Press, Ltd.
London, England

The lyrics from "Beautiful Despair" (on p. 58) and "Yellow Bird" (on p. 185) are used by permission, as specified in the notes on pp. 303 and 313, respectively.

Library of Congress Cataloging-in-Publication Data

Ivey, Bill J., 1944–
 Arts, Inc. : how greed and neglect have destroyed our cultural rights / Bill Ivey.
 p. cm.
 Includes bibliographical references and index.
 ISBN 978-0-520-24112-1 (cloth : alk. paper)
 1. Art and state—United States. 2. Art and society—United States.
3. Cultural property—United States. 4. Arts—Economic aspects—
United States. 5. Arts—Political aspects—United States. I. Title.
 NX730.I93 2008
 700.1'0309073—dc22
 2007039516

Manufactured in the United States of America

17 16 15 14 13 12 11 10 09 08
10 9 8 7 6 5 4 3 2 1

This book is printed on New Leaf EcoBook 50, a 100% recycled fiber of which 50% is de-inked post-consumer waste, processed chlorine-free. EcoBook 50 is acid-free and meets the minimum requirements of ANSI/ASTM D5634-01 (Permanence of Paper).

For my folklore colleagues,
for all those who value the art of everyday life,
and for Grace Christine Ivey
(1917–2007)

Contents

The Cultural Bill of Rights

1. The right to our heritage—the right to explore music, literature, drama, painting, and dance that define both our nation's collective experience and our individual and community traditions.

2. The right to the prominent presence of artists in public life—through their art and the incorporation of their voices and artistic visions into democratic debate.

3. The right to an artistic life—the right to the knowledge and skills needed to play a musical instrument, draw, dance, compose, design, or otherwise live a life of active creativity.

4. The right to be represented to the rest of the world by art that fairly and honestly communicates America's democratic values and ideals.

5. The right to know about and explore art of the highest quality and to the lasting truths embedded in those forms of expression that have survived, in many lands, through the ages.

6. The right to healthy arts enterprises that can take risks and invest in innovation while serving communities and the public interest.

Preface

President Bill Clinton, First Lady Hillary Rodham Clinton, and Chelsea Clinton slipped through the stage entrance quietly; the First Family was in place before any of us realized they had entered the room. It was Friday, December 31, 1999, the beginning of a daylong celebration welcoming a new century. We had gathered in the cramped waiting area just behind the stage of Baird Auditorium, an ornate lecture hall positioned just inside the Constitution Avenue entrance to the Smithsonian Institution's Museum of Natural History. The auditorium is considered one of the finest performance spaces in Washington, DC. Although it only seats an audience of a few hundred and its gray backstage dressing rooms and work spaces exhibit the institutional drabness generic to government buildings, the elegant arched ceilings, intimate, steeply raked seating, and excellent acoustics make it a welcoming venue for lectures, films, and small-ensemble musical performances.

Bill Clinton isn't much of a sleeper, and fatigue often guaranteed a grumpy presence at early-morning meetings. Backstage at Baird his eyes were tinier than usual. He seemed to understand that he didn't look his best, explaining that he'd been up all night talking with Boris Yeltsin, the Russian leader who had become a friend. Although it was not yet public knowledge, Yeltsin had phoned to let him know he was resigning. "I was on the phone for a few hours," Clinton said.

So the president was tired, and I was nervous. My task that morning was to interview bluegrass star Ricky Skaggs onstage and encourage the talented singer and instrumentalist to talk about the connection between his artistry and his eastern Kentucky heritage. It's easy to imagine that performing for the president elicits both excitement and trepidation. Ricky and I walked nervously onto the stage, and the Clintons, followed by warm applause, moved to their reserved seats near the front of the auditorium. With the First Family seated a few feet away, Ricky and I engaged in a "performing conversation" that touched on his musical influences, his childhood in the Appalachian Mountains, and his dedication to making bluegrass and old-time music a part of the educational experience of every child growing up in eastern Kentucky and Tennessee. As Ricky and I talked, and as he sang, fiddled, and played the mandolin to drive home each point in the conversation, my nervousness was gradually replaced by enthusiasm. "This," I thought, "is the perfect opportunity to demonstrate the linkages between art, community, and quality of life for the leader who can really make a difference, President Bill Clinton." Midway through the one-hour performance, as instructed, I extended my hand toward the First Family in a preplanned gesture of introduction designed to enable the Clintons to stand and be acknowledged, then make a graceful exit. But the president demurred. "No," he indicated, palms extended toward the stage; he wanted to stay. "Wow," I thought, "we're really getting through!"

Getting through was an issue. Two years into my tenure as National Endowment for the Arts chairman, I still hadn't held a one-on-one, sit-down arts policy conversation with President Clinton—an especially frustrating empty spot in my tenure because he should have been our perfect "cultural president." An instinctive intellectual and a natural policy

wonk, Clinton could hold forth at length on virtually any subject, re-trieving relevant snippets of history, literature, and science from a hard-drive mind, then extracting core principles and summarizing policy im-plications with ease. Time and again I'd seen him propped against a Rose Room door frame, sipping a Diet Coke, lecturing economists or sociolo-gists on the subtleties of *their* field. Clinton was also a dyed-in-the-wool student of southern culture and a fan of country music, rock, and blues—a politician who, some argued, drew on the same transracial persona that made Elvis Presley a star.

In addition, the president had acknowledged the transforming power of music in his own turbulent and often-unhappy youth, an engagement that led him to embrace his band instructor as a surrogate father. And, un-like Richard Nixon, who could plunk out a tune or two on the piano, Bill Clinton was the real thing—a contest-winning saxophonist who had played in a first-rate high school pop/rock cover band. Surely Ricky Skaggs, exhibiting artistry and a deep understanding of the connections between music and community life, would open the door to a conversa-tion between the president and his NEA chairman about the significance of art and artistry in public policy.

But it was not to be.

A few days after the Millennium Celebration had packed up and left town, I spotted the president, momentarily unattended, at a Gold Room reception. This was my chance to leverage the Ricky Skaggs performance into the beginning of a deep arts policy conversation; I sidled up to him. "Mr. President," I asked, "what did you think of the Ricky Skaggs inter-view?" "Yeah," he replied (with just the hint of a dismissive laugh), "that was really fun."

I was crushed. Faced with firsthand testimony to the power of music, culture, and sense of place in the life and career of Skaggs and, I assume, aware of his own rich experience with music, Bill Clinton still didn't vi-sualize the way art could link up with government policy to advance the well-being of citizens and their communities. Even in the wide-ranging mind of this American president, evidence and direct experience were not enough to let cultural engagement tip over from diversion to public policy.

In truth, I shouldn't have been surprised. The president was merely playing out the set of assumptions that had long defined the cool, arms-length relationship between culture and the *real* work of government. I knew perfectly well that there are two wings attached to the White House. The West Wing, famous even before it was immortalized by dramatic television, is the suite of offices where *real men* make *real policy*. Home to the Domestic Policy Council and the National Security Council, the West Wing is the stage set against which each administration acts out its agenda and, when necessary, figures out how to respond to crisis and ex-plain away failure. The East Wing, on the other hand, is near the Treasury building—to the left if you're gazing through the security fence on Penn-sylvania Avenue—home to the White House social office, the Office of the First Lady, and the banked metal detectors where tourists and event guests are screened. If the West Wing is devoted to national defense, the economy, commerce, and transportation, the East Wing is devoted to, well, parties. From at least the days of the Kennedy administration, arts and culture have been linked to policy through the East Wing. To be fair, Hillary Clinton pushed against the boundaries of this conventional wis-dom. She had a staffed office in the Eisenhower Executive Office Build-ing, and the Clinton administration's White House Millennium Council— promoted by the First Lady and managed by her deputy, Ellen Lovell—created the ongoing Save America's Treasures program. But the office's legacy consists mainly in a string of special events: jazz, poetry, even rock 'n' roll; the arts were still seen as "soft" and "social." My nom-ination and confirmation as NEA chairman were managed by the First Lady's office—another indication of the position of art and culture on the White House agenda. Bill Clinton didn't need a poll (although he prob-ably had one) to tell him how little Ricky Skaggs's heartfelt interview meant to real government work: "Yeah," he said, "that was a lot of fun."

Bill Clinton may not have wanted to talk about culture, but his ad-ministration did plenty to help the media industries. Internet takedown letters, expanded copyright, media consolidation, and diminished capac-ity for cultural exchange all became part of the Clinton legacy, each pol-icy spinning off consequences—intended or not—that transformed America's cultural landscape. Whether you're a rock musician posting

garage band tracks on MySpace.com, a parent wondering why our biggest record companies want to sue your children, or a graying baby boomer baffled by the hatred directed at the United States by citizens of Middle Eastern countries, you've been quietly manhandled by profound policy changes in our arts system that have elbowed culture away from the public interest over the past century. The 1990s merely accelerated a long-standing trend.

Today, eight years into the new century, things are no better. Steven Pearlstein, writing in the *Washington Post,* argues that the term of copyright protection has been extended "well beyond what is reasonably required to meet the aim of encouraging artistic creation." George Lesser, in the *Washington Times,* notes that populations critical of U.S. policy on Iraq or global warming "no longer have easy access to books and periodicals which might help offset their growing hatred for us"; it is time to "recreate the USIA [United States Information Agency] as an independent agency charged with conducting public diplomacy." National Public Radio reports that 73 percent of symphony orchestras ran a deficit in 2003, and *New York Times* art critic Michael Kimmelman laments the decline of amateur art making: "A vast majority of society seems to presume that culture is something specialists produce." The complaints of these and other observers, each coming at the problem from a different perspective, share an underlying theme: our cultural system has become unhinged.

My tenure as chairman of the NEA predates many of these critical shifts in cultural policy. The NEA actually showed signs of new life during the Clinton years, and I was proud of what our team of staffers, congressional supporters, and arts advocates accomplished in the turnaround of our federal arts agency. When I phoned President George W. Bush's chief of staff, Andrew Card, in spring 2001 to tell him I would leave the chairmanship in the fall, I was convinced that I had done what had been asked of me when I agreed to join the Clinton-Gore team: the NEA's relations with Congress were much improved, its budget was growing again, and morale in the building and throughout the nonprofit arts community had picked up markedly.

But as I was saying my good-byes to our terrific cadre of NEA professionals and packing up to leave the agency and Washington, as I reflected

on the way new laws and regulations had reconfigured the cultural land-
scape during the Clinton administration, I couldn't shake the fear that
we'd been fiddling while Rome burned. The interests of big media, abet-
ted by government, were running roughshod over the public interest.

Granted, the NEA's community arts initiative, Challenge America, had
convinced Congress to begin increasing the agency's budget again. But
what does it mean to bring $10 million or $20 million to nonprofit arts or-
ganizations when copyright extension, radio consolidation, the aban-
donment of art and culture as a tool of diplomacy, and the promotion of
trade in American arts products around the world are turning our cul-
tural system upside down?

To make matters worse, the community of nonprofit organizations that
benefited most from NEA funding didn't seem to care about this unbal-
anced cultural system. I suppose an unengaged cultural sector should be
no more surprising than West Wing apathy; after all, since the 1960s our
cultural policy has pretty much been about bringing more fine art to the
American people. Increasing supply made sense in 1960, but this single-
minded agenda has made it too easy for self-declared arts leaders to avoid
engaging the breadth of America's unique cultural system, focusing in-
stead on a couple of narrow issues—arts education and expanded fund-
ing for nonprofits. And, tit for tat, "real" policy specialists don't care about
culture. Authentic, West Wing–style "hard" public policy only mixes it up
with the arts by accident, through trade promotion or media regulation or
when Congress rises up in a snit over offensive television programming
or unsettling government-funded art. The democratic *public interest* in a
fair and vibrant arts system has never really come forward; again and
again culture ends up roadkill on the highway to some other destination,
usually foreign trade promotion, media mogulizing, congressional chest
thumping, or pumped-up intellectual property protection.

How might we turn things around?

Tinkering with a few regulations or convincing a company or two to
revise corporate practice just won't work; the problems, embedded by
generations of inattention, are too big. Instead, we need to reframe the
picture, stepping back to take a fresh look at how the arts can best partic-
ipate in a culturally vibrant democracy.

When I was still in Washington, I tried to jump-start a new conversation about public policy, corporate practice, and the public interest with a National Press Club speech, "Toward a U.S. Cultural Bill of Rights." But my timing was awful: I addressed a luncheon audience at the Press Club on December 18, 2000, a few days before the Christmas holidays and just one week after the Supreme Court decided our disputed 2000 presidential election. With a complete change in government looming, nobody was too concerned about the opinions of a suddenly lame-duck NEA chairman.

But the idea of a "Bill of Cultural Rights" continued to flicker, albeit dimly. A few months into 2001 I was given the opportunity to reprise the "Bill" speech, in a slightly revised form, at the Harvard Club in New York City. In midtown Manhattan, speaking to a wine-mellowed audience coddled in a toasty wood-paneled conservatory, I sensed that a cultural bill of rights might somehow take root.

· · · · ·

Our scattershot cultural policy has failed to balance the public interest with the marketplace. It is time to establish a new set of goals designed to reclaim art and culture for the American people; it is time to assert the rights of citizens to the multiple benefits of an arts system turned to public purposes.

But how do we define a vigorous arts system, and just what is the public interest in it? What rights do Americans have to elements of their cultural heritage, such as the films of Alfred Hitchcock or the recordings of Louis Armstrong, when that heritage is also some company's corporate asset? Should cultural originals be bought, sold, and moved out of the country without limitation, as if art were of no greater consequence than bricks, aluminum ingots, or auto parts? Why should we care about our rights to culture—what is the relationship between engagement in the arts and quality of life? Can artistic values relieve the burdens of materialism, consumerism, and invidious competition that today weaken our civil society? What contributions can artists make to the realm of government and public policy, and how can we ensure that artists get through the manufacturing and distribution choke points that dot America's arts

system? How can people throughout the world gain the opportunity to encounter the range of art that is possible in our plural democracy and free-market economy?

We love *American Idol*, HBO, vintage guitars, Elvis, Chrysler 300s, Mozart and Monet, George Gershwin and Georgia O'Keeffe, *Casablanca* and Michael Graves soap dishes on sale at Target. Clearly, culture and art matter to American families and communities, but, even bundled together, do they matter enough? Can we engage art in the right way?

This book is my attempt to answer these questions and in the process to demonstrate that the health of our cultural system is as critical an issue as others that press on public policy.

Today we need to start again from first principles; we need a Cultural Bill of Rights that *asserts* how things should be. But before we begin again, we must inevitably *assess* where and how we got off track. Sadly, a century of unedited market excess and haphazard government intervention has ensured that tales of greed and neglect will make up most of my story. All Americans should enjoy the benefits of a vibrant expressive life, but that expressive life can flourish only after we satisfy a set of basic cultural rights—rights that enable us to claim our cultural heritage, to engage different forms of artistic expression, to come into contact with living artists and artworks of lasting value, and to have access to responsible arts institutions. It is these cultural rights, and the policies and practices that flow from them, that are argued chapter by chapter in this volume.

Something has to change.

In a speech to the American Folklore Society in fall 2006, author and environmentalist Barry Lopez identified "a weakening of our culture: a stumbling." He is exactly right; by failing to link our expressive life to America's public purpose, we have placed our nation's heart and soul at risk. We are forcing our great artists to navigate a complex and discouraging marketplace in order to survive. We have converted the shared memory embedded in our priceless cultural heritage into mere "intellectual property," which is bought, sold, abandoned, or simply locked away in the vaults of giant media companies. We have allowed global trade and satellite and cable TV deals to spread products shot through with sex and violence around the world, inadvertently promulgating a

vision of American society that can fuel hatred and extremism. And we have allowed gatekeepers who manage rights to art from the past to get in the way of art that is here and now. America's founding documents promise "the pursuit of happiness," but studies show we are not an especially happy people. By neglecting our cultural environment, we have ignored one of our nation's most important and economical avenues to a life of satisfaction beyond materialism and consumption. Today young and old alike lack the means to acquire the art-making skills that can, at little cost, elevate the quality of life across the arc of a lifetime.

These challenges are vexing, so vexing that only a coordinated, muscular program of legislation and regulation can realign our arts system with the public interest and provide the vibrant expressive life that should be the birthright of citizens in our enlightened democracy. If the task requires consideration of a new government agency—a cabinet-level department of cultural affairs—so be it. Critics have long argued that such a consolidated government presence would somehow derail our cultural life, interfering with free expression by defining officially acceptable artistic work. This perspective must be revisited and challenged. After all, how could a department of cultural affairs possibly generate a cultural system less functional, less attuned to public purposes, than the one we've been handed by a century of marketplace arrogance and government indifference?

I believe we can, and must, do better. By adopting a new, comprehensive approach to our arts system and by coordinating cultural interventions so they serve the public interest, we can provide every American with the benefits of a vibrant expressive life—a reservoir of identity and spiritual renewal powerful enough to replace the fading allure of empty consumerism.

An old southern farmer, talking about keeping rows straight when plowing behind a team of mules, said, "You have to put a *staub* [stake] out there, and then plow right at it." An understanding of what's gone wrong and the assertion of our Cultural Bill of Rights can be a kind of staub—an aiming point for public policy and corporate practice. The American people must take back some of what has been given away. Our cultural system is running away with us; rights that should be taken for granted

have been lost, and the public interest has been left choking on corporate greed like a small dog chasing a fast car on a dusty road. We need to reclaim creativity and heritage for the American people, acknowledge the diverse, multiple connections between a vibrant expressive life and quality of life, and secure a new economy grounded in knowledge and innovation.

Introduction

I was only half paying attention to a segment on public television's *News-Hour* featuring Esa-Pekka Salonen, conductor of the Los Angeles Philharmonic. I perked up when reporter Jeffrey Brown asked how he had "made his way" in the musical environment of America. Salonen's answer contained an accurate assessment of the character of the U.S. arts scene:

> The real shock was coming to this very complex society, because I had this typical European attitude where the ranking list is completely clear. That the greatest dramatist of all times is Shakespeare, the greatest composer is Beethoven, or Bach perhaps, and the greatest sculptor is Michelangelo, and the greatest painter is, you know, endless, stupid list of this top-ten kind of thing. And then I came here and I realized that in this kind of amazing melting pot of cultures and people, my list is no more valid than anybody else's

list. . . . I woke up one morning and I looked around myself and I saw myself in the mirror, and I said, "You're free. You can do whatever you like, artistically speaking."

Salonen is clear about what he was suddenly free *from:* the smug European hierarchies that confidently stacked artists and art forms one above another. What has replaced the Old World's "endless, stupid list" is a new artistic order—an open-ended array of artistic options offered through a combination of America's diverse society and our centuries-old commitment to egalitarian democratic values. Salonen's expressive life is richer here than it could be in Europe; he senses a capacity for greater choice, both in the artistry he absorbs from others and in the art he creates.

The maestro is not alone.

For the past century, our democratic values and our expansive view of what qualifies as "art" have been subliminal messages buried in American music, TV shows, and movies as they spread around the world. In his enthusiastic endorsement of the variety and openness of America's arts system, Salonen is at one with thousands of European, Asian, and Latin American record collectors, musicians, film scholars, and students of culture who have fallen in love with the unique promise of our nation's rich cultural mainstream.

But here at home, we do not think of ourselves as a cultural powerhouse on a par with the ancient societies of Europe. As cultural historian Lawrence Levine puts it, "The idea that Americans, long after they declared their political independence, retained a colonial mentality in matters of culture and intellect is a shrewd perception." Levine is correct; we *do* harbor an inferiority complex in the arts—notably, the fine arts of Salonen's "lists." The grassroots vernacular arts that give America its cultural clout matured in the shadow of a perceived absence of cultural achievement. How has our arts system evolved; what is the character of a culture that can be powerful and inferior at the same time? How can reforms and the assertion of rights aimed at this system serve the public interest?

In addition to culture grounded in nationality, community, race, and gender, all Americans are proud inheritors of the tradition of Western

thought and art—a tradition that has provided not only political, social, and scientific ideas but also a legacy of visual art, music, literature, and dance. Before 1900 the American extension of this cultural mainstream, when measured against its European antecedents, came up short—a thin trickle compared to its Old World headwaters. In the eighteenth and nineteenth centuries the artistic achievements dotted across our hardscrabble frontier didn't add up to anything approximating the scope and quality found in Europe. True, colonial artisans designed a few gracefully rendered utilitarian objects—well-crafted furniture and elegantly understated silverware and serving pieces; in addition, some notable buildings executed in the classical revival style were scattered through Washington, DC, and other big cities. A few master painters of landscapes and portraits had emerged but not a unique New World vision. America still measured itself against European leadership in the visual arts. Classical music, too, looked across the Atlantic and beyond the confines of the nation's few real cities. Theater was maintained only by touring companies peddling abridged versions of Shakespeare's plays to pioneer audiences, and these were roughshod, catch-as-catch-can affairs: serious drama was generally preceded by a popular singer or two, interrupted at intermission by acrobats or jugglers, the whole topped off by a short, comic "farce"—a slapdash "follies" unimaginable today. By the mid-1800s an indigenous American literary voice could be heard, but even writers who had been at work for decades had only begun to achieve recognition that approached that of their European and English counterparts. (This situation was abetted by the widespread piracy of English titles by U.S. publishers. By ignoring copyright and paying no royalties to European and British authors, prices of U.S. editions of foreign work were consistently lower than their homegrown counterparts.)

But just below this repository of European-influenced art making, a powerful natural spring gurgled, hinting at what was to come. In the early nineteenth century descriptions of grassroots music making—reels and party songs performed by slaves on farms and ballads heard on front porches in the Appalachian Mountains—began to show up in the writings of adventurous travelers and journalists. This entry from the June 9, 1805, journal of the Lewis and Clark expedition is typical: "Towards the

evening we had a frolick. The officers gave the party a dram, the fiddle played and they danced late." In fact, the word *fiddle* turns up in twenty-three Lewis and Clark journal entries, providing an early, tantalizing suggestion that "real" American culture, the foundation of an authentically American art, was flowing beneath the insubstantial landscape of a quasi-European formal cultural life. At the time, no system existed to let this down-home stuff rise to the surface of our cultural mainstream.

The missing ingredient wasn't artistry but technology. In music, just as in literature and drama, print had for centuries been the key to cultural authority. Folk songs often weren't written down, and when they were printed it was usually in one-page "broadsides," texts without relevant musical notation. The cultural authority bestowed by printing never elevated folktales and folk songs the way it did fiction, travel writing, and classical music. But as it turned out we had only to wait a few decades—into the twentieth century—for new technology to link up with America's diverse grassroots expressive life to produce a complex, market-driven arts system—a system that elevated the vernacular and revolutionized the connection between art and the nation.

$$\bullet \quad \bullet \quad \bullet \quad \bullet \quad \bullet$$

So Salonen's embrace of the liberating power of America's diverse arts environment would have been unlikely in the nineteenth century; the expansive democratic character of America's performing arts had not yet been established. In fact, it strains the modern imagination to consider how completely the arts—especially the performing arts—were transformed between the end of the 1800s and the early twentieth century. As recently as 1890, drama, dance, and music exhibited a fleeting character almost inconceivable today.

Imagine, for a moment, the constraints surrounding a nineteenth-century arts aficionado. In the 1800s if you wanted to hear a Sousa march twice, you'd ask the band to play it again; if you wanted to see a dramatic production, you'd assemble a cast and put on a play; if you wanted to repeat the performance, you'd bring everybody back onstage and start over. Connecting with folk traditions was even more difficult. To enjoy or study the music of freed slaves—the music that would become gospel

music and blues—you'd first take a train to Memphis, then a horse and buggy to Jackson, Mississippi, and from there hope that a friendly field hand would direct you to a rural party house where the forebears of Robert Johnson or B.B. King might be scratching out some primitive lines on a fiddle or mail-order guitar. Scarcely more than a hundred years ago, access to the performing arts was infrequent and experiences short-lived, and if your taste led you toward one of the hundreds of vernacular forms of music, storytelling, or dance that defined much of America's diverse heritage, you had to proceed with an understanding that a firsthand glimpse of grassroots culture—in the Delta, in Appalachia, or on a Texas cattle ranch—might require a journey into an environment that was unfamiliar, uncomfortable, and perhaps even menacing.

Of course, every generation believes that it lives in an era of unprecedented change, and today there seems to be a signpost at every intersection telling us that this is a time of incredible technological transformation. Certainly, the Internet and digital transmission have altered the cultural system dramatically; we *have* encountered change in the past two decades, but in the early twentieth century new technology reworked the very character of American culture, allowing our vernacular performing arts to come forward and define a uniquely American cultural mainstream, which, almost from the beginning, exhibited a capacity for global reach. Sound recording and film, and later radio and television broadcasting, gave fleeting performances by unschooled folk dancers, singers, instrumentalists, and storytellers a permanence and portability that had for centuries been the exclusive province of literature, painting, and written-down classical music. For drama, dance, and humor, film allowed performances to be preserved over time and transported through space. A play produced in New York, captured on film, could be replicated precisely for audiences all over the country; a vaudeville comedy routine, written into a radio broadcast, could reach millions in an instant. Radio and records had an especially profound effect on the music of hillbilly musicians in the Appalachian Mountains and blues and gospel musicians from the Mississippi Delta—African Americans only a generation removed from slavery. As Leon Wynter observes in *American Skin*, "Where formal and informal segregation severely limited social interaction

between the races, the widespread ownership of phonograph records allowed whites to freely choose from an expanding array of black musical voices and bring them into their living rooms." When, in the 1960s, the Rolling Stones validated the blues for a generation of young Americans, they were acknowledging the power of media to disburse the vernacular language of our borderland society. America's vernacular expressive life—what critic Gilbert Seldes labeled the "7 Lively Arts"—when filmed, recorded, and broadcast, constituted something entirely new: a democratic alternative to art tailored to European elites.

The magical technologies of sound recording and film allowed grassroots art making to leapfrog over the print stage, memorializing greater detail than could ever be conveyed by a script or musical score. In a sense, film and sound recording one-upped the manuscripts that had for centuries preserved drama or classical and composed popular music. After all, manuscripts are essentially *prescriptive,* providing the musical notes or dramatic lines from which a full performance can be crafted by a skilled artist schooled in nuances of presentation that lie outside the manuscript or score. Film and recordings, in contrast, are almost perfectly *descriptive,* preserving every nuance of a particular performance. To hear a recorded performance of Louis Armstrong singing "Up a Lazy River" is a more complete experience than reading the lyrics and musical notation for the same tune (even assuming that the interested fan can read music well enough to hum the decoded melody). Reading Shakespeare requires aspiring actors to fill in many details with prior knowledge or imagination; watching Sir Laurence Olivier as King Henry is a more complete artistic encounter.

Just as time-motion photographs by Eadweard Muybridge allowed painters to craft a new approach based on deconstructed human and animal activity, movies and recordings enabled precise repetition of specific performances. Films and records created, in effect, a powerful *super-literature*—a documentation of every nuance of a performance sufficiently precise to put mere manuscripts to shame. For the first time in human history, it became possible to study the gestures, expressions, and diction of deceased actors to incorporate the subtleties of their work into contemporary performance. It was the character of sound recording—*repeatable*

precision—that enabled me, and thousands of other teenage guitar students, to imitate every note of complex performances by master musicians like Chet Atkins or Merle Travis.

Of course, technology also touched refined arts grounded in our Old World heritage. It expanded the reach of art forms such as literature and classical music, historically dependent on written manuscripts and print to preserve and advance their legacy. Foreshadowing the impact of recordings and film, improved printing technology had allowed the rise of the popular novel, and photography converted everyday life into works of art—ultimately freeing painters to explore abstract shapes and textures. In general, it can be argued that the technological revolution that triggered the emergence of America's cultural mainstream generated a kind of aftershock that greatly advanced our fine arts. Modern dance, abstract expressionism, and a cluster of authentically American classical music compositions all emerged between the 1920s and the 1950s.

But for America's grassroots art forms—the performing arts that historically had been relegated to the bottom of what Salonen called the "endless, stupid list"—technology added energy and reach that enabled jazz, blues, soap operas, vaudeville comedy, and tap dance to compete with and ultimately overwhelm those classical arts that dominated the age of print.

To bring the lively arts to an increasingly eager public, a new American arts system and new "arts industries" grew dramatically during the first three decades of the twentieth century. Edison introduced manufactured cylinders in the 1890s, but the industry gravitated to the flat, ten-inch record. Music of all kinds made its way onto molded shellac 78 rpm discs, introduced by Columbia Records in 1904; by 1921 record sales totaled $16 million, a figure that would increase tenfold over the next decade. In 1920 there were 20,000 silent movie theaters operating across the country, screens fed, in mid-decade, by fifteen film studios. In 1927 New York City's Roxy Theater opened, offering silent fare to 6,000 moviegoers. KDKA, our first commercial radio station, went on the air in 1920, and by 1923 a full-fledged radio boom was under way. Like recordings, radio was open to diverse voices; according to Wynter, broadcasting "allowed Americans to freely identify with their individual interests and desires

without regard to barriers of class, gender, ethnicity or race." Although it featured two white comic actors, the *Amos 'n' Andy* program offered a window into black culture to a depression-era audience that totaled an astounding one-third of the U.S. population.

Our arts heroes on radio, records, and in movies—Louis Armstrong, Jack Benny, Katharine Hepburn, James Dean, Bruce Springsteen, Bix Beiderbecke, Bill Monroe, B.B. King, Gene Autry, Desi Arnaz—were not only compelling exemplars of the social, creative, and economic opportunity available in America, but exactly the kind of vernacular artists who never could have built careers in the European world of "endless lists." My father's favorite record, Bunny Berrigan's "I Can't Get Started," featured a jazz trumpeter who grew up in Wisconsin interpreting a song cowritten for a Broadway review by a Russian émigré, performing in a musical style created by African American musicians in the Deep South. My father, an amateur singer and trumpet player, was the son of an immigrant laborer—a jazz record fan who grew up in a wide-open mining town in the Upper Midwest. He met his wife-to-be, my mother, through a shared affection for jazz. Their music-inspired courtship was only possible because technology had made vernacular culture richly portable. In its best formulation, records, movies, and radio encouraged the cultivation of multiple aesthetics, as Americans were, often for the first time, given the opportunity to understand and enjoy Jewish humor, cowboy folk songs, and New Orleans jazz.

Today, DVDs, movies-on-demand, satellite radio, the iPod, and ringtones top off the transition begun a century ago: Americans can engage the performing arts on our own terms, on our own timetable, at home, in the car, or while strolling or jogging in the park. We no longer need to accommodate the schedules of theaters and concert halls, which traditionally nurtured the connection between artists and audiences. Of course, first-run movies still insist that consumers leave home and gather at a specific time, but 2004 multiplex attendance was down, even as multiple screens and frequent start times have made it ever easier for fans to schedule convenient viewings. And today DVDs are released mere weeks— sometimes only a few days—after a film has opened on the big screen. The cache of live theater and music on tour persists, but *most* citizens

My parents, Bill and Grace Ivey, circa 1942. Technology enabled a northern Michigan romance grounded in a love of jazz. (Photo: collection of Grace Hammes Ivey. Fee: none.)

consume *most* performing arts through some form of technology—usually technology that delivers music, drama, and dance right into the living room or the family car.

But cultural change always exacts a price. The rise of vernacular art made possible by technology enriched America's expressive life, but the market-driven system producing films, records, and broadcasts evolved with little attention to the way the creation and distribution of art in America linked up to "Life, Liberty, and the Pursuit of Happiness." The problem lay not with these transforming technologies, and certainly not with the blues musicians, movie stars, and vaudevillians who provided early cultural "content." Instead, the public interest was subverted by the business practices that made up the rules and laid out the playing field for producing and consuming our modern mainstream culture.

The new media required big investments and complex distribution organizations. Inevitably, market forces and corporate practices began to reshape the relationship between audiences and culture. Increasingly, Americans became consumers, rather than makers, of art. In 1909

American piano factories built 365,000 instruments; in 1925, the year my mother began lessons, they built only 307,000—down significantly during a period when the U.S. population grew by 20 percent. To this day the 1909 annual sales total has not been equaled. By the 1920s new arts companies offering new arts products were converting engagement in art into an act of consumption. The notion of participation was reshaped—its sense of *doing* replaced by passive activities like purchasing a recording or attending a concert or exhibition. If we think of expressive life as split between the culture we *take in* and the culture we *create*, the commoditization of emerging art forms pumped up the taking in (consumption) at the expense of making art. As critic Michael Kimmelman points out, technology and rapid-fire concert tours have "eradicated music-making as a common activity, a shared experience in the home." The same can be said of drawing, the recitation of poetry, and "home theatricals."

Music education responded: If participation now means consumption, well, we'll nurture well-schooled discerning consumers. School music shifted from teaching young people to make music (mostly through ensemble singing) to something more like the intelligent enjoyment of music—what came to be known as *music appreciation*. Although it had been assumed that one had to perform or compose in order to be literate in music, it was now understood "that careful and intelligent listening could also be a sign of a musical person." Students in elementary grades still sang or played some rudimentary instrument (my grade school featured a black, recorder-like flute called a tonette) in an effort to teach basic notation. The talented were soon singled out and handed trumpets or saxophones. Thereafter, for the majority, it was music appreciation or nothing at all. It's true that sound recordings meant it was no longer necessary to journey to central Mississippi to hear the blues, but 78s also eliminated the need to master a musical instrument in order to entertain family with informal after-dinner concerts. Movies, records, radio programs, and television shows gradually but steadily drained from society some of the most obvious incentives to becoming a *citizen-artist*.

The arts products and new technologies that ushered in the age of cultural consumption were not created like works of art from the past. Movies, records, and radio shows bundled artistry and technical skill; no

individual artist, no matter how talented, could create a film, record, or radio drama alone. Unlike writing, composing, painting, or photographing, recording, filming, and broadcasting were inherently collaborative. They were also expensive, requiring not only the talents of artists but also the practical input of technicians, specialized studios, and complex broadcasting or distribution systems. Someone had to pay those upfront costs.

Movies, records, and broadcasts became America's dominant expressive forms, but in most instances there was no single "author" of these new arts products. So who would own the musical or dramatic content? The obvious answer was to place ownership and control of the finished product—the film, radio show, or disc—with the corporation that had assembled the creative team, financed the project, and distributed it to audiences. Fortuitously, the Supreme Court had ruled, in 1886, that corporations, in the eyes of the law, held many of the rights once reserved for individuals. The groundwork was firmly in place to permit corporations to, in effect, create and own the rights to new works of art.

This was something totally new. In the mid-nineteenth century even impresarios, those whose efforts to assemble a cast and crew resembled those of studios or record companies, didn't find any value in the performance of an opera, symphony concert, or play—beyond the admission fees charged at the door. A long run with full houses constituted success; a short run meant financial disaster. But without any mechanism for recording what took place onstage, thereby transforming a performance into a product that could be sold to audiences unable to attend the live event, producers of theatrical or musical works had no motivation to police ownership of the performance itself. Of course, composers were compensated when scores were purchased (and a *performance right* was created to ensure that composers would be paid whenever their work was staged), and actors, singers, instrumentalists, and technicians were also paid for their work, but once the marquee lights were extinguished and the sets and costumes packed away, the performance itself—the specific coming together of art and artists—simply evaporated.

In contrast, with the new technologies not only did corporations own works of art as though they had created them, but the earning power of the performing arts was severed from the arts event itself. Live audiences for

the actual performance became either incidental (in the case of radio shows) or unwanted (in the case of movies and sound recordings). Instead of paying for face-to-face performances, the audience purchased interchangeable parts (like records), bought tickets to one of hundreds of theaters that simultaneously exhibited duplicate film prints, or paid indirectly by rushing to the store to buy Ivory Soap, Lucky Strike cigarettes, or hundreds of other products that sponsored "free" programming over the radio.

Because corporations own or control some of the most representative and influential American art products of the past one hundred years, it should be no surprise that questions of ownership, access, gatekeeping, and price continually challenge any effort to understand and advance our cultural rights. Today's intellectual property law is a complex and at times nap-inducing subject, but it cannot be ignored, for copyright law helps shape the relationship between citizens and art. Our cultural rights are everywhere constrained or directed by forces that control creative work; we all need a working understanding of the basic rules of the road. I hope my approach is light and not too legalistic (I'm not a lawyer, so that part should be easy).

.

We bump up against the effects of our complex intellectual property legal system every day. Through copyright, film studios and record companies claim their "ownership" of movies and CDs (although it is both odd and increasingly problematic that sound recordings were not covered by federal copyright law until 1972). Copyright also lets authors decide who can publish their work and ensures that songwriters are paid when one of their compositions is recorded or performed in public. Stated simply, copyright is a government-protected right—a monopoly of sorts—that allows artists to produce copies of their creative work while preventing others from making copies without their permission. Copyright protects original words, music, images, and choreography. For Americans, it is an eighteenth-century legal innovation that has recently been reconfigured by Congress and the courts in an attempt to accommodate our twentieth-century arts revolution.

Copyright is a major component of U.S. intellectual property law, but

it is not the only one. It coexists with related rights like those that enable Barry Bonds to earn revenue from the sale of baseball cards featuring his photograph *(personality)*, protect the secret formula for Coca-Cola *(patent)*, and make it illegal to sell knockoff duplicates of Coach handbags *(trademark)*. Although the boundaries separating multiple intellectual property rights intersect and overlap, it's copyright law that has expanded most over the past thirty years. And, because it is attached to creative work, it's copyright that has exerted the greatest influence on the character of our arts scene.

Copyright law is grounded in a few words in the U.S. Constitution: "Congress shall have the Power . . . To promote the Progress of Science and useful Arts, by securing for limited Times to Authors and Inventors the exclusive Right to their respective Writings and Discoveries." Even though our courts have been generous to copyright interests by treating copyright as just another form of property, property protection is not the duty assigned to Congress by the Constitution. Read the constitutional phrase again: the power granted to Congress is to *promote progress*, not protect property. The limited term of copyright is also important, because the intent of the framers was not to institute a variation of property rights—like rights to a tract of land—that would secure ownership in artworks and inventions forever, but rather to encourage creativity. So once the term of copyright ends, work enters the "public domain" and can be used and reconfigured by anyone without permission—a steady flow of old art into new that, presumably, promotes progress. When our cultural industries were created, and for three-quarters of the twentieth century, that "limited" time was twenty-eight years, renewable for a second term of the same duration. And you had to register your copyright, submit a copy of the work to the Library of Congress, and actively renew your rights at the end of the first twenty-eight-year term.

Not only is copyright, as the Constitution specifies, of limited duration, but it also covers only a specific expression of an idea, not the underlying idea itself: Margaret Mitchell (today the Margaret Mitchell *estate*) controls the *text* of *Gone with the Wind* but doesn't own the *idea* of a Southern belle struggling for dignity and survival against the backdrop of America's

Civil War. Two other aspects of copyright law, both in place a century ago, have an impact on our cultural rights today. First, copyright applies to both the *creation* of a work and its *interpretation*. Think of it this way: a song and the performance of that song are separate creative acts; each can be protected against unauthorized duplication. Bob Dylan and his publisher control the copyright to the composition "Blowing in the Wind"; Warner Brothers Records controls the copyright to the hit recorded *performance* of the song by Peter, Paul, and Mary.

Using copyrighted material in a new way almost always requires a negotiation between the copyright owner and the user. If I want to use a clip from *Dirty Harry* in my documentary on movie violence, I need to discuss the license fee with Warner Brothers. I don't know what the license will cost until I describe my project in detail; the copyright owner determines what to charge. However, an important exception exists in the world of music: if a record company wants to release a recording of a song, the publisher and composer can't say no if the company will pay a rate prescribed by a government committee. The cost of this *compulsory license*—one that will let me record a classic George Gershwin tune on my new CD (even if the publisher would prefer a cut by a better singer)—is currently nine and one-tenth cents for every CD I sell. This revenue stream, first created to collect payment for the use of music in nineteenth-century player pianos, is the *mechanical royalty*.

Copyright protection can be considered either "heavy" or "light." As we will see, the heavy protection of copyright owners' rights has been ascendant in Congress and the courts for the past fifty years. Today, as copyright guru Lawrence Lessig explains, "the law's role is less and less to support creativity, and more and more to protect certain industries against competition."

How different it was in the early twentieth century! Our cultural industries, and the regulations and laws that influenced them, were "green field" endeavors. Copyright couldn't last longer than fifty-six years, music and book publishers rarely tried to collect fees for the quotation of lyrics or poems, the right of personality didn't exist, and much of American art was still homemade—"participation" meant the after-dinner sing-along, not a movie date. The outlines of a bold new arts system were

in place, but the overarching question was yet to be answered: Would America's artistry—the great metaphor for our diverse democracy—evolve as a public good or a private asset?

·　·　·　·　·

As sociologist Pierre Bourdieu observed, "The consumption of art works constitutes one of the supreme manifestations of ease." At the very moment America's lively arts arrived, borne on the wings of technology, wealthy urban industrialists seized upon "fine art" as a symbol of achievement and a marker of class distinction superior, in its lack of apparent utility, to both yachts and high-end real estate. At the same time, however, that the U.S. copyright and regulatory systems were laid down and America's entertainment industry advanced, dance and opera companies went in an entirely different direction, sidestepping emerging market forces by embracing a business model based on old-time patronage, combining the newly created nonprofit status with old-fashioned philanthropy. As Lawrence Levine, Paul DiMaggio, and others have pointed out, by 1900 the fine arts had become closely aligned with the social aspirations of philanthropically able, big-city financial elites. In his landmark study of cultural entrepreneurship in Boston, DiMaggio observes that as early as 1890 the city was home to four hundred millionaires. For this wealthy cohort, classical music, sculpture, and painting offered an arena of "exclusivity" and "the definition of a prestigious culture they could monopolize as their own."

It was everywhere assumed that classical music and the other fine arts possessed unique social value. However, during most of the nineteenth century high art functioned cheek-by-jowl with rough-and-tumble entertainment. Museums of the era were a far cry from today's cultural temples; instead, they resembled P. T. Barnum spectaculars, with paintings exhibited alongside two-headed calves and demonstrations of the amazing effects of electrical current. Classical music itself was not above employing show-business tactics; an outdoor performance in New York by the Thomas Orchestra featured piccolo players on tree limbs and tubists hidden in the shrubbery. But as social elites gained control of museums and classical music ensembles and as Brahmins and their ilk (what

DiMaggio labels "organization-forming status groups") took over leadership positions on the boards of arts organizations, refined behavior and symbols of status switched the fine arts onto their own side track. Audiences gussied up in formal attire, gathered in cultural shrines named for wealthy donors who had financed their construction, became hallmarks of the symphony, opera, ballet, and art museum.

When Alexis de Tocqueville toured the United States in the mid-1830s, he praised early "civil associations" as unique incubators of human and community development. Almost two centuries earlier, when Massachusetts chartered our first nonprofit corporation (Harvard University), it codified the idea of these civil associations and launched the business model that would allow most of America's fine arts to organize as public charities, updating an Old World tradition of public and private patronage. As Seattle journalist Matthew Richter correctly observes, the nonprofit dream held great potential: "It was an entirely new way of thinking about *business*—as an ownerless, mission-driven entity that worked not for the glory of a man but for the glory of mankind." In 1917, at about the same time that the radio, film, and recording industries appeared, changes in the federal tax code exempted nonprofits from tax payments while simultaneously permitting patrons to deduct donations from personal taxes due. Thus, the government became a policy partner supporting the city ballet, symphony orchestra, and art museum, and nonprofit status became a marker of our fine arts scene.

Schools and hospitals were obviously deserving of the benefits of tax exemption, but for the fine arts to retain their position of social value, they had to be special, so it was necessary that other art—popular art—be maligned. The term *highbrow,* derived from the influential pseudoscience phrenology, entered American discourse in the 1880s; its obverse, *lowbrow,* became part of the vocabulary about a decade later, just as the new arts industries were injecting our vernacular arts with cultural clout. Once the high/low juxtaposition was established, social elites derived ongoing benefit from keeping popular entertainment, no matter how "excellent," locked in the lowbrow basement. As Levine wryly observes, American society understood that Fred Astaire was a great dancer, Louis Armstrong a wonderful singer, and Charlie Chaplin an incisive social critic,

but the work of such artists was kept at bay by the "popular" label. High art, on the other hand—"Culture" with a capital C—was rendered safe because it was a bastion of all that was "fine and pure and worthy." If our vernacular mainstream allowed Americans to shop for culture in a vibrant, open marketplace, encouraging citizens to take up the aesthetic principles of many artistic traditions, the elite assumptions attached to the fine arts worked to shut down those inclinations. The cultural nonprofit organization institutionalized the distinction between the "fine" and "popular" arts, and provided financial elites with exclusive access to art that conveyed prestige, was socially valued, and was located at a safe distance from the music, dance, comedy, and drama fueling the rise of America's arts industries.

Just as early copyright mixed with market forces to sketch a U.S. arts system to come, so did elitist assumptions combine with nonprofit status to lay out the model within which America's fine arts would evolve. The basic elements of our U.S. cultural system were in place a century ago: movies and recording were advancing in an unrestrained marketplace; the nonprofit fine arts had settled into a twentieth-century version of patronage. Since then our arts scene—already divided one hundred years ago—has evolved on its own pretty much free of coherent policy intervention, and like snowballs tumbling down a mountainside, over time both parts of the system gathered size and momentum.

In some ways the U.S. cultural scene at the end of the nineteenth century can be likened to that of many Third World countries today— free-for-all arts environments in which technology and global finance are interacting with traditional societies, stirring up a confusing array of positive and negative effects. But today emerging cultures have advantages absent in the United States one hundred years ago. In the twenty-first century, as corporate interests and technology collide with traditional art in Africa, Asia, and Latin America, a decade-long conversation within UNESCO, the World Intellectual Property Organization, and the U.N. itself has established a number of agreements and practices designed to ensure that the commercial interests of intellectual property companies do not overwhelm or exploit the creativity of Third World communities. But in the United States of 1900 no such protection existed;

at the same time that technology allowed grassroots art to bubble up into a powerful American cultural mainstream, that mainstream was, at its point of origin, entirely in the control of emerging arts industries. No business or arts leader in the early twentieth century harbored the slightest notion of "cultural rights"; that concept would only emerge decades later, in a global, not a domestic, context. It shouldn't be all that surprising that public policy in the United States has never caught up with the reality of our arts scene.

• • • • •

Cultural rights are the key to bringing the public interest back into America's creative life. In the United States today the idea that a blogger, soccer mom, and weekend guitar player need to fight for "cultural rights" may seem novel, even counterintuitive. After all, culture is all around us—music on the radio, movies on cable television, ringtones on phones, TV clips on iPods, the design of a favorite sports car—easy to find when we want it; just as easy to ignore. In the United States culture is just *there*— part of the backdrop, seemingly both plentiful and available.

But culture is more than the surface sheen of civilization; it's an important reservoir of both identity and individual expression—a reservoir that must be well secured. Around the world, over the past half century, cultural rights have gradually emerged as a subset of *human rights,* the essential privileges designed to protect individuals from political exploitation and oppression. Human rights have a venerable place in the founding documents of a number of nations, mostly those Western democracies that seek to derive government authority from citizen consent. Ironically, although the U.S. Constitution is a pioneering human rights document, we Americans have been minimally engaged in official international human and cultural rights movements.

Typically, human rights are grounded in Enlightenment philosophy, in the Protestant concept that all are equal in the eyes of God, and are sustained by the eighteenth-century notion of the value of equal, self-interested actors taking part in the operation of a free-market economy. Such constitutional or charter rights are assumed to apply to all, and historically they have usually been framed to limit the power of government—

specifying what government *can't* do as opposed to asserting what citizens *can*. By establishing the boundaries of appropriate government authority in the form of citizen rights, the limits of state authority are made clear and simultaneously elevated and secured. It is in this sense that the U.S. Bill of Rights offers a set of "declaratory and restrictive clauses" attached as amendments to the Constitution for the purpose of "extending the ground of public confidence in the Government." The first phrase of the First Amendment begins, "Congress shall make no law respecting an establishment of religion"; the Second Amendment concludes, "the right of the people to keep and bear Arms, shall not be infringed." This formulation of individual rights—as limits on government authority—is woven through the U.S. Bill of Rights and has become standard language in democratic documents of self-determination.

The idea of cultural rights did not enter the minds of eighteenth-century political thinkers. "Cultural rights" made its way into the vocabulary of international public policy through Article 27 of the Universal Declaration of Human Rights, passed by the U.N. in 1948. This document asserts that every human being "has the right freely to participate in the cultural life of the community, to enjoy the arts and to share in scientific advancement and its benefits," as well to benefit from "the protection of the moral and material interests resulting from any scientific, literary or artistic production of which he is the author." This new notion of cultural rights, drafted by committee and advanced, not by a government, but by a multinational organization, represented a significant expansion of the scope and intent of human rights. For one thing, groups as well as individuals were assumed to possess cultural rights. More important, these "rights" advanced through international conventions were framed in a new way—not as *constraints* on government authority, but instead as *demands* for greater community and individual authority in an area of human experience: culture. Moving beyond limits on government authority, Article 27 marshals language that signifies access and involvement; "participate," "enjoy," and "share" define the ways citizens of the world *should* engage culture, assertions that by implication suggest that for many something is absent—that at the time the Universal Declaration was put forward millions didn't "participate," "enjoy," or "share."

Since the middle of the twentieth century, the notion of individual and group rights has steadily expanded in this way. In 1992 the U.N. Declaration on the Rights of Persons Belonging to National or Ethnic, Religious and Linguistic Minorities reworked the old concept of individual human rights, expanding it to cover communities, tribes, and groups. The 1994 U.N. Declaration on the Rights of Indigenous Peoples and UNESCO's 2002 Universal Declaration on Cultural Diversity continued to assert the rights of groups within larger societies, in some cases challenging existing policies of nation-states.

The advance of cultural rights in a global context has exhibited a distinct character, one that doesn't speak to the American experience. After all, in France, China, and Germany, and in many former colonies of European powers, culture is "normative"—a standard against which authentic citizenship can be measured. As NPR's *Morning Edition* reported, the 2007 presidential campaign in France was "invigorated" by "a debate about national identity." France already requires foreigners seeking residency to sign a pledge promising to respect French values, and new conservative president Nicolas Sarkozy has proposed the creation of a Ministry of Immigration and National Identity. The campaign debate over culture and identity in France had as its backdrop suburban violence that underlines the difficulty of linking immigrants with the values of old societies in which a monolithic culture provides the only acceptable markers of belonging. Certainly France and many other nations operate on the premise that culture *precedes* government, so it's no surprise that the job of balancing the rights of competing cultural traditions, or staking out rights of minority communities in relation to an overarching, dominant culture, would emerge as a primary task of national and international policy. And, in fact, for most of the world, cultural rights are about asserting the status of native languages, the preservation of traditional practices, and the protection of indigenous communities in relation to the political power of a preexisting dominant monoculture that controls and defines government.

This sense of cultural rights has expanded the scope of basic human rights beyond their Enlightenment roots, and while the United States lacks the specific set of issues embedded in a European- or Asian-style normative cultural identity, we have steadily embraced a more assertive sense of

rights than the one expressed in the Constitution. When U.S. political movements organized to ensure full participation in society for racial and ethnic minorities, for women, and for the disabled, they were advancing a perspective on rights similar to the one promoted internationally—a view of rights not only as a protection *from* something but also as a way to advance a moral claim *to* some perceived benefit of citizenship. A *right*, in this sense, becomes "something to which one has a just claim."

Our Cultural Bill of Rights is in part foreshadowed by this kind of recent thinking, making the same kind of affirmative argument—that citizens of a mature democracy possess a just claim to a cultural system that enables them to engage heritage and expand individual creative capacity. Fortunately, because the United States has never been dominated by a single national culture, we can focus our discussion of cultural rights on the policies that ensure that a healthy cultural *system* is focused on public purposes and is capable of serving all. After all, the United States has never viewed culture as normative, and although we have never been free of cultural conflict, no convincing dominant American culture has ever been defined. Such a state of affairs is in a sense our unique birthright, for unlike most of the world, in the United States culture *followed* politics. Our system of government was one hundred years old before the character of our cultural mainstream emerged. Diverse and multicultural at birth, the United States has never been burdened with the European "monocultural fantasy." In the United States, groups struggled against each other, not against a permanent monoculture. Our assertion of cultural rights can sidestep the drowning pool of cultural relativism and instead take on the challenges of *arts relativism,* a critical but far less volatile arena of difference and debate.

But the absence of a normative national culture also means we're getting a late start. For the United States, cultural policy still languishes as the final, mostly unexplored realm of public policy. In fact, the cultural rights of U.S. citizens may actually need to be *reclaimed* as a domain of public interest and human development, because the state, as our agent, long ago ceded far too much authority over our creativity and heritage to a web of commercial interests. But that's not all bad. Because we're later to the dance than European democracies, we have a special opportunity to get

it right, to sidestep ethnicity, race, and the burden of an established national culture and directly take on individual creativity, the vitality of our expressive life, and the health of our arts system.

I'm not so naive as to believe our Cultural Bill of Rights will immediately transform public policy or corporate practice, and I don't expect our Cultural Bill of Rights to become law, Montreal-style, nor do I anticipate that lawsuits will be filed when a citizen perceives that his or her cultural rights have been violated. Instead, the Cultural Bill of Rights is placed as a kind of chip on society's shoulder—a set of principles that challenge policy leaders, arts-industry executives, and arts advocates to either stand up and justify the status quo or join in a process that will shape a new cultural landscape appropriately tilted toward the public interest.

· · · · ·

As you may have noticed, *culture* and *art* are used almost interchangeably in the first pages of this volume. Both terms are problematic. *Art,* of course, sometimes refers to painting or sculpture and sometimes to the fine arts in general, encompassing music, theater, dance, and the like. For the most part, I use the term in its broadest sense: for what has been called highbrow and lowbrow; folk, popular, and elite; street and staged; visionary and schooled; religious and secular; nonprofit and commercial. *Culture,* as it is employed in American English, is even more challenged, denoting so many conflicting ideas that this term has almost lost its utility. Over my career in the arts I have witnessed the efforts of many committees unravel while talented specialists struggled to settle on an acceptable definition. Lawrence Harrison and Samuel Huntington, writing in *Culture Matters: How Values Shape Human Progress,* summarize three definitions: first, "the intellectual, musical, artistic, and literary products of a society," its "high culture"; second, what could be termed an "anthropological" definition, "the entire way of life of a society"; and third, "the values, attitudes, beliefs, orientations, and underlying assumptions prevalent among people in a society." Culture, paired with the concept "rights," contains bits of each definition. I employ a sense of "culture" narrower than the broad definition offered by UNESCO (the way of life of a society), but more inclusive than "values." Culture seems to be

bigger than a catalog of attitudes and beliefs—our religious or political philosophy per se. And, as readers may already guess, I won't be using *Culture* in its capitalized sense, to denote the refined or "high" art that every citizen should consume daily, like some good disease-preventing tonic. Of course, Culture, much of it sustained by nonprofit organizations, is part of my story, but fine arts policy has become a narrow backwater where far too much of our conversation about America's arts system has long been moored, safely out of sight. For me, the "culture" to which we have a "right" is our expressive life, the creative capital that is at once our nation's heritage, a contemporary gateway to personal achievement and excellence, and the engine of our cultural commons.

What do I mean by *expressive life?* As I worked through this volume, thinking about citizen rights, cultural vibrancy, and the role of heritage and individual creativity in quality of life and happiness, "expressive life" began to feel more and more substantial and useful: a realm of being and behavior that, with a bit of explication, can be as distinct as "family life" or "work life." My folklorist colleagues will recognize *expressive life* as something akin to *tradition,* a place where community heritage interacts with individual creativity, maintaining the past while letting in the new. Folklorists work with the heritage/autonomy distinction all the time, observing that the performance of a folktale or folk song always contains a mixture of the fixed, community version of a long-lived artwork and the individual creative voice of the performer who gives the tale or song life. Imagine a gland or an organ located halfway between mind and heart. Half of it is a reservoir for heritage—religious and family traditions, acquired knowledge and skills—a kind of cultural stock portfolio that connects us with history, shared values, and community, giving us the strength that comes from a sense of belonging and place. The other half of our expressive life sustains something quite different. Here can be found our individual voice, a place where we can be autonomous, inventive, accomplished, and cosmopolitan—a realm of action where we can sometimes even dare to challenge the conventions of community, received knowledge, and family heritage. A high quality of life depends on the uncomfortable coexistence of both components of expressive life; because this balance engages both the tradition and the process of democ-

racy, it is a public good. The notion of a space where we are simultane-
ously grounded and set free is not brand new; it's contained in Thomas
Friedman's notion of the tension between "the olive tree and the Lexus,"
and it underlies philosopher Kwame Anthony Appiah's conviction that
respect for cultures must be balanced by "a respect for the freedom of ac-
tual human beings to make their own choices." Expressive life is the in-
terior space where heritage and free expression operate simultaneously.
Framed in political terms, expressive life is the place where history and
political precedent are balanced by free speech. The vitality of both halves
is critical. If we can take the measure of the vibrancy of our individual and
collective expressive lives, we can understand just how well our arts sys-
tem is securing our cultural rights.

Expressive life flourishes or declines with the health of our arts
system—the processes of retention, production, and circulation that de-
termine choice, access, and free expression. This system is both official
and informal, visible and hidden. As French philosopher Michel Fou-
cault would assert, control and authority in cultural matters are spread
through every level of government and throughout society, defined and
enforced by many private-sector actors. Both heritage and individual
voice can be diminished by power and authority spread silently
through our cultural system. Today our expressive life is shaped within
an arts system dominated by gatekeepers and market forces—by Target,
Microsoft, Sony-BMG, the Metropolitan Opera, and lawsuits against
students who download music or movies—a system with no mecha-
nism to align action with the public interest. How do we maintain vi-
brant expressive lives in an arts scene dominated by the outlook of big
business?

Government has not responded; it has failed to protect the expressive
lives of citizens and instead politicized and trivialized the cultural con-
versation, even allowing self-interested punditry, advertisers, and media
executives to trample free-speech principles. Two names, Mapplethorpe
and Serrano, still define our National Endowment for the Arts. As Toby
Miller observes, "Public policy debate is minimal in comparison with ar-
guments over whether television rots your brain, or videos turn you into
a mass murderer."

Early in the twentieth century, technology enabled America to discover its cultural mainstream and, by extension, its diverse national identity. Technology made the arts, especially the performing arts, part of daily life as never before. But the business, nonprofit, and public policy models that grew up around our twentieth-century arts enterprises have not protected the rights of citizens within our cultural system. There is much to admire about the democratic character and unique quality of American artistry as we begin the twenty-first century, but as our society encounters a new revolution in technology and work that will irresistibly reshape our hundred-year-old arts system and society itself, it is crucial to understand that a commitment to securing citizen rights in the cultural sphere is long overdue. An unconstrained marketplace has placed barriers of price and access between citizens and cultural choice, and government policy has failed to intervene to help align our arts system with public purposes. The assertion of a cultural bill of rights is America's starting point for a new set of policy interventions strong enough to define and protect citizen rights while nurturing expressive life, quality of life, and happiness.

ONE Heritage

The right to our heritage—the right to explore music, literature, drama, painting, and dance that define both our nation's collective experience and our individual and community traditions.

"Come Friday."

"But Jack, it's Monday now; we'll have to get a truck."

"Just come up this week. If we don't move these things now, they'll be gone."

It was summer 1973. The caller was Jack Loetz, a graying senior marketing executive with Decca (now MCA) Records, based in New York City. I was director of the Country Music Foundation in Nashville; Jack was a dedicated fan of early country music, a trustee of the CMF who took special pride in Decca's country legacy, a legacy that boasted classic recordings by Patsy Cline, Bill Monroe, Ernest Tubb, and Loretta Lynn.

He was calling about a record collection at risk. "Decca's pulling out of New York, moving to L.A.," Jack told me, "and I'm not going west with the company, I'm retiring, and I'm worried about the Decca archive of

78s. Why don't you come up here and we'll see if we can get the country material transferred to the Foundation in Nashville."

Loetz's offer was exciting. Under the guidance of record producer Owen Bradley and his predecessor, Paul Cohen, Decca was arguably country music's flagship label, and the early 78 rpm discs cut in New York and Nashville would be an invaluable addition to the CMF's Nashville archive. "The whole company is moving by the end of this month," Jack said. "Get up here quickly. I'll meet you Saturday morning."

So, with Danny Hatcher, a colleague from the CMF library staff, I flew to New York. Jack was gracious; he treated us to lunch at Jack Dempsey's, the legendary beefery and hangout for "Brill Building" songwriters, and he introduced me to Johnny Marx, the reclusive composer of "Rudolph, the Red-Nosed Reindeer," who kept a small office above the restaurant. We acquired a dusty U-Haul truck from a scraggly lower Manhattan gas station that ran a truck-and-trailer rental business on the side and pulled up to MCA's Broadway headquarters building at eight o'clock on Saturday morning. With the glaring orange and silver truck parked conspicuously in a Broadway loading zone (it helped that it was Saturday), we met Loetz at the door and were escorted past the guard, up the elevator to an eleventh-floor room crammed with shelves supporting the not insignificant weight of thousands of ten-inch 78s.

These were Decca's official file copies of commercially released pressings. The MCA executive had personally selected the mint copies of Decca country discs from the corporate archive; he had, by himself, packed more than 2,500 records for shipping. As we made trip after trip up and down the elevator, lugging boxes through the marbled lobby, past the guard, to the truck, which amazingly hadn't been towed away, Jack talked about his fears for the collection. He didn't think management cared about it and was concerned that the discs would be lost, destroyed, or damaged in the corporate move to Los Angeles. His worries were supported by the intuition that as a boutique division of a relocating media giant, Decca's record business might not get the attention it deserved from Hollywood bigwigs interested mostly in movies.

By mid-morning the task was finished, "good-byes" and handshakes concluded, and the truck loaded, ready for the drive back to Nashville. As

we worked our way out of Manhattan onto the New Jersey Turnpike, it dawned on me—there'd been no paperwork, no contract; no acknowledgment of a donation. Record company archives had long been mined by insiders who spirited away rare originals for sale to collectors. Jack, for a higher purpose, had simply "appropriated" those rare Decca 78s. By nightfall we were in Virginia, rolling south through the sunset-bathed Shenandoah Valley. Two years later we would sign an agreement making the "donation" legal. But tonight, while Danny drove, I leaned back against the seat and closed my eyes, nearly 3,000 "liberated" Decca file discs secured behind me. We'd stolen a record collection, and I was a certified guerrilla warrior in the battle to save America's cultural heritage.

· · · · ·

America's expressive life is a mirror of our society's evolving values and aspirations. Part of our expressive life is all about autonomy and achievement—art that conveys our individual voices, a marker of independence and personal authority. But expressive life also is a container for heritage—the accumulated creativity of our community and our nation. As historian Kevin Starr observed, "A culture failing to internalize some understanding of its past . . . has no focus on the promise and dangers of the present." Bonnie Raitt put it more succinctly: "Music is history you can dance to." And she might just as easily have mentioned movies or old radio programs.

My folklore training, emphasizing continuity and tradition, gave me a special interest in how well Americans are able to stay in touch with music, drama, and images that link us to permanence and place. Once a movie has ended its run at the Roxy or a record or book dropped from lists of hits and best-sellers, each instantly becomes part of the accumulated body of music, drama, dance, comedy, literature, and visual art that constitutes our nation's cultural heritage. And just because some company owns a movie or a record, just because copyright lets it buy, sell, or lock away creative treasures, we don't give up our citizens' right to know that our artistic heritage is secure and preserved for future generations. Americans have an equally compelling right to see and hear art from the past; a right of access sufficient to ensure that young citizens can gain

knowledge and understanding by actually hearing and seeing art from earlier eras. As record historian Tim Brooks put it, "Now more than ever before, preservation and access are inextricably linked."

But the average citizen hasn't fully grasped the alarming truth that our creative heritage is mostly owned, lock, stock, and barrel, by multinational companies that aren't even headquartered in the United States. Parents today have no assurance that music, drama, literature, and dance created over the past century will be made available, or that, when we look for it, the heritage we seek will exist. We worry about the impact of foreign ownership in defense and technology, but to this day our arts system has not been subject to the kind of public scrutiny and policy pressure required to ensure preservation of and access to America's cultural mainstream.

We've all seen the image of JFK Jr. saluting bravely as the casket of his slain father is carried from St. Matthew's Cathedral to begin its journey to Arlington National Cemetery; it's one of the most compelling and familiar images of twentieth-century American photography. For millions of Americans this photograph, cropped from a wide shot, conveys both the personal and national dimensions of the Kennedy assassination. The continuing significance of a decades-old photograph only underscores the capacity of a powerful documentary image to transport us over time, connecting us with a shared period of national tragedy and mourning. Images or sounds from the past often display this kind of cultural sturdiness, and photography was the first of several technology-based art forms—including movies, records, and radio programs—that expanded the reach and staying power of America's national experience during the twentieth century. Once created or manufactured, such art products served as containers of America's cultural heritage—a solid bridge of real-world sounds and images linking the present with decades past. In 1963 the JFK Jr. image could send a message all over the world almost instantaneously, but, more important, it preserved a distinct historical moment. What was *journalism* in 1963 became *history* only a few years later.

But the photograph is not reproduced here only because it highlights the importance of our nation's expressive heritage—certainly it does. Its presence makes an additional point; regardless of its significance, the photograph appears in this volume because I paid for it. I paid because,

Photographer Stan Stearns's famous image of JFK Jr.'s salute at his father's funeral—first published in *Life* magazine—has always been owned by one corporation or another, offering a classic example of heritage as corporate asset. (Photo © Stan Stearns/Bettmann/CORBIS. Fee: $330 for quarter-page inside book placement and a press run of 25,000.)

in the U.S. cultural system, that image—like most of the art that defines the American experience—is simultaneously *cultural heritage* and *corporate asset*. And, in pursuing my determination to incorporate this historic photograph in my argument on behalf of cultural rights, I first had to seek permission from the corporation that owns the image. You might expect that I would have sought permission directly from the photographer whose talent and imagination captured the moment in the first place, but that would have gotten me nowhere. In the world of technology-dependent art forms, the creator generally does not end up controlling, and sometimes even owning, the rights to his or her own work. Instead, anyone who wants to incorporate heritage art into something new must acquire the assent of the corporation where the *rights* to that creative work reside.

The JFK Jr. image was taken by Stan Stearns, using a telephoto lens with fast black-and-white film, on November 25, 1963. Today the copyright to the photograph has ended up among the millions of images owned by Corbis, the intellectual-property asset company created by

Microsoft founder Bill Gates. Long before the photo was taken, Stearns had bargained away any ownership rights to it, for at the time of the Kennedy funeral he was a salaried staff photographer employed by United Press International—the global news service that then competed head-to-head with the Associated Press. Although copyright is designed to provide limited protection for the rights of artists, as a salaried employee, any of Stearns's images created while on assignment were "works for hire"—creative work deemed to belong automatically to whatever entity was paying the artist's salary. "I got $25 for winning 'picture of the month' [at UPI]," Stearns said, "that and my regular paycheck." The copyright to the JFK Jr. photograph first belonged to Stearns's employer, UPI. Rights were transferred to the private Bettmann Archive when it purchased UPI's entire photo collection in 1984; eleven years later Bettmann was absorbed by Corbis.

So the JFK Jr. salute photograph began its life in the sixties as the work-for-hire archival property of the number two international news service. Although Corbis now controls the image, the Stearns picture spent its middle years as part of a vast collection assembled in the Bettmann Archive, historically one of the largest and most well regarded photographic collections in the world. Founder Otto Bettmann was a quirky but not atypical pioneer of for-profit archiving. His collection of prints and negatives, packed in steamer trunks and spirited out of Nazi Germany by Bettmann in 1935, was initially housed in his Manhattan apartment on West 44th Street. By 1938 the collection had only 15,000 images. But the collector's holdings grew steadily; by 1981, when Bettmann sold the archive to the Kraus-Thomson Organization, the transaction included more than 10 million photographs. Following the pattern established by Bettmann, Kraus-Thomson itself then acquired a number of additional, smaller archives, incorporating them under the Bettmann name. When the newly constituted Bettmann Archive absorbed the extensive UPI collection in 1984, the Stearns JFK Jr. shot went along. The additional UPI photographs expanded the total archive to 17 million images.

Today the JFK Jr. photograph can be viewed by any Internet-enabled citizen simply by opening the Corbis Web site. However, if you want to do anything more than look at a two-by-three-inch version of the

picture—should you want to reproduce the photograph in a book, for example, or exhibit a print in a museum, or include it in a documentary film—permission must be granted by the corporation that controls the copyright to Stearns's photograph.

Corbis is aware of the unique value of the photograph; it was among the first Bettmann images digitized. Preset rates have been established by Corbis for a number of easily anticipated uses of the shot, and standard licenses can be secured with online efficiency. However, when a project is outside the scope of prepriced uses, the licensing fee becomes a matter of what the traffic will bear. For a company like Corbis, the going price for a particular use is determined by the character of the image itself in relation to the perceived commercial potential of a specific use: *People* magazine pays more than the *Journal of American History,* and the JFK Jr. image costs more than, say, a generic photograph of sunglasses. Similar calculations determine rates for licensing old movie clips, music for documentary films, and sound recordings for CD compilations. Executives who control historical cultural assets—often individuals with little understanding of what's in corporate archives—ask themselves, "How indispensable is this item, and how much money might the licensor make?" If the JFK Jr. shot is essential to a project, or, heaven forbid, you've already printed the book or edited the film *before* securing rights, get ready to fork over significant money.

When an actual historical object—a disc recording, a piece of photographic paper, or a few hundred feet of film stock—has value only because of the image or sound it contains, the item is often referred to as *intangible* cultural heritage. The concentration of ownership of America's intangible cultural heritage in fewer and fewer hands has followed the trend toward consolidation in our arts industries. Today how much we have to pay for access to the past is determined by a shrinking cohort of corporate players. But the growing global demand for media content has also increased the perceived value of iconic cultural assets. In fact, the *business* of archives—charging fees for new uses of copyrighted images, films, and recordings—is enhanced only when a collection is sufficiently large to become the obvious "go-to" location for anyone requiring access to sights and sounds from the past.

It should thus come as no surprise that software pioneer Bill Gates was among the first to see that digital imaging and transmission would vastly increase the demand for visual material of all kinds. But Corbis was not initially in the business of acquiring existing archives, photographic or otherwise. Instead, immediately after its formation in 1989, the company set out to obtain the digital licensing rights to works of art in the permanent collections of prominent nonprofit and government-managed museums and archives. Gates was anticipating future opportunities to license artworks to owners of devices like flat-screen TVs. Taking full advantage of his insider's grasp of the commercial potential of content on the electronic frontier, Gates understood that art museums in effect controlled the copyrights to early paintings and photographs in their collections, and he also understood that the fine arts world hadn't yet grasped the import of licensing opportunities that would soon be created by the Internet and the digital revolution. Corbis sought to tie up exclusive rights in the digital domain to art treasures in museum collections.

In its negotiations with a museum community innocent of the dawning Internet age, Corbis was able to secure exclusive rights to a number of important collections for a relative pittance. Early on, London's National Gallery, the Philadelphia Museum of Art, and St. Petersburg's Hermitage licensed their collections to Corbis. But the museum community quickly wised up; within a few years Corbis's ability to obtain bargain-basement digital rights agreements had nearly evaporated. That's when the company refocused on building its own collection.

While Gates had initially envisioned Corbis as the company that would, for example, market digital images of great paintings for home display and had secured rights to museum collections accordingly, that model didn't take hold. As Gates recently observed, "Some of the [Corbis] vision won't be here for another five more years." Shifting to a natural plan B enabled Gates's company to absorb a vast collection of twentieth-century news and lifestyle images. It was to this end Corbis acquired the Bettmann Archive in 1995.

Bettmann, like Corbis, had always been a for-profit operation, charging a range of fees for the use of copyrighted images in books, magazines, television documentaries, and so on. In fact, *most* of America's

twentieth-century cultural heritage—movies, sound recordings, old tele-vision and radio shows—gets preserved and disseminated in exactly this way: a company foots the bill for storage, preservation, and retrieval, cov-ering expenses and delivering a bottom-line profit by charging for every use of historical material. Obviously, in radio, TV, and movies, many archives are owned by the companies that created the films or records in the first place. Photo collectors like Otto Bettmann and owners of smaller private archives like Frank Driggs and Michael Ochs rarely paid to have photographs shot but instead purchased existing images, growing their collections over time. These entrepreneurial archivists were passionate about history, and sometimes about specific subjects. Driggs collected jazz images; the much younger Ochs focused on rock 'n' roll. Driggs still maintains his collection in seven tall file cabinets in a Soho basement. In an NPR interview he recalled scouring the alleyways behind New York record company offices in search of discarded photographs: "I noticed a big laundry basket of pictures that were being thrown out either because the artists were no longer under contract or they didn't want to keep the files. So I just raided it; I took everything I could." Early archives were like this—labors of love created by devoted fans of history and art. Today it's business. Corbis and other image archives are big moneymakers, policing copyright-protected revenue streams attached to products created as works for hire or financed by others, so it only makes sense that Frank Driggs put his collection on the market.

The very success of Corbis in pioneering the control and exploitation of heritage property reveals the disturbing vulnerability of America's in-tangible cultural heritage: Corbis is positioned to make money by licens-ing the use of photographic images any way it pleases in part because it scooped up cultural assets without having to accommodate a public in-terest in photographs as heritage. Using marketplace clout to accumulate cultural assets, Corbis and its ilk operate in head-to-head competition against nonprofit organizations and government agencies that treat both preservation and access as high priorities on a public service agenda. But, despite their dedication to preservation, public and nonprofit archives operate at a disadvantage: they almost never control the *rights* to items in their collections. The very existence of Corbis, and its ties to Microsoft's

My father's favorite jazz trumpeter was Bunny Berrigan, a respected soloist who grew up, not in New Orleans, New York, or Chicago, but in rural Wisconsin. This familiar 1937 shot of Berrigan is from the privately held Frank Driggs Collection. The tenor sax player in the background is George Auld. (Photo: Frank Driggs Collection. Fee: a mom-and-pop-archive price of $100.)

Bill Gates, reinforces the notion that in the digital age the ability to *own*, or at least *control*, content—especially heritage content of cultural significance—constitutes an essential marker of market dominance.

Is our *right* to cultural heritage fulfilled if we're allowed to buy our way into access to the past? Does it make a difference that our familiar image of JFK Jr. is part of a global archive of more than 100 million images exploited for profit by a super-mogul of the computer software industry? Should the public see iconic images from our nation's past only if an author, magazine publisher, or television producer pays a price set by the marketplace and enforced by companies that control copyrighted heritage? In a hundred-year-old arts system defined by an unfettered marketplace, tension between culture as *asset* and culture as *heritage* is inevitable. But when a company makes available only what it thinks will sell and then demands the maximum payment possible, the public interest is not well served.

Are market forces enough, first, to *preserve* heritage and, second, to *make it available* to enrich the expressive lives of citizens?

Let's look at Corbis again. As already indicated, the company controls 17 million images in its Bettmann Archive alone, with total holdings having surpassed the 100 million mark. Of course, not all these are cultural treasures; as with any massive historical collection, a significant percentage of the whole probably possesses little or no lasting historical value. For purposes of argument we might surmise that 50 or even 60 percent of the Corbis Bettmann Archive is ephemeral and of little significance. However, that calculation would still leave 5 million or 6 million heritage images, and today Corbis is not actively making available ("rights managing") anything close to that total. In fact, citing the high cost of preservation and access, the company moved the great bulk of the Bettmann Archive from its midtown Manhattan site to an underground storage facility in Pennsylvania. At the time of the transfer, Corbis explained that it had "edited" about one-fourth of the collection and made available 225,000 images that had been digitized—selected on the basis of their "cultural significance" and "commercial potential." The digitized images constitute just over 1 percent of the Bettmann collection, the remainder of which is locked away in the Iron Mountain storage facility tended by a staff of two: one person conducting research, the other digitizing images.

Initially, in 1996, Corbis estimated that it cost the company about $20 to digitize each photograph—an estimate that seems reasonable, even conservative. For obvious reasons, the image of JFK Jr. "made the cut" as one of the Bettmann photographs possessing the requisite commercial and cultural value. But is it in the public interest to assume that those 16.5 million additional Bettmann images locked away in an abandoned mine *do not* have cultural significance? And while a corporation might be adept at assessing the potential earning power of photographs licensed for reproduction, is there any reason to expect that it would maintain the expertise necessary to evaluate "cultural significance"? Is corporate control of heritage what the Founding Fathers had in mind when they gave Congress the right to "encourage Progress"?

These questions are far from academic, because heritage managed as corporate asset is today the default mechanism through which America's artistic past interacts with the present. Corbis is one kind of corporate actor on the heritage scene; as a retailer of the past, the company maintains a

commitment to preservation. Other heritage industries have a more am-
biguous connection with their collections. Historical films belong to stu-
dios; original master negatives are shelved in corporate archives. Record
labels control the copyrights to millions of musical and documentary
recordings produced over the past century, and original tapes, master
discs, are supposedly maintained in corporate archives. To these media
industries, preservation will always play second fiddle to the core
mission—creating shareholder value by selling *new* product in the enter-
tainment marketplace. Can the public's right to our shared heritage truly
be served if the preservation of records, movies, and broadcasting is left
to the whims of a few multinational media companies?

• • • • •

Orrin Keepnews understands the challenges of balancing copyright and
the public interest firsthand. He leans back, heavy-lidded eyes scanning
the stacks of paper, cassette tapes, and vinyl discs that cover the desk of
his sunroom office in his San Francisco home. "What's gotten to me over
the years is just how *arbitrary* it all is," he says, "how some obscure mas-
ter disc survives and, on the shelf right next to it, everything's missing."

Keepnews should know. He has been producing jazz records for more
than fifty years: Bill Evans, Thelonius Monk, Wes Montgomery four de-
cades ago; McCoy Tyner and Joe Henderson in the 1970s and 1980s. Now
in his eighties, Keepnews is rarely in the studio producing current acts,
concentrating instead on the reissue of classic jazz discs he edits, remas-
ters, and assembles into modern CD compilations. This afternoon, pa-
perwork from his latest project, Stan Getz recordings from the 1940s,
flows out across his cluttered desk to filing cabinets tops, extending (as he
puts it while sweeping his arm toward what might be an imagined audi-
ence) "onto about every flat space on the first floor."

"Now, there's a bright side to the situation," he continues. "I'm con-
stantly surprised by what is still around. But even what's left can be hard
to find. You know, everything's computerized now, but that doesn't
mean you can actually *find* it."

A passionate supporter of jazz heritage preservation, Keepnews holds
special affection for 78 rpm jazz discs recorded before World War II.

"That's a finite preservation project," he explains. "There were only three big record labels back then, so it's something we can actually get our arms around." But, according to Keepnews, the size of a record label is no guarantee that original recordings have been preserved: "There are huge chunks of material missing from the RCA vaults, and often nobody on the current staff knows for certain what is or isn't there. I've learned to be intentionally sloppy in my requests for master discs and tapes, just to make certain I'll get *everything* they have."

He laughs. "I guess, for me, sloppiness has actually become a technique. A few years ago, I was working on a Thelonius Monk project for RCA, and I said, 'Just send me everything with the word "Monk" written on it.' They did, and sure enough we found a tape from a Newport Jazz Festival that RCA had in the vaults, but they didn't have any paperwork. If I had asked for a specific master *number*, I never would have gotten anything."

He shakes his head again. "But it's just so damned *arbitrary*."

The preservation of America's musical heritage should not be left to chance, or even to preservation streetfighters like Keepnews. After all, taken in its breadth—Billie Holiday, Elvis Presley, Enrico Caruso, Arturo Toscanini, Bob Dylan, Hank Williams, Isaac Stern, B.B. King, and Thelonius Monk—no segment of America's artistic heritage more clearly mirrors our democratic heritage than does the record business. But our nation's heritage on record has already been placed at intense risk, and many original recordings of great American music have been lost. Keepnews's experience is the rule, not the exception; corporations that own heritage collections have simply not maintained tape and disc archives with care.

In 1980 CBS staff producer Michael Brooks was sorting through a stack of master tape boxes marked with a prominent "S." Intrigued by the label of one box—"Louis Armstrong—Unreleased Concert"—Brooks asked about the tapes and was told, "All that's old stuff getting thrown out to make room in the vault." The "S" was shorthand for a corporate command, "Scrap." Brooks saved the original tape, a rare live recording of a 1956 Chicago show featuring Louis Armstrong and His All Stars. The tape ultimately was released on a critically acclaimed CD boxed set. But a

discovered Thelonius Monk concert and a few Louis Armstrong tapes rescued from the scrap heap should not suggest that the dedication of a cadre of heroic professionals might somehow offset preservation bungles of the record industry. The problem is simply too big.

When my father bought his copy of Bunny Berrigan's "I Can't Get Started" (RCA Victor 36208) in 1938, it was, first and foremost, a popular jazz rendition of a hit song from the Ziegfeld Follies of 1936. But the recording, as well as the original metal master disc stored in RCA's archive, was also an instantaneous, incremental addition to America's accumulating legacy of vernacular music—a performance that would soon be seen as a jazz classic. Although record companies have been reluctant to release precise figures on their holdings of master discs and tapes, reliable estimates place the number of archived recordings at more than 4 million items. Major labels account for three-quarters of the total, with smaller independent company holdings estimated at about 1 million items. RCA, owner of the "I Can't Get Started" master, boasts a collection of at least 1.3 million discs and tapes, while Motown, a sixties-era newcomer, which has operated from seven addresses in three cities, holds about 30,000 master recordings, all created during the era of tape. And more than 30,000 *new* CDs still enter some form of distribution each year. Assuming ten tracks per album, we're adding a million new performances to some kind of archive every three or four years.

This massive cultural treasure, held not as a public trust but as corporate asset, is inherently at risk. Both the MGM and Atlantic labels lost holdings in vault fires. MCA (parent company of Decca and other vintage labels) had a near-miss in 1996 when a movie lot fire came close to engulfing the MCA audio archive. And film prints, master discs, and videotapes are worthless if you can't play them back. Today any corporate archive worth its salt is forced to maintain functioning antique playback equipment simply to make it possible to hear important originals. And, ironically, in this regard the recent past is more problematic than the first two-thirds of the past century; the dizzying pace of innovation in digital audio and video recording has created instant orphans. Where is that Betamax recorder we bought in 1985, and what of the Polaroid Land Camera that wowed everyone in 1958?

Also, archives are subject to pilferage, as well as just plain carelessness. For example, until the 1980s only a handful of individual collectors possessed a full appreciation of the value of historical disc recordings. In the 1970s it was widely known in the record-collecting game that a knowledgeable Columbia Records (now Sony-BMG) senior executive pursued a sideline business supplying his collecting compatriots with rare items he had simply lifted from company vaults—doing for profit what Jack Loetz had done for love. In fairness, at the time nobody assigned much value to file copies of 78s, and Columbia higher-ups winked at the departure of old records. But it was for years an open secret that a collector could, for the right price, obtain rare jazz, blues, and country originals straight from the company archive.

Of course, corporate collections of sound recordings (or of film negatives and prints) are expensive to maintain. So, because archives affect the bottom line, the largest real and potential threat to the survival of original recordings is record company policy—well-intentioned attempts to maintain shareholder value by controlling expenses, reducing the costs of storing, documenting, and retrieving discs and tapes. As an award-winning investigative series by *Billboard* correspondent Bill Holland made clear, corporate policy has been a big part of the problem. One label threw out all its pre-stereo monaural recordings; another scrapped sixteen-inch metal tape reels, arguing that for each tape destroyed the label saved "a nickel a month" in storage costs. Before the CD reissue boom of the 1980s, corporate archives were routinely staffed by low-level employees—individuals frequently careless and generally unaware of the significance of holdings under their control and ill prepared to resist well-intended efforts to reduce costs by disposing of discs and tapes, thus reducing the inventory of warehouse space.

As Orrin Keepnews learned, ordinary carelessness by just one employee could have a devastating impact on an archive. Ten years ago the Country Music Hall of Fame was able to include a never-released cut by legendary singer Patsy Cline in a boxed-set retrospective simply because a request for "everything on Patsy" turned up a master tape that had been hidden away in a mislabeled box for thirty-five years. According to Holland, RCA demolished an entire warehouse in Camden, New Jersey, in

the 1960s, dynamiting the contents—master discs and all—and bull-
dozing the mess into the Delaware River (a hard-to-duplicate "hat-
trick" simultaneously trashing our built, natural, and cultural environ-
ments).

It's all about what companies value, and in an unedited profit-driven
arts system cultural heritage is valued only if it can sell in today's mar-
ket. In that regard the news is not all bad; outright destruction is un-
likely, and the status of archived recordings, films, and TV shows has im-
proved during the past two decades. For one thing, the increasing value
of intellectual property generally and the aggressive policing of rights
and protection of revenue streams have made companies more attentive
to copyright-protected assets. New technology has also helped; for ex-
ample, in the 1980s the advent of compact discs led many consumers to
upgrade music collections by replacing vinyl LPs with CDs. In addition,
when digitally rerecorded, packaged attractively, and accompanied by
authoritative album notes, vintage blues, jazz, and country performances
from the 1930s forward suddenly acquired enhanced commercial value.
With each CD able to hold an hour of music, three or four CDs could
gather up the entire career of even a legendary artist. Thus the CD
emerged as an ideal medium for the rerelease of archival material, and
as labels scrambled to mine the content of archives, boxed sets provided
fans with unprecedented access to historical recordings. Encouraged by
sales of historical tracks, the majors upgraded their preservation pro-
grams during the 1980s and 1990s. As early as 1979 the Grammy Awards,
a sometimes-lagging but nevertheless dependable indicator of trends in
the recording industry, recognized and encouraged this trend by adding
the "Best Historical Album" category to its always expanding list of
awards.

But the market for old art in new technologies is finite. The CD boom
that propped up the value of historical product for two decades has today
wound down, and it's uncertain if music download services will gener-
ate sufficient business to justify preserving everything stored in ever-
expanding vaults. It costs money and time to search out and digitize his-
torical product, and silent movies and pre-1923 acoustical recordings just
don't justify the expense. In fact, a record executive recently told me that
iTunes had complained about inventory that generated just eight or ten

downloads a year. Despite industry assertions of a "long tail," attention still flows to product that sells in quantity.

Big media, big dollars, and carelessness—the very forces that have menaced America's musical heritage are also at play in historical radio, television, and film. Of the hundreds of films produced by commercial studios through the 1920s, only about 20 percent survive. The figure is not much better for the entire first half of the twentieth century; only 50 percent of films produced through 1950 exist today. And many early studio films that do survive exist only on highly flammable nitrate print or negative stock. Ten million feet of nitrate film are housed in studio archives—every foot a fire hazard, every foot in need of transfer to a contemporary medium. But at a cost of more than $3 a foot for the transfer, the $30 million price tag is beyond the capacity of the movie industry.

Frequently, individual studios have been reluctant to pick up preservation costs for their own collections. Dan Melnick, former head of production at MGM, was rebuffed by CEO Jim Aubrey when he proposed a million-dollar transfer of vintage prints to current stock. Melnick got around the decision by launching the *That's Entertainment* retrospective; the low-budget compilation was ultimately popular and highly profitable, and it financed the archival transfers Melnick wanted in the first place. Big studios and savvy executives can find clever ways to pay for the management of vintage assets, but the status of many historical independent productions, documentaries, and educational films, whose master prints or tapes might be housed in a producer's basement, is largely unknown. Here survival percentages are almost certainly worse than for studio-produced commercial movies.

As the CD boom of the 1980s produced a surge in the preservation and marketing of early recordings, technology today has given new life to old movies and television shows. DVD sales totaled $2.3 billion in 2004 and were projected to reach $3.9 billion by 2008. True, most of these are quick follow-up releases of films still playing in the multiplex. But for companies that control significant historical assets, the burgeoning market for old movies repackaged intelligently can have a real bottom-line impact. The MGM film library generated $440 million in cash flow in 2004, outpacing new production. At least for the moment, heritage film doesn't need the intervention of leaders like Dan Melnick to survive.

But even the recent past often lies beyond the reach of citizens eager to engage artistic heritage. Parents who want to share the history of television with their children will find important landmarks missing; Johnny Carson's first appearance on *The Tonight Show* has disappeared, as have the first two Super Bowl telecasts. Patrick Loughney, head of the Moving Image Section of the Library of Congress, cites a conclusion reached by his institution's 1997 study of television heritage: "Much of American television history, well over 50 percent, has either already been lost or is in danger of being lost in the next decade." It should be no surprise that, a year before his death, pioneering television star Milton Berle sued NBC, charging that the network had somehow managed to lose 130 of his shows.

And remember, access and preservation go hand in hand. If intellectual property rights prevent citizens and artists from gaining access to movies, music, and historical media, old films and records might just as well be lost. Two of John Wayne's most important movies, *The High and the Mighty* and *Island in the Sky*, have been kept off the market by Wayne's heirs. A 2004 New York state court decision determined that sound recordings produced before 1972, the year recordings were given federal copyright protection, fall under the provisions of common law and are thus protected by many states until 2067. The ruling even covers cylinders and discs cut in the nineteenth century and secures rights to many "orphan discs"—recordings for which no owner can be identified. Thus old recordings may be preserved, but intellectual property law makes them inaccessible, locking up heritage in what are in effect "dark archives." And, as I discuss below, restrictive music licenses commonly attached to vintage television productions have placed insurmountable obstacles in the path of DVD reissues.

Legal scholar Joseph Sax, in *Playing Darts with a Rembrandt*, makes the point that "unqualified ownership permits the indulgence of private vice to obliterate public benefits." Sax is talking about what might happen if art owners, on a whim, choose to deface or destroy work of lasting artistic and social value. But his observation makes an important general point: there exists no public interest "push-back" against irresponsible actions of individuals who own works of art. When a corporation is the

owner, the threat to heritage assets may be less capricious, but it's every bit as real. After all, it's unlikely that any arts industry CEO is going to suddenly demand that an archive of film or recorded sound originals be hauled to the dumpster; personal integrity and a faint sense of public purpose make such actions unlikely. Instead, the need to hold down expenses while continually eyeing the earning power of every asset in the contemporary marketplace creates a leadership environment in which it is all too easy to cut back on climate control, stop making digital transfers, and relocate an inactive catalog to off-site storage. Insidious erosion of the well-being of collections is the likely result. Corporate leadership chases quarterly earnings while setting policy in broad strokes, but, at the end of the day, it's often somebody with his name embroidered over his left pocket who looks across a warehouse floor and says, "Nobody's looked in those boxes since I started here back in '85; let's get rid of them."

• • • • •

Most of America's twentieth-century culture was produced by for-profit arts industries, and much of our cultural heritage has been no better treated than assets such as buildings and furniture. But what about the network of orchestras, dance companies, theaters, and opera companies— organizations that grew up on the nonprofit side of America's cultural playing field? And what about libraries, archives, and personal collections—have they managed to serve the public interest by preserving intangible heritage and making it available to citizens? When it comes to preserving work they create, nonprofits haven't done very well, and our underfunded public and private archives have struggled to keep up with expanding collections, expensive technologies, and an increasingly burdensome intellectual property environment.

As record executive Dan Sheehy notes, tapes and films are "much more ephemeral than most other broad categories of human achievement," and, although operating under public service charters, most nonprofit cultural organizations have simply never had the resources required to adequately manage historical materials generated by their own work. Often boxed in by restrictive union regulations, orchestras, opera

companies, and nonprofit theatrical production companies have often found it difficult or impossible to legally memorialize their own work. Even when recordings of productions are generated, it's far too costly for the typical nonprofit to maintain archives of those film or tape recordings that can be authorized. Consider that the New York Philharmonic generates fifteen hours of new recordings each week; multiply that total by the two hundred or so orchestras that archive their own work, and add the fields of dance and theater, and the scope of the ongoing preservation challenge emerges.

Even museums and historical societies, nonprofits with stated preservation and public access mandates, have done a far from optimal job of preserving creativity from the past. This is *intangible heritage* we're talking about, sounds and images captured on discs, tapes, films, or hard drives that have value only because of their content. Museums and historical societies have had their hands full simply dealing with buildings, artifacts, and monuments—*tangible* things you can walk up to and touch. In 2005 Heritage Preservation (a Washington-based heritage advocacy organization) surveyed 30,000 collections in museums, libraries, and archives and discovered that more than half had suffered damage from water or light and that "many institutions lack basic environmental controls that prevent photographs from losing color [and] keep rare books from crumbling to dust."

Financial pressures have not only prevented museums from protecting collections; they have encouraged museums to continually look to their holdings as potential sources of income. Tight preservation budgets mean that sometimes holdings are simply sold, usually after a committee has quietly declared them "surplus," arguing that the artworks don't line up with core collecting policies of the museum. *New York Times* art critic Michael Kimmelman pummeled the New York Public Library following the deaccessioning (sale) of the Asher B. Durand painting *Kindred Spirits*. Noting that little public debate had preceded Sotheby's auction of the piece (which was purchased by the Arkansas-based Walton Family Foundation, of Wal-Mart fame), Kimmelman concluded that today, "in America, celebrity and money are the measuring sticks of cultural value." Historical assets attached to nonprofits that *aren't* in the culture

business have fared even worse: witness the dismal handling of speeches, letters, and other documents by the Martin Luther King Jr. estate. After decades of attempting to earn royalties by licensing the civil rights leader's words, the King collection was on the verge of being liquidated by, you guessed it, Sotheby's. (A consortium of Atlanta-based universities stepped in to acquire the King material at the last moment.) Although nonprofit status exists to serve the public interest, financial constraints, union policies, and contractual commitments have made it difficult for tax-exempt institutions to set a standard of preservation and access significantly better than what has evolved in for-profit arts industries.

.

Preservation is not intuitive: how many of us have winced when we learned that Grandma or Aunt Sue discarded those old Ball canning jars or burned the letters Uncle Joe wrote home from the war? The impulse to save is especially elusive when we're not talking about preserving forests, old buildings, or the statue on the town square but rather considering the intangible contents of recordings and films. "Out with the old, in with the new," has emptied many an attic. Grandma's good china, Uncle Fred's comic book collection, and photographs of Junior's first fishing trip are too easily swept away with accumulated winter dust. A box of family treasures squirreled away in a corner can be lost to simple carelessness or to a periodic exercise of those "best intentions," cleanliness and order. But just as Americans have learned to honor and protect the nation's natural environment, we must acknowledge that our children will benefit from democracy's diverse artistic legacy only if we care enough to make it possible.

The twentieth-century body of film, sound recordings, photographs, and manuscripts gathered in corporate archives around the world constitutes America's collective family treasure, the cultural products that hold the tale of our nation's past hundred years. Rescues make exciting stories, but last-minute interventions by Orrin Keepnews, Dan Melnick, or Jack Loetz are nothing more than inspiring exceptions to a much larger trend. Orphaned to the shifting priorities of corporate owners, exposed to

the perils of theft, fire, flood, and deterioration, massive chunks of America's artistic legacy are already gone.

But we are not helpless, and the media industries know it; they're leery of the potential impact of a preservation movement. In 1998 the Recording Academy, in cooperation with the National Endowment for the Humanities, attempted to create a national database documenting the contents of the recorded sound archives of America's major record companies. To the surprise of many, the industry's trade group, the Recording Industry Association of America, just said "No!" Hillary Rosen, then RIAA CEO, claimed, "There's simply no reason for the record companies to categorize for public distribution . . . their privately owned recording masters."

But insiders knew the truth, and it wasn't about the absence of a "reason": media companies then and now fear a public drive toward preservation fueled by the same kind of energy that launched the environmental movement forty years ago. By revealing how much has been lost, how much has never been released, and, following decades of mergers and relocations, just how little record, film, and television companies know about what they do or do not own, the truth would produce public outrage.

We're *not* helpless.

In the preservation of artistic heritage, Americans can leverage significant influence, and law and public policy can help. The National Historic Preservation Act of 1966 created the position of "preservation officer" in every federal agency, calling for every agency head to take into account the impact of policy and programs on the preservation of historic treasures under their jurisdiction. The law has been widely ignored, but parts of the government responded with alacrity; the act launched impressive preservation agendas in the Departments of Transportation and the Interior, and the elaborate preservation efforts directed toward historic buildings, monuments, and landmarks by these agencies have transformed the American consciousness and the American landscape.

The National Trust for Historic Preservation has done a remarkable job of both preserving historic buildings and monuments and raising public consciousness about the value of America's *tangible* cultural

heritage. The Save America's Treasures program, launched in 1999 as an NEA–NEH–White House Millennium project, also focused primarily on the built environment. Similar "trust" or "treasures" programs dedicated to the arts products of our cultural industries, what one preservation trust executive, Charles Granquist, calls "less tangible" heritage, could over time organize public concern about recorded performing arts as a component of our expressive lives.

Both Orrin Keepnews and Joseph Sax are right: heritage can be lost through carelessness, or an owner can simply destroy an original or spirit a collection away. However, more frequently, the effect of corporate control of arts assets is more subtle: it is less about destruction or loss—issues of preservation—and more about access—actually making the past available today. In the realm of intangible heritage, preservation by itself doesn't mean all that much. If a master negative, disc, or tape is on a shelf in a corporate storage facility, it is technically being preserved, but if we citizens are to actually see or hear a performance from the past, an array of contractual relationships and legal obligations must be engaged before we get a chance to watch or listen.

Some cultural observers argue that the challenge of access to heritage—how things get preserved and how citizens connect with art products from the past—will automatically be overcome by technology. Law scholar Paul Goldstein imagines a "celestial jukebox"—a vast, all-inclusive digital archive from which citizens can extract (mind you, for a price) any song or film or television or radio program that has ever been produced, to say nothing of novels and knowledge; it'll all be at hand in a world of bits and bites. Writer Chris Anderson envisions a "long tail" of twenty-first-century cultural consumption, arguing, "You can find everything out there on the Long Tail." For Anderson, the low cost of digital availability is so economically efficient that it will make everything available online; the distinction between a best-seller and a book, DVD, or CD that sells a single copy will be erased. Perhaps the Long Tail, or maybe the mixed metaphor of a long-tailed celestial jukebox, *will* open a magical gateway to heritage.

There's some truth to these arguments; the digital world can store words, images, and music at less cost than ever before, and the resulting

longer tail will give knowledgeable consumers an opportunity to buy obscure works that might never be "published" in a conventional sense in a competitive, hit-driven marketplace. But companies still must choose to digitize what they view as viable, even in a brave new economy, and, as in the case of Corbis, those choices can be surprisingly narrow. By the time this volume is published, iTunes will offer more than 2 million recordings on line. That's a significant "tail," but iTunes remains a hit-driven model that inevitably zeroes in on new product. How impressive is the length of the iTunes tail when more than 300,000 new performances are released each year? And who will make available the truly obscure or noncommercial—for example, pre-1923 acoustical sound recordings that simply can't be made to sound modern?

Any institution or private company that attempts to flesh out the tail (so to speak) must navigate the rapids of our bloated copyright system. Farhad Manjoo, writing in Salon.com, has described how Google's attempt to "make every printed book as accessible as a web site" has foundered, predictably, on the shoals of digital rights. The library today features gobs of pre-1923—read: copyright-expired—material, but it has run afoul of publishers' and authors' rights to the millions of volumes issued between 1923 and the present. Manjoo describes the resulting Google on-line, Long Tail offering as "truncated," suggesting that "if copyright law stands in the way of Google's grand aim, isn't it time we thought about changing the law?"

The inventory of cultural goods *can* be expanded by technology, but the hit-driven mentality of our cultural industries and the minefield of intellectual property rights will still keep the system tilted away from heritage and the public interest.

· · · · ·

What can we do to make certain that what remains will be preserved and that what is preserved will be reasonably available to future generations?

The Preservation Act of 1966 provides one kind of model. The legislation used congressional leverage to steer federal agencies toward appropriate treatment of their self-generated historical assets. But it only applied to the government. Most of America's cultural heritage is owned by

private companies, and public policy has not been deployed to ensure responsible care and reasonable access in regard to collections of historical assets. Nonetheless, regardless of ownership, it is the right and obligation of the present to select what is best in the past in historical film, jazz, classical recording, and radio and television drama and then to bundle this legacy of artistic excellence for future generations.

To link heritage assets to public purposes we must engage the handful of international companies that own millions of old discs, tapes, and film prints. This conversation between corporate and public interests will not only demand special preservation legislation but a fresh look at copyright and intellectual property law as well. Somewhat ironically (since Congress has enacted the rat's nest of copyright-related laws that make access to heritage so difficult), it has been Congress's own institution, the Library of Congress, that has operated for decades on the front lines of media preservation. In fulfilling its preservation mission, the Library has also done its best to assert a public interest in access to arts products from the past. Of course, it is no surprise that our national library would maintain vast collections of historical arts products, but in the past decade the Library has actually gone further, assembling expert committees to develop lists of historically significant films and recordings that are deserving of special preservation efforts.

The National Film Preservation Act (1988; renewed 1992, 1996, 2005) and the National Recording Preservation Act (2000) each established programs that use expert panels to designate historical material of special importance and at the same time created nonprofit organizations with authority to raise funds to ensure the preservation of those movies and recordings that end up on the "most significant" lists. The Library of Congress has the staff expertise and breadth of collections required for a broad preservation and access program. As Librarian of Congress James Billington observed, through copyright deposits the Library has preserved "a mint record of America's private sector creativity."

However, when it comes to advancing the access rights of the American public, the Library of Congress is poorly positioned to initiate head-banging negotiations with media industries. It is, after all, an arm of Capitol Hill, and Congress can be all too easily influenced by trade

associations representing the film, broadcasting, and recording industries. In fact, with regard to the digitizing of film and recordings, Billington has noted, "We have to be scrupulously careful about existing laws." And because it can be "gotten to" through Congress, my early-on guess is that the Library and our new film and recording registries will be strong on singling out great work from the past, strong on the technology of preservation, but weak when preservation and access call for a push back against the hegemony of copyright dependent arts industries. For example, the film program has concentrated its preservation efforts on noncommercial or out-of-copyright "orphan" films. While media orphans are important material deserving of attention, an emphasis on obscure films and recordings deftly sidesteps possible conflicts between the Library and major studios or record companies. If the Library remains on the cutting edge of preservation policy, it will need to be fortified by a sturdy dose of public support; right now it's just too easy for arts industries to have their way with the institution by lobbying Congress.

In addition to the work of the Library of Congress, a handful of nonprofit organizations have taken on the task of preserving specific segments of our arts heritage: the American Film Institute, the Institute of Jazz Studies at Rutgers University, the New York Public Library for the Performing Arts, the Country Music Foundation, the Museum of Radio and Television, and the UCLA Film and Television Archive all maintain significant collections documenting our arts-industry heritage. Like nonprofits that create new work, these organizations face all the challenges of the overbuilt and underfunded cultural sector. In addition, current copyright law doesn't readily accommodate preservation. Legally, an archive can only make three preservation copies of a copyrighted work, and only after the original has begun to deteriorate. The law thwarts wholesale duplication for preservation purposes, and in testimony before a Library of Congress committee in late 2006, a number of archivists and librarians indicated that they assigned high preservation priority not to the oldest or rarest items but to materials to which they held legal rights, simply because those collections could be duplicated with impunity and reconfigured into new products for release to the public. And despite the obvious value of our historical vernacular art as a metaphor for the character of

American democracy, there has been barely a trickle of public, founda-
tion, or individual financial support directed toward the preservation of
twentieth-century popular culture. But institutions such as AFI and
CMF—a step or two removed from industry intervention and political
pressure—can join forces to play an expanded role in pressing for the
public interest in preservation issues—but only if money can be found to
support their efforts.

In addition to the absence of funding for preservation and access,
present-day intellectual property law places too many restrictions on
the work of preservation nonprofits. For example, we must repeal the
section of Title 17, U.S. Code, that exempts pre-1972 sound recordings
from federal coverage. Remember, the copyright in recordings con-
trolled by record companies resides in common law enforced by the
states, and absent overarching federal authority, court interpretations of
some state laws appear to protect all recordings made between the 1880s
and 2067—a period of nearly two hundred years! As Tim Brooks dis-
covered in a Library of Congress research project, record companies
have not made available the oldest recordings; less than 10 percent of
"important" pre-1930 music has been reissued. In fact, of pre-1920 discs
featuring African American music, almost nothing is in circulation
today. The public interest demands that the copyright in sound record-
ings produced after 1972—now extended to more than ninety years—
must be shortened, and at the same time early orphan films and tapes
need to be freed up so archivists, scholars, teachers, and fans of early
popular culture can make rare material part of America's active cultural
memory. Once the obstacles represented by copyright and corporate
policy are cleared away, nonprofit libraries and archives would imme-
diately begin to make rare items of limited commercial value available
on CDs or DVDs or as affordable downloads.

If some version of a department of cultural affairs were in place, regu-
larly checking the pulse of the U.S. arts system, no doubt access to her-
itage, like other aspects of a vibrant expressive life, would be a high
agency priority. Absent such a cultural policy hub, new legislation and
modified regulation—even reconfigured policies within foundations and
state and local governments—can still make a difference. Kimmelman

has suggested that before a painting or sculpture of special significance to a community is deaccessioned, "local museums should be given a reasonable time to match the sale price." Such an intervention might require reworking provisions of the federal tax code or changes in the rules governing public support for local institutions.

In other circumstances it is possible that existing public policy tools—regulations and legislation affecting corporate mergers and acquisitions—might be deployed to advance a preservation agenda. The environmental movement has long relied on impact analysis to influence policy leaders and flesh out regulation, and similar "cultural impact" studies could be required in advance of Federal Trade Commission approval of a media-industry merger or the sale of one of our arts companies to a non-U.S. parent. FTC attorney Neil Averitt has argued that the agency should move beyond evaluating impact on *price* when considering a merger. He notes that in the media industries price might be unaffected in an expanded conglomerate but consumer choice might be diminished. For example, the merger of Sony and BMG—which, among other things, combines ownership of the two largest archives of historical American music—is unlikely to affect the *price* of CDs and downloads, but it is very likely to reduce the number of historical compilations, thereby limiting *consumer choice.* Companies holding significant heritage collections could be required to submit preservation plans to ensure that these collections would be preserved and remain available if companies merge, or if a U.S. film studio or record company is acquired by foreign interests. A serious congressional hearing on the possible application of modified regulations to mandate preservation and access, by itself, might be sufficiently encouraging to make the big players a little more enthusiastic about the public access component of archiving programs.

Lawrence Lessig and other legal scholars have offered mechanisms for expanding fair use and the public domain. For example, these policy leaders have suggested that copyright holders periodically pay modest fees in order to maintain copyright ownership, a practice that would inevitably expand the public domain as rights of little perceived value were not renewed by current owners. Copyright holders have been, to say the least, less than enthusiastic about such ideas. But if genuine public concern

pushes legislators to recalibrate the balance of rights of owners and citizens, we may find that the return of old requirements like copyright registration, renewal, and an expanded public domain will gain traction.

Let me be clear: it's not the fault of film studios, record companies, or broadcasters. I'm not in favor of beating up on cultural industries about preservation or of complaining that media giants should divert resources to archival storage. These companies are organized to secure shareholder value; it's simply unfair to force them to take on more than a modest role as cultural conservator. If all we do is try to force media companies to yield ownership rights while simultaneously pressuring them to take on a costly preservation agenda, we will fail, stopped cold by art-as-asset interests. If the American people want to make certain our heritage will always be with us and that our children and grandchildren will have reasonable access to art from the past, we need to mix mandates with incentives, to give corporate leaders every reason to maintain archives and find creative ways to link heritage with the lives of young citizens. We also need to adequately fund those nonprofit institutions that have already taken up the challenge of preserving pieces of the heritage puzzle.

In addition to government support for preservation, enlightened public policy must be enacted to counter the power of intellectual property rights to secure America's cultural mainstream for the future. It is reasonable to expect that we, as citizens, will have access to the pluralistic, creative past that defines us as a nation and as a people.

But even while yoked to shareholder value, big companies can do better. Too often, instead of a broad safety net, our arts industries deploy a preservation strategy based on current market value. The result is at best a leaky sieve. Some treasures are saved, but others are mislaid, poorly stored, or locked up in service to profit. For many films, recordings, and photographs, starting tomorrow is already too late; our artistic heritage greets us with a gap-toothed smile.

Heritage is the part of our expressive life that tells us where we came from by preserving and presenting voices from the past, grounding us in the linkages of family, community, ethnicity, and nationality, giving us our creative vocabulary. It is the heritage half of our expressive life that provides permanence and continuity; the half that connects us to

our story, providing the resilience that comes with a sense of self in a particular place. Americans have a right to our diverse artistic heritage even if access must be achieved by setting new public policy goals that push back against the ownership rights of market-driven cultural industries.

Artists

The right to the prominent presence of artists in public life—through their art and the incorporation of their voices and artistic visions into democratic debate.

Back when I was a sophomore living on the third floor of the University of Michigan's first coed dorm, I asked an art student friend who lived down the hall what his parents thought about his choice of career. I've never forgotten his answer: "Every family wants a Picasso hanging on the wall, but no family wants one standing in the living room." He'd hit the nail on the head; we Americans love—even worship—our artists from afar, but once the curtain comes down or, as Bob Dylan says, "the gallery lights dim," we're just as happy if they quietly leave the stage. Americans don't take artists very seriously. Bono, the Irish rock superstar who has transformed himself into a respected authority on Third World indebtedness and AIDS relief, is the exception that underlines the rule: apart from whatever beauty and truth that might be embedded in their art and their occasional usefulness as fodder for tabloid gossip, we don't think artists have much to offer.

But artists feed an important part of our expressive life, the world of ideas, sounds, and images that greet us every day. These individuals dedicate themselves to employing their talents, bringing insight and invention to life. Artistic vision makes a special contribution to the quality of our society. If citizens have a right to a broad engagement with artists across the spectrum of public life, what elements must be in place for artists to flourish in American society? I believe three things must be present. First, conditions must be conducive to originality; artists need to be able to find a way to enter and function in our complex arts system. Second, they need respect for their ideas and their approach to problem solving, and respect in the form of sufficient compensation to maintain a creative life. Third, artists must be free to draw on—to synthesize—the work of contemporaries as well as creativity from the past. Respect is critical in securing the benefits of a vibrant arts community. If society sees artists as irresponsible eccentrics, if the arts system is shaped by big companies that value only the big-hit superstar, and if a writer, composer, filmmaker, or even classroom art teacher must pony up a stiff fee every time he or she needs to reference the work of others, then we are a long distance from fulfilling the right of every citizen to the imagination and understanding of the most talented among us.

· · · · ·

A Nashville music publisher once let me in on the first question he asks every new songwriter he signs to a writing contract: "Does your wife (or husband) have a job, and does the job provide health insurance?" The message is clear: even though you've demonstrated enough talent to land a coveted publishing deal, you haven't "arrived" in any conventional sense; you're not going to really make enough to live on—so get ready. Relentless optimism fronting a Teflon-encased ego is a prerequisite for life as an artist.

Just getting in is half the battle. In a cut from his 2005 album, *The Outsider*, singer-songwriter Rodney Crowell laments, "Beautiful despair is hearing Dylan when you're drunk at 3 A.M.; knowing that the chances are no matter what you'll never write like him." Crowell is not alone in citing Bob Dylan as the master American songwriter of the past half century (or

Bob Dylan recording for Columbia in the early 1960s. Could an artist this unconventional find a patron like John Hammond in today's globalized record companies, and could a sympathetic executive operate with enough latitude to build a Dylan-style career? (Photo © Bettmann/CORBIS. Fee: $265.)

in acknowledging the way in which art and artists from the past can simultaneously loom as a challenge and an inspiration). There is no more widely respected U.S. artist than Dylan, but he was nearly dropped by Columbia Records before he had a chance to demonstrate the capacity of his talent to connect with a wide audience.

At the time John Hammond, the legendary record producer (and heir to a Vanderbilt family fortune), had already worked with Billie Holiday, Benny Goodman, and Count Basie, and he would one day sign Bruce Springsteen. Hammond had achieved remarkable success as a talent scout and producer of jazz and blues artists and had a special affinity for American grassroots music. At the beginning of the sixties folk boom he had tried to sign folk-revival diva Joan Baez to Columbia but had lost out to Maynard Solomon, a competitor at Vanguard Records. Hammond was recording Carolyn Hester, a singer who seemed, after the loss of Baez, like a consolation prize, and he still longed to add folk talent with real star potential to the Columbia roster. Dylan had played harmonica on a couple of Hester tracks, and Hammond heard him sing a couple of songs at a

party in lower Manhattan. Sometime after reading a glowing Robert Shelton review of a Dylan performance at a Greenwich Village hangout, Hammond apparently auditioned the singer (who wasn't yet much of a songwriter) and offered him a record deal. They cut eighteen sides in two three-hour sessions in Columbia's Studio A in late November 1961.

One album into his contract, Dylan had sold, according to Hammond, 8,000 or 9,000 albums—"not bad, not good, certainly not much profit for Columbia." Like most record labels in the 1960s, Columbia employed a number of staff producers, such as Hammond, to work with their dozens of signed acts. These producers along with marketing executives regularly gathered to assess product being developed throughout the label. Dylan's work wasn't well received. As Hammond recalled, most attendees at Columbia's weekly A&R meeting were put off by Dylan's "mediocre playing and raspy voice." Author David Hajdu went further, explaining that Columbia executives were "fearful that Hammond's mythic golden ears had corroded."

In the hallways of label offices, Dylan came to be known as "Hammond's folly," and the head of Columbia's pop division, David Kapralik, decided the folksinger had to go. But Hammond, by then established as the dean of Columbia's in-house producers, put his job on the line, and it worked. Mitch Miller, the Columbia A&R head associated with vocalists such as Doris Day, the Hi-Lo's, and Tony Bennett, had little enthusiasm for Dylan's voice but nonetheless backed Hammond. "You had to respect John for no other reason than his track record," Miller explained. Dylan stayed. The singer-songwriter remembers Hammond fondly, "He was legendary, pure aristocracy. . . . John was just an extraordinary man. He didn't make schoolboy records or record schoolboy artists. He had vision and foresight, had seen and heard me, felt my thoughts and had faith in the things to come."

Dylan, of course, enjoyed a long and brilliant career at Columbia, and Hammond was, not for the first time, confirmed in his confidence in a performer who in the early sixties broke just about all the rules. Could, or would, an executive today take such a risk to keep an artist in the game? Hammond, assessing the music business of the early sixties recalled his feelings as he saw Dylan's career take off and managers and advisers

close in. "Too much rides on the success or failure of a record, on guessing the future of a singer or a song," Hammond wrote. "Too many voices have too much to say about too many artistic decisions. And fear is making musical impulses more cautious than they should be." His words, penned in the 1960s, were prophetic; music produced to serve the narrow interests of radio conglomerates and big-box retailers like Wal-Mart is leery of both controversy and artistic surprise. Today Bruce Lundvall (of Blue Note Records) will sign an offbeat act like Nora Jones, but you can count on a few fingers of one hand the major-label executives who have the courage and freedom of action required to sign a singer who works against the grain. In the contemporary scene it is unlikely that an artist as quirky as Dylan would be signed to a major label.

Many artists, in all genres of art making, would envy the arc of Bob Dylan's career. His professional life has been long, and he's strung together enough individual successes to make his life financially stable. After more than forty years he still works about two hundred live dates each year and is both the creator of a significant body of new work and a masterful interpreter of the work of songwriters from the past. As a creator and an interpreter, Dylan combines two artistic roles that are often distinct (novelists create; actors interpret), and he also works both alone (as a songwriter) and as a collaborator (on the road or in the recording studio). In 2007 he began a weekly radio show on XM satellite radio, and Twyla Tharp choreographed a Broadway play based on his songs (it opened and closed within a week).

Whether onstage, working as a composer, or recording with studio musicians, Dylan has essentially been an independent contractor, not an employee—a highly successful contractor at that. Most of us think about artists in an independent role: asked to conjure up a typical *artist*, we imagine a painter, working alone in a high-beamed studio—perhaps standing before an easel in a scarred-floor loft made over from a down-at-the-heel manufacturing space.

However, some artists, such as designers, architects, and symphony musicians, function in stable corporate settings and work regular, predictable schedules. These artists are salaried, and their employers may offer health insurance, retirement programs, and other benefits we

associate with corporate life. So while the solo artist dominates our imagination, artists frequently work together and sometimes labor as employees. And because formal training in design, architecture, and classical music can provide artists with professional credentials, barriers to careers in industrial design or orchestral performance may not appear as daunting as those facing individual artists. But once entry into a creative profession has been secured, the challenges of piecing together enough income to sustain a quality of life commensurate with education or training become apparent. Worrisome trends in employment and compensation cut across the creative professions. Few artists, once "in," are able to sustain financial security from art making alone.

Workers who identify themselves primarily as independent artists face roller-coaster professional lives. Suppose an actor, singer, author, painter, or freelance instrumentalist gets past the primary gatekeepers, as in Bob Dylan's case, because someone with influence notices. Essential professional relationships are forged—a painter finds a dealer or a gallery; an actor, playwright, or novelist acquires an agent; a composer signs with a publisher; a singer or instrumentalist makes a deal with a record label or manager—but even after corks pop in celebration of these landmark events, work as an artist retains risk and uncertainty found in few other career paths. In general, artists earn less than other workers with similar levels of education. For example, in 2000 more than 66 percent of jazz artists made less than $7,000 per year. More are multiple job holders, and their careers exhibit larger income variability (from the *most* to the *least* successful) than exists in other professions. As a recent study by the NEA makes clear, artists suffer from high rates of both unemployment and underemployment, effectively making art a sideline. But despite the difficulties faced by those who embark on a professional career, the number of artists continues to grow. A 2001 Rand research brief reported that during the ten-year period between 1970 and 1980, the number of self-identified artists in the United States doubled to 1.6 million. But growth is not a sign that things have gotten better. Over the past thirty years negative trends have kept pace; while the number of employed artists has increased, underemployment and unemployment have risen.

Painters, musicians, writers, and dancers face the problems shared by other categories of freelancers who work alone. Few can afford health

insurance, and the ebb and flow of income—a painting or short story sold one month; nothing the next—makes it unlikely that money for retirement or the education of children will be set aside. Artist unions are notoriously weak; advancement for women and minorities that depends on organized advocacy lags behind other sectors. In Hollywood only 18 percent of screenwriters are women; 4 percent, minorities. Among working film and TV writers, white males earn an average of $19,000 per year more than their female or minority counterparts. Not only media workers but also most artists must practice where the action is, in big cities where the cost of housing and work space outstrips the financial resources of all but the most successful.

Artists who are paid mostly by a single institution aren't necessarily better off. For highly trained classical musicians dependent on employment in nonprofit ensembles or university teaching, the situation can be both dire and frustrating. Violinist Nathan Holstein, writing in the *Chronicle of Higher Education,* stands ready to press the "big red button," which for him means abandoning his career as a teacher and player to enter law school. Wages for symphony musicians are depressed, and "the market for string teachers in academe has all but collapsed." Although he is concertmaster of his community orchestra, Holstein and his wife are burdened by college debt, living in a California retirement haven town with skyrocketing housing costs. "Unless we win the lottery," he writes, "we'll never be able to afford a house here."

Society's willingness to provide a citizen with a living wage is certainly one sign of respect, but that's only half the story. After all, used car salesmen can make a living without being held in especially high regard. In a 1998 report for the Conference on Social Theory, Politics and the Arts, Columbia University researcher Joan Jeffri tracked the primary concerns of artists. Of course, living conditions, work space, and health care—markers of undercompensation—were identified as problems, but to a degree uncommon in other professions artists also expressed concern about their relationship to the larger society, citing the "public perception of artists," "recognition as a professional," and the image of the artist in "the arts environment."

Jeffri's conclusions are not surprising. Just as we have never come to terms with the unique power of our vernacular cultural heritage, we have

never seen ourselves as a creative people or recognized the value of artistic vision. We've only recently begun to acknowledge the importance of creativity as an underpinning of good government and innovation in corporate life. One sign of our lack of respect for artists is the persistence of evidence that artists have too much trouble piecing together income for an appropriate level of long-term material well-being; another sign is the difficulty Americans have accommodating the special vision, knowledge, and insight of artists as leaders in public life. After all, we've only elected one real artist to high office, actor Ronald Reagan, and his artistic pedigree discomfited his supporters; was his acting experience and apparent skill at playing a version of himself an asset or a liability? We're made so uncomfortable when someone acts artistically that we have scarcely explored the value of an artistic approach to public policy, but a consumerist society caught up in a struggle for money and status seems especially in need of a transfusion of artistic values. If we have a right to the work of artists and if America is going to have the benefit of contact with the brilliance of artistic vision and leadership, public policy at least needs to protect the basics: artists deserve a way in and the social standing that comes from respect and reasonable compensation.

· · · · ·

If we respect artistic vision, access to the best music, dance, and drama possible will be the least of what we can gain from a strong community of creative artists. While our "right" to the work of artists is about performances, paintings, films, and recordings, respect will connect society with the *vision* of artists, the unique combination of insight, imagination, and inspiration that enables artists to see problems with fresh eyes, to craft solutions by stepping outside the boundaries of everyday rule making, and to convey ideas in language and images that surprise and inspire. Beyond paintings and photographs on the wall, music on the radio or iPod, or TV dramas on HBO and other art products that enrich daily life, the creative individuals who make art can bring special perspective to public policy.

Americans are suspicious of artists who insert themselves into the public sphere. After all, artists—especially those who work independently—are unpredictable. They might say or do just about anything. Such a basic

distrust was certainly in play when a newly installed Republican Congress took on the NEA in 1995, ultimately forcing the agency to give up grants made directly to artists. At times art can be off-puttingly political, like the early protest songs of Bob Dylan, and sometimes art with no obvious message can be sufficiently intrusive that it comes off feeling political. When Richard Serra's massive public sculpture *Tilted Arc* was positioned across a busy New York pedestrian plaza, the piece made passersby sufficiently uncomfortable to force a noisy controversy and, ultimately, the work's removal.

Art can be political or have political consequences. How do we react when artists actually take politics in hand?

Not well. Even beloved U2 lead singer Bono is not exempt from criticism. Writing in the *New York Times,* author Paul Theroux expressed annoyance at being "hectored about African development by a wealthy Irish rock star in a cowboy hat." Artists from Jane Fonda and Harry Belafonte to Alec Baldwin have been routinely derided in the press as naive intellectual lightweights, and despite the fact that he boasted a background as "a Peace Corps volunteer with a genuine empathy for his state's neediest residents," pundits commenting on the 2006 election cycle seemed genuinely nonplussed by the (ultimately unsuccessful) gubernatorial aspirations of Texas singer, author, and humorist Kinky Friedman. Theroux's criticism of Bono is typical and revealing. Contempt lurks just below the surface, accompanied by an assumption that an artistic vision is good for only one thing—art. Or, as the title of the Dixie Chicks' documentary put it, "Shut Up and Sing!" Given our ambivalence, it's no surprise that for government officials, art can feel a bit toxic; when President George W. Bush escorted Japanese Prime Minister Junichiro Koizumi—a lifelong Elvis Presley fan—on a tour of Graceland, it didn't make us proud; it made us wince. Bill Clinton steered clear of any action linking his love of grassroots music to public policy. We want our music and movies, but, as my art student college friend observed, we don't necessarily want the artists responsible for our favorite CDs and TV shows to exit the stage or studio to tell us what they think; no "standing in our living room" allowed, a space that metaphorically includes city commissions, chambers of commerce, boards of education, and even the Oval Office.

Of course, there are plenty of reasons to reach for the remote when artists "go political." For one thing American artists in politics usually show up as just another form of tabloid gossip—high-profile movie stars and singers exploiting celebrity to weigh in on issues they haven't taken time to fully understand. But that's less an indictment of artistic insight than of the character of celebrity in the United States. A unique artistic view of life and reality does exist—an artist's take on policy that is more than paparazzi politics.

Somehow citizens in Europe and Latin America seem at ease with the notion of artists as potential sources of leadership and political wisdom. Poet Pablo Neruda, recipient of the Nobel Prize for literature in 1971, mixed art, politics, and a commitment to social reform throughout his career. Václav Havel, called "the ultimate citizen-artist," is the playwright who served as president of the post–cold war Czech Republic—in many ways the modern poster child for artists in public life. As Walter Capps observed in his essay "Interpreting Václav Havel," the author-politician believed "with passion that essayists, poets, dramatists, artists, musicians, and philosophers carry responsibility for the well-being of the societies in which they live." Havel himself took pains to convey his notion of the way artistry should connect with society. In a 1993 essay on the role of the Czech presidency, Havel assigned the highest priority to "care for the political atmosphere of the country—the climate of public life." The president should have "the role of a guardian of the spiritual, moral, and political values on which the state was founded, its long-term perspective, its international prestige, and its ability to sacrifice momentary interests to the general welfare and the interests of future generations." In other words, an artist-leader is not a policy expert but an individual capable of affecting "the political atmosphere," able to convey "political values" framed within a "long-term perspective."

To date, Ronald Reagan remains our most important artist-politician, a role in which he also exemplifies our ambivalence about the value of an artistic approach to public life and policy. Reagan was frequently denigrated by political opponents as a "third-rate actor," but even his admirers had difficulty accepting his background in movies as an asset. Acting, in fact, is a black mark. "Reagan was always a Hollywood creature,"

David Gergen writes, "able to live easily with discrepancies between fact and image."

Ouch!

When Reagan's acting gets praised at all, it's presented as a kind of media parlor trick—an acknowledgment of the skill set that made him our "great communicator." Again Gergen, a onetime Reagan White House director of communications, delivers the conventional wisdom: "Drawing on skills forged in his earlier careers in radio, films, and television, Reagan set the standard in using television to promote his presidency." Kevin Phillips, reviewing *The Reagan Diaries* in the *New York Times,* observes that Reagan "was a more active and alert chief executive than his detractors care to admit." But Phillips, like some other supporters, is troubled by Reagan's "tendency to view the presidency and its challenges in terms of personal media performance and people-to-people salesmanship."

But is this really all that was going on? Was Reagan's long involvement in a creative discipline meaningful only to the extent that it made him an effective speaker or a master salesman before the microphone or TV camera?

In the title of his respected biography *President Reagan: The Role of a Lifetime,* journalist Lou Cannon acknowledges the connection between Reagan's artistry and his success and popularity in the White House. But, although Cannon diligently records how Reagan's close associates— Michael Deaver and Ken Duberstein—"approached his presidency as if it were a series of productions casting Reagan in the starring role," he stops short of elevating the specific process of acting—the efficient distillation of overarching themes and emotions into influential words, gestures, and facial expressions—to the very top of Reagan's inventory of political assets. Like columnist George Will, Cannon takes note of Reagan's mastery of what Will calls the "theatrical element" in politics without advancing the notion that, as in Havel's view, Reagan's artistry gave him unique skills that enabled him to "care for the political atmosphere of the country—the climate of public life."

If the West Wing views the arts as too "soft" to merit the attention of real policy leaders, acting (and, perhaps, dance) would be seen as the

softest practices. So it should be no surprise that Reagan's career as an artist would be interpreted as a liability to be overcome rather than an asset. But eighteenth-century philosopher Denis Diderot, in his still-respected essay "The Paradox of Acting," describes acting as a calculated, intellectual process that combines knowledge and an understanding of human emotion: "He [the actor] has considered, combined, learnt and arranged the whole thing in his head. . . . This is the matter for a cool head, a profound judgment, an exquisite taste—a matter for hard work, for long experience, for an uncommon tenacity of memory."

Acting is about crafting a facade that can convey emotion and ideas—an activity that can appear superficial to the uninitiated. Because acting is about using skill and remembered feelings to create exterior actions that produce a consistent effect on others, professionals can appear to lack understanding. But accumulating evidence shows that Reagan was no lightweight. He was a diligent diarist, and his career-long correspondence with a fan and friend, Lorraine Wagner, revealed parallel commitments to acting and political action that predated any thought of political office. Douglas Brinkley, who documented the fifty-two-year Reagan-Wagner exchange of letters, makes it clear that the texts reveal a Ronald Reagan who is anything but a Johnny-come-lately actor turned politician. In his characterization of Reagan's letters from the early 1960s, Brinkley points out, "The correspondence between Reagan and the Wagners documents with precision his evolution from a Roosevelt-Truman Democrat to California conservative." The letters are also dotted with concise, inspiring patriotic messages, as when Reagan wrote to the Wagners' seven-year-old daughter, "There are so many things to be thankful for in America, so many things that must not be lost." After all, it was Reagan who (without any help from a speechwriter), in off-the-cuff remarks in a 1980 staff meeting after the Republican presidential nomination was lost to Gerald Ford, quoted John Winthrop's phrase "a shining city on a hill."

Lou Cannon credits Reagan with "reviving the confidence of Americans . . . much the way that FDR did it—by telling us in effect that we didn't have anything to fear except fear itself." His concluding assessment of Reagan's achievement brings Cannon to the brink of linking

artistry with leadership: "The greatness of Reagan was that he carried a shining vision of America inside him. He had brought that vision with him . . . and learned in Hollywood and on the GE circuit to play the role of the wholesome American who would set things right. It was a most natural role."

Reagan's use of language and anecdote, his concept of patriotism and a higher good, and his willingness to invoke overarching themes and values place his leadership style precisely in the realm of politics "guided by conscience" prescribed by Havel. Without ever connecting the dots between the president's core leadership skills and his background in film, Gergen seems to agree: "He operated brilliantly at a symbolic level—the nation's father and comforter and booster." But isn't operation at "a symbolic level" exactly what artists do? Isn't artistry, among other things, the willingness to continually take up the challenge of conveying universal truths through specific, particular actions; distilling meaning into a few square yards of canvas, a three-minute song, or a performance onstage or in a movie?

Reagan's successful application of the principles of acting to the presidency should convince us to take a fresh look at the value of artistic vision in leadership. Americans have a right to the good outcomes that can appear when artistry is applied to problems that have nothing to do with art at all. We need to assert that right again and again, until we, like much of the world, grow comfortable with the notion that artists can be especially adept at using emotion *and* ideas to produce novel policies.

Art works mysteriously, and Reagan, we must remember, was always something of a mystery even to those closest to him. In a political environment that carelessly conflates spontaneity and authenticity, colleagues were unsettled by a feeling that there seemed to be too little substance behind the facade, without ever considering the possibility that Reagan's well-crafted artistic surface might have been the key ingredient of his success. Editor Mort Zuckerman admired Reagan's ability to tell jokes that were "apropos of the moment" and honed to perfection. "Every word was the same. Every intonation was the same. He had polished them to the highest gloss imaginable." But we have a hard time accepting that a story repeated to perfection is a key aspect of leadership. As Diderot

When Ronald Reagan repeated the same telling anecdote, in
the same words, using the same gestures and facial expres-
sions, he was not being inauthentic; he was employing the
artistry of an actor in order to influence an audience.
(Photo: © Tim Clary/Bettmann/CORBIS. Fee: $265.)

makes clear, the apparent emptiness may only have been the penalty paid
by an artist who had given his all:

> His voice is gone; he is tired; he changes his dress, or he goes to bed; and he
> feels neither trouble, nor sorrow, nor depression nor weariness of soul. All
> these emotions he has given to you.

· · · · ·

Artists need to "break through," and they deserve respect—not just ex-
pressed through payment for work, but respect for the way they think
and the way they engage and resolve problems. But artists also have to
make art within a system of laws and regulations designed to manage art
as property. Our system must encourage art making and not constrain it;
it must clear away policies that tie artists' hands. Copyright, the system
of laws and revenue streams that came together in the early nineteenth
century, prevents theft and secures payment to artists when their work is
sold or performed. Copyright protection is essential if we want artists to

be paid for their work. As we have seen, the U.S. Constitution defines copyright as a balance between the interests of artists and the general public. Rights are reserved for limited times so that both individual and society at large benefit. Through most of the twentieth century, copyright could extend only for less than sixty years and could be secured and maintained only through a process of registration and renewal. But the copyright regime of the early twentieth century is a mere memory; the breadth and duration of copyright protections have expanded geometrically during the hundred years since our modern copyright system gelled. Today our basic copyright extends for the lifetime of the artist plus seventy years, and no registration or renewal is required. Corporate-controlled copyrights to sound recordings and films can last even longer. Change has been tailored to the demands of corporate copyright holders, not the needs of working artists. Although artists (songwriters in particular) are often shoved forward in congressional hearings to help make the case for greater protection, the "heavy" copyright regime we operate under today does not necessarily serve creative people. In fact, a study by American University's Center for Social Media determined that, for independent filmmakers, heavy copyright protection had the effect of *reducing* creativity.

After all, artists maintain a more nuanced relationship to the protection of work than do the record companies, music publishers, film studios, and media networks that use copyright to secure assets. Of course, artists need income—intellectual property protections can help—but they have two other needs that don't come into play for companies. First, artists need recognition and acclaim, especially when starting out, and are thus frequently willing to give away or discount their work if short-term sacrifice can help build a lasting career. At a recent panel discussion, an aspiring rock musician described his CDs as "business cards"—something he gives away in order to publicize his band. And it's not at all unusual for startup rock acts to encourage free Internet downloads of their performances or to share free music and videos on YouTube or MySpace. New artists understand that by giving up income in the present, they can build an audience that will support them in the future. Attend any annual convention of the Future of Music Coalition—a new-music advocacy

organization—and sessions will often collapse into intellectual property shouting matches, with many young musicians arguing aggressively on the side of free exchange of music in the digital realm. In fact, many emerging artists don't see their professional interests aligned with big media companies at all. Derek Webb, a Nashville-based singer-songwriter in the Christian music field, has been giving away his most recent album online—35,000 copies to date. "I wanted to see it get out there as far as it could," Webb told a local public radio reporter.

Mature artists are often in the same boat. An actor or singer whose hit movies, TV shows, or recordings are mostly in the past might prefer to have work of marginal commercial value widely available, even free, giving up dwindling revenue streams in order to secure reputation and legacy.

And a flexible copyright regime deployed in different ways to launch or sustain a career isn't the only thing. Artists also need a reasonable ability to reshape art from the past and even art of the present. I've heard that Jimmy Buffett calls creativity "undiscovered plagiarism." Similarly, Jonathan Lethem, in his brilliant article "The Ecstasy of Influence: A Plagiarism," notes that appropriation has always been a key ingredient in Bob Dylan's music: "The songwriter has quaffed not only from a panoply of vintage Hollywood films but from Shakespeare and F. Scott Fitzgerald and Jurichi Saga's *Confessions of a Yakuza.*" There have been periodic attempts to apply copyright protection to fashion design. But, as the *LA Times* editorialized, such constraints would yield "less creativity and innovation." In fashion, "inventions become trends, which beget more innovation. And without copying, there'd be no trends." In fact, all artists shape new art out of old ideas, and some artists are in the specific business of creating new work by reconfiguring art from the past. We know collage as a specific form of cut-and-paste visual art, but it's also a metaphor for a range of art making—from documentary film to hip-hop sampling—that creates something new using snippets of existing work. Many films and remixes of existing recordings—samples, mixtapes for dance clubs, and creative combinations of performances called "mashups"—use technology to extend the basic idea of collage into movies and music.

It's here that the interests of artists and art companies diverge most dramatically. Music publishers and record labels have subtly redefined the term *piracy*, talking about *any* unauthorized recombination as if it were a form of music theft, equivalent in every way to the outright copying of complete manuscripts, DVDs, and CDs—the kind of wholesale piracy that is a big part of music and movie sales in China and the Philippines. But artists have a passion for reworking existing art into something new, and "creative copyright infringement—done for love and respect not necessarily money—is thriving online as mash-ups and at street level as mixtapes." For an artist, *piracy* means something bigger than sampled tidbits of sound or pictures—the unauthorized copying and resale of an entire work, such as, as one Web site put it, the copies of Andy Warhol and Roy Lichtenstein originals "painted by our Thai artists totally by hand."

I was finishing a draft of this volume when Mary Gaitskill's novel *Veronica* emerged to glowing reviews. In her moving fictional memoir of a down-and-out fashion model, Gaitskill included a few snippets of lyrics to old and new popular songs. At first glance I didn't see any acknowledgment of writers or publishers; there was no copyright notice attached to lyrics, no opening-page explanations of who owned what in these popular music fragments. Maybe, I thought, this is one of those rare examples of *fair use*. Perhaps Gaitskill's song quotations are so brief, and so transitory in the overall arc of her story, that she and her publisher didn't even ask for permission.

I should have looked further.

The permission notices were all in the back, and, taken together, the number of words devoted to explaining which entities own or control which rights to quoted song lyrics is about five times the size of the quoted sections themselves. Gaitskill's editor was "satisfied" with her licensing arrangement. But tracking down permissions and negotiating the necessary fees can pose undue stress for the central act of art making. Artists create by *synthesizing* the work of others by, first, glancing to the side to reflect on the work of peers, and second, looking back to make art from the past meaningful as a part of something new. Obviously, copyright protects the ability of artists to control and earn from their own

work. But it's one thing to protect an author, painter, or songwriter (or the artist's estate) from wholesale theft, quite another to make it extremely difficult to minimally quote existing work in a new creative project without first locating owners, securing permissions, and paying licensing fees.

Historically, the use of small portions of existing work without permission has in part been protected by the understanding that some uses have no measurable value; they are, in a legal sense, *minimal*. As recently as the 1970s the Country Music Foundation was able to publish a collection of country music lyrics with no payment at all. But today the right of artists to integrate even the smallest piece of existing work without permission has been virtually eliminated. This trend—driven not by artists but by the perceived value of intellectual property revenues in the marketplace—has been to eliminate all free use of words, sounds, or images. A Canadian court actually ruled that documentary filmmakers must receive permission for the use of likenesses from bystanders at an event being filmed. Author Peter Guralnick noted at a 2005 conference at Vanderbilt University's Curb Center, "Twenty-five years ago I could quote two pages of text in my book without permission; it was fair use. Now I need to license five lines." And the *di minimus* defense—that an appropriated segment can be so small as to have no capacity to diminish the value of the quoted material—is also a thing of the past. In fall 2005 the Sixth Circuit Court of Appeals ruled, in a case involving a music sample of less than fifteen seconds' duration, that *no sample* can be sufficiently brief as to not require a license. So much for any visual artist who creates new work by piecing together images snipped from magazines or newspapers! In fact, our system will probably soon generate the kind of "trolls" that now haunt trademark—companies that tie up tiny intellectual property rights for the sole purpose of suing once a new work achieves success.

As Guralnick suggests, the concept underlying "fair use" is also intended to permit, even encourage, a flow of creativity among artists, critics, and educators—the flow of creative "Progress" envisioned in the language of the U.S. Constitution. Policy analyst Timothy Lee writes, "Fair use recognizes that not all unauthorized copies are detrimental to copyright's goal of encouraging creativity." Fair use allows any citizen to quote or copy parts—even large portions—of copyrighted works if the

use advances creativity or democratic discourse. Fair use is intended as a safeguard, a measure of protection that ensures that the rights of copyright holders won't be employed in a way that short-circuits creativity or stifles political speech. Fair use stands as the exception to the term-limited monopoly of copyright that permits quotation of creative work without permission when the new product involves news reporting, commentary, or teaching. In addition, the Supreme Court has determined that new work in science and the arts inevitably "borrows" from the work of others or from ideas or insights that are commonly held.

This borrowing, or appropriation, is obviously essential to progress in science, but it is every bit as important in literature, music, painting, and photography. It is by appropriating ideas and language that artists are freed to synthesize, freed to create a new work that is simultaneously original and linked to the ideas and work of others. In addition, courts have determined that individuals—regular citizens like you and me—can duplicate copyrighted work for personal use simply because it would be unduly burdensome for individual citizens to be required to seek permission every time they wanted, for example, to copy a favorite song so they could play it on a portable listening device.

For the first three-quarters of the twentieth century, the years in which our commercial and nonprofit arts industries were getting up a head of steam, fair use was not codified. Instead, the notion that copyright interests were compelling but not absolute resided in multiple decisions by different courts tasked with deciding specific infringement cases. In 1976, when Congress conducted a general overhaul of the copyright law, Section 107 of the new legislation enumerated the multiple considerations that would help future courts determine the validity of fair use claims. Now, understand, Congress did not say, "If you do exactly thus and so, then you will be operating under the umbrella of fair use and not be subject to legal action and penalties." Instead, the revised copyright statute simply listed four "factors" that courts should take into account when deciding if a fair use defense in an infringement case was sustainable.

So fair use is a "defense," not an exception to copyright, and the burden of proof in any fair use case was placed firmly on the shoulders of the defendant. It's as if we took our speeding statutes and instead of telling

citizens, "If you go over thirty-five miles an hour on this stretch of road, you'll be fined," we simply gave judges a set of guidelines—how new is the car, how experienced the driver, what was the weather like, and how many other cars were on the road. Judges would then weigh these factors to determine guilt or innocence. Facing traffic laws this vague, drivers would forever be on pins and needles, never certain when an arrest might occur, and just as uncertain whether an arrest might result in a conviction and a fine.

But, unfortunately for artists and citizens, this is the way fair use works today. Given the uncertainties of a fair use defense, it's no surprise that legal "risk analysis" is a new feature of contemporary art making. Judges in an infringement court action examine the nature of the original work, the purpose or character of the new use, how much of the work has been duplicated, and the potential effect of the new use on the value of the original copyrighted work. To make things more complicated, judges can also consider factors such as bad behavior by either party or the possibility that the lawsuit is being pursued simply to avoid unwanted criticism.

Fair use is essential to artists, critics, and scholars, but copyright-dependent corporations hate it. From the inception of the 1976 Copyright Act, corporations that control sound recordings and films and companies that contract to represent the interests of individual copyright holders like composers and novelists have worked diligently to narrow the scope of fair use. For individual artists—painters, filmmakers, authors, and composers—the meaning of "fair use" is more subtle; it cuts both ways. On the one hand, fair use can be seen as a threat to the monopolistic authority of copyright (exclusive rights) and hence to the earning power of movies, songs, and novels. On the other hand, artists rely on the ability to reconfigure historical work into something new (synthesis), and it's fair use that gives an artist the ability to make elements of existing work part of something entirely new.

Sometimes new art is synthesized from quoted portions of a painting, novel, or song; sometimes a new piece actually takes very small elements from an existing work and recombines them as parts of something entirely new—think of Alice Randall's reshaping of characters from *Gone with the Wind* in her own novel, *The Wind Done Gone*. However, Randall's

case only underlines the challenges of making new art that contains elements of earlier work. The author worked on the assumption that her all-new novel (it didn't quote a word but instead created a new narrative using characters from *Gone with the Wind*) was within the realm of fair or minimal use, but the Margaret Mitchell estate sued, claiming infringement of their rights to the original characters. Fortunately and properly, the court sided with Randall, and the Mitchell estate's claim was dismissed. But the litigious journey of *The Wind Done Gone* makes an important point; even the strongest fair use claim may be forced to justify itself before a judge or jury, often at considerable expense.

Clearly, artists need give-and-take in both fair use and copyright itself. Not so the companies that police copyrights; they have every reason to prevent others from using even small portions of their protected films or recordings free of charge. In chapter 1 we saw that copyright can prevent citizens from gaining reasonable access to arts heritage when corporate interests aggressively police their revenue stream monopolies. It is even more difficult for artists or educators to make use of contemporary literature, film, or recorded music without worrying that a lawsuit might be right around the corner. Over the past twenty-five years it has become increasingly common for corporate attorneys to use the threat of legal action to intimidate artists, social commentators, and competitors. And because fair use is only a defense, and a defense of uncertain effectiveness at that, a cease-and-desist letter from the legal department of a big corporation can, all by itself, frighten a regular-Joe Web artist into abandoning a project.

In recent years, owners of intellectual property have been quick to pull the trigger when it comes to policing rights, and they've often succeeded in chilling fair use. In trademark, for example, a logo or brand name can be used if it doesn't compete with or decrease the brand's value. But owners of trademarks have become more aggressive in claims that artistic reuse of a brand damages the original in some way. In October 2006, for instance, President Bush signed HR 683, the Trademark Dilution Revision Act, into law, making it illegal to use a photograph of a Hummer, for example, to illustrate an article on gas guzzlers.

Imagine the plight of sports artist Daniel A. Moore. A graduate of the University of Alabama, Moore has made a career from the sale of his

paintings and prints depicting dramatic moments in Alabama football. But today the university has demanded that Moore stop, arguing, as the *New York Times* reported, that the artist is, among other things, infringing on Alabama's "famous crimson and white color scheme." Citing First Amendment rights, the painter has asked a Birmingham judge to dismiss the case. The parties were still awaiting a decision in mid-2007, but the very existence of this case exemplifies a startling new aggressiveness on the part of trademark and copyright holders.

It is essential that artists are free to rework materials at hand. As one *New York Times* reporter put it, "Our surroundings are so thoroughly saturated with images and logos, both still and moving, that forbidding artists to use them in their work is like barring 19th-century landscape painters from depicting trees on their canvases."

It is, of course, axiomatic that the advent of the digital age has brought exciting opportunities to create new work by recombining existing photographs, text, or graphics. But the copyright environment today is far more restrictive than the system set in place a century ago, and corporate interests have been especially aggressive in relation to the Internet. The Digital Millennium Copyright Act, signed into law just as I joined the Clinton administration as NEA chairman, made it especially easy for copyright owners to intimidate and even punish unauthorized use of protected material online without any need for litigation or court action.

The DMCA's nonjudicial intellectual property enforcement system works like this: Internet service providers, known as ISPs, are absolved of any liability for copyright infringement *if* they agree to promptly remove any material on their services that a copyright owner tells them is infringing. Publishers, film studios, and companies protecting intellectual property rights are handed the power to force America Online, Comcast, YouTube, and other carriers to issue "take-down notices," requiring Internet users to remove material from Web sites without any legal determination that the site is, in fact, infringing. The law may have been unconstitutional from the outset, since it is unlikely that ISPs would have been responsible for the infringing actions of subscribers in the first place. But despite a questionable legal foundation, take-down notices—like threats of lawsuits challenging fair use—intimidate Web users into

ceasing perfectly legitimate activities, in effect shrinking the domain of art and creativity on the Internet.

What about education? The educational use of protected material is critical to, among other things, the training of new artists, and it's specifically cited in fair use guidelines; if citizens have a right to make the art and insight of artists part of our expressive lives, shouldn't the classroom be a protected haven in which images, words, and music flow free?

Unfortunately, like collage artists, educators face an increasingly hostile intellectual property environment. Twenty-five years ago, when I was a visiting professor at Brooklyn College, the campus copying service routinely duplicated newspaper and magazine articles and individual chapters of books for limited distribution to my class. Today, here at Vanderbilt, our copy center won't duplicate anything that hasn't been cleared by the licensing office of the university's legal department. Faculty members who want to use copyrighted material in classroom settings must plan well in advance and submit lists of articles and sections of books they want to distribute for classroom use. If a teacher wants to be spontaneous, distributing copies of articles related to current affairs or new trends in art or media, well, he or she just needs to drive to a commercial copy service that isn't too picky about copyright and get the job done. But heaven forbid that your educational activity should leave the campus or classroom: quotations in a Ph.D. dissertation are protected by fair use, but try to publish your dissertation as a book, and negotiations over rights will kick in.

The nonspecific threat of legal action and the desire to do the right thing encourage school rule makers to overreact. Although court decisions have actually extended broad latitude to educators using copyrighted works, university self-regulation on the issue of duplication for classroom use has resulted in a set of rules more cumbersome and restrictive than those established by legal precedent. Classroom-use guidelines that found, their way into the legislative history of the 1976 Copyright Act are themselves more restrictive than fair use guidelines applied in court cases. In the 1990s the government convened an ultimately inconclusive conference to set rules for the use of copyrighted material generated by new technologies; here, too, the few limits that emerged from several years of meetings had the effect of narrowing fair use. In an effort to advance fair use and a "light"

copyright regime, I fought to include a statement permitting free classroom use of limited portions of *Arts, Inc.* on the book's copyright page. Predictably, invoking fears of dangerous "precedent" and lost licensing revenue, UC Press nixed the idea at the eleventh hour. The atmosphere of intimidation and uncertainty that surrounds fair use in education is a real-life example of what Michel Foucault calls "governmentality"—self-imposed constraint based on *internalized* rules—rules that end up being more restrictive than laws or regulations.

If fair use is the counterweight to unrestrained copyright monopoly— a kind of "canary in a cage" testing the atmosphere surrounding the public interest in intellectual property—then the increasing timidity of fair-users is an alarming symptom. While the expanded footprint of copyright and trademark protection has damaged our arts system in many ways, no single change in the way artists work is more indicative of the trend away from citizen rights than the increasing assumption that *any* quotation or collage image requires permission and payment.

What happens when an artist—a filmmaker or a producer of CD anthologies—wants to pay in order to move beyond fair or minimal use to license the use of existing material?

If securing permission from copyright holders becomes a permanent part of the creative process, artists at least deserve to engage a licensing system offering predictable pricing and efficient licensing procedures. Unfortunately, the reality of the "rights world" is exactly the opposite; costs vary wildly, and the system is unwieldy. For example, for filmmakers or CD anthologists who *must* acquire the rights to specific old news footage or specific pieces of period music, corporate copyright owners can, by saying no or by pricing their holdings out of reach, affect the very character of a film or compilation recording: the inability to clear essential old material makes the new work incomplete or even historically inaccurate. To further complicate matters, because some heritage films, recordings, and TV shows have been orphaned, no one knows who can authorize new uses. But whether material is lost or simply too difficult to license, consumers end up viewing or listening to a contemporary product that isn't exactly what the producer, compiler, or editor of the new work intended.

Over the years, I've had the opportunity to work as a "collage artist"

myself, producing a number of historical record packages, including several in a hundred-album set documenting American music and timed to the U.S. Bicentennial Celebration in 1976. The series was the out-of-the-gate project of a nonprofit music company, New World Records. New World was funded—in effect, founded—by the Rockefeller Foundation, and the $7 million project represented, at the time, the largest single cultural grant ever given by the foundation. New World Records was created to make music part of the Bicentennial in an innovative way: the series would present the history of American music in one hundred LP recordings that would be distributed free to nonprofit libraries and to public broadcasting outlets.

At first the project set out to document only American classical music but soon expanded to encompass jazz, blues, country music, and the roots of rock 'n' roll. Of the two country albums I was working on, the one designed to showcase contemporary country performance had become especially problematic. New World envisioned the project as a gift to the American people, but its insistence that record labels and publishers adopt its charitable vision put all the producers of folk and pop projects—especially those that included recent performances—in a distinct "licensing hole." Because the hundred-album set would only be distributed to nonprofits and because the series would be free, New World insisted that record companies and music publishers with rights to original recordings make the performances and songs available to the project without charge. Most record companies and publishers went along (an unlikely scenario today), but each inserted a "most-favored nations" clause in its licensing agreement.

Like fair use, "most-favored nations" is an important intellectual property concept. It's a fairly simple provision inserted in every licensing agreement that states all copyright holders are compensated at an amount equal to the highest fee any participant was actually paid for its license. So if I pay $300 to license a clip from *Sixty Minutes* for my film project on a most-favored nations basis and *Nightline* charges me $600, I have to pay *Sixty Minutes* at the higher rate. The contractual clause is used all the time, preventing the producer of a new compilation CD or a film from driving down payments to less commercially valuable existing work while paying top dollar for, say, a big star performing a classic hit.

So although our New World licenses were "free," the most-favored nations rule prevented the label from making an "exception," paying only for cuts deemed crucial to the story line of an album; if we paid *one licensor*, we had to compensate *all* at the same level—that meant free or not at all.

We were licensing the content of New World sets in 1974 and 1975, anticipating a Bicentennial release the next year. I was determined to include Loretta Lynn on the contemporary country disc. At the time Lynn was one of the hottest acts in country music—certainly exemplary of the best in country music from the 1950s to the 1970s, a period when her career had flourished. To convey her stature as an artist in the set, we needed one of her major hits. I went after her biggest single, "Coal Miner's Daughter," a song she both wrote and recorded, and one that was tied to childhood memories and her eastern Kentucky heritage—a perfect cut for a reissue tied to American history.

Lynn's Nashville office, managed by her friend and cowriter Lorene Allen, was completely agreeable, but David Skepner, then a vice president with MCA Records (Lynn's label; the victim of my heritage "heist" a couple of years earlier) was adamant; he did not want to license any cut to the project, regardless of price, and he was especially determined not to let us use "Coal Miner's Daughter." After a dozen phone calls to Skepner's West Coast office, I still hadn't gotten anywhere. And despite Lynn's willingness to have "Coal Miner's Daughter" on the New World album, it wasn't her decision: standard recording contracts and longstanding industry practice dictated that only her record label could license the performance.

I was baffled by MCA's unwillingness to let us use Lynn's hit. But unknown to me, the corporation and Skepner had their own objectives.

Loretta Lynn was completing a biography titled *Coal Miner's Daughter* (it was a great publishing success in 1977), and the film rights were already being negotiated. The 1980 movie would earn critical acclaim and its star, Sissy Spacek, an Academy Award. But back in 1974 David Skepner was determined to hold Loretta Lynn material off the market until reissues of her recordings could be timed to support the publication of her book, the inevitable talk show appearances that would follow, and,

ultimately, he hoped, a movie premiere. It might seem odd that a record company executive like Skepner would hold back recorded performances in order to support the prospects of a forthcoming book. But beyond protecting label interests, the MCA VP had his own agenda: Skepner soon resigned his position, relocated to Nashville, and pursued a career as Lynn's personal manager.

Though ignorant of the personal and corporate "backstory," it became clear to me that MCA was dead set against granting New World Records a Loretta Lynn track—not free; not at any price. Desperate, I pursued one last alternative. Lynn's first regional hit had been on the tiny Zero label, and that cut, "Honky Tonk Girl," had been acquired by Decca (in the same way MCA bought the entire Decca label), but the record wasn't *really* on MCA. It didn't make Skepner happy, but after another half-dozen phone calls we worked out a free license for "Honky Tonk Girl," and Loretta Lynn was, to my relief, included on the New World album, *Country Music in the Modern Era: 1940s to 1970s.* But Lynn was not represented in the set by her most artistically and historically appropriate performance; corporate practice and personal ambition had intervened. Instead of her biggest hit demonstrating her place in country music as a mature songwriter and singer, she was represented by her first success, a fine recording but one suggesting promise rather than achievement. Perhaps, to the average listener, it only matters that Loretta Lynn was part of the American music story. But the vagaries of heritage ownership, the ability of individual ambition or corporate policy to "edit" the past, provided New World and its unique audience with a less than optimal example of one important artist's work.

Every day "rights" issues shape what we see and hear in just this way. For years, the most reissued Ray Charles recording was his performance of "I'm Moving On," the classic song composed by Hank Snow, covered by the R&B giant in his *Modern Sounds in Country and Western Music, Vol. II,* album. Why does this cut appear in historical compilations more often than others? Is it considered the vocalist's best or most important recording? The answer is simple: "I'm Moving On" is the only recording master that wasn't controlled by Ray Charles himself. Because Charles was notoriously unwilling to license his early tracks to independent labels,

film, or TV, the only thing that ends up in compilations is the one cut he couldn't say no to.

Ray Charles isn't the only recording artist whose work comes with special licensing problems attached. The great country singer-songwriter Hank Williams is also often represented in historical reissue compilations or in film soundtracks by a single performance. Hank's most rereleased early recording is "Lovesick Blues," the only hit Hank cut that he didn't write himself and thus the only song *not* controlled by Acuff-Rose publishing (whose song catalog is now owned by Sony Music), a company that was for years notorious for using control of Williams's copyrights as a point of leverage to exercise all manner of control over multiple aspects of the deceased artist's career.

In this case it was the music publisher, not the record company, that for years made it difficult to rerelease Hank Williams tracks. If you need to include a song in a movie, or in a TV commercial, or if, like novelist Mary Gaitskill, you want to quote song lyrics in print but are wary of claiming fair use, you must negotiate with the song's publisher. And remember, there's no set fee for any particular use; the publisher can charge whatever traffic will bear.

But, as we have seen, CDs and legal downloads are different, and that difference accounts for the vitality of the record business. Payment to writers and publishers by record companies is governed by what's called a *compulsory license.* As already indicated, it's compulsory because, if you pay a fee set by law for every CD you sell, the publisher can't stop you from rewording and releasing a particular song. Publishers don't like the compulsory license. They'd rather have the ability to negotiate for every use, demanding higher rates for classic standards like "Yesterday" or "Tennessee Waltz" than for new songs by unknown composers. But it's hard to imagine a functioning record business if singers had to negotiate a price every time they wanted to record a song; superstars would negotiate cut-rate license fees while beginners would be priced out of the market. The compulsory license is good for the art of music making.

However, there remains one circumstance in which a publisher can withhold a song from a project, and that is when a record company wants to pay less than the full statutory royalty of 9.1 cents per composition.

That's frequently the situation with historical reissue albums. Such projects—the kind produced by Orrin Keepnews—often include fifteen or twenty tracks instead of the ten or twelve typical in a major-label superstar release and are assembled on shoestring budgets for specialized audiences. Because full royalties on a twenty-track reissue would be $1.82 per disc, reissue producers typically request a reduced rate. That's when publishers have a veto over what can be reissued; by saying no to a price cut when every publisher must be paid at the same level (the favored-nations clause), a refusal effectively forces the reissue producer to move on to select another artist or at least a song controlled by a more compliant publisher. That's how Acuff-Rose kept Hank Williams out of historical compilation albums and why "Lovesick Blues" became the most reissued of all Williams's performances. The work of artists who employ any existing or historical art to make something new is too easily subverted by subtleties of law, regulation, and corporate practice.

Today TV networks and production houses are bringing in big bucks by releasing entire series on DVD. However, historical and artistic significance—or even popularity—don't determine which historical television series will find their way onto DVD. Even substantial contemporary demand isn't strong enough to pry old television shows loose from the sticky web of rights and contractual obligations that must be satisfied if the past is to live in the present.

It took years for *The Cosby Show*, the groundbreaking sitcom that dominated prime-time television in the 1980s, to become available on DVD; the same is true for *Roseanne; Dynasty* is available, but ony a few seasons of *Gunsmoke* and *Hill Street Blues* have made it so far. Some shows are perceived as too old and noncommercial; others are tied up in contractual knots (multiple studios, talent contracts) that make DVD release nearly impossible. And, as is the case with any project that links music and moving images, licensing is a frequent problem. Obtaining music rights can range from "time-consuming to impossible," and sometimes the only solution is to replace music that is too difficult to license. One industry leader observed that licensing musical compositions for DVD release is frequently so expensive that "you would be in a loss position on every single DVD that comes out."

The sitcom *WKRP in Cincinnati* is a textbook example of the way aggressively policed intellectual property rights attached to art of the past can block new product—a DVD compilation—and force collage-artist producers to change the original. The *WKRP* series first aired on ABC, produced by MTM Enterprises, which retained rights to shows when the network run ended. MTM was acquired by International Family Entertainment, which was in turn sold to Fox, which got rid of all but a few MTM assets that were seen as still marketable. *WKRP in Cincinnati* was syndicated by Fox to independent stations in the United States and Canada. In addition, the programs were released for home sale on videocassette in 1998.

That's where problems with music rights showed up.

To present an authentic backdrop to the radio-based comedy series, the original MTM production licensed snippets of rock and pop recordings of the day to provide disc jockey Johnny Fever with real hits to introduce during his fictional broadcasts. The American Society of Composers, Authors and Publishers (ASCAP) and Broadcast Music, Inc. (BMI), the two organizations that collect payments for use by the use of songs in broadcasting, charge predetermined standard rates for use by network shows; the collected funds are divided equally and distributed to the composers and publishers of featured selections. Payments for the use of music in a network television broadcast are substantial but usually can be accommodated in a big-time production budget; at the time *WKRP* was on ABC it cost the producers about $1,000 for each song included in an episode. (*WKRP* was shot on videotape. It was assumed that the only function of tape was to shift the airtime of a show that was essentially a live performance. The music licensing bodies charged their lowest rates for live shows or programs that were taped as if live. The sitcom would have paid more for the use of music at the outset had it been shot on film, a medium designed not for time shifting but for distribution. Such are the arcaneries of our intellectual property system.) But music broadcast rights are limited in scope; the $1,000 payment to BMI or ASCAP buys the producer and network only the original broadcast plus a handful of repeats.

To assemble a TV series for sale on tape or DVD, producers must acquire synchronization, or sync, rights from the publisher. For a program

like *WKRP in Cincinnati,* the task of licensing multiple sync rights was too time-consuming and costly to allow for transition into syndication and home video in the program's original form. The solution was to replace recognizable hits with sound-alike performances that could be licensed for little money or generic tunes that were completed as works for hire by staff composers and musicians. Because the music in *WKRP* was an integral part of each script, the elimination of original music sometimes required changes in language or, when language was unchanged, produced eyebrow-raising non sequiturs. As a Web site passionately devoted to the integrity of *WKRP* observed, the meaningless line, "Hold my order, terrible dresser," replaces an original phrase that referenced Elton John's "Tiny Dancer." In another episode the line "There's no holdin' back Eric Clapton" remains in the edited show, but it is not Clapton who is heard after the introduction. To keep *WKRP in Cincinnati* alive after its network run, distributors have had to replace dozens, if not hundreds, of songs woven into original shows. Other series that featured pop music, such as *Ally McBeal,* are in the same boat, at least in the United States. If such programs somehow make the final jump from tape to DVD, they may no longer be the same hit sitcoms so popular when first broadcast. As in the case of my New World country set, licensing problems create subtle shifts in artistic intent and in the historical record.

Whenever a program is recorded in a medium that allows theatrical distribution, or sale on videocassette or DVD, the sync license kicks in. Publishers generally demand a payment for every DVD or tape sold, based on a percentage of the wholesale or retail price of the final product. And because publishers are ill equipped to track down and audit the manufacturers or distributors of the many products containing licensed songs, most attempt to obtain significant up-front payments. An agreement might be for five or seven years, granting rights to sell DVDs in the United States and Canada, in return for twenty cents per selection for each unit sold, with a guarantee of ten thousand units. A producer would thus budget to pay the up-front guarantee of $2,000. In a DVD that included a dozen songs, the initial music budget would be $24,000—an example that would be something of a bargain in today's intellectual property environment.

And remember our favored-nations clause: a producer who wants to use music in a new work of art will almost always end up paying the same price for every composition, even if multiple publishers are involved and even if different prices are negotiated for different songs. As in the case of recordings licensed for compilation, sync licenses routinely include a most-favored nations clause. So our imaginary producer must budget her project understanding that the highest fee paid for the use of *any* song in an audio or visual package will set the level of royalty paid for each composition included in the set.

The sync license will cover the producer if she's going to create new performances of a song for a movie, but if she wants to use tracks from a CD (like the songs in *WKRP*), she must *also* negotiate with the record label that released the cut. The record company doesn't control the rights to the *song*—the composition—but it does hold a copyright to the *performance:* as interpreted by a New York court, that right that now reaches from the 1880s to 2067, secured by common law and enforced, not by federal statute, but by the states.

Maybe *WKRP in Cincinnati* isn't the most important artifact of our nation's cultural history, but a copyright system that makes it too hard for artists to make something new using something old is an equal-opportunity villain. The great PBS documentary of the civil rights era, *Eyes on the Prize*, spent years locked away from public view, unable to be shown in theaters or on television or repackaged for home sale as a DVD. The license agreements attached to the use of news footage, still photographs, and music—limited, like *WKRP*, to original broadcasts—expired, and the complexity and cost of relicensing the program elements stymied producers and orphaned an outstanding heritage film for years. Collage artists are hamstrung by shrinking fair use and the expanding cost and complexity of clearing rights. It is time to push back against bloated corporate copyright and its hammerlock on progress in art and ideas.

· · · · ·

Compilation CDs, documentary films, and TV shows sold on DVD are very much "traditional media." Perhaps the world of online music and coinages offers an easier path to creativity and artistic independence?

Today the Internet is still touted as an affordable venue in which artists in many disciplines—especially those who "mash" existing work into something new—can place movies, graphics, literature, and music before a vast potential audience. However, given the ability of copyright-dependent companies to shut down file-sharing services and force service providers to take down Web sites at the drop of a hat and the increasing influence of advertisers and search engines, the Internet is losing its image as an anything-goes creative playground for a new generation of artists. In fact, the flow of art and artistry on the Internet has actually served to enhance the perceived value of intellectual property. After all, the digital character of online communication means that "once it's out there, it's gone for good," so maybe it should be no surprise that fair use is narrower and licensing more difficult than was the case twenty-five years ago. The ultimate character of the Internet has always been an open question: Is it a qualitatively different artistic gameboard, with new rules and a wide-open creative playbook, or is it more like television, just another technology to be gradually subdued by arts industries and advertisers unconstrained by the public interest?

As we'll see, we're losing the battle for an open online playing field; the Internet won't automatically save art and artistry.

· · · · ·

But, if citizens have a right to engage artists as respected, well-compensated, effective leaders in society, what must we do to advance our right to engage the work and ideas of a vibrant community of artists?

Even modest investments of public money can help to connect artists with communities outside the classroom. During my years with the National Endowment for the Arts, the agency invested a major grant in a special Millennium Initiative called Continental Harmony. The premise of the project was straightforward: place a composer in residence for an extended period in at least one city in every state in the nation. The project, executed by the nonprofit Composers Forum in Minneapolis, was wildly successful. Communities applied for "their composer," and the resident artist worked with community organizations, writing special music for civic events, holidays, and commemorative ceremonies. In

addition, citizens had first-time opportunities to work face-to-face with an artist, defusing the prejudice that artists are eccentric, unsocial, or a bit flaky. In the end the project was about both engagement and respect for new artistic work; Continental Harmony derived as much value from linking artists with citizens as it did from the creation of musical compositions tailored to community interests.

Using Continental Harmony as a metaphor, a national "arts corps" modeled on the Peace Corps or Job Corps could place artists-in-residence in cities all over the country. For artists just emerging from training programs or for actors, singers, and painters just getting started, a one- or two-year residency in which talent and skill is linked with community projects would help to launch careers while defining the essential connection between artists and citizens envisioned in our Cultural Bill of Rights. And artists need to know how to craft a career. Conservatory training is almost always just about painting, playing, or singing. However, a small but growing cohort of artists and educators is having some success at integrating entrepreneurship into the offerings of arts training programs.

Work for artists is important, but it's also crucial that we reform copyright law so that the essential balance envisioned in the Constitution and the concept of fair use—the notion that copyright is a monopoly but not an *absolute* monopoly—is reestablished and reenergized. We also need to craft public policy with an understanding that the interests of artists do not always coincide with the designs of copyright-dependent arts industries. Artists must be free to give away work if they think it's to their benefit, and they shouldn't be prevented by law from making reasonable use of the work of others. Just as inactive heritage copyrights should enter our cultural commons, old work or films, records, or broadcasts without legitimate owners should be available for free use by artists, perhaps for a modest, predetermined compulsory license fee. If a filmmaker can know with certainty, in advance of planning a production, that commercial film more than fifty years old can be licensed for, say, no more than $500 a minute, then the budgetary mystery that makes collage-style projects risky or impossible would be eliminated.

In *The Future of Ideas*, copyright expert and advocate Lawrence Lessig

put it this way: "The aim is therefore not to find a world without constraint; it is to remove constraints that might otherwise inhibit innovation." Converting ideas into action, Lessig and his Stanford colleagues have developed the Creative Commons, an intellectual property system that allows artists to parse copyright to secure specific rights while giving up others. For example, an author can permit online or educational uses without permission but retain rights should a poem or short story be incorporated into a movie or television show. Brazilian singer-songwriter Gilberto Gil was quick to link his nation with the Commons when he became culture minister in 2003. In a *New York Times* interview conducted early in 2007, Gil called for "a new culture of sharing," arguing that in the world of intellectual property "we are moving rapidly toward the obsolescence and eventual disappearance of a single traditional model." He speaks with the authority of personal experience highlighting the tension between the interests of copyright-dependent industries and working artists, but such views have not influenced the position of "heavy copyright" adherents in the United States or Europe. Like a more balanced application of fair use, the Creative Commons is anathema to the copyright industries, but despite opposition from publishers, record labels, and studios, the Commons today contains more than 145 million creative works.

A complementary initiative was launched in summer 2006 by the Brennan Center for Justice at New York University; its "Fair Use Network," an online reference service, is designed to help artists, scholars, and journalists assert fair use rights by linking users of copyrighted material with legal precedent and best practices.

If America's arts system can be viewed as a giant machine connecting artists, heritage, and our expressive lives, fair use is the lubricant that smoothes the give-and-take of creativity. It's crucial that citizens weigh in on intellectual property legislation and regulation that make it easy for artists to create, and also easy to *re-create* or *reconfigure* existing art into new work. For example, when copyright interests return to Congress to extend the scope of intellectual property protection to cover a new technology they find threatening (and they *will* be back), any quid pro quo Congress negotiates must at the very least convert fair use from a vague territory into a solid legal concept; from a *defense* into a *right*. If artists and

educators know, in advance, that certain actions are permitted under fair use and if they can proceed without constantly glancing in the rearview mirror to avoid being run down by a lawsuit, take-down notice, or cease-and-desist letter, then we will have begun to reestablish the balance between the rights of copyright holders and the larger public interest.

And the more outlandish provisions of the Digital Millennium Copyright Act must be rolled back. Record companies and film studios shouldn't be allowed to determine who does what on the Internet—take-downs are a matter for our legal system.

Most important, our right to the best that artists can give will only be realized when we embrace the larger value of artists to society. If Americans can grasp the utility of artistic vision—the unique perspective and skills that artists bring to everyday problems—many challenges now inherent in the artistic life would fall away. But policy leaders are persistently uncomfortable when engaged by the intuitive, spontaneous, and imaginative style of artists in decisive settings.

What would a community or institution look like if it honored artistry in its every action? The United States, quietly alienated from its own creativity, boasts few examples.

Robert Redford's Sundance Preserve offers a glimpse of what institutional life can become if artists are not a frill but at the core of an organization's work. Sundance, a six-thousand-acre recreation center, nature preserve, and conference retreat near Provo, Utah, is, as its official literature puts it, "dedicated to maintaining the balance of art, nature, and community." Redford notes that in most settings the arts are viewed as an accoutrement, but "we took the concept and flipped it, using art in a nonprofit forum, as the starting point." To an unusual degree, artists are integrated into the routine rhythm of Sundance programming. A recent conference on arts policy, sponsored by the advocacy group Americans for the Arts, didn't use expert speakers to frame issues but instead employed members of Chicago's Second City comedy ensemble. During a break in the meeting, the release of a rehabilitated golden eagle into the wild was preceded by the reading of a poem by Susan Elizabeth Howe, "Why We Need Wild, Living Creatures." The closing dinner concluded with performances by professional songwriters from Nashville. Through-

out the meeting Second City actors nudged conference participants into acting out, not merely presenting, their arguments. And when the meeting wrapped up, attendees left carrying a souvenir—a glass tile hand-fired by artists working on the Sundance campus. One or two of these activities would be a mere frill, but a pervasive, intense engagement using artistry as the glue of debate and decision making creates a process that is distinctive. In 2007 Sundance began construction of a full-blown conference center, one that will place art, according to Redford, "at the top, at the start of things." Regardless of the subject under discussion at the new facility, the actor/activist insists, "We think art is so important that we're going to put an artist at the table for *every* conference."

Bring poets, actors, musicians, and artisans into the heart of government, business practice, and nonprofit leadership, and our right to the work of artists as a centerpiece of public life can be realized.

A Creative Life

The right to an artistic life—the right to the knowledge and skills needed to play a musical instrument, draw, dance, compose, design, or otherwise live a life of active creativity.

It was March, early spring in most of the country but late winter in the Northeast, and dirty, melting mounds of snow still made the sidewalks treacherous for political appointees trapped in the wrong footgear—standard-issue Washington dress shoes. The year was 2000, and I was visiting Lynn, Massachusetts, to learn about Raw Art Works, an arts therapy program targeting children and teens caught in the numbing surroundings of the housing projects in this economically challenged industrial town nine miles north of Boston. Then as now, 22 percent of Lynn families with children lived on incomes below the poverty line.

Raw Arts was impressive; I took in exhibits of student work (surprisingly imaginative and accomplished), talked with longtime program participants, and heard a firsthand, heartfelt narrative from a participant-turned-counselor who spoke movingly about the way involvement in

visual arts had given him the discipline and sense of worth that had enabled him to do well in school, get along better with friends, and, in short, turn his life around. By the time I was topcoating-up to head back into the blustery morning, RAW had provided evidence of something I and all my colleagues at the NEA firmly believed: engagement with art—real participation in art making—could be a source of meaning, satisfaction, and success powerful enough to shape character and behavior.

Just before I headed downstairs from the friendly remodeled abandoned factory that had become RAW's workspace, Mary Flannery, artistic director and cofounder of Raw Art Works, eased me aside for a final word. I expected a pitch; after all, these visits were opportunities for me, as NEA chairman, to look over some of the most striking arts activities under way in the country. Not infrequently, a firsthand look translated into a grant—a small, discretionary "chairman's action" intended as a token of recognition and support. I was ready for the final "ask" from Mary and was prepared to be positive—"Sure, we'll try to help"—but she had something else in mind. "You know," she said, "these kids are going to find their way out of here. They've got our program, and dozens of other agencies are trying to make certain that they can break free; they know their stay here in these Lynn projects is temporary. But for the old people in the projects, this is the last place they're going to live. What are we doing for them? What is making life better for those who aren't going to get out but who have come here to die?"

Flannery's pitch was rare for a nonprofit administrator: given the opportunity, she hadn't argued for support of her youth program but instead had raised a new issue that she thought the NEA should be thinking about. What could we do for the mature or elderly poor, often living alone with few family ties, whose circumstances were fixed, trapped in lives that would never resolve into opportunity, progress, and success? Back in 1961, at the first White House Conference on Aging, President Kennedy had said, "It's not enough for a great nation merely to add to the years of lives. Our object also must be to add new life to those years." Forty years later John Kennedy's challenge had not been answered.

It had started to rain, and the drive back to Boston was slowed by traffic and the tortuous detours of the "Big Dig." My packed schedule of

meetings and events gave me plenty to think about, but I couldn't dislodge Mary's question: What are we doing for the elderly poor, or older citizens in general? Is food, shelter, television, and the occasional visit by a social worker enough? Is something more needed, and can involvement in the arts play some role, providing satisfaction, autonomy, and success over the long haul, enhancing quality of life from childhood until the very end? When it comes to securing the overall quality of life that we claim as an outcome of democracy, is the food, shelter, and, yes, even the subsidized health and social service network that our government should provide sufficient? If heritage gives us a grounded identity and sense of place—part of our expressive life—can learning to make art help provide the counterbalance to heritage, an autonomous *voice?* Can a rich expressive life be a realm of independence and achievement, offering a path to lifelong happiness that sidesteps the treadmill of consumerism?

A few weeks after I visited Raw Art Works and Lynn, I joined forty guests in an ornate U.S. Capitol meeting room to celebrate the publication of Isaac Stern's autobiography, *My First 79 Years,* written with Chaim Potok. Alfred A. Knopf, Stern's publisher, had sponsored the reception to create a policy-leader "buzz" around the great violinist's book, but Stern, in fact, had other things in mind. Long a supporter of New York City's Carnegie Hall and formerly its board president, Stern was now lobbying for a direct legislative "earmark" to bring federal money to bear on a major Carnegie Hall renovation and expansion. When he stood behind the podium to accept congratulations on his book, he made the same kind of impassioned argument for federal support for a revitalized Carnegie Hall—a landmark he had helped save decades earlier when the legendary New York performance space was threatened by the wrecking ball. Later, still working his "issue," he took me aside to make certain the Arts Endowment had no objection to direct federal support for the project, and although federal agencies hate it when constituents go straight to Congress, short-circuiting established grant making procedures, I wasn't about to complain. This was, after all, Isaac Stern.

How remarkable he was then! Eighty years of age, still concertizing, still advocating on behalf of his beloved Carnegie Hall, and, even as his biographical coventure with Potok was being launched, more interested

in his *next* project than the last. If we were to imagine an ideal old age, isn't this what we would have in mind?

And, though unusual, the example of Isaac Stern is by no means unique. In fact, it is so common to find senior artists still capably caught up in their life's work that the *fact* of age—the reality of an octogenarian still in the trenches—is scarcely noted when their work falls under critical scrutiny. When veteran pianist Earl Wild performed a solo concert in Carnegie Hall in December 2005, at age ninety, critic Bernard Holland observed, "I think I hear in Mr. Wild's later years a more sober and thoughtful, and thus a more interesting, musician than the one I remember from his slam-bang, shoot-'em-up prime. . . . I suspect that being a little less of a pianist these days has made him a better musician."

And the longevity of engagement in art is not limited to classical music. Bill Monroe was a bluegrass hero until the very end; as of this writing banjo legend Earl Scruggs still performs, and contrary to the predictions of those of us who once trusted no one over thirty, Mick Jagger seems determined to prove that you can rock in the presence of your own great-grandchildren. Michael Kimmelman, in *The Accidental Masterpiece*, reports that Chuck Close visited Willem de Kooning when the painter was old and suffering from Alzheimer's and that Close found de Kooning "slumped in a living room chair, glassy-eyed, staring at a television." But when asked about his work, "he rose from the chair, straightened up, and suddenly became focused." A lifetime of engagement with art can produce habits of attention and discipline that transcend even the most destabilizing aspects of old age.

But the benefits of a vibrant expressive life—the autonomy, engagement, and achievement over a lifetime that can *only* come from music making, painting, writing, or acting—can't be reserved for the supertalented few. It is not enough for the rest of us to be passive consumers; rather, we must assert our right to the knowledge and skills needed to make art and live the creative life that sustains us over a lifetime.

· · · · ·

Yo-Yo Ma has become one of the most famous cellists and one of the most celebrated classical musicians of his time. He's shown on the right in the

Lynn Chang, Richard Kogan, and Yo-Yo Ma, three Harvard students who were musical colleagues. Each would continue his engagement with music but in different ways. Beyond the disparate career paths of these professionals stand millions of talented amateurs. (Photo courtesy of Richard Kogan. Fee: none.)

photograph here, not with his latest collaborators from the Silk Road or tango projects, but with the violinist and pianist he performed with during his years at Harvard University. We know what became of Yo-Yo Ma, and society celebrates (but, perhaps, does not fully appreciate) the value of great talent and stardom as a source of artistic inspiration and as a model of discipline, imagination, and achievement. But what of the other two players? Classical insiders will recognize Lynn Chang, the violinist in the trio; Chang is a successful chamber musician who still lives in the Boston area. But the pianist, Richard Kogan, has not built his work life primarily around music. Although he still performs professionally, he's a successful psychiatrist in a midtown Manhattan private practice. Three musicians—one a classical superstar, one a respected journeyman artist, and one who most of the time practices medicine—pursuing careers that exemplify three different ways of integrating art and everyday life.

We know from the careers of professionals that art can last a long time; but what is the value of music making, painting, photography, singing,

and dance across the entire spectrum of artistry, from "professional" at one end to "amateur" at the other? What is the value of deep engagement with art when you are not a professional artist but rather a *citizen-artist?* Does art have an important, ongoing role for those of us whose first responsibility is to "regular" work, who paint, play, sing, or act when time allows, in opportunities stolen from everyday responsibilities? The photograph accompanying a *New York Times* profile of Trammel Crow executive Richard Bernstein pictures him at an office keyboard; the caption reads, "He arrives about 6 a.m. some days to practice the piano." The sports pages of the same edition feature a photograph of Baltimore Colts owner Jim Irsay strumming one of the guitars in his collection. A few months later Secretary of State Condoleezza Rice is featured in the Sunday *Times,* not in the news section, but on the front page of Arts and Leisure in a piece about her dedication to maintaining her skills as a classical pianist. These leaders are proud of their creative lives; how does their engagement with music affect their work in management and government, and how does it enhance their quality of life?

In a wealthy society that boasts a diverse something-for-everyone cultural mainstream, do Americans have a right to the feelings of achievement, heightened experience, and sense of cultural place that is a companion to a creative life? How close are we to providing citizens with the tools of art making that can be a source of inspiration and accomplishment over a lifetime?

· · · · ·

If democracy offers a single, overarching promise, it is that our system of government, linked, perhaps, to an equitable and energetic economy, will produce widespread happiness. When we Americans think about happiness, we default to material well-being, then to prestige and influence, then to psychological health. Through our purchases, the cost of vacations, the size of homes and cars, and our willingness to forgo savings and future wealth in pursuit of consumption *right now* we express confidence that accumulated possessions and stimulating experiences can constitute a satisfying life. A nagging spiritual emptiness may whisper from the wings, but we maintain our belief in the efficacy of consumption in

the face of daily evidence that disaffection and depression have reached epidemic levels.

The word *happiness*, of course, appears in America's founding documents, and whenever we sing the praises of our system of government, or feel sufficiently emboldened to attempt to export our model to other societies, we do so in the confidence that democratic institutions will encourage an elevated quality of life—that citizens will be happy: not happy in the fun-and-games sense, but blessed with deep life satisfaction. Yet accumulated evidence doesn't support the assumption that citizens of democracies are particularly happy. In fact, since World War II the overall level of happiness in the United States and other Western democracies has not advanced but has instead remained flat or, in some settings, actually declined. In a sense free-market democracies have engaged in a half-century-long experiment testing the premise that enhancing material well-being will produce a related increase in overall happiness. It is testimony to our near-religious belief in the power of money and possessions that we ignore reports that consumption can actually reduce our quality of life, discouraging thrift and devaluing modest lifestyles. As psychologist Tim Kasser writes, we have "learned to evaluate our own well-being and accomplishment not by looking inward at our spirit or integrity, but by looking outward at what we have and what we can buy."

To this day, governments, nongovernmental organizations, foundations, and philanthropists gravitate toward advancing material well-being as the only sure mechanism for improving the lot of suffering children, families, communities, and nations. However, growing evidence suggests that, once "absolute material scarcity" has been alleviated, immaterial factors like religion and the quality of work and family life become just as important as more food, better clothing, and more impressive shelter. The crude Marxism that conflates happiness and wealth is unachievable, and studies have shown that it also doesn't work. Some scholars, such as economic historian Avner Offer, go further, arguing that for the richest societies, affluence is actually harming quality of life by, among other things, driving down savings rates and encouraging obesity. And even if we resist growing evidence and maintain our shallow confidence that more money can buy happiness, it is becoming increasingly

difficult for each generation to outearn its forebears. If our children will not be as rich as we are, we must open our eyes and look around us; might other components of life, if enhanced, best secure happiness in the face of diminished material resources?

Admittedly, the half-century-long downturn in perceived happiness has not been precipitous, but even a gentle downward slope on a graph that tracks "happiness" is unsettling, especially when it stands in contrast to indicators that show a dramatic increase in material well-being in the same societies over the same period. Although in the United States perceptions of happiness rose just a little for the first few decades after World War II, the trend peaked in 1976 and then reversed itself to begin a gentle downhill slide.

Symptoms aren't hard to locate. As economist Robert Lane observes, "There is a spirit of unhappiness and depression haunting advanced market democracies," a spirit that "mocks the idea that markets maximize well-being." Or, in the words of psychiatrist Peter Whybrow, "Americans have embraced a culture where steep profits and shallow relationships have multiplied our possessions but reduced our social values. . . . Material wealth has been decoupled from contentment and personal fulfillment." Sociologist Richard Sennett argues that in our contemporary high-tech, work-from-home, always-on-call business environment, "people feel a lack of sustained human relations and durable purposes." For Sennett, "the system radiates indifference." It should be no surprise that Americans spent $750 million on self-help books in 2006.

We are richer and less happy; busier but less connected to family and community. Although we probably talk and know more about "unhappiness and depression" than we do about "contentment and personal fulfillment," today there is a surprising level of expert agreement about what feelings define "happiness." Economists, sociologists, and mental health professionals employ different language, but most present happiness as a two-sided coin—one side emphasizing stimulation, the other reassurance. Psychologist Jonathan Freedman characterizes the first realm as encompassing excitement, fun, and pleasure; the second, peace of mind. Economist Richard Layard defines happiness as "feeling good—enjoying life and wanting the feeling to be maintained." It is this everyday sense of

happiness that has declined in American society, a loss that flies in the face of decades of unprecedented confidence in the power of money, material objects, and increased status to produce happiness.

Although conclusions are grounded in research, on a gut level we Americans find this new reality hard to accept. We've all had this experience: one morning you read a newspaper account of a university study demonstrating that money does not buy happiness—a page 8 news feature—and it gets picked up by TV and is subsequently derided by talk show hosts and late-night stand-up comedians; perhaps we even share an uncomfortable joke about "crazy professors" during a watercooler get-together at work. We remain so steadfast in our belief that materialistic consumerism will provide pleasure and security that evidence to the contrary simply doesn't sink in.

It remains to be seen if the study of happiness emerges as a full-blown academic discipline drawing on new psychology, brain science, economics, sociology, and philosophy; Richard Layard thinks it will. But regardless of the scholarly standing of happiness research, it is fascinating and a bit ironic that sociologists and economists, specialists whose academic fields have long accepted economic self-interest as a primary motivating principle of human society, would be among the first to question economic reward as the be-all and end-all of happiness. As Layard suggests, it may be that once a society achieves a certain level of material well-being and absolute material scarcity is left behind, enhanced feelings of joy and security can only be derived from things that, quite literally, money can't buy. So, our subjective well-being may not depend all that much on bringing in more things or more money.

Suppose we agree that society should attempt to stop or even reverse America's perceived decline in happiness; what should we do? This is a thorny policy challenge because, though we can agree with our Founding Fathers that happiness is a legitimate public good, it is one that mostly shows itself as a private, individual, idiosyncratic benefit. When a society is caught up in alleviating material scarcity, it's easy for policy leaders to enthusiastically support the relief of suffering; but advancing policies that augment happiness elicits confusion and reserve. After all, happiness may consist of fun, pleasure, excitement, and peace of mind, but the balance

among these disparate ingredients will be different for everybody. Happiness for me might be cross-legged meditation on the back porch of a quiet cottage in a friendly neighborhood in a small town; you, on the other hand, might be happiest steering a battered jalopy through a demolition derby. There's no accounting for taste, and that's the problem: policy makers prefer interventions that can be reduced to rules and regulations that apply to everyone equally, and the idea of addressing "happiness" through government action seems like a tough sell. In addition, at least so far, the experts haven't been nearly as prolific in generating ideas about how we might produce an uptick in happiness as they have been about tracking the symptoms of our distress: analyses produced by students of unhappiness describe our situation brilliantly, but the work thins out when it comes to making policy recommendations.

If we read between the lines of happiness research in order to figure out what to *do*, one message comes through: stop behavior that makes you miserable. "Step away from the rat race, turn off the TV set, tear up those divorce papers, stay in the town where you grew up, and don't buy a new car just to one-up your brother-in-law."

Easy to say; hard to do.

Americans are not about to push toothpaste back in the tube or return the genie of materialism to his (presumably golden) bottle. Instead, if we want to place fresh emphasis on the pursuit of happiness as good public policy, we need to identify a set of achievable interventions that can move us ahead, not back. What can make the biggest difference in quality of life for the most people over the longest time for the least expense? I believe that reworking America's arts system to enhance the expressive life of citizens to serve the public interest is exactly this kind of achievable, affordable goal.

• • • • •

The words may vary, but there's an underlying agreement among experts about what it takes to increase happiness once the basic material needs of society have been satisfied. Strengthened communities, families, and friendships are important, as is a sense of accomplishment (sometimes described as "status"). Security in work seems more significant than

ever-expanding income, and, finally, a balanced inner life seems impor-
tant. Layard argues that a balanced spiritual life is sustained when
"people are able to appreciate what they have, whatever it is; if they do
not always compare themselves with others; and if they can school their
own moods." Nobel laureate Robert Fogel also places special emphasis on
personal growth, envisioning a postmaterialist society in which "spiritual
resources" replace status-seeking consumerism. He advances a special
sense of "self-realization," defined not by selfish gratification but by a
sense of purpose, a vision of opportunity, a sense of community, a ca-
pacity to engage diverse groups, a thirst for knowledge, an appreciation
for beauty, and self-esteem.

For political scientist Robert Putnam, happiness is grounded in "bridg-
ing social capital" and "civic engagement," the bonding agents capable of
restoring America's community life. Layard posits four instruments that
can help individuals achieve happiness: religion, secular spiritual prac-
tice, positive psychology, and what he terms "education of the spirit," un-
derstanding feelings, serving others, and understanding how to socialize
with others. Sociologists Michael Hughes and Carolyn Kroehler expand
the definition of quality of life beyond "affect, happiness and satisfaction"
to encompass "meaning." For them, "meaning" imbues life with "pur-
pose, significance, validity, and coherence . . . ; [for] people are primarily
motivated to maximize the meaningfulness of their lives." Kasser uses
"autonomy" much as Hughes and Kroehler employ "meaning," arguing
that "materialism derives from a motivational system focused on rewards
and praise; autonomy and self-expression derive from a motivational sys-
tem concerned with expression of interest, enjoyment, and challenge, and
of doing things for their own sake."

It's unfortunate and perhaps telling that our experts on happiness and
quality of life, those who have analyzed America's unhappy state and of-
fered prescriptions for recovery, have not found their way directly to art
as the defining path to a new set point for happiness; an avenue to status,
personal achievement, and sense of place that will ease us away from "the
strain of manic pursuit" that, according to Whybrow, "is damaging both
health and happiness." We've already seen that Americans have never
come to terms with the value of our connection to art making and

heritage, so it shouldn't surprise us that scholarly opinion lacks the confidence required to make art the center of a necessary societal transformation; expert inattention is a sign of how far we have to go.

But art unquestionably gives us a way to pursue self-realization without forcing us to deny the materialist and competitive drives that pass for human nature in the West. When I was a boy growing up in a poor mining community in northern Michigan, records, radio, TV, and movies enabled me to connect with America's folk music heritage, with art making in other lands, and with big-city rock and pop. Homemade music—when the family gathered around the piano while my mother led us in selections from her *Heartsongs* collection of nineteenth-century favorites, or when riding in the car we improvised harmonies in imitation of the Weavers and their hit single "Goodnight, Irene"—nurtured musical self-confidence and tied us together without requiring the expenditure of money that nobody in town really had. Later, when I learned to play the guitar, I filled up hours alone with intense practice, often losing all sense of time as I struggled to master a new set of chord changes, a complex melody, or a (to me) exotic blues or hillbilly riff. The guitar gave me an appreciation for beauty, a sense of the importance of self-discipline, channeled my thirst for knowledge, and focused my desire to achieve and consume. I concur with art critic and amateur pianist Michael Kimmelman: "the ability to play music gave me a purchase in the absolute sublime." And there were practical results; the guitar provided me part-time work as a teacher, a pathway to graduate study in folklore and folk music, and ultimately helped connect me to a career in nonprofit management and a term as the head of America's federal cultural agency. However, with the exception of a few college dollars earned teaching beginning students at Ann Arbor's Herb David Guitar Studio, I never made any money directly from music; I never really tried to be a professional. Still, the guitar was always there beside me or just in the background, providing the multiple pleasures of a rich expressive life, allowing me to put myself on the line in situations in which, unlike the world of work, risk was a matter of choice, not part of the job. And finally, and perhaps most important, music and the guitar gave me a steady source of self-esteem independent of money, power, and other conventional markers of success and

achievement. Economists claim there is only a fixed amount of status in the world, but art and art making can create a parallel universe that offers new and unlimited ways to succeed. Music and the guitar remain important in my life today, a continuing reservoir of pleasure, challenge, and achievement—what Layard calls one of those "treasured skills we can fall back on throughout our lives."

Of course, personal anecdote doesn't go very far in justifying public policy. But isn't there something to this? Art making is spiritual, long-lasting, and (compared to psychotherapy and drug rehab) relatively inexpensive; it contains and even expands many parameters of a well-lived life that have to date mostly been attributed only to work, religion, family, and community. In addition, an engagement with art permits us to indulge our drive toward success and self-realization without forcing us to buy into the nastiness of America's unhappy rat race. It is the yin of individual achievement that complements the yang of heritage, making our expressive life whole. Thus completed, a rounded expressive life can be a reservoir holding the two overarching ingredients of happiness—adventure and security.

And art making *does* provide a powerful connection to cultural heritage. When we take up painting, poetry, or the piano, we ultimately begin to place ourselves in the web of enthusiasms and interests that link us to poets, pianists, and painters who worked in the past. Thus our engagement in art is an invitation to study the life histories of the art forms we love, and that study inevitably becomes a gateway to heritage, and heritage brings an understanding of how each of us connects with ancestry and the ways nations, communities, and families are tied together over time. This is the way art worked for Americans when my parents were young and our cultural mainstream was brand-new; if we are serious about shaping a better society, this is the way art needs to work again. Meditation and positive psychology can help sustain the human spirit in the face of status-driven materialism, and religion can rebuild individual values while cementing bonds of civic life. But, for my money, engagement in art is the best way to give more Americans, in more places, with more divergent interests and points of view, an expressive life that can build and maintain essential spiritual resources over a lifetime.

· · · · ·

If we can agree that a vibrant expressive life offering opportunities for creativity and achievement is an important source of postconsumer happiness, how should we proceed? If we accept the notion that, like religion and secular spiritual practice, art represents a lifelong alternative to consumption and materialism and that it can, perhaps, lessen the sting of poverty and loneliness, where can we find the skills and knowledge required to make a creative life for ourselves and our children?

Certainly we could begin with our schools. In fact, attend a tribute dinner or tune in to the Oscars or the Grammys, and you'll find artists crediting a teacher or school program that gave them their start. But we're not interested in paths to stardom; professional artists will find a way. Instead, we seek a generation of citizen-artists, each equipped with the skills necessary to extract joy, meaning, and achievement from the practice of art. So while it's true that in disciplines like music or drawing (but not dance or theater) our elementary and secondary schools can give especially talented young people the start they need, public education is failing to provide the rest of us with the skills and interests necessary to sustain a creative life.

It's not that we don't have art in schools; more than 90 percent of public and private elementary schools offer at least basic programs in music and visual art. In addition, three-quarters of American high schools sponsor after-school arts programming, and nearly 70 percent provide field trips to performances and museum exhibitions. There's significant arts training in America's schools, but, as in the fine print of a recording contract, the devil is in the details.

Art classes directed to the entire school population are pretty much restricted to the elementary years, when students stay in one classroom all day. In instrumental music and chorus, interested students often are siphoned off into special classes as early as grade 5. And young students often have little choice in which instrument they play. As one university educator told me in confidence during a recent conference, "The high school band director figures out what gaps he'll need to fill in a few years, and instruments are assigned to fourth- and fifth-graders accordingly."

In the early grades, schools tend to employ one teacher for visual art and one for music, each offering at least some programming for the entire school. Dance and theater, on the other hand, tend to be taught by artists-in-residence; few elementary schools employ professionals in these disciplines.

In high school almost all art classes are taught by specialists, but there's a trade-off: offerings geared to the entire student body fade away, replaced by elective courses. As in the elementary years, music and art are available in most American high schools while other disciplines show up less frequently—fewer than half offer theater courses and only a few arts curricula include dance. Somewhat surprisingly given the present-day emphasis on basic reading, writing, and math, only 35 percent of secondary schools offer courses in creative writing distinct from English literature.

But, despite the absence of several important arts disciplines, isn't the overall picture in arts education pretty good? Even if it's before or after the regular school day, most schools offer music and visual art training, and most parents and school administrators think arts education is important. In fact, parents are generally satisfied with art in American schools. Doesn't our present-day arts education system offer a point of entry into a lifelong engagement with creativity?

Let's take another close look. Although the numbers suggest that nearly all U.S. high schools emphasize both music and visual art, it's music—targeting singers and players who are cut from the herd during the last few years of elementary school—that emerges as the "big dog" of American arts education. After all, it's music that is most likely to control a dedicated space within a school building, music that is most likely to have more than one specialist on a faculty, and music that is most able to attract private money in support of its activities—nearly half of all high school music programs receive nondistrict support. But music's dominant role in arts education has made it something of a world apart; school principals report that visual art is far more likely to be integrated into the teaching of other disciplines, such as history or English.

Music's unique isolation from the rest of the curriculum in U.S. secondary schools isn't so surprising when we remember that the cornerstone of American arts education is the high school band. It's true: no other arts

activity is more firmly embedded in public education than the brass band featured in pep rallies, on the sidelines of Friday night big games, and out in front during Fourth of July parades. Frequently linked more closely to the athletic department than the academic program (hence the revealing lack of connection to mainstream academics), high school bands exhibit an enviable immunity to budget cuts and shifting educational priorities: "No Child Left Behind" may push arts to the margins of education, but bands will march on. It should be no surprise that if a school employs a single full-time art specialist, that faculty member is likely to be a band director. Not only does band instruction bask in the reflected glow of athletes, it also benefits from its ability to get little Jill or Johnny to work cooperatively with other kids; these are teens, after all, who won't take out the trash or load the dishwasher at home. Parents watching a usually morose child fit into a clarinet section are properly impressed. Of course, music isn't *only* about bands; many schools maintain choruses and, if resources are available, concert and jazz ensembles; in a few schools maybe even string instruction and orchestras can be found. A fifth-grader can get a start on trumpet and transition into a high school band program, or a visual art teacher may offer a drawing course to third-graders, but arts education in the United States exhibits fundamental flaws that shortstop engagement in art broad enough to make art part of the life of every citizen.

Remember, in terms of the arts, problems get worse, not better, in high school. For one thing, by then just about every art course has been shoved out of the curriculum or is an elective subject; in many schools art courses are not included in the calculation of student grade point averages. Counselors interested in helping students establish the kind of academic record most likely to bolster chances for college admission often steer them away from academically neutral arts electives. A few years ago the Florida state legislature required all public schools to factor art course grades into student GPAs, but such mandates are rare. Even if a high school includes art course performance when determining GPAs, many colleges, like my own institution, Vanderbilt University, may simply render these courses "grade point neutral." Ironically, even as many schools devalue art courses, a number of states have mandated arts training as a prerequisite for admission to state college systems. But such mandates break down in

implementation; required arts training generally arrives top-down, un-funded and understaffed—the kind of regulation easily ignored by public school districts strapped for money while functioning under the Damoclean menace of No Child Left Behind math and reading standards. The state of California and New York City both have made new commitments to arts education, but as of this writing the increased funds haven't found their way into the classroom. In New York, the "Blueprint for Teaching and Learning in the Arts" sets new benchmarks for K through 12 arts education, but the plan is a recommendation, not a funded program. Overall, the city has made remarkable strides in rebuilding education after the financial collapse of the mid-1970s, adding 40,000 teachers over three decades. But in fall 2005 there was only one visual art teacher for every 943 students; one music teacher for every 1,200 students. Of the 84,000 teachers in the New York system, only 2,000 are arts specialists.

In addition, our public school arts education process gives up on the idea of "art making for all" pretty early in the game. By the fifth grade instrumental music is pared down to those students with demonstrated interest in playing, and by high school no one is encouraged to start an instrument from scratch. Picture it this way: if education overall can be represented as a cylinder, with young people entering at the bottom in first grade and gradually advancing upward, through the grades, as they master history, English, math, and science, then arts education looks quite different—more like a pyramid or cone—with the number of students engaged in art classes shrinking as each cohort moves toward graduation. In fact, for the average student who doesn't engage in elective art classes, art training in most schools drops to zero in the high school years. The connection with art shifts from doing to consuming, through the occasional art appreciation course or, in many schools, through field trips to museums or to live musical and theatrical performances. Missing are activities that would enable students to actually *make* art. College extends these tendencies; except for art appreciation, curriculum-based arts training in higher education is mostly available to those players, singers, painters, and photographers who harbor serious aspirations.

A final important point: the basic orientation of in-school arts education is out of whack. What gets emphasized in school programs is really on the periphery of art as Americans really live it. Ask an average citizen,

somebody who doesn't already paint or sing or play the piano, what they'd most like to get personally from a connection to art. Most would like to play an instrument for their own pleasure or for friends or to accompany a family sing-along. They'd like to be able to draw an accurate likeness of a loved one or paint a picture with sufficient skill to earn compliments from friends, or perhaps take a photograph good enough to hang on the wall at home. They'd be proud to craft a short story or poem or an essay about their childhood that they could send to relatives in another city, or one that might win a contest or get published in a local newspaper. In short, most Americans would like to engage in art making for personal satisfaction and for the admiring attention from friends and family that even modest achievement in music or visual arts can bring. Our schools don't teach this kind of art.

Don't get me wrong, participation in a high school band or chorus is an enriching experience for millions of young people, one that for some can be the start of a journey leading to advanced study in a conservatory or university department of music. But once we're no longer captive in high school assemblies, how much time do Americans spend listening to brass ensembles? How does devotion to the clarinet, sousaphone, trumpet, or glockenspiel serve the average player once school years are behind her? Are these instruments vehicles for informal music making, for the kind of art that leads to an elevated quality of life? Is the emphasis on reading notation and a classical and band repertory really a way to open doors to a lifetime of informal music making? The answer may be a hearty "yes" for the special few who make a career in music, but for every instrumentalist who heads for the conservatory, dozens pack their trombone, snare drum, or saxophone away and never open the case again. If every clarinet sold in the United States were fitted with a tiny dynamite charge, and I could push one button to detonate them all, I'd blow up 15 percent of the closets in America. To be fair, singing has done better: choral music plays a bigger role than band music in the lives of adults. There are 250,000 choruses in the United States, serving 24 million singers. But the connection between community singing and school music instruction is unclear.

The art world that Americans live in is not filled with marching bands, or even concert bands playing arrangements of classics; visual art isn't

painting or even museum visits. Instead, our music is pop, blues, jazz, country, and rock 'n' roll; visual art is design, illustration, and advertising photography. Think, for a moment, about the piano and guitar. The two have vied for "most popular instrument" status over more than a century, but neither is taught in our public schools. True, some districts have instituted guitar programs, and as electronic instruments make keyboard instruction affordable and space-efficient, piano training has also begun to nudge its way into elementary and secondary education. But guitar and piano have only recently been brought in from the periphery of accepted school music, and it is astonishing that these two instruments, both popular, both capable of functioning in the broadest range of musical styles, and both anchors of informal social music making, have *not* been at the very center of efforts to make music a part of the life of every American from the beginning.

I learned firsthand that the music education establishment is tenacious. Early in 1998, months before my Senate confirmation as chairman of the National Endowment for the Arts, I was invited to an after-hours meeting at the offices of the Wexler Group—a top Washington K Street lobbying firm. After a quick exchange of niceties, Anne Wexler and her then-new associate, former Pennsylvania congressman Bob Walker, began the arm twisting. It turned out that the firm represented the Music Educators National Conference—an organization that for the most part represents high school band instructors—and it was made perfectly clear to me, as the as-yet-unconfirmed NEA chair, that MENC disapproved of NEA's efforts to place artists in school residencies. As I remember it, Wexler explained that funding artists in schools lets boards of education cut back on the employment of certified art teachers, and if the Endowment persists in funding artist residencies, arts educators may not be in a position to support a budget increase for the NEA. Wow; that was real hardball, and an eye-opening signal to me that advocacy on behalf of arts education can sometimes be nothing more than an effort to preserve jobs. True to their agenda, MENC and the same lobbying team dogged the issue of artists in schools throughout my NEA tenure. While honoring their "teacher displacement" theory by trying to convince the NEA to stop supporting artists in schools, the same special interests simultaneously

worked to carve out a direct appropriation for their agenda in the Interior bill (where the NEA budget is found), arguing on Capitol Hill that Congress should insert language into all funding legislation that defined "arts education" as "sequential, curriculum-based, and taught by a qualified specialist." At first glance the definition appears little more than an innocuous description of what happens in schools. But think for a minute: had such language been memorialized in an authorizing or funding bill, the altered meaning would have prevented schools and agencies from identifying artist-in-schools programs as "arts education," seriously compromising government funding for an important educational resource.

Because the band status quo is hard-wired into the center of music education, to the extent that young Americans take up music as it exists in everyday life, they must for the most part learn outside school. In the past it was the patient, slightly eccentric maiden piano teacher, perhaps working from her home for a few dollars a lesson, who was a staple character of twentieth-century community life. My mother learned to play the piano from just such an independent music teacher. Aspiring guitarists, until the past few decades, did not even have access to a network of teachers working at home; someone who took up the guitar in the 1950s or 1960s probably learned from friends or informal mentors: an older, more experienced player would demonstrate a few chords, or a lick or two, and the novice would head home to practice the new material. Millions of players learned this way.

There are a few institutions that have taken up the task of teaching the music that citizens enjoy in their everyday lives. But they're few and far between and not in the education mainstream. In the early 1990s I visited the Old Town School of Folk Music in Chicago, a nonprofit music school grounded in the guitar-centric folk music revival of the 1960s. By the time of my site visit, Old Town had steadily expanded its offerings to include after-school and evening instruction in a variety of instruments, from accordion to cello to harmonica or ukulele—offerings that continue to this day. More important, the school has developed innovative ensemble training programs in which five or six players would gather for group lessons concentrating in the repertory and performance styles of the Beatles, the Grateful Dead, or Bob Dylan. Ensemble classes are also offered in

bluegrass, jazz, blues, and mariachi performance. Young people and adults eagerly pay for these lessons; their appeal is obvious. But why hasn't this kind of learning—music instruction grounded in the instruments, styles, skills, and repertoires that we hear on the radio, watch in music videos, or listen to when we enjoy our own iPods and CD collections—made its way into our schools?

Americans have abandoned huge chunks of our expressive life and cultural heritage to the whims of the marketplace; in a different way we've done the same thing with training in the arts. If the skills in drawing, writing, and instrumental music taught by schools aren't the ones Americans want or need to craft a lifetime involvement with art, well, American businesses will fill the vacuum. It's been going on a long time; one of the most famous advertisements in the history of magazine publishing promised mastery of the piano, brilliantly exploiting the images that portray music, visual art, and writing as gateways to an elevated quality of life. Many Americans over the age of fifty have seen the clever pitch: the headline, "They Laughed When I Sat Down at the Piano; But When I Started to Play!" was the perfect, alluring come-on, enticing readers to take in the eight-hundred-word story of "Jack" and the amazing power of his secretly acquired skills as a pianist. In his narrative (penned in the first person by legendary ad copyrighter John Caples), Jack encounters both the transcendent power of music making and its capacity to make an artist popular—the "life of the party." Once Jack begins to play, the laughter of doubting friends is silenced, and he is transported: "As I played I forgot the people around me. I forgot the hour, the place, the breathless listeners. The little world I lived in seemed to fade—seemed to grow dim—unreal. Only the music was real. Only the music and visions it brought me." And as the last notes died away, "the room resounded with a sudden roar of applause. I found myself surrounded by excited faces. How my friends carried on! Men shook my hand—wildly congratulated me—pounded me on the back in their enthusiasm!" Jack, fully armed with skills imparted by the U.S. School of Music home study program, has mastered the piano, achieving both personal satisfaction and the acclaim of friends and, we can presume, making music a part of his life forever.

Extolling both the spiritual and social benefits of piano mastery, John Caples's advertising copy captured the imaginations of millions. The self-instruction movement filled a real need, for despite their central role in America's expressive life, neither the piano nor the guitar has ever made much of a dent in school-based music education. (Image: © Bettmann/CORBIS. Fee: $260.)

This famous advertising campaign took early advantage of the unfortunate truth already noted: schools did not teach people to play the primary instrument of social music making of the era, and many citizens could not find or could not afford a personal piano teacher. From the 1920s to this day, American enterprise has offered self-instruction products intended to satisfy America's passion for personal engagement in art making. In the early 1940s Charles Cooke introduced his *Playing the Piano for Pleasure* method, an approach in the "they all laughed" tradition but also heavy on self-improvement and empowerment. Today Scott "The Piano Guy" Houston offers the same promise of quick and easy success at the ivories: "Within days, even hours, you can be playing your favorite songs." Although Houston offers a mild disclaimer: "Is this book going to prepare you for a career as a concert pianist? Absolutely not!" But you can "achieve your dream" in "a surprisingly short time with a minimum of note reading."

John Caples's famous tale of Jack, his skeptical friends, and his remarkable heroics at the piano represented the first of many products and services crafted to help hone artistic skills at home—and they weren't only about music. In the 1940s the Famous Artists School and later the Famous Writers School promised professional success to aspiring illustrators, novelists, and nonfiction writers. Founded by Albert Dorne, these correspondence schools boasted credentialed artists on their list of "guiding faculty," faculty, according to a former Artists School executive, who actually reviewed student submissions. Norman Rockwell, Robert Fawcett, John Atherton, and Fred Ludekens were associated with the artists' program; Bruce Catton, Rod Serling, and Max Shulman, with the writers' school. Both of the Famous schools were acquired by Cortina Learning International in the early 1980s; you can still take their courses.

Correspondence courses aren't the only route to artistry. Today, more than ten years after his death, Bob Ross, the soft-spoken, 'fro-coiffed host of *The Joy of Painting*, still haunts Saturday afternoon public television, instructing viewers in the big-brush and palette-knife techniques required to produce sweeping imaginary landscapes. Ross's message still resonates because it links art to autonomy and achievement; it's as much

about self-esteem and confidence as it is about painting. ("We don't make mistakes; we just have happy accidents.")

Betty Edwards's *Drawing on the Right Side of the Brain* is less about personal growth and more about the importance of shedding left-brain knowledge in order to see, then draw, what is before us. Michael Kimmelman has written that "from 1820 to 1860, more than 145,000 drawing manuals circulated." These popular instruction books were intended for people who drew for pleasure, but in an era without much photography, "it was the best way to preserve a cherished sight." *Drawing on the Right Side of the Brain* is in this tradition. Framed by a lucid discussion of brain structure and function, Edwards's terrific self-instruction volume has been deservedly popular; it became a *New York Times* best-seller two weeks after publication and remained on the list for more than a year, selling more than 2.5 million copies to date. Translated into thirteen languages and still in print after more than twenty years, the instruction book has spawned a rash of "right brain" approaches to everything from writing to athletics and made its author, once a teacher in the California State University system, both rich and famous.

Magazines like *Guitar Player, Contemporary Keyboard,* and *Acoustic Guitar* serve the self-instruction market, and technology has allowed a close approximation of one-on-one instruction. *Drawing on the Right Side of the Brain* was straightforward—a sophisticated but in many ways traditional step-by-step self-instruction book. But in music videotape and DVDs have enabled the marketing of face-to-face master classes with famous musicians; one company, Homespun Tapes, offers more than five hundred one-on-one instructional DVDs. Want to study R&B piano with New Orleans legend Dr. John, or the technique of Andrés Segovia with guitar master Eliot Fisk, or learn banjo with John Hartford? Just drop about thirty dollars in the mail, and these stars will teach you, at home, via tape or DVD. In a way this electronically facilitated music teaching is a throwback to the apprenticeship and mentoring required by arts learning before movies, records, and radio transformed us into mere arts consumers—an era in which households depended on homemade entertainment; an era when we worshiped stars less and educated citizens were expected to play an instrument, sing a song, recite a poem, and draw

a landscape or the likeness of a friend. An era, as Kimmelman writes, when "amateurism was a virtue, and the time and effort entailed in learning to draw, as with playing the piano, enhanced its desirability."

Unfortunately, the resources that make this kind of learning possible have not been part of "arts education" but have emerged within the for-profit world of self-help media. The tools to equip Americans with the skills to maintain an artistic life abound, but they are only available for a price, and to those who can ferret out exactly the right book, correspondence course, DVD, or computer program or online service.

The honing of online art-making skills also functions outside the education mainstream. Music-sharing sites like MySpace and its video equivalent YouTube offer young people online outlets for individual creativity. The quantity of shared material is impressive; in 2006 participants were uploading 60,000 videos to the YouTube site every day. In theory, the digital world offers a magical route to personal creative expression that is the right of every citizen. But, as we will see, full participation in a digital, online world requires expensive hardware, fees for high-speed Internet connections, knowledge of the ins and outs of complex systems, and considerable time to navigate online and digital opportunities. In addition, hardware and software must be frequently updated. Too often, the time, knowledge, and money required for participation in the world of digital artistry makes this world available to the few, not the many. In addition, the acquisition of wide-open Internet sites by companies like Yahoo and Google combined with the imposition of tight restrictions on the creative digital reworking of copyrighted materials threaten the entire practice of online amateur art. It is still too soon to tell if the Internet can retain its early promise as an arena in which individual creativity, accomplishment, and autonomy can flourish.

If a vibrant expressive life that offers independence and achievement is a route to happiness and if art making contributes to lifelong quality of life, what will it take to bring the benefits of an artistic life to every citizen? How can we resolve the contradiction between how Americans *live* art and how we *teach* it?

We first need to reframe our connection to art making to match the way we think of athletics and exercise. In the world of museums, symphony

orchestras, and dance companies, "participation" today means "attendance"; we're *participating* in art when we buy a ticket to an exhibition or plant ourselves in a seat at the Mozart festival. In the world of sports we also participate by purchasing tickets and attending competitions, sometimes alongside thousands of fellow fans. But real sports activity is spread throughout the population; for those who don't play tennis or golf or compete in an amateur softball league, society offers plenty of encouragement to exercise—even if it's just a long, brisk walk three or four times a week. Our relationship with amateur sports seems healthy and rounded; we are accepting of wide disparities in talent and generous to those who can only take part in limited ways: we applaud the ten-minute miler just as vigorously as the sub-four-minute champion. "Participation," in sports and exercise, means just what it says, *doing*. And, as a bonus, broad participation produces knowledgeable, enthusiastic audiences who support substantial compensation for thousands of professional athletes.

In contrast, most Americans are almost afraid to make art casually; there's no longer an equivalent, in music, dance, drama, or drawing, to the pickup touch football game on the back lawn on a Sunday afternoon. If we're going to make art, it's got to be serious business, and the result has to be good. As Kimmelman observes, "Amateur equates with amateurish." My friends in classical music talk with envy about European opera or symphony performances at which innovative or controversial performances once produced audience outrage and near-riots—people, over there, really care! Of course, American enthusiasts are just wishing for the kind of audiences we find today at U.S. sporting events. To reach such a point, we need to reconfigure the hierarchical pyramid that today is geared toward elevating only the best.

This will not be easy. Nor will it be easy to rework our arts education system to bring students the kind of training that can make artistic practice last a lifetime.

Years ago, when I directed the nonprofit Country Music Hall of Fame, we developed a well-regarded songwriters in schools program, Words and Music, that for many elementary school students served as a first opportunity to try hands-on music composition. We found, every year, that 10 or 15 percent of the teachers in the Nashville system would make the

program part of the curriculum, but the number of classrooms involved never grew beyond that small percentage, and we had to remarket the program late every summer during teachers' in-service conferences. The obstacle in the path to greater participation was simply the difficulty of launching any program at the point of delivery, for what goes on in the classroom is for the most part predetermined by state and district standards, by the training of classroom teachers, and by policies, principals, and boards of education. By working exclusively with classroom teachers, the Hall of Fame songwriting program was connecting with that bold minority of educators who will go the extra distance required to bring nontraditional experiences into their classrooms. But attempts to reconfigure arts education wholesale at the classroom level simply won't work—especially in an era of narrow, teach-to-the-test instruction.

And, unfortunately, if we redirect our efforts to connect such programs with the worlds of teacher training, national and state standards, and school district policy, we will quickly encounter entrenched forces determined to keep standards and the curriculum just as they are. In addition, arts education advocates have taken their eyes off the ball by emphasizing questionable arguments about the impact of arts classes on test scores or improving student performance in math or reading. Already in 2000, Ellen Wimmer and Lois Hetland, researchers in Harvard's Project Zero, found that "some of the bonus claims are just plain bogus." Arts learning must instead be advanced as the key to heritage and achievement, as a gateway to a high quality of life in a postconsumerist society, and as a basic cultural right.

So it's probably unrealistic to think we can build a gateway to lifelong arts engagement for all by transforming in-school arts. With the status quo firmly established in national standards, federal policy committed to math and science, and state guidelines and powerful lobbying groups prepared to trip up reform that might affect the jobs of dues-paying members, the chances that we can reshape education policy to nurture the next generation of citizen artists is pretty slim. Beatles bands, Bob Dylan touring groups, and mariachi ensembles in high school fashioned after the programs of Chicago's Old Town School of Folk Music are barely on our horizon.

If we really want to give all Americans access to a creative life, and to a measure of the commitment, discernment, and sense of meaning and accomplishment that art making brings to expressive life, we need to avoid quixotic jousting with education establishments and figure out one or two interventions that can really change things. My conservative friends might argue that it's sufficient that the private sector makes available thousands of learning opportunities in the arts, but these books, DVDs, compact discs, and online services cost money, and, further, it takes time and expertise to locate just the right training tool.

Well, maybe there's something to that line of thinking. Let's let the marketplace handle arts education, but at the same time let's provide subsidies to make certain that every citizen can acquire the tools that can open doors to an active life of art making. An instructional DVD might be purchased for the cost of a couple of face-to-face music or drawing lessons, but the proliferation of technologies that make art learning easier than ever before today carry hidden hardware and software costs that make the acquisition of art skills outside school *more* expensive and therefore *more* challenging for the average citizen. If we are concerned with providing every citizen with an enhanced quality of life, through real participation in music, drawing, dance, and drama, then we must find the resources and develop the policies and partnerships that can make it happen.

· · · · ·

Heritage is the part of our expressive life that grounds us in a sense of who and where we are; art making—personal creative practice—is the part of our expressive life that moves beyond heritage to grant every citizen a realm of achievement and autonomy. But, as Kimmelman notes, today amateur art making is not especially valued as a marker of high quality of life, for "with the arts, American adults have acquiesced to playing the passive role of receivers." But although underappreciated, an artistic life stands out as an economical path to personal achievement and, more important, as one essential gateway to well-being and happiness in a postconsumerist society—a policy goal that clearly serves public purposes.

Over the coming half century, the United States will face two interrelated challenges. First, we will be forced to accommodate the needs of an aging population. In part, this problem can be addressed through policies that compensate for material scarcity and provide basic health care. But, as Mary Flannery of Raw Art Works argues, quality of life isn't just about meeting material needs. An engagement with art making can be the key to a high quality of life even if society's capacity to provide material goods is limited. Second, it's increasingly unlikely that the U.S. economy will endlessly generate the rising incomes required to sustain the illusion of happiness through the acquisition of ever more expensive possessions. As art can provide life satisfaction in old age, art making can offer an alternative to the disease of affluence—an alternative that, for a modest investment in public resources, can enrich our daily experience over the arc of a lifetime.

Consider, again, the notions of happiness and quality of life advanced by cutting-edge critics who frame the values and experiences that must emerge if Americans are to step away from the treadmill of materialism. They write about "increased freedom," "joy," "competence," and "sense of purpose"; a "vision of opportunity," "self-esteem," "authenticity," a "thirst for knowledge," an "appreciation for beauty," a "capacity to focus and concentrate energy," and "absorbing yourself in some goal outside yourself." Read back over the list. Aren't the challenges and rewards of a lifelong engagement in art the best formula for securing the Good Life even when big houses, fast cars, and elaborate holidays become for most a thing of the past?

If the private sector has come forward as the most democratic provider of educational services in the arts, doesn't a system of arts vouchers seem an excellent way to broaden access to lifelong arts participation? If those guitar, keyboard, drawing, and creative writing programs that are only now creeping into our schools from the margins are already readily available as books, DVDs, private instruction, and online offerings, wouldn't vouchers that let young and old citizens purchase art instruction of their choice constitute an efficient and effective investment in citizen quality of life? But where can Americans even begin to discuss such a program? What agency could make it real? Perhaps, as I discuss in chapter 7, Americans

would be better equipped to address the value of an artistic life if policy could evolve within a U.S. version of a European-style cultural ministry.

In 2002 the Higher Education Research Institute's Survey of Freshmen reported that "being well-off financially" ranked number one among student goals. Materialism, television, passive consumption, and income-derived status remain hallmarks of American life. At the same time researchers have identified a longing for a sense of authenticity, achievement, and a sense of place and progress. Unfortunately, our educational system is not geared to giving creativity, heritage, and immaterial assets a bigger role in the lives of citizens—if anything, the emphasis on basic reading and math skills is moving Americans in the opposite direction. Yet self-help books, many grounded in spiritual pursuits, abound. It should be no surprise that self-help art instruction products are also wildly popular; they obviously respond to real demand. In fact, it would scarcely be a surprise if research were to discover that arts learning aids fill the same "happiness gap" targeted by books about relationships, parenting, and spiritual tranquility.

For Isaac Stern, in his seventy-ninth year, it was *still* all about the music. "I continue to enjoy the sheer sensuous, personal, delectable opportunity of talking through music to others," he wrote; "if anything, my passion for that has increased. . . . I want to share my ideas and what I've learned about what is possible in music, share all that with younger performers and particularly with young teachers; how to search inside for what is achievable in music."

Feminist author Brenda Ueland framed an important goal as a question: "Why should we all use our creative power?" She answered, "Because there is nothing that makes people so generous, joyful, lively, bold and compassionate, so indifferent to fighting and the accumulation of objects and money." Americans have a right to that kind of life.

FOUR America, Art, and the World

The right to be represented to the rest of the world by art that fairly and honestly communicates America's democratic values and ideals.

Late in his October 2001 press conference on "the state of our war against terror," with his eyes on the finish line, President Bush asked rhetorically why "vitriolic hatred" of America exists in some Islamic countries: "I'm amazed that there is such misunderstanding of what our country is about, that people would hate us. . . . Like most Americans, I just can't believe it. Because I know how good we are, and we've got to do a better job of making our case." In her postconference analysis for ABC News, commentator Cokie Roberts distilled the president's musings to a simple phrase. "President Bush," Roberts observed, "thinks their propaganda is better than ours."

Within weeks the White House named a quartet of administration communicators tapped to shape and implement America's wartime public relations effort. The team was charged with crafting a global ad

campaign—what the *New York Times* called "a 21st century version of the muscular propaganda war that the United States waged in the 1940s." Within months veteran public relations executive Charlotte Beers was confirmed as undersecretary of state for public diplomacy. But her first project, the Shared Values Initiative—an ad campaign featuring on-camera endorsements of democracy and the American way by U.S. citizens of the Islamic faith—was, to put it bluntly, "laughed off the air." Viewed by many as ineffective and by some as counterproductive, the costly ad campaign scarcely aired. After a discreet interlude of several months, citing health concerns, Beers quietly exited her State Department post.

With the exception of those few intrepid travelers who might sing, play an instrument, recite a poem, or deliver an informal lecture while overseas, Americans as *individuals* don't possess much capacity to carry our expressive life abroad. But our *collective* expressive life embodied in movies, music, and TV shows does offer the world insight into American ideas and values. And we should be concerned about what messages get out; as President Bush's post-9/11 comments suggest, we harbor a suspicion that what the world thinks of us has importance—a feeling that can, in times of conflict, expand into an unsettling notion that the image of America projected by art and entertainment might be a critical component of our national security.

Historically, governments have accepted an inevitable flow of art and ideas from one culture to another; these cultural connections have developed naturally and organically. But today government purposefully interferes with cultural relations and exchanges in two ways. First, we engage in "cultural diplomacy," what Richard Arndt defines as an effort "to shape and channel this natural flow to advance national interests." Second, government intervenes in commerce by actively promoting the distribution of U.S. arts products around the world.

America's cultural mainstream—our collective expressive life—grounded in grassroots art making and carried across borders in CDs, movies, and radio and television broadcasts, constitutes an essential metaphor for our democratic values. The diversity of America's arts practices and the feisty individuality of jazz and abstract expressionism

honestly convey the character of a free society. Bill Clinton accurately observed, "I think it's probably not wrong to say that Elvis Presley did more to win the Cold War when his music was smuggled into the former Soviet Union than he did as a GI serving in Germany." Even in the 1960s, when our nation struggled to implement domestic civil rights policy, the American arts system stood out as an arena in which diverse voices could find acceptance, respect, and opportunity. Many of the art forms at the heart of America's cultural mainstream have arisen directly from minority populations; the expressive life of such populations might never see the light of day in hierarchical societies. Culture was a kind of proxy for a broader sense of democracy and American life. So when jazz took the stage as an accompaniment to Eastern European resistance to cold war Soviet hegemony, it served as a two-part metaphor, simultaneously symbolizing the power of individual free expression to energize a coherent whole and the ability of America's black minority to affect the character of the mainstream in a free nation. This is powerful stuff; jazz, rock 'n' roll, modern dance, and abstract painting stand as art forms that connect with both the aesthetic sensibilities and the political and economic aspirations of all who engage them. But however potent the message, art delivers it gently; it's an invitation to, not a shove toward, the virtues of democracy.

If Americans have the right to assume that the windows we open to the outside world offer an accurate view of the character of our society, our government, and our values and reveal the truth of life in a plural democracy, we must answer these questions: How accurately does the world see us? Do the messages conveyed by our culture abroad help keep us safe and strong? Are government programs and global media corporations that move culture around the world making citizens of other countries more knowledgeable, more empathetic?

Unfortunately, two diverging trends in cultural exchange have conspired to answer those questions with a resounding "No!"

As William J. Holstein wrote in the *New York Times,* after the cold war "we decided that history was over and we had won." As a result, since the late 1980s the United States has cut back on cultural diplomacy and exchange while simultaneously promoting whatever movies, TV shows, and CDs would sell in the global marketplace. The character of our

culture abroad has been radically transformed by the collapse of public diplomacy and the explosion of trade in U.S. cultural goods. In 2005 the National Science Board reported that funding for cultural exchange was cut by nearly a third between 1989 and 2003. But over roughly the same period, international revenue generated by entertainment on film and tape rose from $1.68 billion to $8.85 billion, an increase of more than 400 percent. Given this transformation, it should be no surprise that today American culture abroad is what will sell—and it is culture that often alienates the very populations whose respect we need. As media critic Martha Bayles points out, much of our newly privatized de facto diplomatic exchange system circulates content that violates "norms of propriety still honored in much of the world."

We don't have to look far for evidence. Beers's successor as undersecretary for public diplomacy, Margaret Tutwiler, was an experienced State Department hand. She had emerged as a familiar media figure during the administration of George H. W. Bush, when her position as official spokesman afforded her frequent opportunities to engage reporters during televised State Department press conferences. Tutwiler took on the public diplomacy post early in 2004 after a two-year stint as U.S. ambassador to Morocco. In speaking engagements in the weeks leading up to her confirmation as undersecretary, Tutwiler employed an anecdote drawn from her ambassadorial experience to frame one of the challenges facing the United States as we work to communicate our values to the world: Every evening, in a country with an illiteracy rate of about 33 percent, some of Morocco's most impoverished citizens drive home to villages lacking electricity, take the battery out of the car, bring it into the house, hook it up to the TV set, and tune in to *Baywatch*. On both occasions when I heard her speak, Tutwiler's story extracted audience titters and mild head-shaking. *Baywatch!* Of all things!

After all, American viewers consider *Baywatch* a fluffy tidbit of American entertainment television, mixing drama and surfside romance, with plenty of buffed, underclad, jiggling female bodies. We know, instinctively, where to place *Baywatch* along the spectrum of serious art making—more meritorious, certainly, than *America's Funniest Home Videos* but obviously lacking the depth and sophistication of *The Sopranos*

or *Law & Order*. More important, watching here at home we understand exactly how much, and how little, *Baywatch* conveys about life in the United States, life in Southern California, or our personal experience should we get a chance to strip down to bathing suits on our gorgeous Pacific Coast beaches. Because we can provide a nuanced context for domestic TV programming, it's easy for us to dismiss, as irrelevant, content so obviously at odds with the way we actually get through our lives. How amusing that Moroccans living in poor villages could be caught up in this lightweight television series!

However, the intent of Tutwiler's anecdote was entirely serious. For nonelite populations in the Middle East, *Baywatch* and its ilk too often function not only as entertainment but as a kind of anthropology as well, serving up what can all too easily be consumed not as exaggerated fiction but as a documentary glimpse into the reality of American life and values. And, according to Tutwiler and others, the view through that window is not helpful; it may provide pseudo evidence to those intent on portraying the United States as a bastion of Godless excess. "A show like *Baywatch* exhibits and reinforces almost every negative stereotype of the U.S. held by Muslim populations," Tutwiler explained. "By allowing our society to be represented overseas by popular art that portrays us as secular, violent, undisciplined and obsessed by sex, we are only making it easier for extremists to recruit terrorists from the poorest villages of many Middle Eastern countries that are critical to the success of our foreign policy and our national security."

Viewed through a foreign policy lens, the popularity of *Baywatch* among nonelite populations in the Middle East is an unfortunate accident. On the other hand, judged only as an international media success story, *Baywatch* stands as a minor triumph of American cultural enterprise. The series' ten-year run required both an unconventional approach to television production and faith in a risky distribution model. According to corporate president Syd Vinnedge, *Baywatch* is the "jewel in the crown" of All-American Television, Inc.—the company that produces and distributes the show. *Baywatch* achieved its standing among All-American offerings by pioneering an approach to international success in television that would have been impossible only a decade ago.

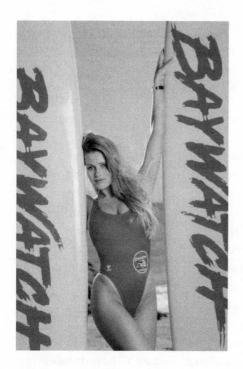

Following *Dallas* and a few years ahead of *Sex and the City*, an innovative business model and free-to-air transmission placed *Baywatch* at the cutting edge of America's de facto twenty-first-century cultural diplomacy. (Photo © CORBIS/SYGMA. Fee: $265.)

Most domestic viewers may be unaware of *Baywatch*'s international pedigree. Because the show has become thoroughly familiar to American audiences, it will surprise many that the series did not have much of a life on U.S. network television: the program had not quite completed its first year on NBC when low ratings forced cancellation. But the world had turned, and by 1991 a network deal was no longer the only path to television success. In the late-twentieth-century broadcasting environment, the cancellation of a series did not necessarily mean the show was finished, for even as the network ax fell the production team had lined up alternative financing—substantial guarantees for European broadcast on satellite and cable.

Conventional broadcast industry wisdom dictates that a program must have several seasons "in the can" before it can be repackaged for syndication, but *Baywatch* tried a new approach. By the time NBC canceled the one-season series, initial foreign sales—totaling about $450,000

per episode—appeared sufficient to allow a slenderized *Baywatch* to resume production. Operating on a tight production budget and retaining its star, David Hasselhoff (who took a pay cut and became co–executive producer), *Baywatch* emerged from its one-year stint on NBC with a business model and a global distribution system that would make the program the first American TV series primarily produced for and sustained by an overseas audience.

The innovative approach of the tenacious *Baywatch* team has paid off handsomely; today the series airs on cable or satellite in 140 countries and in 195 major cities of the world. Outside the United States *Baywatch* is available on many "free to air" channels that carry signals directly to set-top boxes equipped with special decoding chips. Unlike American satellite TV that employs dish receivers and cable requiring monthly subscription fees, Middle Eastern countries can tune in FTA channels by purchasing set-top boxes at a onetime cost of between $20 and $50. These digital receivers use a thirty-inch antenna; they aren't encrypted by the service provider and don't require a subscription. *Baywatch* caught this new wave of transmission technology and its novel revenue streams. Borne by an adventurous global business model, a TV show dismissed by critics, largely ignored by U.S. viewers, and quickly canceled by NBC became the most-watched American dramatic series in the world. More recently, shows like *Sex and the City* carry the *Baywatch* torch. Sad to say, if we want to understand how nonelite populations in the Middle East come to understand American values, we should begin by examining *Baywatch*.

It's one thing if we *want* Moroccan villagers to learn about the United States by tuning in to the fictional antics of hard-bodied California lifeguards. Framed properly, there may even be an upside to the *Baywatch* take on American romantic love, equality of sexes and races in the workplace, and the societal benefits of dedicated, unselfish professionalism. A student at South Africa's Rhodes College described the essence of the *Ally McBeal* series as "heterosexual colleagues and friends working closely together for a common objective and sharing each other's daily life experiences." But such positives may be beside the point in our current conflict with radical Islam; shows like *Baywatch, Sex and the City,* and *Ally McBeal* are also determinedly secular, drenched in sex and near-nudity, and unabashedly

exemplary of American materialism and hedonism. When the 9/11 Commission's report laments that Middle Eastern views of the United States are too often "informed by cartoonish stereotypes," its authors might well have had *Baywatch* in mind.

But, ultimately, the tragedy is not the presence of a wildly skewed depiction of life in the United States beamed down by satellites hovering above the Middle East. It is instead the total absence of calculation, coordination, or policy purpose in determining what should stand for America in the television sets and movie theaters or on the radios of citizens of other nations. Anecdotally, we sense that some American television programs and some music and movies might convey an incomplete or downright inaccurate view of American life, and in the same way we understand that other interactions—face-to-face communication among young musicians or athletes, for example—might be just the thing to communicate the remarkable opportunities afforded citizens of a pluralistic democracy. But there has been no institutional conversation, no meaningful engagement of the private sector, about just how America should tell its story. As a society, we have failed in many different ways to make the public interest—our cultural rights—part of America's arts system, but a failure to present a balanced expressive life abroad can have life-and-death consequences. Indeed, in the aftermath of the 9/11 terrorist attacks on Washington, DC, and New York, virtually every observer has identified the current global conflict as "cultural" in character, lamenting the absence of empathy and understanding that might mitigate differences in religion, history, and values.

Margaret Tutwiler's Morocco-based *Baywatch* anecdote conveyed an unstated but important central fact: as ambassador, Tutwiler could *observe* the impact of American culture on the nonelite village populations, but she lacked the capacity to *shape* that impact in any significant way. Even as a longtime public servant armed with high-level political connections and an important diplomatic assignment, Tutwiler did not have access to the tools required to deflect, reformulate, or counteract the presence of *Baywatch* in the homes of poor Moroccans. It wasn't that she lacked vision; her tenure in Morocco had enabled her to observe firsthand the intense and positive connection that quickly emerged when American

jazz musicians toured villages and jammed with indigenous players. She could see that more face-to-face interaction of that kind would help off-set the message of terrorist recruiters, in the same way she understood how nightly doses of *Baywatch* did the opposite by reinforcing the message that America was a secular, hedonistic, Godless, and ultimately dangerous society.

· · · · ·

Margaret Tutwiler couldn't do much to mount a program of cultural communication. Even if the Foreign Service and Department of State had been committed to the one-on-one cultural contact Tutwiler advocated, commercial trade in American movies, CDs, and TV series held all the cards; government broadcasting and exchange efforts were too puny to offset the forces of our arts industries in pursuit of global markets.

Contrary to the fitful efforts of recent years, in decades past the U.S. government approached cultural exchange and diplomacy more aggressively and with a measure of coherence. U.S. efforts to place art and culture in the sphere of international affairs—official, government-sponsored or government-sanctioned activities—first surfaced in the 1930s, after a well-orchestrated effort to advance the Nazi cause in Latin America through cultural export attracted the concerned attention of the Roosevelt administration. The Roosevelt White House responded with the new Division of Cultural Relations launched within the State Department. It was not only an early and direct pushback against Nazi expansionism, but it initiated the long-standing pattern in U.S. international work: bringing in the arts and the humanities as a kind of last resort. As historian Milton Cummings has noted, cultural diplomacy programs in the United States have usually been stimulated by a "perceived foreign threat or crisis."

After 1941 and the U.S. entry into World War II, the Office of War Information was added to the American effort at cultural diplomacy with the assignment of shaping a propaganda initiative more muscular than the Latin American tours of U.S. visual art initiated in the 1930s. This first-ever wartime cultural initiative established a second pattern in "official" cultural diplomacy—the U.S. tendency to mix cultural exchange with the murkier worlds of intrigue and propaganda. It is perhaps because our

cultural diplomacy has been crisis driven that the two strands of international cultural work—the "case making" effort of building up support for U.S. policies abroad and the more benign efforts directed at international understanding—have coexisted awkwardly. Each approach has had a hand in defining official efforts at diplomacy through culture since World War II.

Any time an external threat was more than military and in part grounded in cultural difference, it became easier for elected officials and career diplomats to allow cultural work to get into the tent that included trade negotiation, global finance, and the destructive power of various configurations of conventional and nuclear arms. In 1946, faced with the postwar task of energizing a new democracy, the United States initiated just such a program of cultural exchange designed to familiarize Germans with the character of the American political system. During the ten years of the project's existence, nearly 15,000 exchanges occurred—mostly involving Germans traveling to the United States.

In addition to moving scholars, artists, and students hither and yon, U.S. cultural diplomacy early on featured the visual arts, an emphasis that continues to the present day. During the cold war struggle with the Soviet Union, the visual arts were especially valuable in transmitting a subtle propaganda message while informing the world of the work of American painters and sculptors. After all, what could be a better metaphor for the unique character of America's freedom than the experimental canvases of abstract expressionist painters? When exhibited alongside Soviet socialist realism, American art of the fifties and sixties presented a stark contrast. As Louis Menand observed in the *New Yorker*, "Abstract painting was an ideal propaganda tool. It was avant-garde, the product of an advanced civilization." Who could possibly prefer the constrained, message-driven images of happy workers and smiling peasants to the deep, highly personal experimentation of Jackson Pollock, Mark Rothko, or Willem de Kooning? Surely only the American system could celebrate such inventive art making, and surely the political system that tolerated such unusual and challenging artwork possessed a moral superiority to a system compelled to make its creative citizens toe an ideological line? No doubt many government officials and members of Congress, confused or

even offended by abstract expressionist painting and modern poetry, held their tongues and supported international tours of modern art and artists simply because its allure as democratic metaphor was, at least during the cold war, too obvious to pass up.

Predictably, the cold war era produced America's most extensive investment in cultural exchange of all kinds. As early as 1946 the State Department spent government dollars touring exhibitions of corporate art collections. But it wasn't all sweetness and light (or, later, drips and splatters). Although the utility of modern art in cultural exchange kept negative forces at bay, the marriage of diplomatic purposes and cutting-edge art was never comfortable. Emboldened by early success, program director J. Leroy Davidson used $50,000 in State Department funds to purchase works for a touring exhibition of modern American art. But in a tripartite reaction that eerily presaged attacks on the National Endowment for the Arts five decades later, conservative political leaders, spurned contemporary artists, and resentful painters in the classical tradition ganged up to attack the legitimacy of the government program, and the exhibition was quickly canceled. The art selected for purchase by Davidson was ultimately sold off as surplus government property.

Other early cold war programs in cultural diplomacy found more secure roles in the federal system. In 1953 the United States Information Agency was created, bringing the Voice of America—which had been a State Department broadcasting program—along with other cultural and educational exchange work under a single government agency. The USIA sustained its independence for more than four decades. At about the same time Public Law 79-584, known popularly as the Fulbright Act, launched the program of academic and cultural exchange that remains a centerpiece of U.S. cultural diplomacy to this day. The contest of political philosophies that pitted the United States against the Soviet Union—competing visions of modernity—possessed a cultural component and sense of urgency sufficient to create a golden era in the government-supported movement of American art abroad. Nevertheless, even duck-and-cover cold war fears were insufficient to cement the role of music, drama, history, and painting into a permanent place in international relations. Perhaps we should not have been surprised.

Remember, the U.S. cultural system and its new arts industries could only trace roots to the early twentieth century, when technology facilitated the emergence of America's populist cultural mainstream. By the cold war our vernacular art making—blues, musical theater, movie drama, jazz—hadn't yet been elevated to its deserved status as a marker of American democracy. In addition, we didn't possess a ministry of culture or department of cultural affairs that might have argued the importance of art to diplomacy; we didn't even maintain an underlying shared belief in the links between art and national identity. It was not helpful that when U.S. policy makers thought about arts and culture at all, they still mostly had in mind the great artistic and philosophical traditions inherited from Western Europe.

U.S. cultural nonprofits sensed opportunity in the instinctive refined-art bias of early efforts at cultural diplomacy, and arts organizations saw international work as a way to expand programming opportunities for orchestras, museums, operas, and dance companies. Thus in the cold war era government-sponsored culture abroad generally translated into exhibitions of painting, sculpture, or performances by dance companies and classical music ensembles. These activities lent themselves to glittering black-tie opening events at U.S. embassies around the world: it was good diplomacy in an era when our task was the promotion of American values to intellectual and political elites. But while cold war conflict could be fought over the minds of newspaper editors, scholars, and political leaders, such elite-to-elite engagement offered only limited opportunities to touch entire populations directly. Today, as we face radical ideologies grounded in poor, nonelite villages in the Middle East and elsewhere, it would be folly to return to the lectures, exhibitions, and performances that defined cold war cultural diplomacy: it is difficult to imagine that a black-tie event in a barricaded consulate featuring great art of the Western tradition will do us much good.

Art and diplomacy were always prickly bedfellows, with focused diplomatic outcomes shoved up against the expressive freedom of art making. Policy leaders had a choice: were they only interested in delivering a tailored propaganda message, or content to simply turn American art loose on the world unedited, confident that the democratic message

would get through on its own? Our State Department generally let art and ideas speak for themselves. However, from the 1950s through the 1980s the Central Intelligence Agency maintained a covert program of support for cultural exchange, research, and the publication of literary and scholarly journals. The CIA programs aimed to shape the opinions of experts and researchers around the world and engaged reputable U.S. scientists, historians, and literary scholars as authors in agency-funded journals and experts in exchange programs (usually without the knowledge of the American intellectuals involved). Although much of this CIA-funded research and cultural exchange was indistinguishable from work developed in straightforward, nonpolitical research and publishing efforts, observers saw the CIA program as crossing the line between scholarship and propaganda. A chamber music performance or art toured behind the Iron Curtain was one thing, but was the manipulation of ideas in a government-funded effort to influence leaders in other countries acceptable behavior in a democracy?

This problem—the challenge of implementing balanced, long-term programs in cultural diplomacy when government instead demands disciplined messaging and quick results—persists to this day. Appointed by President Bush in spring 2005, veteran Bush political adviser Karen P. Hughes is the third undersecretary of state for public diplomacy appointed since the 9/11 terrorist attacks. Hughes entered a State Department that exhibits entrenched ambivalence about both the meaning of culture in international affairs and the specific value of an arts agenda in achieving foreign policy objectives. Though her close personal relationship with the president should have made it easier to advance her initiatives, Hughes's reputation as a master administration spinmeister pointed toward an agenda strong on message, weak on cultural substance.

In spring 2005 the General Accountability Office criticized the Bush administration for its failure to develop a global communication strategy. In fact, efforts to address culture and communication had been notable nonstarters in the Bush War on Terror. The National Security Council launched two interagency committees in 2002, one dealing with "information strategy," the other with "strategic communication." Nothing

much happened, and they were subsumed under the Muslim World Out-
reach Policy Coordinating Committee in 2004. Undersecretary Hughes's
"listening tour" of the Middle East was a PR fiasco—every bit as coun-
terproductive as the earlier Charlotte Beers advertising campaign. In
June 2006 the administration announced a new NSC interagency com-
mittee headed by Hughes and charged with a global effort to marginal-
ize extremists, and in September Hughes launched the "Global Cultural
Initiative" in a White House ceremony, but the project was for the most
part a repackaging of existing NEA and National Endowment for the Hu-
manities programming. In mid-2006, paraphrasing an "insider," *U.S.
News & World Report* concluded that "Washington still has no strategic
plan on how to fight the ideological war against Islamic radicalism."

• • • • •

I was in Shanghai on official business and something was seriously
wrong with our cultural attaché. Housed in the U.S. Consulate, she had
been well informed of my travel schedule long before I arrived in China,
but I didn't seem able to get her attention. She would greet me in the hotel
lobby at 7:30 A.M., ride with me to an eight o'clock meeting in a govern-
ment office building, but vanish by 8:20, only to reappear at my side be-
tween 10:45 and 11:00, only to disappear again until 1:15 in the afternoon.
We never had more than fifteen or twenty minutes together; it didn't
make any sense.

My official business in China was to attend the opening ceremonies of
the November 2000 Shanghai International Arts Festival, the launch of a
major international arts event. In fine Chinese fashion, the festival kicked
off with spectacular fireworks and an elaborate program of choreo-
graphed music representing the many ethnic communities that make up
the nation's diverse cultural landscape. It was only a few days before the
2000 U.S. presidential election, and I traveled with one eye glued to CNN
International for clues as to whether the candidate who had sworn me in
as NEA chairman, Al Gore, was likely to prevail.

In a country that splits authority over art and culture among dozens of
agencies, in which Foreign Service professionals view culture with dis-
dain, and whose government generally ignores culture as public policy,

it's not surprising that the U.S. Department of State can't really go higher than the chair of the NEA, a "small-agency" head, when it seeks a "designated appropriate authority" to represent the nation at gatherings of cultural leaders from around the world. That was my role in Shanghai— a kind of pretend cultural minister—and thus far my meetings had gone pretty well. In the timeless fashion of responsible diplomatic guests, my cultural colleagues from other countries and I had toured the ballet academy, enjoyed a special presentation of excerpts from Beijing Opera, and even met with Sun Jiazheng, then China's minister of culture. In a gigantic hall, interpreters crouched at our sides, we conversed slowly while comfortably sunk back in carryover staples of Mao-era diplomacy— monstrous, slab-sided, elbow-elevating armchairs. On the way back to the hotel, as we dodged traffic in the bicycle-jammed Shanghai streets, my driver turned around and said something to my interpreter, who repeated it in English. "Nixon," he said, "rode in a car just like this."

Although my casual interaction with international colleagues was cordial, I was aware at every turn that I was meeting world leaders in the arts who managed portfolios of funding and influence far beyond anything that had ever been imagined by the Arts Endowment and its supporters. After all, the NEA is just a grant-making agency with a domestic mandate; most of its money is disbursed through a competitive, juried selection process that directs funds to the most effective organizations and the most imaginative arts projects inside the United States. Unlike cultural ministers, the NEA chair does not have authority over U.S. national museums, theaters, or sports stadiums, nor does the NEA advance American art products in global trade. I was meeting with leaders who could, in their own countries and in international affairs, take positions and make commitments that might reshape entire arts systems.

I finally got the answer to my question, why was our Shanghai-based cultural attaché darting in and out of my schedule in ten-minute bites? On the third day of my visit, an assistant from the consulate showed up, and I asked her about the attaché. She replied, "Her bosses don't care much for cultural work, and they wouldn't let her put you on her official schedule. She's been carving out time with you by slicing up her lunch hour into segments so she can link up with you a few times a day." On the way

to the airport I asked directly about what I'd heard, and the attaché confirmed what her assistant had said. "In fact," she told me, "there are several people in the consulate who are so convinced that we shouldn't spend time on cultural work, they would have forbidden me to even meet with you if they'd had the authority to stop me." It was nothing personal, and it wasn't even a State Department attempt to pass judgment on the NEA. Instead, it was an illustration of the fact that in the State Department and the U.S. Foreign Service, an individual, or even an entire consulate or embassy, that gets too engaged in culture can be easily written off as "going soft."

But the idea of "soft" diplomatic work isn't a negative for everybody. Joseph Nye, an intelligence and defense official in the Clinton administration who also served as dean of Harvard's Kennedy School of Government, coined the phrase "soft power" to describe a range of public actions designed to "shape the preferences of others." Nye includes expressive life, political and social values, and trade as elements of a soft diplomatic agenda that has the capacity to advance U.S. foreign policy by growing a foundation of understanding and support. But the commitment to the "hard" alternative—economic influence and military strength—runs deep; although Nye has argued his case over more than a decade in three books, "soft power" has not achieved significant standing with America's key foreign policy actors, the Department of State, the National Security Council, the Office of the U.S. Trade Representative, or our intelligence agencies. Maybe it's trickle-down thinking from one White House to another. Just as domestic cultural agencies, prejudged as purveyors of lightweight "women's work," have no traction in the West Wing, so is the use of ideas, art, and political ideals as components of foreign policy disdained by America's professional internationalists.

This view persists despite the fact that residents of every part of the globe, when surveyed, listed American television, music, and movies, along with American political values, as among the most liked elements of American society. But those respondents were less enthusiastic about the spread of American ideas and customs abroad. Brought forward as symbols of what is both most liked and least attractive about the United States as a global actor, it would seem that our expressive life should be

an attractive and productive arena for the work of career diplomats. Instead, it seems that the disregard for culture that permeates government continues to separate expressive life from foreign policy agendas. It is a sad irony that although experts and government leaders continually cite the need to build global support for U.S. culture and values, the same individuals are so infected with distrust of cultural work that they have been nearly paralyzed when it comes to creating programs that can engage a soft agenda.

Just look at what's happened since 9/11.

We've spent hundreds of millions of dollars launching and maintaining radio and TV networks targeting the Middle East. Alhurra TV costs more than $40 million annually; Radio Sawa, $12 million. Despite the fact that unedited American music is readily available on TV, radio, and Internet outlets in the region, Radio Sawa eliminates offensive words from American popular songs, a practice Martha Bayles dismisses as "quaint." And Alhurra, eschewing VOA's fidelity to accuracy and balance, is widely ignored as a mere purveyor of propaganda. For example, Alhurra didn't cover Abu Ghraib prison abuses until four days after the *60 Minutes* special report aired. In fact, congressional critics of Alhurra learned that top management of the U.S. government station were generally unaware of exactly what content was being aired, because none spoke Arabic. And the GAO still found that as of 2006 "there is no interagency strategy to guide State's, BBG's [Broadcasting Board of Governors], and other federal agencies' communication efforts."

Indeed, despite a post-9/11 consensus that culture and communication are key components of our struggle against radical Islam, we are less effective in cultural work than we were in 1990, at the end of the cold war. America's global competition with the Soviet Union and communism, uniquely framed as a struggle of ideas, justified an investment in expressive life as a component of international relations sufficient to support the Voice of America, the U.S. Information Agency, and the Fulbright exchange program. The collapse of Soviet Russia at the end of the 1980s pulled the rug from under cold war programming, and the Clinton administration reduced funding for the Voice of America, cut the State Department's Public Diplomacy budget, and eliminated the USIA

altogether. What was left of the USIA became part of the Department of State, and its cultural work was transformed into a program of international aid that stressed not culture but infrastructure—roads, water and sewage systems, and the like. In the mid-1960s the USIA had 12,000 employees; today the State Department has about 6,700 working on USIA-style programs. The U.S. commitment to communicating with the world through culture had always been reluctantly supported and meagerly funded; in the 1990s even that small investment was scaled back. We have not yet recovered.

Even back in the 1980s, with the cold war going strong, America's diplomatic apparatus did not view cultural interaction as a frontline weapon in the struggle against Soviet communism. And the few strategies of cultural exchange that *had* maintained a measure of traction during the decades-long cold war had been dismantled or cut back by the time of the 9/11 terrorist attacks. Richard Arndt, a former State Department official, offers a blunt assessment of our commitment to cultural work around the world: "Today the cultural dimension of diplomacy has been slashed, its independence compromised, its values blurred, its human resources driven away, its budgets strangled, and its honest servants befuddled by misguided reorganizations and meretricious rhetoric." Not the best backdrop against which to mount a new war of ideas.

But, even as our government's enthusiasm for international cultural work was waning, America's arts industries were steadily expanding their global reach. The trend lines form a giant *X*; as the cold war and official cultural exchange wound down, exports of U.S. cultural products ramped up, increasing fivefold between 1980 and 1998. If our State Department, USIA, and Voice of America could for a time claim credit for bringing America's pluralistic expressive life to the world, by the late 1990s such assertions rang hollow: responsibility for the spread of American art had been taken over by big U.S. movie, broadcasting, and music companies. Although it is easy to criticize American efforts at public diplomacy—they lean too far toward propaganda; they are poorly funded—at least during the cold war period citizens could be assured that what got out through the Voice of America or the USIA tour had to some extent been vetted and that the artwork or performance was at least

generally congruent with American values and with the U.S. diplomatic agenda.

As the private sector ramped up, filling all gaps in the availability of American culture around the world, any sense of a coordinated cultural message was overwhelmed by the expanding arts trade. Fueled by the global ambitions of U.S. film studios, recording companies, and broadcasting companies and supported by a generalized enthusiasm for American products throughout the world, American popular entertainment could now be found everywhere. And technology, always the handmaiden to cultural innovation, played a role once again: cable television and direct-to-satellite broadcasts were important new channels for the distribution of American "content." U.S. broadcasting and film industries generated billions in annual foreign sales. For movies, foreign distribution has become critical; today only one in ten films can recover its cost from domestic revenues alone. With global trade in U.S. arts products ascendant and "official" cultural exchange diminished or dismantled, how did a post–cold war, 1990s approach to arts around the world actually play out?

While representing the State Department in fall 1999, I encountered the de facto power of media industry cultural diplomacy firsthand. The occasion was an informal meeting of thirty ministers of culture at a new conference center in the city of Oaxaca, in south central Mexico. I attended as the U.S. government official who most resembled a cultural minister, serving in a different setting as the department's "highest appropriate authority." The "official" agenda of this unofficial meeting was "cultural diversity," but the subtext was defined by the expanding efforts of France and Canada to use the concept of diversity and international protection of indigenous culture as levers to create an "exclusion" separating out cultural products as a special category within NAFTA-style free-trade negotiations and agreements. The protection of cultural diversity, Canadian-style, was nothing more than a cynical reworking of "diversity" into a justification of barriers designed to turn back U.S. movies, magazines, and television shows.

I was accompanied at the conference by Omie Kerr, cultural attaché for our embassy in Mexico City; our task was to head off efforts by France and

Canada to convince other cultural ministries (from Spain, the Sudan, and Switzerland, for example) to cosign a document advancing a cultural trade position detrimental to U.S. interests. The sessions were long and tedious; headphones on and off to follow intricate maneuvering through simultaneous translations connecting French, Spanish, and English speakers. However, in proper diplomatic fashion, conversation outside the formal discussions was relaxed and friendly. At an evening reception on a patio bathed in a sunset glow, Benjamin Gbane, the cultural minister representing South Africa, approached me with a question. "Chairman Ivey," he began, "would you help me understand your government's policy in relation to an incident that recently occurred in my country?" Once I had respectfully disclaimed any special mastery of U.S. foreign policy, I agreed to listen.

Gbane explained that about a year earlier his government had begun to consider the implementation of local content regulation—a rule requiring that South African radio and TV stations devote a specified percentage of entertainment programming to music, dance, and drama produced in South Africa. Such a rule had been in place for years in Canada, which, like a number of other nations, had used domestic content rules to prevent imported U.S. music and television programs from pushing aside the work of homegrown arts industries. "We had not even begun to seriously consider how such a rule would be implemented, and we received a very sharp phone call from your embassy," Gbane continued. "I thought your official State Department position was to encourage diversity and to acknowledge the importance of protecting indigenous art? If that is your position, how could we have received such an official phone call?"

Omie had overheard the question, and I looked to her for guidance. She shrugged; the official policy at State *was* to be supportive of local efforts to preserve cultural heritage and identity; she had no idea what would have prompted such an embassy call. But the question stayed with me through the conference and after, and whenever I was around State Department specialists or administration internationalists, I'd ask about the apparent contradiction between official policy and that embassy phone call. I confirmed that State had treated the sensitive issue diplomatically, and although the department was frequently dismayed by the

negative trade effects of local content rules, official policy had continued to recognize the right of nations to protect the integrity of culture and heritage.

I finally got my answer a year after the Oaxaca meeting. I had been asked to address a group of senior State Department career staff. Unlike political appointees who come and go with changes in administrations or the White House mood, career professionals provide expertise, continuity, and institutional memory in federal agencies. Sure, at times they dig in and resist change, but career staff are generally deeply patriotic and unfailingly loyal to the mission of their department or agency. Today I was speaking to the best of the best—top professionals at State, thirty leaders who had competed to take a year away from their regular assignments and tour the world, engaging issues critical to international relations. I brought them up to date on the NEA and its relationship with Congress and described my vision for the future of federal arts funding. After my talk I took questions, and on a sudden whim I asked if they would take one from me. As I completed my anecdote—Oaxaca, Minister Gbane, local content, and the embassy phone call—several heads were nodding in recognition. "Oh, I know," somebody spoke up. "It was the USTR; somebody with the U.S. Trade Representative's Office got wind of the local content rule. They called the embassy and got the embassy to complain to the minister. It happens all the time." Again, there was widespread nodding in agreement.

The explanation made perfect sense; just as the arts industries had become the primary purveyors of American culture to the world, the Office of the U.S. Trade Representative had emerged as their advocate—a major actor in semiofficial arts diplomacy. After all, our State Department had never placed emphasis on cultural work; in the Foreign Service time spent as cultural attaché was little more than an anchor dragging down a diplomatic career. But business leaders had long suspected that, in State, trade issues also played second fiddle to diplomacy based on aid and military might. As far back as the Kennedy administration, pro-business legislators had sought to bypass normal diplomatic channels. Using the Trade Expansion Act of 1962 to appoint a representative for trade negotiations within the administration, Kennedy issued Executive Order 11075 creating

the Special Representative for Trade. By 1974 the position had acquired permanent status within the executive branch; in 1980 President Jimmy Carter increased the number of employees attached to the office and approved the name change to United States Trade Representative. Even as other government efforts at cultural exchange wobbled after the cold war, the Office of the USTR grew, emerging as a leading actor in overseas work in film, recording, and broadcasting.

In part, the expanding role of the USTR in the global distribution of U.S. culture was simply a result of growth in the export of audiovisual arts products. In addition to their earning power, cultural exports have remained uniquely immune to issues of trade imbalance—a perennial bright spot in U.S. foreign trade. At the same time, indigenous arts industries in other countries have been incapable of creating products of sufficient appeal to export anything close to the amount of U.S. film, television, and sound recordings that are imported. In fact, non-U.S. domestic arts industries have even had great difficulty competing with American culture in their home markets; hence a tendency for governments to embrace protectionist restraints on trade designed to shore up domestic media production. But even in the face of growing U.S. trade deficits and pushbacks from countries resentful of the power of U.S. movies and CDs abroad, year after year America's cultural industries have been able to proudly proclaim their arts products "America's biggest export." (There are signs, however, that America's automatic hegemony in entertainment products is on the decline; India's Bollywood film industry is an export powerhouse.)

In part because U.S. arts products are so successful on the global scene, audiovisual material and other intellectual properties have surfaced as major points of contention in international trade negotiations and agreements. Persistent efforts to create exceptions to free trade in arts products put forward by countries on the receiving end of America's cultural juggernaut have engaged the staff of the USTR in near-continuous negotiation. The unique character of U.S. arts products has effectively immunized American movies, CDs, and television programs from the effects of global competition. It has never been much of a challenge to pump up demand for the products of America's cultural mainstream; instead, our

cultural industries have been challenged to set in place mechanisms of distribution, licensing, and payment strong enough to offset the ability of illegal duplicators to serve demand through pirated copies. Both in size and in their ability to vanquish competition, America's arts exports hold unique stature in the U.S. foreign trade agenda. When we read of contentious negotiations surrounding NAFTA, GATT, the World Intellectual Property Organization, and the World Trade Organization, arts products are certain to be at the heart of many disagreements.

As the official trade advocate for the U.S. arts industries, the Office of the U.S. Trade Representative has emerged as the most powerful single actor advancing America's expressive life abroad. Long-standing antipathy to cultural work within the State Department, the elimination of the USIA, and the ambivalence of elected leadership regarding the value of international arts exchange has in a sense left the USTR's Office as the "only man standing." If the USTR's Office can direct an embassy of the United States to intervene in the internal affairs of an ally on behalf of the U.S. domestic recording industry and if that intervention advances a trade position somewhat at variance to the posture of the State Department, it is clear that today trade in culture trumps diplomacy.

The way government connects with the movement of American culture in the world illustrates a major thread of my argument: In terms of both domestic and foreign issues, what passes for cultural policy work in the U.S. system is split into small pieces parceled out among dozens of federal agencies, administration offices, and congressional committees. But what is merely dismaying on the domestic scene can be dangerous and tragic when played out in international affairs. The movement of American culture abroad, a transfer of creative expression that takes place absent any central conversation about goals, principles, or content, too readily provides an inaccurate portrait of American society while simultaneously failing to anticipate coming problems in trade, rights, and distribution that will turn back our enviable history of success in global cultural commerce. Ironically, other countries have taken advantage of the fact that America's cultural portfolio is divided to actually counteract our trade agenda.

The Oaxaca meeting where I learned of the USTR's intervention in South African public policy had been organized by Canada's minister of

heritage and culture, Sheila Copps. Copps was a major proponent of Canada's anti-American cultural content restrictions. Beginning nearly a decade before the 1999 meeting, Copps and her counterpart in the French Ministry of Culture had developed a strategy to seize control of an emerging issue in diplomacy—the protection of the integrity of tribal and nonelite cultures in an environment of global trade. But Copps and her allies had an ulterior motive—the reconfiguration of *cultural diversity* into a headline behind which countries could project trade barriers resistant to U.S. audiovisual exports. They used the attractive notion of *diversity*, to, as George Will wrote, "attempt to legitimize cultural protectionism." By bundling diplomatic and trade issues and aligning the combination under the hot-button diversity question so important to emerging nations and minority populations, Copps effectively packaged a trade issue in a fashion that didn't fit the mandate of any single U.S. agency. Our State Department, weak on culture, had been supplanted in arts trade by the USTR's Office, which lacked a mandate to take on issues of cultural rights and diversity and thus was rarely even at the table when UNESCO, the U.N., or other diplomatic forums took up the demands of indigenous and minority communities around the world.

By positioning the diversity/protection issue in the policy void between the uninterested authority of State and the limited portfolio of the U.S. Trade Representative, Copps had brilliantly hit the ball right between first and second base, dividing the talents of America's primary global actors and ensuring that nobody (or only an official as relatively insignificant as the NEA chair) would effectively represent U.S. positions on protectionist trade policy. By the time I met with the thirty ministers of culture gathered "informally" in Mexico, Minister Copps and her collaborators had, for nearly ten years, patiently assembled a coalition of like-minded ministries determined to extract audiovisual materials and other arts products from international free trade agreements. In fall 2005 the long-term plan to plant protectionist trade policy inside the Trojan horse of diversity came to fruition; UNESCO passed a convention on diversity containing the key trade provisions promoted by Canada and France. The final vote was 148 to 2, with only Israel and the United States voting no. Sheila Copps had left her position as Canada's minister of

heritage and culture more than two years earlier, but her plan, taking full advantage of our disjointed approach to art abroad, worked brilliantly.

Ministries of culture or departments of cultural affairs frequently combine cultural and trade issues in a single portfolio. Then and now the chair of the NEA has no such broad responsibilities—only limited contact with the State Department, none with the USTR's Office, and none with the National Security Council. So by the time I met the Canadian-French juggernaut in Oaxaca, it was too late in the game to head off a vote on a final meeting report antagonistic to U.S. interests. But I learned a lesson: on a very important trade issue, our incoherent system of managing cultural issues had put America behind a diplomatic and trade policy eight ball.

Bringing American culture abroad in the right way can be an important tool of diplomacy, even a national security asset, but it's not a magic wand. Sometimes people don't like us because of what we're doing, not because of the way our art, ideas, and values are presented by embassies, touring entertainers, and media. David Rieff frames the question this way: "Is hostility toward the United States based largely on misperceptions of America's actions and intentions or on a genuine dislike of the power America wields around the world?" One thing is clear: today's market-driven model of cultural interaction hasn't helped our image abroad. According to the Pew Global Attitudes Project, "In Brazil, 52 percent held a favorable view of the United States in 2002; by the following year that had dropped to 34 percent. In Russia, the pro-American portion of the population dropped from 61 percent to 36 percent over a year." In spring 2004, also according to Pew, 93 percent of Jordanians had a somewhat or very unfavorable view of the United States, in Morocco the numbers were a bit better: negative opinions were held by only 68 percent.

But can the arts help when war, terrorism, or other acts of violence subvert the civil exchange characteristic of "normal" diplomatic relations? I believe they can play an important role.

In times of general accord it's possible for diplomacy to be transactional: I give you money, trade advantages, access to information or other resources, and I then get something in return. But when military action, trade sanctions, or conflicts over human rights create intractable policy differences, transactional diplomacy that aims at short-term quid pro quo

outcomes may be impossible. Acknowledging the reality that periods of heightened conflict make it difficult for nations to trade favors, political scientists in the United Kingdom have embraced the concept of mutuality—trust based on a shared understanding of long-term values and aspirations; the kind of nontransactional trust we place in family members or close friends. After World War II the United States could draw from a deep well of this kind of nonspecific trust, and it is fair to argue that today we are suffering from the long, slow evaporation of that reservoir.

Mutuality is a mechanism for building long-term trust, and art and culture—as arenas of *difference without conflict*—can be its handmaidens. If cold war cultural diplomacy was about getting political elites in other countries to respect the values of our market democracy, mutuality serves a pressing contemporary need: letting common people around the world know that we—the only superpower in the world—respect the values of others. However, because mutuality, by definition, rises above the dispute of the day, it can be a hard policy sell at home. After all, mutuality, like soft diplomacy, doesn't promise short-term solutions, requiring instead lasting two-way communication and a real acceptance and understanding of the overarching goals of even those who oppose us: mutuality is less about talking loudly and more about listening well. Even in the halcyon days of the cold war, when public diplomacy was an important gear in the engine of international affairs, almost all our work was in the "send" mode, using touring, international broadcasting, and subsidized intellectual journals to "get our message out." Today post-9/11 insistence on quick results eliminates long-term solutions: no time for the luxury of Joe Nye's soft diplomacy; we want effective transactions right now. In addition, whether through Arabic-speaking TV networks or Muslim-targeting ad campaigns, we're almost entirely caught up in pounding away at the delivery of our message.

It shouldn't be this way. Ideally, when policy disputes make short transactional diplomacy impossible it should be possible to regroup, to slowly rebuild trust on the foundations of mutuality. However, in the face of pressure to reverse global negative views of the United States, it is probable that Undersecretary Hughes and company were never afforded

an opportunity to pursue mutual concerns or long-term trust with the nonelite populations of the Middle East.

Other countries are way ahead of us when it comes to cultural work bold enough to grow mutual interests from entrenched mistrust. In September 2007 the British Museum opened an exhibition on Qin Shi Huangdi, China's first emperor. The exhibition, which included terracotta warriors from Xi'an, was given five stars by London's *Times*. As an opinion piece in the *Financial Times* observed, the British Museum, targeting not only China but also Iran, "has been at the forefront in using cultural links to deal constructively with 'difficult' countries." Denmark and Sweden invest actively in efforts to introduce musicians and other artists to audiences in the United States. Trade and culture officials regularly scope out U.S. music festivals, work to influence critics, and subsidize recordings and tours for acts. According to the *New York Times*, Canadian artists can assemble grants and loans to cover up to 75 percent of expenses. In Australia the government provided nearly $2 million in grants to eighty acts, just for the export of their music. One goal, of course, is market development, but the positive diplomatic impact of direct contact with popular musicians from outside the United States is undeniable.

The incoherent voice of our expressive life abroad is telling evidence of the absence of commitment and coordination around public interest goals in the implementation of U.S. cultural policy. When *Baywatch* or *Sex and the City* trumps Alhurra TV, when Canada's minister of heritage and culture can redefine *diversity* and *cultural heritage* without our noticing, and when short-term trade interests overrule State Department principles, the public interest is not being served; our right to expressive life as a vehicle for authentic communication and understanding is denied. Obviously, framing a more coherent international message is challenging in a democracy. We must take care: organized expressive life easily tips over into propaganda, and the desire to craft content to convey a specific message can undermine First Amendment rights.

Given our devotion to free expression and open markets, what can we do to sustain our right to an international cultural message that accurately presents both America's creativity and American values? First, even if the power of media products makes it unlikely that our official instruments

of cultural diplomacy will ever be restored to positions of cold war dominance, much can be accomplished by simply coordinating the efforts of the many entities that have some responsibility for the movement of art and culture around the world. Certainly the U.S. State Department, the Broadcasting Board of Governors, and the Office of the U.S. Trade Representative are the lead actors; in addition, the Department of Defense, the Central Intelligence Agency, and the Department of Homeland Security manage programs that use scholarly research, art, and culture on a global stage. Both the National Security Council and the Office of the U.S. Trade Representative are proven models for coordinating the efforts of many departments and agencies.

Journalist George Lesser, writing in the *Washington Post*, had a simpler proposal: "Re-create the USIA as an independent agency charged with conducting public diplomacy." Perhaps Lesser is right. But it will need to be a very different USIA—one tasked with a twenty-first-century challenge, to communicate both the dream of democracy and the validity of our long-term goals and our regard for the heritage, values, and aspirations of others. Bringing back the cold war USIA just won't work.

But a resuscitated USIA, a slightly reconfigured USTR's Office, or even our cultural agencies—the NEA, the NEH, the Smithsonian Institution, and the Library of Congress—can help define and coordinate international cultural communication. In some ways, because they already engage trade, touring, and scholarly exchange year in and year out, these agencies are best equipped to lead a new approach to cultural work abroad. Of course, ultimate responsibility for U.S. foreign policy resides in the White House, and here, unfortunately, the long-standing, bipartisan lack of interest in cultural work exhibited by one administration after another will make it especially difficult to find the interagency juice necessary to pull competing agendas into a coordinated effort.

When the long-anticipated "National Strategy for Public Diplomacy and Strategic Communication" emerged in summer 2007, the plan promised to "identify, highlight and nurture common interests and values" and provide "expanded arts and cultural partnerships," but it clearly tilts away from cultural diplomacy toward "strategic communication." Among other things, the plan fails to mention the role of trade in music,

television, and film as a component of the U.S. image and message abroad. Available only as a draft in fall 2007, the Center for Strategic and International Studies Commission on "Smart Power," co-chaired by Richard Armitage and Joseph Nye, of soft-power fame, called on the United States to "move from eliciting fear and anger to inspiring optimism and hope." If the commission's report gains policy traction, culture will be an important part of any resulting initiative.

Predictably, discussion of cultural issues lies buried in chapter 12 of the 9/11 Commission Report, and it has taken the Bush administration nearly six years to develop a coordinating committee on culture and communication—interrelated facts, each symptomatic of an absence of interest and urgency at the top. Further, it is important to recognize that we would not find the words *culture* and *art* in the official authorizing language of many of the agency actors that actually work with expressive life, so there's no existing statutory mandate requiring attention to the character and impact of our expressive life abroad. It should thus come as no surprise when agencies and offices find themselves working at cross purposes as, for example, when Radio Sawa or Alhurra broadcast programming that contradicts what is aired on VOA's English and Arabic stations, or when programming that undercuts the content of "official" American entertainment runs on free-to-air satellite stations, to say nothing of trade practices that effectively offset State Department commitments to diversity of content. In fact, cultural authority is scattered so randomly among international actors that it is not even clear which agency is best equipped to lead the discussion should a serious coordination effort ever be launched. An updated USIA can help, but an independent department of cultural affairs or a standing White House national cultural council would be even more effective.

Once we decide which of our actors inside government can best speak for the nation on international cultural matters, we need to make our commercial media industries partners in the pursuit of America's diplomatic agenda. The First Amendment properly protects the purveyors of culture abroad from any attempt by government to restrict or edit the content of what they sell in foreign movie theaters or on cable or satellite television. However, there's nothing wrong with bringing in top entertainment pro-

ducers to think through what *might* be done to coordinate our cultural message without trampling on First Amendment rights. For example, perhaps episodes of shows like *Baywatch, Dallas,* and *The Sopranos* can be framed by experts who, speaking in the language of a targeted country or region, can place the plot elements in context. It's not a perfect idea, and just explaining that American women don't wear bikinis *all* the time won't turn around negative views of the United States, but at least we can begin to search for niches within entertainment products where official public-interest objectives for culture abroad can function effectively alongside the goals of commercial distributors of movies, records, and media.

We can also find ways to offset the perception that our media exports are suppressing indigenous arts industries. Trade negotiator Carol Balassa of the Office of the U.S. Trade Representative has argued that we should soften the impact of our exported entertainment by helping to build up the domestic production and distribution capabilities of other nations around the world—especially the capacity of those countries with emerging film and broadcasting industries, or those that find American culture offensive or oppressive. Again, the solution is not perfect, but strong domestic arts industries in other countries can allow homegrown products to find their way to theater screens and satellite channels, thereby making it less necessary for countries to construct strategies for keeping U.S. movies and television out.

The role of our nonprofit arts communities in a twenty-first-century initiative of cultural diplomacy and mutuality is uncertain. In the elite-to-elite atmosphere of the cold war competition between U.S. and Soviet political and economic models, the fine arts played an obvious role. But U.S. nonprofits failed to develop their own foreign exchange policy objectives; our orchestras, museums, and dance companies never moved beyond the view that government-supported culture abroad was primarily an additional revenue stream. To play a role in today's overarching global struggle, nonprofits must develop a vision of public service, pitch their efforts away from economic and intellectual elites, and partner with the for-profit cultural industries that are the big dogs of U.S. art abroad. The sector may not be up to, or even open to, the task. On the other hand, our

foundations are well positioned to lead. But if rap lyrics, dance beats, and three-on-three basketball workshops in remote villages are the currency of mutuality, our grant makers will need new partners.

Some challenges to America's cultural rights—access to heritage, training in the arts, and linking public policy with the insight of artists—exhibit a subtle character and are only now beginning to enter our national conversation. But the state of American culture abroad is different: our inability to gather our cultural assets into something approaching a coherent diplomatic message constitutes a tragic failure of imagination in public policy.

We need to take action now.

The U.S. cultural system is defined partly by public policy but mostly by corporate practice, and in an open society purveyors of art in the global marketplace are, most properly, under no obligation to bend their artistic visions to suit some foreign policy objective. But Americans have the right to expect that the totality of our expressive life abroad responsibly conveys an accurate picture of American life and values. This citizen expectation—our right to representative culture abroad—would be reasonable in any era. It is crucial at a time when our values are competing for the goodwill and hopes of nonelite populations around the globe. Just as an incoherent approach to cultural trade allowed substantial U.S. interests to ride on the modest negotiating skills of the head of our federal arts funding agency, the absence of a "center" around which to hold a conversation about art as a democratic metaphor abroad too often allows the marketplace to define America's message to the world. Two months after the terrorist attacks of 9/11, President Bush observed, "Too many have the wrong idea of Americans as shallow, materialistic consumers who care only about getting rich or getting ahead." With the United States served by a policy system uninterested in coordinated cultural exchange and willing to carelessly cede the movement of expressive life abroad to media industries, neither we nor our president should be surprised when our character is defined not by assertions that we are "good people" but instead by the image of a gaggle of hard-bodied beauties romping on a Kodachrome rendering of a California beach.

Art of Lasting Value

The right to know about and explore art of the highest quality and to the lasting truths embedded in those forms of expression that have survived, in many lands, through the ages.

In northern Michigan, March is still the dead of winter. It was blowing hard enough to make me think twice about driving the upper road to Hancock—a route guaranteed, when the wind was from the northwest, to hand you nine miles of dusty, sideways-blowing snow. I sure didn't want to spend late-night hours digging out of a drift when there was school the next day. Most seniors had it pretty easy, but my mother was one of the high school teachers, so there was no way I could be late. But there were no longer any movie theaters operating in my town; we had to plan on a drive to and from Hancock to see a film.

In the end I took a chance, and the weather was fine. Sitting nearly alone in the Pic Theater, I saw *Black Orpheus* (*Orfeu Negro*, in Portuguese), the French-produced film that retells the Greek legend of Orpheus and his love, Eurydice, through the language, music, and atmosphere of the 1959

Carnival in Brazil. By winter 1961, when general distribution had brought the film to Hancock, it had become one of the most honored international productions of modern times. It won the Palm d'Or at the 1959 Cannes Film Festival, a Golden Globe award, and the Oscar for Best Foreign Film of 1960. The popularity of the movie had helped advance a new style of samba music, a fresh, relaxed and accessible approach that was equally appealing to pop music fans and jazz hipsters of the time. Late in 1957 Antonio Carlos Jobim had released the album *Desafinado*, featuring this new approach to samba, as well as Jobim's guitar playing and the singing of João Gilberto. Jobim and composer Luiz Bonfá wrote the sound track for *Black Orpheus*, and the popularity of the movie combined with the success of *Desafinado* to launch the new samba style, soon known as the "new wave," *bossa nova*.

The original Orpheus legend is timeless, the adapted story of doomed lovers moving and tragic, and the music unforgettable. The soundtrack album sold millions of copies, and at least two selections from the film and disc, "Manhã de Carnival" and "A Felicidade," became jazz and pop music standards. Forty years after bossa nova swept the western hemisphere, it is still common to hear one or two bossa nova pieces included on newly recorded jazz CDs.

Black Orpheus combined many elements to achieve its appeal. The film—in many ways crude by today's standards—was a transporting glimpse of an exotic world for many audiences in the early sixties. Director Marcel Camus's exotic Carnival atmosphere conjured from Brazil's pagan-Christian vernacular ensured that the film would end up as more than a doomed, documentary-style artsy experiment. The costumes, dance, Carnival backdrop, and exciting new music in *Black Orpheus* provided an open window into Brazilian traditional culture and into the creativity and dynamism of the Brazilian musical scene. And, of course, the film succeeded in part because it combined the lasting story line of Greek legend with the dynamic expressive character of dance, costuming, and music—one example of the many combinations of African, European, and native artistic traditions that have defined expressive life in the Americas.

My experience in the chilly theater that March night was transforming. I had already heard bossa nova guitar and was only then trying to play

the guitar using the fingers of my right hand to sound the strings—classical style—in an attempt to imitate the seductive "three-against-four" samba rhythm perfected by Gilberto and Bonfá. But the glimpse into sunlit Rio and Carnival was an almost unimaginable contrast to the piled snow and sharp night air of a northern Michigan winter, and for me it was the first real hint that there existed different ways of life that were far away, exotic, richly creative, and important. *Black Orpheus* revealed artistic complexity—a mash-up of jazz, indigenous music of Brazil, African rhythms and dance, native costume, pagan and Christian ritual, all framed by a centuries-old Greek myth. I had to learn more about this stuff!

· · · · ·

There are cultural traditions that we absolutely must make part of our expressive lives if we are to be, as movie critic David Denby puts it, "armed for selfhood and citizenship." Certainly African art and art of the African diaspora—Afro-Latin and Afro-American culture—are central to an understanding of art making in the United States. Blues, rock 'n' roll, jazz, salsa, bossa nova, and *Black Orpheus* come out of these traditions. Music and ceramics and calligraphy in the Far East, the music and storytelling traditions of India, and the tales and art of Native Americans and other indigenous peoples of the hemisphere—each body of art possesses deep roots and contemporary significance. And, of course, even in an era in which U.S. training in art, literature, and history has shifted away from the Western canon, most young Americans—iPod and cell phone addled as they might be—have an idea that a great culture flourished in Europe, that the United States has inherited some of it, and that to some extent we have both shaped and been shaped by it. Our heritage of European art and art making is an important part of a vibrant expressive life.

If our diplomatic challenge, as the world's only superpower, is to let other nations know that we respect them, American engagement with the art of other nations is essential. But we haven't done a very good job of gathering up the great traditions of the world to make the heritage of others a coherent part of our cultural vocabulary. Consider, as a kind of

thought experiment, art making that seems simultaneously close at hand and, sadly, hopelessly remote—the traditions of Native Americans. What would our school curriculum in the arts (or, history, for that matter) look like if we offered American Indian painting, sculpture, dance, woodcraft, and storytelling as a coherent set of skills to be mastered alongside drawing, choral music, and poetry? Such an approach to arts learning would not only engage young citizens in a set of unique skills and practices but also provide a window into a cultural system grounded in a powerful sense of the earth as the source of spiritual and material well-being. Wouldn't American society be better off if we possessed a collective understanding of the culture that in many ways constitutes the origin of what we call the American experience?

We've done a pretty good job of teaching the elite parts of our European heritage—novels, painting and sculpture, classical music—but the vernacular has mostly come in through the back door of folk tradition empowered by recordings, radio, and movies. Bill C. Malone, in *Southern Music/American Music,* makes the point that in the American South "there was a long and vital interrelationship between our two greatest folk music traditions, the African and the British." So, what most of us know of the African diaspora (and what we know of British folk culture) comes through consumption of music forms derived from "blended" southern genres—blues, jazz, gospel, country, and early rock 'n' roll. As with the arts of Native Americans, we have never organized an understanding of the overarching importance of art out of Africa: art that includes not only music but also design, dance, and sculpture.

If the democratic diversity of the U.S. cultural mainstream has given us an arts landscape that most resembles a permanent border, the same metaphor can be writ large to encompass our relations with a globalized world. Just as any denizen of a border town needs to speak the languages, eat the food, and appreciate the heritage and creativity of others, so must a citizen today possess sufficient empathy to enable a degree of understanding of different people, living in different places and in different times, leading lives from different perspectives. Expressive life—ours and theirs—remains a guilt-free zone—a place where we can audition difference free of suspicion and anger.

We've seen that fragmented, market-dominated trade policy undermines our cultural message abroad. How well does our arts system connect us with the great artistic traditions that contain alternate visions of family life, individual achievement, society, and the human spirit?

If, as Freud argued, maturity is measured by the capacity of an individual to hold contradictory ideas at the same time, then the maturity of a society can be judged by its ability to simultaneously honor multiple aesthetics. Our individual expressive lives are enriched as we take in more examples of the nature of the human predicament and as we experience different approaches to the representation of cultural values and different attempts to convey universal truths. Of course, unconstrained cultural relativism produces moral and artistic paralysis; if everything is equally good and everything is great and important, then nothing can be decided, advanced, or condemned. But a measure of empathy is an entry-level attribute in a "flat" world order. Does our access to art of the world satisfy the minimum level of cultural relativism required for life on a global border?

The answer is, not very well.

Our bloated arts system, rich in cable TV channels, multiplex movie screens, CD releases, and iTunes downloads, isn't geared up to let in art that is really different. A few years ago, when I was visiting southwestern China, local visual artists in Kunming revealed, in a lunch meeting, an astounding knowledge of the global gallery scene and detailed knowledge of the controversies that had swirled around the National Endowment for the Arts here in the United States. Their knowledge of the U.S. was in part an acknowledgment of the importance of American art in the current world market, but it also underlined an intellectual curiosity and engagement with different creative traditions that is lacking here, even among arts specialists.

The failures of our system are subtle. Although we have hundreds of cable channels, international fare is slim—mostly the BBC and Mexican-based Spanish-language networks. American series like *Dallas* and *Baywatch* are standard fare among nonelite populations everywhere, but those same audiences can also tune in CNN, Al Jazeera, and a host of other news and entertainment networks from around the world offering

distinct artistic visions and diverse political points of view. The difference is in how programming is delivered: U.S. television places what is in effect a gatekeeper—a cable provider—between each network and the consumer at home. Networks that find their way onto cable systems do so because they help attract viewers, thereby sustaining hefty monthly subscription fees. Cable also prices its programming in *tiers;* services that provide a glimpse into other artistic traditions or other political points of view rarely show up in "basic" service, only reaching those parts of the audience willing to pay a higher monthly fee. Cable systems also exercise judgment as to what networks provide appropriate content. Sometimes channels offering controversial fare (nudity and realistic language, for example) are available only by special subscription; others simply may not be picked up at all.

While the federal government is not about to *prevent* a U.S. cable system from carrying programming sympathetic to, say, radical Islamists, the fear of condemnation by pundits and politicians is sufficient to keep networks with widely divergent points of view off American TV sets. Cable systems did not trip over one another in a rush to add the new English-language Al Jazeera network. But, as we've seen, much of the rest of the world consumes television via free-to-air satellite systems. Because no monthly payments are required, the consumer can pick from hundreds of stations available. No cable executive is selecting from a slate of stations based on perceived viewer appeal or appropriateness of broadcast content.

In part we're caught up in a vicious circle. Programmers know that most Americans speak only English, so they're reluctant to provide films or TV or radio programming that won't find an audience, and because the material isn't available nobody seems interested. My satellite radio service boasts more than two hundred stations, but apart from the BBC and a couple of Spanish-language outlets—the same foreign voices conveyed by cable TV—offerings just slice up the spectrum of standard American fare into thinner portions—"contemporary" versus "traditional" jazz, for example. We do a bit better in athletics; Lance Armstrong dragged American viewers to Tour de France coverage on the otherwise-obscure Outdoor Life channel, and, despite the collapse of the U.S. team early in the

2006 competition, there's a growing American audience for World Cup soccer. But in sports English-language commentary can help bridge cultural distance, something that's harder to accomplish in theater or music. Sure, there's "Europop" on satellite radio, but it's nothing but dance tracks that for the most part bury lyrics anyway. In the arts nothing *really* different gets in.

The same is true of film. Each year, something like 2,000 feature-length films are released worldwide—films that are premiered somewhere in the world and reviewed by industry trade publications like *Variety*. Of these offerings, about 600 will open on a screen in New York City, maybe 300 in cities like Chicago, San Francisco, and Boston. For residents of smaller towns dependent on suburban multiplex theaters, screens will be dominated by U.S. studio releases. Ironically, the United States has been and remains the world's largest market for movies, but that's the dollar size of the domestic market, not the number of titles available. Foreign films have never accounted for more than about 7 percent of annual box office sales. And that modest 7 percent high point was achieved in the 1960s, an era considered by many the heyday of international film in the United States. That decade, of course, preceded the widespread introduction of multiscreen theaters in shopping malls, as well as the introduction of VHS and DVD releases for films. In the late 1990s *Film Comment* magazine polled nearly one hundred critics and programmers to determine the most important foreign-language films that had *not* been released in U.S. theaters; the list included works by such famous directors as Jean-Luc Godard, Federico Fellini, and Akira Kurosawa. Important and obvious films, in some cases, simply haven't gotten in.

Of course, DVDs and to an extent CDs *have* created an outlet for all sorts of exotic offerings, including obscure classical and pop recordings, old radio and TV shows (when the music rights can be cleared), and historical and foreign films. The trick, of course, is that DVDs are a prime symptom of America's fast-emerging multitiered arts consumption system, a system that offers ever-expanding choice to well-heeled, knowledgeable niche consumers while draining content from the cultural commons.

The rich have always exercised greater cultural choice; the success of our arts system (some might say the success of our entire economy) is in

its ability to allow more citizens to behave as if they were rich. Unfortunately, access for those who can buy their way in has been achieved at the expense of an open commons. In fact, if we were to graph trends in theatrical exhibition of foreign films against the distribution of the same titles on tape and DVD, the lines would exactly cross; theatrical release would decline as DVD sales grow. And remember, sixties-era foreign movie distribution was for everybody—films played in the same theaters that featured *Goldfinger* and *Breakfast at Tiffany's;* that's how I saw *Black Orpheus.* Today movies like *Black Orpheus* are around, but they reside on high-tiered cable channels or specialized DVD outlets, not on screens in small-town northern Michigan theaters.

It should come as no surprise that changes in immigration policy after 9/11 have made it more difficult for Americans to experience live performances by artists from other cultures; it's especially difficult for musicians, actors, or writers to gain entry to the United States if they have any connection to a country at odds with U.S. foreign policy or if any quirk or blemish shows up on their official documents. Eckart Runge, cellist for the Berlin-based Artemis Quartet, was kept from entering the United States long enough to force cancellation of the group's entire 2002 tour. His offense? He had been cited for an insignificant shoplifting prank during a 1991 visit to the Aspen Music Festival. Although he was cleared of any wrongdoing and his visa now indicates he is not a security risk, when he entered the United States in 2004 he was detained for hours while a background check was completed.

Artists have never had an especially easy time entering the United States for short-term visits—problems predate 9/11 by decades, and, again, the marketplace has played a defining role. Shaped long ago by pressure from unions and U.S. artists' associations, U.S. immigration policy in the arts is designed to prevent any wholesale importation of musicians, dancers, and actors who might take American jobs. When applying for entry, foreign artists must demonstrate that they possess "extraordinary ability in the arts," generally by submitting evidence of awards or reviews with a visa application. They can also be considered for visas if they are part of a reciprocal exchange program (guaranteeing, I suppose, that no net loss of employment will result for American artists) or if their

artistry is "culturally unique." For example, folk artists like Indian tabla players or Balinese puppeteers—artists with no obvious American counterpart—would fit this description. Pre-9/11 concert promoters or orchestra managers could anticipate a wait of anywhere from forty-five days to two months between visa application and approval, but by the end of 2002, following implementation of provisions of the Patriot Act, the waiting period doubled.

And there were additional snags. Spanish guitar great Paco de Lucía canceled six shows and postponed six others when his bass player, Alain Pérez, was initially denied a temporary visa. Perez, although living in Spain, was traveling on a passport from his native Cuba. It's no surprise that Cuban connections have proven especially troublesome to musicians. It was untimely that the Homeland Security crackdown began just as the film and CD documenting the brilliance of the Buena Vista Social Club had kicked off a new wave of enthusiasm for Cuban music. Five Cuban musicians were denied visas that would have allowed them to attend the Grammy Awards telecast in Los Angeles, and the Afro-Cuban All Stars, a prominent Cuban act, had to cancel their entire twenty-date tour.

The challenges facing some artists and scholars involved in the arts can be downright Kafka-esque. In August of 2006 musicologist Nalini Ghuman, a native of Wales traveling on a British passport, was without explanation denied entry into the U.S.—even though she was an assistant professor at Mills College in Oakland, California, and had lived in the U.S. for the past ten years. More than a year after armed immigration officers detained her and tore up her visa, Ghuman still had no idea why she had been kept out of the country and had made no real progress in resolving her case. The State Department wasn't talking.

Artists often bump up against other restrictions that can make it difficult to obtain a visa. Any individual who wants to enter the United States must demonstrate a measure of financial security as well as family and professional ties in their home countries. But artists in the United States and around the world are often young, poor, single, and, because they work as freelancers, often appear to be marginally employed.

It is understandable that since the terrorist attacks on the United States and the implementation of Patriot Act security measures the entire visa

process has slowed down. But unlike the average tourist or guest worker, many artists can boast established track records of trouble-free employment in the States. Surely we can expedite visas for those artists who are known to have previously worked in the United States without generating problems or complaints. Right now, even established international artists are subject to numerous background checks, fingerprinting, and frequent interrogations. As Boston concert promoter Maure Aronson says, "It's not the way to show artists from other countries that America is a culturally diverse society, a free society. This is a policy which is going to hurt us economically, culturally and politically."

The effects are being felt in the arts and beyond. In 2005 overseas travel to the United States was 15 percent below the peak year of 2000; excluding visitors from Mexico and Canada, the decrease was 22 percent. Despite the overall slowdown in the processing of new visas, State Department statistics indicate that the number of applications denied—about 20 percent—has remained constant since before 9/11. But that figure deceives; the number of visa applications dropped by more than a third between 2000 and 2004; in other words, the actual number applying for visas was significantly lower than before the implementation of increased security (6.6 million in 2004 vs. 10.1 million in 2000). And new refinements in border security measures have made it less convenient for visitors from the mostly European nations whose citizens are not required to obtain visas for stays of ninety days or less in the United States. These guests must now carry machine-readable passports with embedded electronic chips containing facial recognition data; they must also submit to digital fingerprinting on entry.

America's tourism industry is concerned that border security threatens a $75 billion annual business, but we are all worse off if artists, intellectuals, and citizens of other countries can't get in. It's known that most foreign visitors leave with a favorable impression of the United States; these visitors—especially artists—also leave something behind: a glimpse of the values and attitudes of the world that can help Americans achieve a cosmopolitan resilience essential to life in a flat, shrinking world. As Mahatma Gandhi wrote in the journal *Young India* in 1921, "I do not want my house to be walled in on all sides and my windows to be stuffed. I want

the culture of all lands to be blown about my house as freely as possible. But I refuse to be blown off my feet by any."

· · · · ·

In fall 1991 David Denby reentered Columbia University to repeat the core curriculum courses he had been required to take as a freshman thirty years earlier. The courses were "Western civ" surveys, great books and great thinkers "assembled in chronological order like marble busts in some imagined pantheon of glory." He was revisiting Aristotle, Augustine, Kant, and Shakespeare to answer a specific question, "What role should the Western classics and a 'Eurocentric' curriculum play in a country whose population was made up of people from many other places besides Europe—for instance, descendants of African slaves and American Indians." Denby distrusted the conventional-wisdom answers to his question framed by the academic left and conservatives, one side arguing that the ideas of Dead White European Males had little relevance to newly empowered minorities, the other that the European canon represented an essential noble body of work that should "be inoculated into every generation of American students." For Denby, the debate sucked real significance out of the classics of literature and philosophy, all but guaranteeing that no great book would ever, under any circumstances, find a meaningful place in a reader's life.

Denby's foray into the world of lasting literature presents a challenge to the way we organize our expressive life: Why move beyond the buzz of new art to dig into the finest examples of expressive life from other places and other times? Why wander into territory where nothing will be gained unless the visitor is willing to work hard—employing empathy, tools of critical observation, and historical and psychological insight to gain understanding? Classical music, simultaneously the poster child and the mine-shaft canary for the fine arts in America, poses for art lovers exactly the same question: In an arts environment where hip-hop, jazz, Eurobeat, and rock provide music grounded in immediate experience, why bother to integrate a tradition grounded in the long-ago and faraway into our expressive lives? Arts people have tied themselves in knots over these questions and their conventional responses, which, too often framed by

unstated prejudices, hierarchical assumptions, and a sense of entitlement, have failed to make classical music—and in many ways all the fine arts—a central feature in the everyday expressive lives of Americans.

We can agree that, unlike the case of Native American art or even the sculpture, dance, and music of the African diaspora, there has been a concerted and coherent attempt to advance classical music as a distinct art form of significance to a mainstream U.S. audience. Early in the twentieth century the symphony had begun to separate itself from other forms of entertainment even as technology made it easy for classical music to reach a mass audience. Although classical music was an important, even essential part of the fledgling recording business, the symphony orchestra had already cast its fate with nonprofit-status, tax-exempt patronage and philanthropic connections to the wealth of urban elites eager to maintain status-rich modes of consumption.

What is the problem with classical music today? If the great intellectual and artistic traditions of Europe deserve a secure place in our expressive life and if most Americans have at least some inkling that Shakespeare, Brahms, and Plato are important, what has kept classical music and its cousins perpetually in our peripheral vision, distant from the art Americans live every day?

Keep in mind that it wasn't always this way. True, America's arts industries laid the groundwork for the popularity of a new, democratic, grassroots expressive life when film, broadcasting, and sound recordings first brought all kinds of performing art to all kinds of people. But until the last three decades of the twentieth century, classical music was very much a part of America's expanded buffet of cultural choice. Its presence in twentieth-century entertainment was significant. Enrico Caruso was one of the recording industry's first superstars; Arturo Toscanini and the NBC Symphony were flagship performing artists on America's premier broadcasting network. *Fantasia*, the collaboration linking the Philadelphia Orchestra, conductor Leopold Stokowski, and Mickey Mouse was a critical and financial success for the Walt Disney Company—a "hit" classical music movie; Leonard Bernstein's Young People's Concerts remain landmarks of early television. Van Cliburn's fifties-era triumph in a Moscow piano competition was front-page news.

But ironically, even as individual giving to nonprofit orchestras and support from foundations and government agencies grew, classical music gradually lost its hold on the popular imagination. Of course, classical music has a special marketing problem. If David Denby wants to purchase a literary classic in a Borders superstore, he looks in the "literature" or the "fiction" section; there he'll find Thomas Mann next to, say, Thomas McGuane. Critic Alex Ross makes it clear that things are different in music: "I hate 'classical music,'" he argues, "not the thing but the name. It traps a tenaciously living art in a theme park of the past." In magazines and record stores (if you can even *find* a record store these days), you find, as Ross puts it, "Popular Music in one section and . . . Classical Music in another, so that the latter becomes, by implication, Unpopular Music." For Ross, classical music's supporters have got their message wrong by trying to browbeat the rock- and hip-hop-loving audience with the dead-on-arrival assertion, "The music you love is trash. Listen instead to our great, arty music."

And Ross is right; too often classical music employs a sales pitch that, right out of the gate, treats every other form of music as inferior. The process is not about finding ways to connect with the interests and concerns of listeners but rather to convert consumers *from* the popular *to* the refined. But, in an age of cultural politeness, it's hard to find allies willing to make such an argument. Juilliard president Joseph Pelosi, in an online interview, laments the fact that "there's no question that any politician or individual will shy away from saying that Beethoven is in fact better than Bruce Springsteen," adding, "If you use the standard of *American Idol* as the standard for a singer I think you might be going down a very dangerous road."

I don't mean to pick on Juilliard or its president; both are making valuable contributions to our arts scene. But this wan mission—that the task of classical music and its followers is to somehow "cure" rock 'n' roll—has energized decades of cultural intervention, from the early Young Audiences program to Young People's Concerts. Fifty years of free concerts for high school students hasn't changed things much, though.

This notion—that the fine arts are *categorically* superior to other forms of aesthetic experience—goes straight back to Matthew Arnold, to his

elevation of the fine arts as "the best that has been thought and known in the world . . . the study and pursuit of perfection." Or, as in Allan Bloom's more contemporary formulation, the fine arts are "everything that is uplifting; . . . the peak . . . something high, profound."

But classical music, like painting and other visual arts, actually lives with smug pride in what is hardly a permanent condition, but rather the third stage of a three-century convergence of social, institutional, and intellectual changes that produced our current fine arts system. Larry Shiner, in *The Invention of Art*, fixes the last stage at about 1830, when "the term 'art' began to signify an autonomous spiritual domain, the artistic vocation was sanctified, and the concept of the aesthetic began to replace taste." This notion of a higher realm of expressive life can be traced to Immanuel Kant, through Matthew Arnold, and forward to the early critics who began to separate art from mere entertainment. Classical music was part of the scene as mid-nineteenth-century ideas of "fine art" and "fine artists" were just taking hold, but, as we have seen, classical performances were then presented side by side with what today would be viewed as popular culture, with venues and audiences indistinguishable from those associated with prize fights or fiddle contests. It was in Boston where, as Paul DiMaggio tells us, the long-term marriage between classical music and social elites was consummated and classical music was pulled away from its "popular" fellow travelers.

Joseph Horowitz, in his expansive history *Classical Music in America*, also cites Boston as the place where our modern understanding of classical music and the symphony orchestra came together. For Horowitz, it was Boston music critic John Sullivan Dwight who created the symphony orchestra as a showcase for Old World compositions by conflating the classics with sacred music. For Dwight, "real music was religion itself." Horowitz quotes Dwight in a passage that conforms exactly to Lawrence Levine's description of late-nineteenth-century fine art as transcendent, the work of genius: "I hazard the assertion, that *music is all sacred;* that music in its essence, in its purity, when it flows from the genuine fount of art in the composer's soul, when it is the inspiration of his genius, and not a manufactured imitation. . . . To me music stands for the highest outward symbol of what is most deep and holy." This kind of rhetoric still infuses writing about the meaning and value of fine art and artists. In

Shakespeare: The Invention of the Human, Harold Bloom first observes that many have compared the importance of Shakespeare to that of the Bible: "Shakespeare's works have been termed the secular Scripture." But Bloom embraces a more naturalistic but no less far-reaching metaphor: "He is a system of northern lights, an aurora borealis visible where most of us will never go. Libraries and playhouses cannot contain him; he has become a spirit or 'spell of light' almost too vast to apprehend."

And in a natural extension of the sacred, lofty character of fine art and classical music, they are "hard"—not readily grasped by the untrained ear or eye. "I have read and taught Shakespeare almost daily for these past twelve years," Bloom laments, "and I am certain that I see him only darkly." But Shakespeare's original role as a purveyor of popular entertainment is well known. Does his elevation into a figure of remote impenetrability really help? Susan Sontag, in "Against Interpretation," thinks not: "[Shakespeare's] appropriation by certain groups and the manner of his presentation in theaters and schools often converted him into an alienating force; a symbol of irrelevant, impractical, pretentious, effete learning."

Julian Johnson, in *Who Needs Classical Music?,* manages to avoid the elitist boilerplate of typical arguments asserting the unique, lofty character of symphonies and orchestras, but he still plays the "challenge card"— the sense that if music is remote, it's good. It's not about "what the work means to me; it is about the meaning the work has *beyond* my immediate response." In short, classical music distinguishes itself by being "different from the everyday world, a world that it transforms rather than reproduces." Some "modern and recent work," Johnson notes, exhibits such a high degree of sophistication that it "prevents [it] from being immediately understood or enjoyed by a general public."

But some fans want it just that way, and these ideas—the notion that classical music, the symphony orchestra, and the fine arts are secular manifestations of sacred artistry and that classical music is both lofty and difficult—played perfectly to the desire of financial elites to distinguish themselves from the masses, by assembling what Ross skewers as "a cult of mediocre elitism that tries to manufacture self-esteem by clutching at empty formulas of intellectual superiority." For members of the classical music set, popular art merely references everyday reality; it can be

understood without special training or knowledge and is for the most part disposable and of little lasting value. It then follows logically that classical music exists for the few who understand.

If the emergence of cultural industries in the early twentieth century helped our arts scene develop an atmosphere of artistic acceptance and cultural diversity, classical music took on the mantle of the exception that proved the rule, retreating from the mainstream into a backwater of exceptionalism and exclusivity. Ross imagines this depressing entry in the journal of a first-time symphony-goer:

> It is not a very heroic experience. I feel dispirited from the moment I walk in the hall. My black jeans draw disapproving glances from men who seem to be modeling the Johnny Carson collection. I look around dubiously at the twenty shades of beige in which the hall is decorated. The music starts, but I find it hard to think of Beethoven's detestation of all tyranny over the human mind when the man next to me is a dead ringer for my dentist. The assassination sequence in the first movement is less exciting when the musicians have no emotion on their faces. I cough; a thin man, reading a dog-eared score, glares at me. When the movement is about a minute from ending, an ancient woman creeps slowly up the aisle, a look of enormous dissatisfaction on her face, followed at a few paces by a blank-faced husband.

We've all been there, and with a moment's thought we can imagine an equally numbing visit to the ballet or the art museum "blockbuster" exhibition. The intellectual construct that elevates the symphony orchestra and many of our fine arts contains an inherent, guilt-inducing conflict: "On the one hand [classical music] is presented as one of the greatest achievements of the Western mind, but on the other it may betray its origins in social privilege and exclusion." Despite this destabilizing contradiction, unshakable confidence that the symphony orchestra preserves music blessed with a unique spiritual and intellectual value has been sufficiently strong and widespread to enable nonprofit organizations to stake a decades-long moral claim to the resources of the caring community—philanthropists, foundations, and government agencies.

So it's not about whether or not classical music is "dying." Today there's plenty of fine art out there—unfortunately, much of it relegated to

the "theme park of the past." Writing in the *New York Times*, Edward Rothstein describes classical music as "a dying tradition," lamenting, "What has changed is not how much the tradition means to its devotees, but how little it means to everyone else. From being the center of cultural aspiration, art music has become almost quaintly marginal." As NPR reported on *All Things Considered*, symphony attendance dropped by 10 percent between 1993 and 2003; that year 73 percent of orchestras reported deficits. The number of commercial classical radio stations decreased by one-third between 1998 and 2005. On public radio classical music is being squeezed out by news and talk.

Some observers still don't see a problem. Allan Kozinn, writing in the *New York Times* in spring 2006, interprets the surfeit of classical music in the contemporary scene as the sign of a new "golden age," in the process dismissing those "classical music partisans furrowing their brows and debating what went wrong, what can still go wrong and whether it's too late to save this once-exalted industry." Kozinn ignores the loss of classical music on mainstream radio and the absence of major-label record deals for U.S. orchestras. Instead, relying on encouraging iTunes classical download numbers, the presence of classical stations on Internet radio, and the variety of recordings offered by boutique classical record labels, Kozinn concludes that things are not really so bad.

He has a point. The total quantity of available classical music is greater than a few decades ago; perhaps there's more available than ever. In fact, as I argue later in this volume, there may be *too much* fine art; our nonprofit cultural sector may have outgrown its natural base of support. But Kozinn acknowledges that the exposure on mainstream radio and television and in movies enjoyed by classical music has disappeared and that few classical performers possess the name recognition of reigning stars from the first two-thirds of the twentieth century—from "Toscanini to Bernstein, from Heifetz to Stern, from Horowitz to Van Cliburn." And, while seasons have expanded, Kozinn admits that audiences "want their repertory dials set at 1785 and 1920." So quantity is not the problem; perception is. We've got more classical music than ever, but it doesn't mean as much, it's not in the mainstream of expressive life, as it was half a century ago. Of course, Sontag hit the nail on the head; there's plenty of fine

art, but too much of it has been reshaped by its advocates into an "alienating force." It's not that we don't have great painters and musicians; it's just that the contemporary equivalents of Leonard Bernstein, Jackson Pollock, Van Cliburn, and Alexander Calder can't get arrested in *People* magazine. We may not let the art of Native Americans or Islam in the choir, but our fine arts have been made so *special* that no one cares.

Of course, there's nothing all that unusual about different sectors of society raising money for their favorite nonprofit purposes, even if the services that result aren't there for everyone. As Johnson points out, societies fund all kinds of activities that don't directly connect with the lives of every citizen: "If funding of public institutions and services were left to voluntary individual contributions, few would survive." The problem, of course, is that unlike a standing army or a high-functioning transportation system, classical music and symphony orchestras are critical priorities for a pretty small group of people. In part for that reason, the case for philanthropic or public support for fine arts has never been made in terms of demand but rather by talking about the importance of increased supply—the intrinsic value of access to a higher art, or access to art that is better for you than what you consume on the radio, on television, or in popular fiction. In recent years the need for an increased supply of the fine arts has been justified by invoking secondary effects like economic development or the growth of a "creative economy." Today, when orchestras and museums actually try to increase demand, they don't build on the character of fine art but instead invoke what economists call "externalities," offering the allure of status, of course, but also marketing everything from "singles nights" to pops concerts to day care with entertainment attached.

So Kozinn and Rothstein are both right. There's plenty of classical music out there, but its production by orchestras with salary and labor troubles and its distribution on the Internet or by boutique, low-budget record labels suggest that it can be *available* without being healthy. And, in a sense, Kozinn "buried the lede." The real story is not that clever entrepreneurs have found ways to keep the quantity of classical music growing by employing innovative strategies to serve a niche market but that classical music has almost entirely lost its hold on the imagination

of the larger American public; it's become "alienating"—art with a capital *A*.

When my grandmother got up into her eighties and was a little bit "hoo-hoo," as my mother used to say, she'd end almost every story by repeating, "Well, Billy, you can't be first and last." For years I didn't think much about the phrase; just something peculiar that tagged all of Grandma's stories. But I came to realize she was saying something profound.

For her, it meant, "You can't be young and old at the same time; you can't bundle together the energy and innocence of youth and the wisdom and serenity of old age." You can't, in other words, be two opposite things at the same time. Classical music has tried to be two things at the same time, and it has taken itself out of the cultural mainstream. First, it claims to be unique, challenging, and accessible only to those willing to study and reflect; in that role it is the willing hostage of social elites drawn to black-tie opening nights. But at the same time it claims universal value; it is the music everyone *should* listen to—just a little more money and a few outreach programs directed to inner-city schools, and the world will beat a path to symphony hall. And in the guise of an art form with universal appeal, classical music has assumed an ongoing claim on the philanthropic dollar, public and private. So classical music, the symphony orchestra, presses on; "the shark," as Kozinn puts it, "is still moving." But it moves on autopilot, far beyond the source of consensus support that it needs to sustain current levels of intensity.

.

So the real bottom-line problem isn't that classical music will disappear but rather that it has lost its place among the multitude of artistic traditions that in combination give Americans our rich expressive life. Beyond survival, isn't it a question of how classical music can work its way back into America's cultural mainstream? How do we again make classical music what British event producer Andrew Missingham describes as "my music: the magical stuff that I spent every waking hour glued to the radio to seek out, and saving my pocket money for." Education isn't really the answer. First, American arts education "is what it is"—a training

ground for budding specialists honing their skills in band and chorus programs. Believe me, we don't have a problem with the supply of great classical musicians. Second, just learning about classical music doesn't mean you'll come to enjoy it. As critic Bernard Holland put it, there is a suspect "contract" at work in the part of music education that targets appreciation: "It states that if I understand a piece of music, I'm likely to like it, too. This is not true. No amount of experience and analysis can by itself induce the stab of communication between art and its beholder." Further, Holland continues, music appreciation holds a danger for classical music. "If we put it in the wrong hands with the wrong motives, we end up with a superior class charged with remedying the illiteracy of the unwashed."

He's right; most music appreciation proceeds this way. In fact, it not only hopes to remedy the assumed illiteracy of the "unwashed" but also aims to simultaneously disabuse them of "base" attachments; listen to the symphony long enough, and you'll give up all those hip-hop CDs. But classical audiences are gray for a reason. Young people use music as an avenue to communication and identity; classical music simply does not fill that need. As Holland makes clear, education and knowledge do not produce love and respect.

So what is the way back in?

In mid-August 2006 radio host Don Imus, very much in character, complained on the air for three consecutive mornings, threatening to force newsman Charles McCord to present his on-air piano recital on the everyday Yamaha piano in MSNBC's Secaucus, New Jersey, studios. A midlevel Steinway staffer had made the mistake of quoting list-price rental and cartage fees to the Imus program, producing a low-key but relentless whine from the popular on-air host. The company gave in, apparently waiving fees to deliver a top-of-the-line nine-foot grand to the set of the *Imus in the Morning* show. McCord, newscaster and sometime Imus straight man, is a dedicated amateur pianist, and the show had been promoting his upcoming classical performance for weeks.

Imus in the Morning, broadcast on network radio and the MSNBC television network, was one of the most successful drive-time radio shows in the country. In April 2007 it was abruptly dropped by MSNBC and CBS

radio when racist and sexist comments by Imus generated massive media, Internet, and advertiser outrage (an example of censorship by market-driven punditry worthy of a separate volume). But despite its tendency to overstep accepted boundaries of on-air language and opinion, the Imus show was a last bastion of personality-driven variety programming—a genre that had exited the networks by the end of the twentieth century. The production mixed hard news; phone-in interviews with politicians, pundits, and sports figures; live and recorded music; and comedic send-ups based on real-life characters like Jerry Falwell, Bill Clinton, Dr. Phil, and Brian Wilson (of Beach Boys fame), the whole conducted by the curmudgeonly but vaguely lovable persona of veteran radio personality Don Imus. It was a variety show every bit as exemplary of our cultural commons as earlier programs starring Ed Sullivan or Dick Cavett.

When the Imus show featured live performers, they were generally drawn from what could be termed "grassroots" music—country artists like Dwight Yoakam or Hank Williams Jr.; blues singers like Delbert McClinton; pop stylists like Aaron Neville—artists high in credibility but whose careers landed just short of superstardom. Classical music was not standard fare. But suddenly, there it was: Charles McCord at the Steinway, a tiny audience of production staff seated near the piano in folding chairs, and a small chandelier suspended over the piano in acknowledgment of classical music's links to high-class living.

The newscaster had chosen Chopin's Fantasy Impromptu in C-sharp Minor, Opus 66—a popular and challenging piece not for the beginner or the faint of heart. Although saddled with a case of starting-gate nerves, McCord's performance was solid; it was recorded and replayed a number of times later in the show.

The striking fact, of course, is just how scarce classical performances in mainstream settings like this are today. There exist few opportunities to acknowledge the special, complex character of the Western art music tradition, and it's especially rare to find classical music mixed in with comedy and popular music. In the old days, when our cultural commons was dominated by a few outlets, *The Ed Sullivan Show* often delivered classical music by sandwiching the latest violin prodigy between a stand-up

comic and the guy who could run around a table keeping eight plates spinning on sticks at the same time. In its ten thousand performances over a twenty-three-year run, the Sullivan show gave us Topo Gigio, the ten-inch foam rubber Italian mouse puppet, but it also introduced us to ballerina Margot Fonteyn (1958), to Fonteyn and Nureyev (1965), and to Richard Burton and Julie Andrews in the Broadway hit *Camelot* (1960). Roberta Peters made forty-one appearances on the show, to say nothing of the Beatles, the Rolling Stones, Elvis Presley, the Doors, and Marvin Gaye.

But in this century, with Ed Sullivan's artistic commons a distant memory, it was refreshing to hear, and see, classical music presented on *Imus in the Morning* on network television, albeit a cable network with nowhere near the reach of CBS television in the 1960s. In addition, the performance was presented by a "regular citizen" blessed with a rich expressive life—a talented amateur musician, Charles McCord, who inserted Chopin into a news, comedy, and popular music program broadcast to a morning-drive listening audience all over the country.

The Imus show is an illustration of what classical music needs: a path back to an appropriate position in the U.S. arts mainstream. To get there, supporters and classical music institutions must first confront the dysfunctional combination of arrogance and entitlement that has caused the fine arts to drift from the popular moorings essential in the arts scene of a diverse democracy. Then Western art music can begin to forge the alliances that can make it part of our national musical conversation.

A century ago our cultural industries overturned existing musical hierarchies, and a rich mixture of blues, jazz, hillbilly, polka, bluegrass, Broadway, western swing, and klezmer entered the mainstream to enrich our cultural commons. But classical music headed in the opposite direction, pretending that American art could still be stacked up totem-pole fashion—like Esa-Pekka Salonen's "endless lists"—with the world of music organized in a pyramid: the symphony orchestra at the top, Cleveland polka bands anchoring the bottom, and everything from country to rock and jazz stacked somewhere in between. Once classical music bundled up its money, its high-society pedigree, and its smug sense of self-worth to occupy a perch high above mass culture, the unsurprising

result was that the music, its stars, and its institutions floated out of the popular imagination.

And landed us where we are today.

Sure, plenty of classical music gets made, but, as even insiders acknowledge, nobody seems to care.

So the toxic cocktail of exceptionalism and entitlement must be confronted head-on, twelve-step-program style. Classical music is hard? Sure it is, but so is blues. Every art form has its own internal aesthetic standards, and learning the ins and outs of jazz, rap, or bluegrass in order to figure out what's excellent and what's just everyday dross is taxing. It takes an investment of time to acquire the knowledge necessary to make reasonable qualitative judgments. Although an understanding of classical music requires discipline and study, there exist art forms whose traditions, practices, and aesthetic standards are even more daunting. Think about the challenge of really mastering any aesthetic tradition grounded in a culture that exhibits traits markedly different from our own. Folklorist Henry Glassie accomplished this kind of cross-cultural artistic engagement in his massive study of Turkish traditional art, but to do so he moved to Turkey, learned a new language, and lived among rug makers for years to gain an understanding of a unique art form.

It's time for classical music to see itself not as the one and only but as one among many. Once we can honestly say, "Every American needs to understand classical music because it's as important as rock 'n' roll, jazz, and blues," the symphony will be on its way back to the mainstream.

Cost is part of the problem. As the nonprofit arts sector has expanded beyond the funding capacity of philanthropic revenue streams, organizations have placed new emphasis on earned income. As a result, price increases in the fine arts have grown faster than in other sectors of the economy. In 1966 the average ticket to a Lyric Opera of Chicago performance was $12; in 2005 it was $170. You could hear the Chicago Symphony for $6.50 in 1966; the same ticket cost $110 in 2005. Sure, simple inflation is a factor, but rooms in Chicago's Palmer House Hilton went for $28 in 1966; rates had increased to $199 a night by 2005. Punch a few numbers into your calculator, and it'll be clear that the percentage of increase in the cost of live classical music has outstripped inflation and the cost of other

services. But, remember, consumers *will* pay a premium price for something they really want to see; the average price of a ticket to the 2006 Barbra Streisand tour approached $300.

In addition, classical music needs to look at models where cultural outreach has really been effective. NASCAR, for example, has worked consciously and successfully to make women and young people part of the audience for modern-day stock car racing—historically a sport of young to middle-aged men. The racing organization was a partner in the hit Will Ferrell film *Talladega Nights: The Ballad of Ricky Bobby,* and early in 2006 NASCAR signed an agreement with Harlequin, cooperating in the publication of romance novels based on racing themes. NASCAR promotions might be a "bridge too far" for the classical music world (think tuxedos adorned with STP stickers), but a return to the kind of production spectaculars that characterized classical music in the early nineteenth century might go a long way toward reconnecting the music with the mainstream. A white-maned maestro is surely as worthy a hero of a "bodice ripper" as is a Saturday afternoon NASCAR idol.

Remember, John Sullivan Dwight gave us the vision of classical music as a kind of secular religion, locked away in a concert-hall temple; that vision remains in the DNA of America's classical music community. But there was always an alternative; it was Dwight's Boston counterpart, conductor and promoter Patrick Gilmore, who saw the classics not as sublime offerings from on high but as vehicles for what were then, quite literally, mass entertainments. Gilmore's Peace Jubilee, held in Boston in 1869, featured 1,000 instrumentalists and 10,000 singers, performing beneath giant portraits of Handel and Beethoven hung from rafters festooned with flags and banners. This was classical music in the NASCAR mode, a real *event* mixing patriotism and music against a backdrop of show-biz excess. Gilmore's extravaganzas were too much for Boston; it was Dwight's conservative vision of classical performance that ultimately prevailed. But perhaps, in the long run, it was classical music's loss that attitudes derived from decorous necessity in Puritan New England managed to secure a grip on an entire art form, setting standards in the presentation of art music that would last two centuries. Let's think again about classical music as show business: not only by firing a real cannon

at the climax of the 1812 Overture, but seriously revisiting, for example, those Bernstein Young People's Concerts from the 1960s. Let's see what made them work.

Why does it matter that classical music has drifted away from public consciousness? Why not let classical music bump along, selling online downloads to aficionados or placing boutique CD releases in the back bins of whatever retail outlets inherit the dregs of Tower Records' business?

The answer is simple: our expressive life is diminished if we cannot connect with the experience only classical music can provide. It is not important because it is the "greatest music to which all should aspire"—such arguments and their underlying attitudes are ultimately alienating and marginalizing. Instead, classical music today provides an alternative to the steady background roar that characterizes modern media and entertainment.

And there's a need for something different.

Julian Johnson accurately observes, "A contemplative mode of being is essentially being denied our generation. We have unprecedented freedom, but we are often overwhelmed by the sheer number of possibilities, mesmerized like deer in the headlights." This is the way almost everyone I know places classical music in our expressive lives: it is the space reserved for contemplation, where things stay the same, where it is worthwhile to think in depth about what we are hearing. Johnson feels that "the most important cultural choice we face today is between distraction and contemplation." All art can be analyzed, traditions and practices laid out, performances, manuscripts, and photographs assessed. Everything from finger painting to an artful tennis serve has been studied, but it is fair to say that classical music is unique in the power of its invitation to contemplation.

The notion of classical music as an essential complement to expressive lives dominated by culture intended to distract is a more modest claim than classical music exceptionalists would advance. But it's an argument that can work. It claims simply that Americans have a right to engage the great artistic traditions of Europe and that classical music, one of many forms that can augment our expressive lives, has special attributes that

encourage deep contemplation, a state more difficult to achieve in rock, blues, or hip-hop.

Americans live within the biggest art market in the world, but the gate-keeping system that defines that market does a poor job of letting important but exotic art and art forms in. A. O. Scott, writing in the *New York Times*, notes the lack of foreign films in U.S. distribution: "These days, the cosmopolitanism of international filmmaking is matched by the parochialism of American film culture." Scott isn't arguing that a subtitled Romanian movie should shove aside the latest multiplex blockbuster but that the "adventurous, intellectually curious" moviegoer has fallen away. As we will see, our arts companies today fail in their responsibility to stock our cultural commons with meaningful choice. Today it is doubtful that an Academy Award winner like *Black Orpheus* would play a one-screen small-town theater. A rich expressive life needs something other than more of the same, but real variety can only be achieved if we find ways to push back against the homogenizing influences of consolidation, research, and de facto censorship.

Like foreign films and the traditional art of non-Western societies, classical music, and much fine art, isn't in the mainstream but for very different reasons. There's plenty of classical music in plush downtown arts centers, online, and in the catalogs of record companies, big and small. But by claiming to be the best and by yoking its fortunes to the social aspirations of financial elites, classical music has given up its all-American right to stand proudly beside jazz, country, and dozens of other art forms to maintain its rightful value in expressive life. For Alex Ross, classical music must embrace the "shuffle—the setting on the iPod that skips randomly from one track to another." In short, classical music and the symphony orchestra will succeed by backing down from Olympian heights to enter the rough-and-tumble of America's art gumbo.

There are encouraging signs. A few distinguished artists are working to bring classical music down off the pedestal to mix it up with the vernacular mainstream. Anthony Tommasini, writing in the *New York Times* in spring 2007, encouraged the New York Philharmonic to "Be Bold" in selecting a new musical director. Tommasini cites the example of the Los Angeles Philharmonic's Esa-Pekka Salonen as a model, noting that he

"turned the orchestra into an athletic, urban, scrappy but always spirited ensemble." The LA Philharmonic is "adventurous and inviting," and attractive to new listeners, a standing achieved, in part, by bypassing the "Old World attitude" that honored a "sacred responsibility to maintain the timeless Germanic masterpieces." In time we will know if forty-year-old Alan Gilbert, selected as the New York Philharmonic's new musical director in spring 2007, will fulfill Tommasini's expectations.

Composer-bassist Edgar Meyer is an artist who moves easily among classical, country, and pop repertories; Yo-Yo Ma has grounded his recent work in folk traditions and cultural history; and cellist Matt Haimovitz has toured the rock club circuit. But artists are always willing to experiment; exceptions still prove the rule. The problem is not artists, the system, or money, or even access to fine work. Instead, the fault is in classical music itself and the entrenched inability of key institutions and leaders to come down off the mountain to scuffle in the arena of mainstream music making. Only by honestly configuring a new connection with art, American style, will the European tradition recover the stature that has seeped away over the past half century.

There exist some hints that times may be changing at the top. In 2006 the thousand-member American Symphony Orchestra League (now the League of American Orchestras) began a planning process designed to rethink the ways orchestras relate to communities and consider new business models that could reshape connections between symphony artistry and artists. A draft of a new strategic plan argued, "Orchestras are now recognizing that they must connect more closely to their communities and redefine their value as civic institutions." Under the leadership of veteran orchestra manager Henry Fogel, the league appears committed to policies that can give the symphony new life in the U.S. arts mainstream.

Will a more open and adventurous classical music community be rewarded with support from a new audience? The evidence is mixed. The Intelligence Group, the research arm of Creative Artists Agency—the powerhouse LA-based agency that represents, actors, directors, musicians, and authors—has studied and profiled young consumers of music: generations X and Y. Taken together, generations X and Y encompass

young people from fourteen to forty years of age, a cohort distinct from the graying audiences that populate classical music performances. For this group, listening to music is the number one leisure activity, occupying nearly twenty hours a week. In addition, young audiences are busy and actively seek opportunities to "turn off"; music is therapy, an arena of expression, a "badge of cool," a way of connecting with friends: the "soundtrack of life." And young audiences are open to diverse forms of music, actually favoring eclectic, unconventional collaborations merging artists and art forms.

So far so good. A commitment to music combined with a willingness to take in diverse styles suggests that classical music can nurture a young audience, and the desire of generations X and Y to find respite from the noise and pressures of contemporary life can be satisfied by classical music's contemplative character. But young listeners want to consume music on their terms: "IWWIWW+HIWI" (I want what I want when and how I want it) is scarcely a formula for increased attendance at Saturday night symphony concerts. Also, young audiences want to be *engaged* in the music they consume—they want backstage access and close contact with artists. Historically, classical music has offered few opportunities for this kind of audience engagement. The bottom line: America's youth is passionately involved in music, but the classical community will have to work hard to carve out and maintain a competitive place in an environment in which choice, creative participation, and collaboration are markers of appealing products.

We have a right to great art from the past and from around the world. It is important to society that citizens have the opportunity to engage different cultural traditions that have lasting value. Today art that, at first glance, seems alien has far too difficult a time getting in. The "asset piece" of our expressive life—our cultural stock portfolio—will remain vibrant only if art and artistry from the outside can enrich our inventory of creativity. On the one hand, foreign films, plays, translated fiction, and even performing artists and scholars have difficulty moving in the U.S. arts system; access for art and artists from other places has not improved. Classical music, simultaneously remote and close at hand, constitutes an important metaphor for the role of great artistic traditions in everyday

expressive life. If the symphony orchestra can reconfigure itself to match the demands of generations X and Y, classical music will obtain an appropriate place within the mix of American art forms, proving that the great traditions of the world can flourish in the democratic diversity of U.S. culture.

SIX Strong, Responsible Institutions

The right to healthy arts enterprises that can take risks and invest in innovation while serving communities and the public interest.

Back when I was chairman of the NEA, I made a point of handing a dollar to every street entertainer I passed. "It's my job," I'd half-joke with friends. "I'm the head of the U.S. agency that makes grants in the arts; this is the least I can do." In the late 1990s Washington, DC, harbored a number of outdoor musicians who appeared in the same spots, day after day. There was the trumpet player near the Metro stop across from the World Bank who somehow managed soulful solos during the bleary-eyed morning commute of White House staffers. Every weekend, in my Georgetown neighborhood, a tenor sax player, offering "My One and Only Love" in imitation of John Coltrane, planted himself firmly on the pedestrian-packed northeast corner of Wisconsin Avenue and M Street. My personal favorite could be found a few blocks farther east, just inside the entrance to the Georgetown Square shopping area. He played the steel drum and

apparently knew only an incomplete version of one song, the calypso standard "Yellow Bird." Somehow he had managed to skip the obvious first step, learning the bridge to the tune without ever mastering the verse; rather than play the first section, which begins, "Yellow bird, up high in banana tree," he played the "B" section over and over.

> Did your lady friend,
> leave the nest again?
> That is very sad,
> make me feel so bad.
> You can fly away,
> in the sky away.
> You're more lucky than me.

Facing a half-of-one-song repertory, I never lingered, just dropped a buck in the cardboard box out on the sidewalk and quickly moved on. But because the one-tune player always took shelter in a resonant side alley, his steel drum and the mechanically repeated chorus to "Yellow Bird" could be heard up and down M Street three or four nights a week, the melody carrying especially well in the cold night air of Georgetown's Christmas shopping season.

When I returned to my old neighborhood a couple of years ago, I learned to my dismay that stricter enforcement of an antinoise ordinance had pretty much moved live music off the streets: no saxophone at Wisconsin and M; no "Yellow Bird" at the entrance to Georgetown Square. On that brisk February afternoon I encountered only Bernard Aljaleel, who was set up on the corner across the street from the Pottery Barn, pounding away on an elaborate drum set assembled from downside-up plastic paint and trash cans. He had attracted an admiring crowd, and money was dropping into a hat at a good clip, but just seconds after I snapped Bernard's photograph a polite but firm DC policeman had him rolling his stacked-up drum kit down Thirty-first to the parking lot beside the Potomac.

My modest program of personal support for street entertainers never strained my pocketbook; it never cost more than $5 or $6, even on a stroll up Manhattan's Madison or Lexington Avenue. For, despite encounters

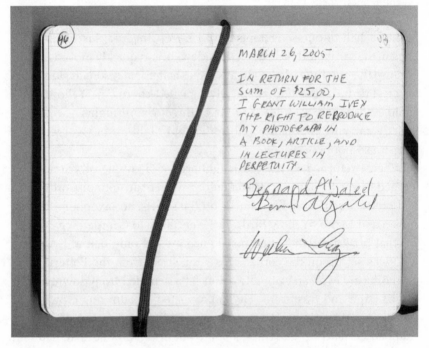

MARCH 26, 2005

IN RETURN FOR THE
SUM OF $25.00,
I GRANT WILLIAM IVEY
THE RIGHT TO REPRODUCE
MY PHOTOGRAPH IN
A BOOK, ARTICLE, AND
IN LECTURES IN
PERPETUITY.

Bernard Aljaleel

Drummer Bernard Aljaleel, an artist in an up-close-and-personal setting ready to bang away for donations on a Georgetown side street. He was shooed away by police minutes after this photo was taken. (Photo: collection of the author.)

My improvised agreement with Bernard. I could probably have published his photograph without permission, but a $25 payment for the use of his name and likeness kept me on the safe side, and made his short, ordinance-constrained performance on the sidewalk worthwhile.

with violinists in the subway, or the photographers and painters who used to hawk their wares on Fifty-third Street next to New York City's then unexpanded Museum of Modern Art, or the mimes, jugglers, and Human Jukebox who enliven sunny afternoons on San Francisco's Pier 57, face-to-face financial transactions between artists and consumers of art are rare in the American cultural system. There is almost always an array of intermediaries separating artists from those of us who engage art for enlightenment and pleasure. Some of these institutions, like concert halls, theaters, and art galleries, have been with us for centuries, but others have come along only in the past hundred years or so, when new technologies made it feasible to build new kinds of companies around the exploitation of arts products.

Art doesn't find its way to audiences by itself. The gatekeepers—our arts companies—are absolutely essential to creativity and artistry. In a revealing experiment, *Washington Post* writer Gene Weingarten convinced violinist Joshua Bell to perform at Washington's L'Enfant Plaza Metro stop during morning rush hour. The result was a long, hilarious *Post* article that, among other things, offered compelling evidence that artistry doesn't speak for itself. Bell performed six classical pieces over forty-three minutes and was passed by 1,097 commuters. Seven people stopped to listen to the performance, and 27 gave money, "most of them on the run." Bell is a true classical music superstar, but without a concert stage, the support of record label publicity or reviews of a performance with a non-profit orchestra, it's obvious that even his artistry doesn't break through. Creativity needs collaborators capable of advancing talent in the media and the marketplace.

Today we not only depend on film studios, record companies, and radio and TV broadcasters to finance the development of arts products; we also rely on wholesale and retail businesses to bring CDs, movies, TV programs, books, and DVDs into nearby stores and theaters or even directly into our living rooms. Artists may be the creators, but American businesses are sometimes the nurturers and almost always the gatekeepers who decide what art and artists can move ahead in the U.S. arts system. We like to believe that the nature of art that gets through these gates is determined only by artistic vision and talent, but in fact it's more often forces acting within the world of cultural enterprise that ultimately

determine what finds its way to consumers. We are deeply dependent on these intermediaries, and as arts companies have increasingly been bundled into multinational corporations, key decisions shaping the arts system are realigned in accordance with shareholder and management values that have nothing at all to do with art.

The basic building blocks of our arts industries were in place one hundred years ago. It would have been easy then for our federal government to enact all manner of special rules designed to ensure that culture served the public; the fledgling industry was too weak to resist. Instead, from their formation in the early twentieth century, America's arts industries have enjoyed an open playing field. With the exception of light-touch FCC media regulation and copyright (which in practice is not really "regulation" but something more like an expandable license), the character of our expressive life has mostly been determined not by public policy but by its absence, and by the unedited practices of corporations. A vibrant cultural scene is a public good; if access to heritage, a coherent cultural message abroad, art and artistry in the lives of citizens, and a productive, engaged community of artists are important to the health of our democracy, we have the right to expect that arts companies—like oil companies and airlines—will integrate the public interest as a component of corporate policy. Absent a government hand on the tiller, we must trust leadership in the private sector to take the risks required to bring artistry to the marketplace, to preserve heritage, and to make certain that the gates of manufacturing and distribution will be sufficiently open to ensure that the artistic choices available to consumers reflect the breadth and depth of America's expressive life. Every day the business sections of national newspapers feature stories of media consolidation, mergers, and acquisitions. And the arts or entertainment sections of the same papers detail efforts to strengthen the programming and the finances of nonprofit cultural organizations. How well do the companies that finance, present, and distribute America's cultural products serve artists and consumers? Do they nurture what is best, and are the gates of distribution open enough to allow artistry and invention—even the best of the kind of art you might buy for a buck or two on a Washington street corner—to find its way to audiences?

Sound recordings, movies, and broadcasting were born as commercial enterprises, and despite the communal value of arts products, cultural corporations have been free to behave like any other actors in U.S. business—working to increase profits, control expenses, maximize return on investment, and deliver quarterly profits, enhancing shareholder value. With the exception of broadcasters, U.S. arts industries have never been subject to special regulations simply because their stock in trade was our nation's heritage and creativity. So it's no surprise that over the past twenty-five years business innovation in our arts system has mimicked trends in other sectors, seeking expanded profitability and business efficiencies by increasing the size of cultural companies. Legislation and regulations targeting cultural industries have been generally defined not by public purposes but by competing interests—unions versus corporations, creators versus distributors, and so on.

In movies and the record business, growth has been achieved by combining existing companies through mergers and acquisitions; in broadcasting and book publishing, the same result has been achieved by scooping up many independent companies to form consolidated networks and chains of radio and TV stations and giant publishing conglomerates. But does conventional wisdom about merged companies and business "synergies" apply to arts companies? Can a multinational conglomerate accommodate the public interest value—the cultural rights—inherent in any cultural system? Can we live with the fact that the public interest has no voice in making the rules? Do U.S. nonprofits offer a better way?

.

During the 1940s Dave Dexter had a brilliant idea. An executive with Capitol Records—then a modest, West Coast startup in an era when any company worth its salt was headquartered in New York—Dexter surmised that records distributed free to influential radio stations might give his artists a leg up in popularizing Capitol releases. His idea was radical, but he went ahead and ordered the pressing plant to produce a couple hundred 78s of a new Capitol release with plain white labels; he and a few associates stayed up all night personally inscribing each disc with such messages as "To John Jones, KSRP; hope you like the new single," addressing

whichever disc jockey might appreciate the attention and in return decide to give the potential hit a spin. Dexter's scheme worked, and today the distribution of free music to radio is the most taken-for-granted component of the record industry's business model—stimulating sales by first generating radio hits. But what is commonplace today was a radical departure from standard record company policy established during the 1930s. In fact, back then radio was the enemy. Beginning in the late 1920s free music over the airwaves pulled the rug out from under the startup U.S. record business; between 1926 and 1936 record sales declined by more than 50 percent. In a scenario remarkably similar to our modern-day digital revolution, the record industry struggled during the darkest years of the Great Depression to overcome the impact of broadcasting—like today's music downloads, a perceived alternative to a record purchase. Gradually, by making special deals with retailers like Sears and F. W. Woolworth, by promoting big-band jazz and other new pop music forms, and through innovative technology like the obvious but then revolutionary radio/phonograph, the record industry recovered.

So throughout the 1930s it was conventional wisdom that radio was little more than a drain on record-industry earnings and that music on radio should either be performed "live" or, if prerecorded, acquired from special services producing radio transcriptions. In fact, 78s of the era generally included label copy that indicated records were for "home entertainment only," specifically prohibiting radio broadcast. Capitol Records' innovation helped establish the company as the first major West Coast record label and, more important, set the terms of an informal but crucial alliance of two disparate industries, music and broadcasting, that extends to the present day.

But modern-day radio is a far cry from the decentralized, mom-and-pop business that Dexter courted with free discs more than sixty years ago. As Lon Helton, former editor for *Radio and Records*, a music industry trade publication, points out, "Radio is in the business of renting ears to advertisers." Notoriously research driven, twenty-first-century radio fine-tunes the content of every minute of airtime, not to draw listeners in, but to prevent them from tuning out, keeping their ears in place past the quarter-hour markers that determine Arbitron ratings. The "ratings

books," published four times each year and distributed free to agencies and other advertising buyers, rank stations in quarter-hour segments during every time period according to both total audience and the station's share of radios that are actually turned on. Stations live and die by the ratings. For most stations, a decline of even a fraction of an Arbitron rating point can cut ad revenue significantly, turning black ink bright red. Indeed, over the past two decades many stations have changed hands in multimillion-dollar deals sustained by substantial debt.

So nothing can be left to artistic chance. Today stations test audience response to every record that is, or might be, played on the air. Researchers call listeners, playing song snippets to willing subjects. Sometimes stations rent theaters and play portions (generally, the first fifteen seconds!) of hundreds of songs for a live audience in order to determine what fans want to hear. Over the years, radio has learned lessons that dictate the content of modern broadcasting: familiarity, repetition, and content that doesn't generate an intense reaction—positive or negative— characterize music that does the best job of preventing listeners from turning to another station. Radio thus gravitates toward familiar-sounding material presented by recognized recording artists, rarely selecting more than about twenty cuts for concentrated, repeated airing— what's called "heavy rotation."

In the 1940s Dave Dexter mailed his innovative white-label Capitol releases to a music-savvy disc jockey who would get behind a favorite record and play it on a creative whim, spinning a selection until other stations caught on and the performance became a hit. Such independent on-air personalities no longer exist. Today in the high-stakes art of programming radio, science has trumped experience and instinct.

In addition to shifting away from disc jockeys toward research-minded music directors as the gatekeepers determining what music will be played on the radio, ownership of stations has become concentrated in fewer hands, especially since passage of the Telecommunications Act of 1996. For the membership of the National Association of Broadcasters, which had long lobbied for its provisions, the new telecom act opened the door to reconfiguring regulations that had limited the number of stations that could be owned by a single company. The new law benefited

consolidated broadcasting by making it easy to sell special advertising packages that could, in a single buy, target a region or a national audience of a specific age and gender. In addition, programming decisions could be organized around centralized corporate policies. At first glance the new law appeared to enable radio to compete with other media on a more equitable basis. But by 2002 the FCC had received millions of negative responses to the consolidation made possible by the 1996 law, and a broad coalition of music industry organizations also objected, citing "anti-artist, anti-competition, and anti-consumer" practices in the merged radio industry.

The poster child for the excesses of radio consolidation has been Texas-based Clear Channel Communications. In 2005 Clear Channel alone owned just over 1,200 stations, about 10 percent of all licenses in the country, many in the nation's biggest and most lucrative markets. Combining Clear Channel stations with the holdings of its nearest competitor, Viacom (now CBS Corporation), we find the two players reached more than 40 percent of all U.S. listeners. In 2003 alone the company posted more than $1 billion in profits.

For management, consolidated ownership enables a pared-down staff to program multiple stations from a single site, an activity impossible in locally owned stations. The resulting economies of scale are attractive to shareholders, but they tend to produce almost identical playlists for stations that already feature only twenty or so hit records, making the task of getting a new cut on the air more daunting than ever before. In fact, it is increased pressure on record company staffers and consultants working to place records on radio that has triggered the reemergence of 1950s-style "payola"—business practices that have drawn the investigative ire of New York State Attorney General (now Governor) Eliot Spitzer. As a result of payola inquiries, major recording and broadcasting companies have paid significant fines and agreed to air music by independent labels and artists.

The character of nonmusical programming geared to individual communities has also been transformed by the practices of Clear Channel and other multistation chains; not only are playlists researched and assembled in remote central locations, but many stations are "voice-tracked." On-air

personalities who "sound" local actually originate in the studios of a single station and simultaneously air on dozens of outlets around the country. Stories abound of stations that failed to report on traffic or weather emergencies because local-sounding personalities remained oblivious, hundreds of miles away. The challenge faced by record companies trying to access restricted playlists encouraged illegal or unethical promotional practices on the part of record companies desperate for airplay; the same consolidated programming makes it all too easy for broadcasters to engage in a kind of de facto censorship. When the Dixie Chicks criticized President George W. Bush during a London concert, Cumulus Broadcasting, a Clear Channel competitor, famously banned the act from station playlists. Senator Barbara Boxer called the ban "akin to Marxism," and Senator John McCain added, "It's a strong argument about what media concentration has the possibility of doing."

We know that someone is deciding what music gets played on radio, but citizens at least imagine that stations program music to attract the largest possible audiences and ratings. That once was true, but the Clear Channel model has introduced a new approach to deciding what gets played. When the chain owns multiple stations in a single city, station playlists are not assembled to attract the largest or widest audience but instead to target a specific segment of the population. The country station, for example, would likely target female listeners forty and older. Demographic targeting benefits Clear Channel in two ways. First, it enables a single station to offer advertisers—such as cosmetics manufacturers—access to a specific set of preselected customers. Second, it prevents a Clear Channel country station from competing with, say, a Clear Channel rock station targeting males eighteen to twenty-four in the same city. While this technique helps Clear Channel rent very similar sets of ears to eager advertisers, the playlists that draw only one type of listener are inevitably loaded up with records that sound pretty much the same—in the case of a country station aimed at an audience of adult women, positive love songs.

It's easy to see the way programming like this narrows the gates for recording artists and songwriters and narrows choice for listeners. Clear Channel programming tactics are widely known in the record business;

it's in part why so many happy love songs are written and recorded and why consumers think country radio (or radio formats featuring rock or contemporary hits) is boring. The Clear Channel approach flows all the way back to the recording studio and songwriting sessions, dictating what gets written and recorded, in effect shaping the character of the entire creative process.

In spring 2000, in a move that came as a surprise to telecom regulators, Clear Channel purchased SFX Entertainment for more than $4 billion. SFX is one of the largest operators of live entertainment venues in the world (it was SFX owner Robert Sillerman who "purchased" Elvis Presley, a few years back, acquiring the rights to his name and likeness). Clear Channel acquired 120 concert and sports venues as well as America's leading concert promotion business. Less than a year after the sale of SFX, recording artists, record companies, and concert promoters began to complain that Clear Channel was wielding its accumulated influence in live entertainment and radio to suppress competition, control prices, and extort special favors. For example, touring performers charged that Clear Channel insisted on reduced live-performance fees in return for assurances of radio airplay, and independent concert promoters claimed that fears that Clear Channel might deny access to airplay made recording artists reluctant to book live performances with anyone other than a Clear Channel–owned venue or promoter.

Perhaps fearing retribution on radio, representatives of music talent didn't translate their discomfort with Clear Channel business practices into court action or official complaints to regulators. And necessity dictated that record companies as well as performers do their best to work without complaint within the narrowed pathways of a constricted radio and live-performance system. By 2002 Clear Channel dominated live entertainment to an even greater extent than it did radio broadcasting, selling 70 percent of all concert tickets and owning or exclusively booking 135 concert venues. With radio stations in 247 out of 250 U.S. radio markets, the opportunities for both cross promotion and anticompetitive mischief were enormous.

A 2001 lawsuit alleging that Clear Channel had unfairly used its leverage to block a small event company from acquiring primary sponsorship

in a dirt-bike race series around the country was decided in favor of the plaintiffs, an outcome that some hoped would encourage future self-restraint on the part of the media giant. In 2004 Clear Channel reorganized its concert business as a separate corporation, Live Nation. The move may have been dictated in part by the perception that insider deals between radio and live entertainment venues were subverting competition, or, as one manager of an independent venue argued, "They don't know how to make those SFX properties profitable." The degree of ongoing cooperation between Clear Channel and Live Nation is unclear.

In a private conversation, one Clear Channel executive indicated that the company may also begin to sell a few stations in order to "trade up," exchanging two or three underperforming licenses for a single, more valuable channel. The sale of assets hasn't been finalized as of this writing, but it is in the works. Clear Channel agreed to a $19.5 billion buyout offer, which was approved by its shareholders in September 2007; at the same time it is selling more than 400 of its radio stations. Lon Helton asked, "Will these stations be purchased by one of the other big radio companies that exist? Or will we see a return to more local ownership? That's the $64 million question."

Clear Channel didn't invent research-driven programming; by the time the giant company came along, music and audience research and narrow playlists had already made it difficult for new music to find an audience through radio. But by making it easier to make centralized decisions that affected multiple stations, adding a tight focus on a single segment of the population, then folding in schemes to commingle the earning power of broadcasting and live entertainment, the Clear Channel business model has made things worse. For the consumer, there remains little more than the illusion that everything is available. It's definitely not the radio I grew up with, when WHDF in Calumet, Michigan, featured country singer Ramblin' Bob, Lodi Mihelic's polka show, and a daily noontime newscast in Finnish! But because regulators don't assess cultural impact but only look at competition and ownership as indicators of community service, highly merged arts companies like Clear Channel can damage the cultural system without straying from the rules of the road.

.

I bought my first LP, *Pete Kelly's Blues*, at the Dover Music House in Hancock. Owned by the Dover brothers, Paul and Charlie, the Music House was a classic full-inventory music store common in small towns in the 1950s and 1960s. In traditional mom-and-pop fashion, the Dovers stocked a wide variety of popular music in all genres and kept on hand the printed catalogs listing complete offerings from all the major record labels. You could find just about any music you wanted in the Music House bins, and Paul and Charlie would make recommendations or help you order a disc if your musical enthusiasm reached beyond their current inventory. They also sold musical hardware—radios and record players—and a smattering of instruments. Like bookstores of the era, music outlets like the Dovers' were quirky clearinghouses for culture, serving the perceived taste of customers while providing a point of contact with the larger world of variety and sophistication.

Over the decades mom-and-pop bookstores and record stores have disappeared for pretty much the same reasons. As shopping malls replaced downtown commercial districts, chain stores moved into the new high-rent mall environment. High rents limit square footage and ultimately dictate the maximum size of a store's inventory. The resulting smaller inventory and centralized buying strategies of retail chains tilt outlets toward "blockbuster" product—books and records popular enough to sell millions of units. Stephen King, Garth Brooks, Yo-Yo Ma, John Grisham, and Bruce Springsteen are, in a sense, products of shopping mall thinking. In his analysis of the contemporary publishing business, Andre Schiffrin indicates that successful publishers historically "clearly saw their mission to reach a large audience through serious work." Today, he continues, commitment has been replaced by shareholder value: "Belief in the market, faith in its ability to conquer anything, a willingness to surrender all other values to it—these things have become the hallmarks of publishing." As Sheelah Kolhatkar wrote in the *New York Observer*, publishers and editors face "the impossible task of creating products that will both sell at Costco and serve as intellectual currency at Upper West Side dinner parties." Remember, it was in the 1980s

and 1990s, when mall chains began to dominate book sales, that block-buster stars like Tom Clancy and John Grisham came to dominate publishing. It's clear that across-the-board changes in the retailing of arts products have produced the same narrowing effects that consolidated radio inflicted on the record business.

The transformation in the distribution of cultural goods didn't end with the death of mom-and-pops. Once-potent chains like Tower and Sam Goody struggled to maintain full-line inventories in free-standing stores outside malls, and ultimately even the mall chains were pushed aside by "big-box" retailers—by Target, Best Buy, and Wal-Mart and their combined capacity to deliver the hottest books, music, and DVDs at the lowest price. Today only a few Sam Goody stores remain. The Tower Records branch near my Vanderbilt office soldiered on in Chapter 11 bankruptcy through most of 2006, but by Christmas sandwich-boarded hawkers were touting a liquidation sale—Tower too was gone. Wal-Mart and other big retailers are also in the book and magazine business, but although mall bookstores have vanished, for now chains survive. It is an open question whether the coffee-shop, gift-and-gadget model offered by Borders will continue or, pressured by online sales and the big boxes, go the way of Tower Records.

Wal-Mart has been roundly criticized for its devastating impact on small-town businesses and the health of downtown retail districts. But the rise of Wal-Mart isn't just about the demise of small-town hardware stores; the retail giant is a significant player in the U.S. arts system, and, as is true of Clear Channel programming strategies, the Wal-Mart model for the distribution of cultural goods effectively narrows the gates through which movies, books, and games must pass to find their way to audiences. With more than 4,000 stores open today and another 4,000 "superstores" planned for the next decade, Wal-Mart is an end-game provider so powerful that conventional wisdom about what works on Wal-Mart shelves, like record company assumptions about Clear Channel programming, finds its way back into the recording studio or movie sound stage.

As in the case of commercial radio—which is *really*, as we've seen, in the ear-rental business—the real big-box business model is not exactly as it

Despite the Internet, Netflix, and iTunes, it is the purchasing and merchandising policies of Wal-Mart that define the limits of artistic choice for millions of Americans. (Photo © Najlah Feanny/CORBIS/ SABA. Fee: $265.)

appears. We think of Wal-Mart as the place to purchase products we want or need at the lowest possible price—true, as far as the statement goes. While the *price* part of our assumption is on the mark, Wal-Mart is really about selling us things we *don't* need or desire, or at least items we don't think we need when we enter the store. Seventy percent of Wal-Mart purchases are impulse buys, and that simple fact has defined a new way of using arts products in a retail setting. And, as in the case of other innovations, it's an approach that poorly serves both artists and audiences.

Each year nearly 130 million customers walk through a Wal-Mart, and chainwide sales on a good day—nearly $1.5 billion—exceed the gross domestic products of thirty-six countries. The chain accounts for 40 percent of all DVD purchases in the United States, and about one in every four CDs sold will come from a music department at Wal-Mart. It's no surprise that the music and movie sections revolve around hit "product"; in CDs, 40 percent of revenue comes from the top-selling two hundred titles.

Although Wal-Mart claims not to use products as "loss leaders," the company competes aggressively and has held manufacturers to price points many argue are impossibly low. Pricing varies from store to store in part to avoid antitrust complaints, but most CDs are priced below $10, rarely higher than $13, and DVDs sell for about $15 per disc. As one music executive explained, "For practical purposes, Wal-Mart has told us that the price of CDs will be $9.98." Inventories are relatively small: in music, for example, the average Wal-Mart superstore carries no more than 5,000 titles (and that number has been steadily heading down; some outlets only carry 2,500), less than 10 percent of which will have been released in the preceding year. Wal-Mart also carries magazines and books; although the market share is not as big as in music and movies, sales are substantial and the basic strategy is the same: hold prices down and use top-selling books to attract customers who will inevitably purchase other goods.

Given the importance of Wal-Mart as an outlet for movies, music, and books, it is initially surprising that DVDs and CDs are almost always tucked away toward the back of the store in what vendors call "the bull pen." There's method here, of course; Wal-Mart is all about impulse purchases (the number-one selling item overall for the chain last year was bananas), so the function of arts products is not to put music and movies in the hands of consumers, or even to make more than a few pennies on an arts product sale, but to force the consumer on a long journey through aisle after aisle of impulse-purchase opportunities. Customers arrive seeking the new Norah Jones CD and leave with the CD plus a new pair of sunglasses and, I suppose, a couple of pounds of bananas.

As *Variety*, noted, the chain is content to use music and movies "as loss leaders to drive volume sales of blue jeans and puppy chow." To this end Wal-Mart provides special low pricing on current hit CDs and DVDs and features new releases on in-store posters for a week in advance of product availability. New media products are introduced on Tuesdays, a slow shopping day when the chance to buy the latest CD or movie might bring a customer in for a visit. Since every square foot of a Wal-Mart store is precious, inventory is closely monitored and continually repositioned to reinforce the appeal of items that are selling particularly well. In music and

movies, the need to stock high-performing product tilts inventories toward sure things: Bruce Springsteen, Coldplay, or Usher in pop; Alan Jackson or Martina McBride in country; and Yo-Yo Ma in the diminutive classical bin.

And Wal-Mart has not been shy about restricting inventory to conform to what are presumed to be customer sensibilities; no "NC-17" DVDs are sold, nor are CDs that carry a parental guidance sticker, and the chain has been willing to keep a few best-selling books with perceived offensive content off the shelves (although, as of this writing, it was rumored that the chain was dropping the parental guidance restriction in deference to urban—read "African American"—shoppers' interest in uncensored hip-hop releases). As public television's *NewsHour* reported, "Recording labels and artists recognize they cannot afford to ignore Wal-Mart's strict family values. Otherwise, their music sales could suffer."

A music section displaying a few thousand titles might seem adequate in the expanse of a giant, big-box, full-inventory store. But considering that only 500 of those CDs were new within the last year and that in the average year more than 30,000 CDs are released into some type of distribution, the notion that a quarter of all music sold moves through this extraordinarily narrow opening is astounding. And in spring 2006 Wal-Mart informed record labels that it was actually *reducing* the square footage devoted to music sales by 12 percent.

Clear Channel and Wal-Mart employ efficient, research-driven business models to, in the first case, deliver specific sets of ears to advertisers and, in the second, provide shoppers with the maximum opportunity to make impulse purchases. But a cultural system based on business efficiencies of this sort, one not at all grounded in cultural or artistic value, is hard-pressed to contribute to community expressive life.

We're a long way from WHDF and the Dover Music House.

Wal-Mart must order CDs likely to sell several hundred thousand copies and often must place orders before cuts are released to radio, an approach that clearly favors established stars. Across consolidated media and retail, our modern systems of distribution offer little or no space to new artists, and the inevitable emphasis on the "tried and true" encourages imitation and repetition.

The movie business also commits early to what look like sure things. A new Disney family film opening on 2,000 screens has an obvious advantage in achieving public acceptance, especially when a competing independent film of great quality might appear on only a few dozen outlets. It's true that something on the order of 600 new films are reviewed by the *New York Times* each year, but the average U.S. community will be lucky to see 100, and those that do make it to the heartland are likely to be big-budget studio films that sometimes appear on two, three, or even four screens in a single multiplex.

Even with multiple screens and flexible start times, the movie business increasingly looks like the record industry; movies today don't reach us through theaters but through the shelves of Wal-Mart, Best Buy, and Target, or rental services like Netflix. And as the capacity of Internet services and home computers grows, downloads will no doubt replace even new high-definition DVDs. The Pew Research Center reports that today 75 percent of Americans prefer to watch movies at home, up from 67 percent in 1994. Studios have been eager to accommodate this trend. Although at first glance the movie business seems to derive most earnings from box-office receipts, revenue splits with distributors and theaters and expensive marketing campaigns subtract nearly all the profits. But DVD sales can generate profits of more than $15 per unit sold, and although the growth of the DVD business has slowed, it remains a productive cash cow for the film industry.

Consolidated arts distributors distract us with the illusion of quantity; 5,000 CDs looks like a lot, but too often the shelves are filled with numerous copies of the same big seller; the same blockbuster fills four multiplex screens; the same hip-hop cut plays on 150 radio stations. This kind of quantity doesn't equal choice. Even cable TV deceives in this way: 300 channels seems like a lot, but dozens of them carry nothing but old movies, news channels (NBC, CNBC, and MSNBC are prime examples) repeat the same features and news bits again and again, and the best of cable is available only if you're willing to pay an extra fee every month. The quantity is there, but it's time-consuming to navigate, and it frequently lacks the real diversity that should define expressive life in a democratic marketplace.

Aware that the gates of distribution are becoming ever narrower, producers of recordings and films become wary of artists whose work "pushes the envelope." "Will it work for Wal-Mart?" and "Will Clear Channel program it?" become central questions influencing even early stages of the creative process—songwriting or film editing. Could a novel by William Faulkner get published if it had to find its way to the shelves of Wal-Mart, or could the quirky singing and songwriting of young Johnny Cash break through on Clear Channel country radio? And if today decision makers *know* exactly what will and won't work in the distribution systems, will book publishers, record companies, TV networks, and film studios even sign talent or develop product that doesn't appear to be a sure thing in our constrained distribution model?

They won't if they have any sense.

It's sad but true; consolidations, mergers, and acquisitions among companies that produce arts products only reinforce the tendencies toward repetition, imitation, and celebration of the already celebrated that generally define big-box retail and consolidated broadcasting. And much the same holds true for the record business itself. At a seminar for midlevel managers in the music business, an executive made a point that holds true for all of our cultural industries: "I don't think you can run a record company from the point of view of a multinational company that's traded on some stock exchange."

The book and record businesses share many of the same challenges and over the years have employed some of the same business strategies. Book clubs spawned record clubs, and paperbacks are similar to budget-line CDs. Both industries are in the business of taking risks on new talent, making advances against future earnings to nurture artistic careers while building substantial backlists of words and music. Both book publishing and the record business are essentially cottage industries, as Jason Epstein puts it, "decentralized, improvisational, personal; best performed by small groups of like-minded people, devoted to their craft, jealous of their autonomy." No matter how savvy an editor or a record executive may be, the record business and book publishing are burdened by failure rates that would drive an executive in, say, the manufacturing business, all the way up the wall. In music only about one in eleven CDs released by major

labels ever recovers its cost. If you move beyond major labels to track overall CD sales the numbers are even more daunting: in 2006 just over 34,000 CDs were released into distribution, 11,200 by major labels. Of that total, only 364 sold more than 100,000 units, and only 7 a million or more. One thousand titles accounted for 80 percent of all sales. The book business is similarly top-heavy: in 1994, 70 percent of the total fiction sales came from books by six authors: Tom Clancy, John Grisham, Stephen King, Michael Crichton, and Danielle Steel. In 2003 more than a third of all titles were returned by bookstores, unsold. Movies exhibit the same challenges. The average film costs $100 million, about $65 million for production and $35 million for marketing. Theaters retain about half of the box office, so a movie must take in $200 million to break even. Few can manage it without back-end foreign sales and DVDs. If the book, movie, and record businesses could restrict their output to those products that would do well, then music, film, and publishing would be in the business of printing money. Of course that's exactly the point. It's *not* possible to significantly reduce the failure rate. Success depends on effective marketing campaigns, radio airplay, good notices from literary critics, but above all the presence of that elusive magic that connects a performer or writer with an audience.

Success in these arts industries almost always depends on a close connection between an artist and an advocate on the corporate side who can help convert talent into a sustainable career. Without editor Maxwell Perkins, we might not have had Ernest Hemingway or F. Scott Fitzgerald, and almost certainly wouldn't have read Thomas Wolfe. We've seen that without John Hammond's tenacious support, Bob Dylan might never have broken through, or might have achieved only the second-tier, small-label, coffeehouse career that was the norm for his folk-revival cohorts. Individuals like Hammond and Perkins made judgments on the basis of taste and artistic instinct, and, once committed to a writer or performer, they were in for the long haul. Building a career meant helping to shape quality product and then methodically introducing new work and new talent to a system capable of getting the word out.

To succeed in this business environment the editors and producers needed patient managers up the line, executives who understood that art

Behind the scenes at Columbia Records for more than four decades, producer John Hammond took risks to advance the careers of artists ranging from Billie Holiday to Bruce Springstseen. Modern multinational media companies simply lack the capacity to nurture the careers of executives who place art and artistry ahead of "sure things" geared toward quarterly earnings. (Photo © Jeff Albertson/CORBIS. Fee: $265.)

takes time and that a red-ink investment might stretch over many quarters—even over several years—before a writer or recording artist would begin to make a profit for the publisher or record label. Mike Curb, a writer, producer, and songwriter who has owned the successful Curb label for forty-five years, claims to have never tried to maximize profits. "I tried to make enough to pay salaries," he says. "Everything else helped develop new talent." Such boutique businesses need a high tolerance for both risk and failure; they must encourage executives to follow their best instincts and then provide room for them to get up off the floor to fight again when those instincts are proven wrong. A good working relationship between owners and managers is a must.

During the 1980s and 1990s, acceptance of the CD, the success of big-name recording artists, and sales of blockbuster books and movies made entertainment companies attractive targets for corporate raiders. But these "cottage industries" fit uncomfortably into the efficient, vertically integrated business models of global media giants. When Edgar Bronf-

man and a group of investors acquired Warner Music in 2005 he imme-
diately trimmed operating expenses by $250 million, cut a thousand jobs,
dropped a third of Warner-signed recording artists, and reduced the size
of new contract advances (there was no official comment on the status of
funding for Warner's archive of historical recordings). These are the very
efficiencies that raise alarms about the fate of heritage films and music in
corporate archives, and while such cutbacks can boost profits in the very
short run, they're rarely a formula for long-term success and never a path
to artistic vitality.

A friend told me that in his record company he and other top managers
(he's a CFO) are linked through a "financial forecasting" telephone con-
ference call every two weeks, during which each participant is expected
to explain current performance and then project revenue for the next
month, and the next quarter. "We have no idea what's going to happen
in the next quarter," he said. "Ninety percent of the time we're just mak-
ing things up." His motive for "making things up" is obvious; my CFO
friend works for a subsidiary of a global media company, and the be-all
and end-all of corporate performance is a positive estimate of quarterly
earnings that can sustain or advance the price of publicly held stock. In
the arts business, burdened with inherently high failure rates and long
ramp-up times for artists' careers, financial performance is unpredictable.
That fact, however, does not sidestep the anxiety produced by top-down
pressure to produce earnings estimates and hit quarterly targets. In fact,
fear and its offspring, aversion to risk, have come to pervade our arts
industries.

And how do you avoid risk?

Unfortunately, you first make conservative decisions and then find
ways to maintain "deniability." It's conservative thinking that gets arts
companies doing the same thing over and over. Witness the spate of nov-
els in early 2006 that seemed to replicate (without copyright infringement,
mind you) the defining ingredients of *The Da Vinci Code*, the blockbuster
Dan Brown novel that had sold more than 60 million copies worldwide
by spring 2006. *The Templar Legacy* by Steve Berry, *Labyrinth* by Kate
Mosse, and the translation of *The Last Cato* by Matilde Asensi all mix
thriller plotlines, Catholic church intrigue, and a firm grounding in his-
torical details. In late 2005 the Associated Press reported that Dutton

Books senior editor Mitch Hoffman had been receiving proposals "invoking *The Da Vinci Code*" at the rate of about one a week, a number that tops the total of all titles Dutton publishes in any given year.

The movie *The Da Vinci Code,* starring Tom Hanks as symbologist-detective Robert Langdon, represents another trope on risk aversion: the tendency to invest in what looks like a sure thing. Hanks is pure gold at the box office and, linked to a dramatized version of one of the most popular novels of the past decade, should have delivered audiences commensurate with a major studio investment. However, even more important, Hanks's reputation provided every decision maker on the *Da Vinci* project with a bought-and-paid-for excuse for failure. "Chief, I can't believe it didn't do big numbers! Christ; we had Tom Hanks!" (The Tom Hanks *Da Vinci Code* opened in spring 2006 to generally negative reviews, but the first-weekend box office was strong, and the studio anticipated excellent foreign and DVD sales.) Excuses of this sort, probably fleshed out with additional expletives and tailored to this or that failed movie, TV, or record project, are heard in executive suites every day. I'm certain they echoed down the halls of MGM when another best-selling novel, *Bonfire of the Vanities,* bombed at the box office despite the best efforts of a famous director, a high-end production budget, and the presence of the film's big-draw superstar. And who was that superstar? Tom Hanks!

Famous actors, legendary recording studios, credentialed lighting directors, and superstar vocalists can demand top dollar because of their artistry and technical capabilities. But there's more than just talent and expertise in the mix; in part, the millions spent on name talent provide industry executives with a Wizard of Oz–style "deniability license," a Teflon coating that can shortstop negative consequences by deflecting responsibility.

Why does this matter?

Well, with fear and aversion to risk rampant in arts companies, the very best work that our artists can do simply can't get through the system; the gates are too narrow. Dan Brown kicks off a repetitions series of religious thrillers; John Grisham, two decades earlier, does the same thing for lawyer novels. Ten years of "hat acts" follow the success of Garth Brooks, and every fourth or fifth hour of TV drama is about a peculiar kind of sim-

ulated "reality" (or forensic medicine). For a couple of years *Who Wants to Be a Millionaire* was so popular that ABC didn't even bother to imitate itself with similar programming; instead, the network just hooked Regis Philbin to an IV, plugged in his catheter, and aired the game show six and even eight times a week.

A. O. Scott, writing in the *New York Times*, complained about the absence of really, truly bad movies in the current scene—films on the order of the much-maligned *Ishtar*. Why should we care about the absence of bad Hollywood product? Scott makes an important point: "Disasters and masterpieces, after all, often arise from the same impulses: extravagant ambition, irrational risk, pure chutzpah, a synergistic blend of vanity, vision and self-delusion." He notes that "fifty or a hundred million dollars can buy a lot of competence," so that "the script will have been worked over by one committee, and another will have kibitzed in the editing room and collated the results from the test screenings." Subjected to such a process, movies today end up "tasteful, familiar, and safe." For Scott, "the worst is not just the opposite of the best, but also its neighbor." Movie industry aversion to big-time failure has produced a film scene dominated by projects that are either so-so or not very good; the brilliant and the excruciatingly bad have exited, holding hands. This problem pervades America's arts industries and threatens a vibrant cultural system. Business leaders so caught up in quarterly corporate earnings are no longer willing to take risks on art and artists capable of enriching our expressive life. Could Glenn Gould, Dustin Hoffman, Johnny Cash, or Frank Zappa get into the big time if they were starting out today?

Perhaps the digital world, the world of art making and art distribution online, offers a haven for creativity: Are we merely witnessing a transfer of cultural authority from one business model to another? Will the Internet survive as a haven for consumer choice and creative risk?

Sure, there's art all over the Internet. But let's be a bit cautious. The Internet is a great place to *buy* something but not such a great place to *shop*. I never entered a Tower Records or a mom-and-pop bookstore without making a purchase I didn't intend when I walked in (and I'm talking about music and fiction, not *bananas*). With iTunes, on the other hand, it's straight to what I'm looking for, click for the download, and that's it—a

process that's great for buying but terrible for shopping. And even if you have the time, the essential gear, and Internet connection, cyberspace increasingly herds consumers into tight circles. Amazon.com is constantly badgering me about products that are just like things I've already purchased; YouTube points toward what other people have looked at; the online *New York Times* tantalizes with the "Most Popular" articles. Some may disagree, but most of what's on the Internet seems every bit as targeted, researched, and narrowed as the hits on a Clear Channel radio station. With Google's acquisition of YouTube and News Corporation's purchase of MySpace, the days of freewheeling Internet blends of professional and user-generated content may be about over. A healthy measure of artistic risk-taking lives on in boutique companies marketing low-budget projects to niche Internet audiences, but if the main stream is dry, it doesn't matter much if the little rivulets and creeks are flowing.

•　　•　　•　　•　　•

But perhaps there's another way? What about America's nonprofit cultural organizations; don't they offer an alternative to the narrow choices of multinational media industries? Remember, the very notion of a nonprofit arts organization was to free arts leaders from the profit motive and the compromises that limit risk, giving us art that isn't homogenized by the forces that plague our commercial arts industries. It's an attractive idea—an ownerless, mission-driven company that worked not for the aggrandizement of man but the glory of art. Does America's vast nonprofit arts sector provide a place where art and artists can "get through," where creativity isn't squeezed through a narrow, risk-averse gateway that chokes off risk, variety, and choice?

The sector certainly *should* be vibrant. After all, unlike our vast art marketplace, nonprofit organizations have evolved in a world fine-tuned by public policy—promoted by citizen activists, protected by legislation and regulation, secured by public and private largesse. In fact, to the extent that the United States has a self-conscious arts or cultural policy at all, it's been centered on two nonprofit issues—the well-being of cultural organizations and arts education. In the United States, if someone calls herself an "arts advocate," it is fair to assume that she is expending time and en-

ergy trying to drum up public and private support for art museums, sym-
phony orchestras, dance and opera companies, and the like, or working
to expand the availability of arts experiences in public schools (and not,
for example, e-mailing the Department of Justice to argue against the
merger of Sony and BMG). So, when we think of, or talk about, the ways
government policy addresses the arts, the priorities of nonprofit cultural
organizations and arts education advocates dominate. With so much at-
tention directed to their needs, shouldn't our nonprofits be a cut above
our arts industries, serving as those strong, citizen-oriented arts organi-
zations to which we all have a right?

But nonprofits have been diverted from their public-interest mandate.
Today the desperate need to retain grant support, patrons, and subscrip-
tion audiences constrains creativity and encourages conservative, repeti-
tious programming that is a far cry from the innovation and experimen-
tation envisioned by the sector's advocates.

The evolution of modern fine arts organizations in the United States
goes back one hundred years. Nonprofit status became important to the
fine arts with tax legislation in 1916 and 1917, at the same time U.S. "com-
mercial" arts industries were emerging. Early on, nonprofits in social ser-
vices and the arts relied on wealthy donors, but by the Great Depression
and World War II, the limits of tax-deductible private philanthropy di-
rected to nonprofits had been exposed. Major foundations, themselves
new actors on the policy stage, then entered the picture, funding non-
profits but also beginning to craft strategies to shift responsibility for key
nonprofits—especially those that supported education and services to the
poor—over to the government. This approach was successful in the field
of social sciences, and by the late 1950s and early 1960s, with welfare and
education initiatives already handed off to Washington, the Ford and
Rockefeller Foundations began to redirect a portion of their enthusiasm
for social reform toward an effort to improve the American arts system.
In a nation that possessed only a couple dozen symphony orchestras and
with live theater, dance, and art museums huddled in a few big cities, it
was easy—and probably on target—for leaders to assume that cultural vi-
brancy and quality of life could be enhanced if the fine arts were to be-
come more widely available.

Foundations consulted with arts leaders of the day—mostly big-city arts-aficionado philanthropists—and proceeded from this basic assumption: the public interest would be served if the supply of refined arts experiences across the nation was increased. (Rockefeller produced rhetorical justification; Ford, the precise model for action.) The policies and practices of those influential foundations laid out the boundaries that have fenced in our cultural policy agenda for the past half century: first by describing the challenge—insufficient access to the refined arts—and then by crafting a specific solution—matching grants to nonprofit cultural organizations. Within the fine arts the Ford program focused on the cultural community's darling child, the symphony orchestra, and here the results of Ford intervention were especially impressive. In 1966 Ford launched an $80 million program of support for orchestras, a figure that required a two-to-one match from grant recipients, an astounding commitment at the time. The Tax Reform Act of 1969 provided additional incentives for foundation largesse; the act stipulated that foundations must spend 6 percent of their assets each year, forcing a sudden increase in disbursements. The arts were an obvious target for new giving. (This requirement was later reduced to 5 percent, where it stands today.)

It's hard to overstate the impact of midcentury foundation investment in culture. For example, Ford grants actually changed the character of U.S. symphony orchestras. In 1960 year-round employment for orchestras was unheard of; ten years later—just four years into Ford support—six orchestras had fifty-two-week contracts. Ford also invested in museums, nonprofit theater, and Lincoln Center for the Performing Arts, whose first building, Philharmonic Hall, opened on the west side of Manhattan in 1962. The Lincoln Center idea was instantly attractive and kicked off a nationwide boom in downtown cultural facilities: the Los Angeles Music Center opened in 1964, Washington's John F. Kennedy Center for the Performing Arts in 1971. In addition, the federal government had begun to respond, structuring a framework for supporting culture. Legislation creating the Arts and Humanities Endowments was signed in 1965; the Public Broadcasting Service was created in 1969.

Significant grants from major foundations, important in their own right, started a trend that spread throughout philanthropy and public

support. The growing influence—in aggregate budget and community impact—of the nonprofit part of the arts system was also possible because the basic matching-grant approach invented by Ford VP W. McNeil Lowry was successfully handed off from Ford and Rockefeller to other parts of the support system. From its inception in 1965, the National Endowment for the Arts employed the matching-grant-to-nonprofit model, as did every state and local arts organization and virtually every American foundation that funded cultural work. John Kreidler, writing a decade ago, labeled the spread of the matching grant formula "a chain reaction," and to this day what Kreidler labeled the "Ford model" remains the gold standard shaping intervention in America's nonprofit arts.

Over the past fifty years, growth within the nonprofit part of America's arts system has been extraordinary. In 1965 there were 7,700 nonprofit arts organizations; today there are well over 50,000. In 1970 there were 60 symphony orchestras; today, depending on how you define *orchestra,* as many as 600. Forty percent of U.S. nonprofit museums were created after 1970. In terms of percentage growth in employment and the sheer number of companies, the nonprofit sector grew more than any other part of the arts system—even more than film, radio, and television. Viewed as a forty-year intervention in the arts system, the model has been wildly successful. And the nonprofit sector has not only grown in size; it has also grown in influence: powerful advocacy organizations, like Americans for the Arts, work to grow philanthropic and government support for cultural institutions.

As we've seen, cultural nonprofits have close links to social elites and most work with the refined arts—Western European high-art traditions carried forward in the United States. Over the past three decades the spectrum of cultural nonprofit activity has expanded somewhat to take in jazz, nonprofit theater, independent film, and even folk arts. Still, community leaders who assert the potential economic impact of a new performing arts center, or who support school music, or who worry about the financial stability of dance are, to this day, primarily invested in the well-being of the refined arts—the kind of art you'd find toward the top of Salonen's "endless lists." For these arts advocates, "music" is classical music; "performing arts" are theater, ballet, opera, and symphony

orchestras; "dance" is . . . well, it's George Balanchine, maybe Fred Astaire, but probably not Gene Kelly and certainly not Paula Abdul.

Because the fine arts are mostly organized as nonprofits and because the fine arts are viewed as markers of sophistication, educational accomplishment, and virtue, the sector has come to think of itself as the only significant source of quality arts programming in the United States. When arts people talk about the cultural industries the dismissive term used to characterize the for-profit arts is *commercial*, suggesting an arena in which bottom-line concerns consistently trump the demands of artistry. In contrast, the nonprofit arts are seen as "mission driven"—purveyors of "excellence." This assumed qualitative distinction, of course, does not hold up to even superficial scrutiny—many of our most highly regarded arts activities are almost exclusively organized for profit—but the notion survives as an often-invoked mark of nonprofit distinction—one that has allowed long-standing elitist prejudice to insert itself into policy. Over time the dismissive attitude of nonprofit advocates has taken on the character of a full-blown ideology—an explanation of reality that is widely shared but unexamined. Thus the notion that a nonprofit business model invariably produces higher-quality art is a tenet of *nonprofitism*, an ideology that has encouraged a smug sense of entitlement in the arts community. In addition, nonprofitism has kept the sector isolated, preventing arts organizations and arts advocates from engaging *real* cultural issues like fair use, media regulation, trade in cultural goods, and the scope of intellectual property protection. Unfortunately, nonprofitism's intellectual bookends, disdain for the commercial sector combined with an obsessive concern for public and philanthropic support, have to date pretty much defined the limits of the U.S. cultural policy debate.

Think about it. The presumed differences separating the work of non-profit and for-profit arts companies are so ingrained that even university programs designed to train entering management professionals teach toward one kind of organization or another—almost never both. If you want to manage an orchestra, study "arts management"; if you want to head a film studio, get an MBA.

But nonprofit growth and funding trends have flattened over the past decade; the programmatic and financial flexibility required to provide

**NATIONAL
ENDOWMENT
FOR THE ARTS**

A great nation
deserves great art.

The NEA logo offers a typical supply-side slogan for America's nonprofit arts. It's not the art you *want,* but the art you *deserve.* Similarly, the advocacy group Americans for the Arts transcends questions of demand with a slogan that sounds like a bootcamp marching order—"Art: Ask for More." You can almost feel the exclamation point. (Image: Government promotional publication. Fee: none.)

nonprofitist ideology with a measure of truth has been drained away. Kreidler, in fact, marks the end of the expansionist "Ford era" as early as 1990, and over the past two decades it has been increasingly difficult for nonprofits to experiment with programming in ways that risked dampening the ardor of essential patrons and audiences.

Today inflation-adjusted funding by state, local, and federal arts agencies is less than in 1992, and arts grants as a percentage of total foundation giving have also declined; foundation giving to the arts actually decreased slightly in 2006. Finally, as Americans for the Arts recently reported, modest recent gains in overall giving to culture disguise the fact that the percentage of overall philanthropy devoted to the nonprofit arts—the sector's "market share" of all giving—has declined by nearly one-third since the early 1990s.

All this should come as no surprise. The old approach to enhancing the cultural landscape—increasing the capacity of fine arts nonprofits—was both innovative and effective in its day. But scroll forward fifty years, add research in HIV, global health, education, and the environment to the foundation to-do list, and it should be obvious why another round of giving to a budget-impaired orchestra wouldn't increase the pulse rate of an average foundation board member. A thirty-two-page special section called "Giving," published in the *New York Times* in fall 2006, didn't contain a word about grants to culture. It's clear today that if we want philanthropy to care about cultural vibrancy, the system needs to advance

a more compelling agenda than what can be derived from the self-identified needs of arts organizations.

So our nonprofit arts have grown bigger without getting richer, and we can see the result. Between 1982 and 1997 the number of arts organizations expanded by 80 percent, double the percentage of growth in the for-profit arts industries; however, average revenue per nonprofit declined. Not surprisingly, percentage growth in the number of workers employed in nonprofit companies was also substantially greater than in other parts of the economy, but as we now know, a growing nonprofit workforce in a period of flat funding simply generates depressed levels of compensation. In fact, in 2001 compensation for the heads of cultural organizations was the second lowest of any segment of the nonprofit community; only employees of religious organizations were paid less. Financial difficulties seem endemic, and in meeting after meeting nonprofit leaders complain that their organizations are chronically undercapitalized and that they cannot recruit new managers into a field offering uncompetitive salaries and few benefits. It should be no surprise that twenty-four important art museum directorships were vacant in summer 2007.

We've seen that for film studios and record companies, consolidation and narrowed gates of distribution encourage conservative, risk-averse artistic decisions. But our cultural institutions are in a similar boat, drifting in a different sea. Competition for audiences and funding among nonprofits encourages the same kind of conservative artistic choices that are forced on record companies and film studios by the demands of shareholder value.

Why, after all, does just about every dance company in the United States stage *The Nutcracker* each holiday season? "Because it's beloved," according to the *Times*, "but being beloved translates into . . . tickets purchased." As in movies, pop music, and broadcasting, "safe" choices offer managers and boards both the promise of guaranteed profitability and a good measure of deniability; *The Nutcracker* is the Tom Hanks of the dance field.

"How could our year possibly end up in the red? We added four extra nights of *The Nutcracker!*"

So music festivals give us more Bach and Mozart, and museums program ancient Egypt, dinosaurs, or privately funded vanity pieces: the

Guggenheim's Armani exhibition or the Metropolitan Museum of Art's tribute to Chanel.

Predictably, museums have also taken to exploiting their own collections—their "heritage assets"—for revenue by deaccessioning pieces for substantial sums. But, as Michael Kimmelman has observed, museums trade on not one but two kinds of assets, "the quality of their collections and the public trust"; mishandling the first can undermine the second. The *New York Observer's* blunt attack on Guggenheim Foundation director Thomas Krens itemizes most of what a museum director can do wrong. According to the *Observer,* Krens "drew down his endowment to pay for operating expenses, created blockbuster exhibits for blockbuster's sake, engaged in questionable deaccessioning-related accounting, and built the Guggenheim Bilbao, which helped usher in an era of destination architecture."

Is the nonprofit cultural sector really a bastion of artistry and excellence?

Even public broadcasting has lost its way, with public TV only airing three hours of local programming each week while featuring prime-time programming indistinguishable from offerings on Bravo, the History Channel, or American Movie Classics. Believe me, when my local public television station airs a thirty-year-old rerun of the *Lawrence Welk Show* on Saturday evening (as many stations do), management is not innovating but instead implementing a conservative choice that plays to a graying audience of loyal station supporters.

In our arts industries—movies, records, and TV—vibrancy has been sucked out of the arts system by something new—bottom-line-driven, risk-averse global media. The nonprofit world has been operating within its own set of constraints, the result of an overextended matching grant and philanthropic model. And as arts institutions have pandered to the interests of donors, foundations, and corporate sponsors and to the taste of audiences, the notion of a sector free to experiment and innovate has evaporated. Our approach to funding the nonprofit arts is more than mature, and for at least the past decade our nonprofit refined arts sector has presented striking indicators of an overbuilt industry: depressed wages, lack of capital, defensive, conservative business practices. Fifty years ago

the nonprofit arts appeared as a promising alternative to the hard-edged arts marketplace—an arena where artistry, heritage, imagination, and the public interest would trump the bottom line. Today an overbuilt sector has set aside core principles in the hunt for survival.

How has the nonprofit arts community responded to these challenges? Well, for the most part, museums, orchestras, and theaters have simply tried to generate new tactics for pumping up venerable nonprofit revenue streams, either by expanding existing resources or by placing the non-profit arts on new funding agendas.

Back to the old well with a shinier, bigger bucket.

For years it was "more arts education, more exposure to the fine arts," but those arguments are on the back burner. Today we argue the economic impact of the arts to community leaders, try to convince parents that arts training will bump up math and reading test scores, or that the presence of a vibrant symphony will move a city up a notch on Richard Florida's "bohemian index." This process has produced some wonderful, productive connections between the arts and community, but it's probably fair to say that for the past decade the search for "new partners" has pretty much been about a reformulation of the very old search for new money.

Doug McLennan, editor of the online *artsjournal*, concludes that non-profits are in deep trouble; organizations "are suffering from a persistent low-grade flu in the form of eroding audiences, sharply rising expenses and increased competition that may mask more serious structural problems." "Has the nonprofit model . . . outlived its usefulness?" he asks. Earlier, John Kreidler's "Leverage Lost" painted an equally gloomy picture of an approach to cultural work that had grown to overtax the capacity of society to continually pump up government and NGO funding streams.

It's clear that advocates who care about the fine arts need to implement a new, more critical approach to leadership. First, we should be more skeptical of start-up nonprofits, demanding, at the very least, a sound, multiyear financial plan before a new theater or dance company sets up shop. Many small art enterprises will do better as partnerships or sole proprietorships. Second, let's be cautious about embarking on new building projects. It's easy to raise money for bricks and mortar, but

every facility adds to the basic cost of annual operations. Buildings shouldn't come on line without a dedicated source of money for the increased cost of doing business. And third, we need to find ways for failing nonprofits to exit the stage gracefully. The sense of mission, artistic virtue, and entitlement that prop up our nonprofits makes it very difficult to accept defeat and move on. The marketplace has little trouble dispatching failed record companies or film production houses; we need to find an equally direct mechanism for letting unsuccessful cultural organizations go.

The challenges facing nonprofits today don't diminish the significance of the Ford era; after all, the forty-year application of the matching-grant model was not only the most successful intervention in the U.S. arts system; it probably stands as one of the most transforming interventions in any cultural system, in any nation, ever. But times change, and it's time for the nonprofit arts to declare victory and move on. It's time to consolidate the gains of the past four decades. It's time to stop thinking that the potential for societal support for the nonprofit arts agenda is limitless, constrained only by our inability to craft and then advance exactly the "right" argument in order to motivate the "right" financial partners. Instead, we should today think about strategies that will minimize erosion of the gains achieved over a half century of leveraged matching grants to cultural nonprofits. It's also time to find ways to help struggling cultural organizations exit the stage gracefully. Unlike our arts industries, the nonprofit world can't depend on collapsing demand to weed out organizations that just aren't working, so the same funders who prop up arts organizations must help shut them down when it's just not working.

The nonprofit arts have for the most part disdained the lively art forms that define America's cultural mainstream, but as the sector has approached the limits of its traditional sources of money, it has adopted many of the strategies that have diminished the creative capacity of film studios, record companies, and broadcasting networks. Nonprofits are too often careless with historical assets, risk averse, and too often drawn to projects that have no real importance beyond an impact on the bottom line. Today neither segment of America's arts system is positioned to advance our right to a vibrant arts scene.

• • • • •

What can possibly be done to enable the interests of artists and citizens to penetrate the self-serving agendas that characterize both for-profit and nonprofit arts companies? Three things come to mind.

First, we need to build a policy community linking the broad spectrum of American arts industries. We've never had one. Of course, the record, film, and broadcasting industries each support trade associations—"business leagues"—that exist primarily to lobby Congress on a narrow range of issues. And in addition, a number of "academies"—think the Emmys, the Oscars, CMA Awards, and the Grammys—have been organized to bring attention to the best work produced by different segments of the entertainment community. A couple of these organizations, such as the Recording Academy, have even developed respectable reputations for educational programming and service to musicians or actors who have fallen on hard times. However, for the most part, these groups are more about awards, TV specials, and lavish black-tie parties than serious discussions of art and the public interest.

The cultural sector needs an entity like the Conference Board or the Aspen Institute—policy forums in which the self-interested exploration of issues affecting the entire sector, nonprofit and commercial, can take place alongside discussions of choice, creativity, risk, careers, and the public interest. Such a forum should include distributors of culture like NPR, Wal-Mart and Target, Clear Channel, and big multiplex chains, nonprofits like the Kennedy Center and the Metropolitan Museum of Art, and the "usual suspects," the movie, recording, and television industries. Certainly, in an age of technological transformation these cultural powerhouses can (without colluding) identify many shared concerns; some could benefit from some time spent contemplating citizen rights and the public interest. Wal-Mart—infamous for shuttering small-town commercial districts—and the Recording Industry Association of America—today best known for suing the nation's young music fans—could each use some quiet time with the subject of corporate responsibility; to take on, for example, the false assumption that it's all about stock price.

As the *Financial Times* reminds us, corporate leaders often "believe that a company board's duty is to serve the interests of the shareholders. It is not. The board's duty is to act in the best interests of the company." The longer view implied by "best interests" might not keep the stock price up, but it could give managers the elbow room required to advance art and artists. Mixed together in this way, leaders of our cultural industries would no doubt constitute a lively cohort of wary competitors, but just bringing those leaders together would be a good start.

Second, we need to incorporate "cultural impact" into regulatory work that strives to keep corporate practice from harming the general public. As we've seen, some experts are arguing that "consumer choice" should augment price impact as an element in the process of evaluating mergers among cultural industries. Today, mergers are pushed for their impact on national security. The approval process affecting corporate mergers could ultimately be broadened to allow the Federal Trade Commission to directly assess the impact of mergers on "cultural security," an approach that would, among other things, help protect heritage assets. But, even beyond heritage, corporate structure and ownership generate broad and powerful effects within our arts system, and regulators and legislators must address the collateral, as well as the direct, impact of government action.

The FCC was blindsided in 2001 by the intense, negative public reaction to radio consolidation. Although the agency has tried to catch up, it seems uncertain as to how to define and measure cultural impact and incapable of fully penetrating the ways in which broadcasting practices influence creativity and narrow choice. And it's especially difficult to redo regulations after the fact, to reassert the public interest after the rules have been changed to benefit media companies. Cultural impact should be assessed out front, and mergers, acquisitions, and consolidations in cultural industries should proceed only after the public is assured that our right to an open, accessible arts system is not undermined. In the end, we may need to take responsibility for cultural industries away from the FTC, the FCC, the NEA, the Library of Congress (copyright), the Department of Justice, and the IRS, reinstating arts regulation in a new entity geared to public purposes.

Third, we should together rethink the priorities of our nonprofit cultural organizations. For the past fifty years most cultural nonprofits have

attempted to emulate big-city major institutions. Funders, like the NEA and major foundations, have employed the "E-word," *excellence,* as a club with which to pummel any orchestra, dance company, or museum that became too identified with local art making. To be *local* was to be *provincial,* and to be provincial was to be not excellent and, inevitably, not to be funded. In the 1970s, when I first began serving on the music and folk arts grant review panels of the NEA, I quickly became aware that a project with a local identity went nowhere. A music pageant based on community history written by local poets and composers had almost no chance for NEA support; offer to produce it outdoors during the tourist season, and the application would be dispatched with rolling eyes and pinched nostrils. But disdain for community art making limits creative elbow room and narrows the gates that separate citizens from a vibrant expressive life.

Maybe local arts are exactly what we should have been funding. The charm of Christopher Guest's delightful film *Waiting for Guffman* is its representation of the powerful way in which art brings together a community around a cast of quirky misfits. Let's encourage 25 or 30 symphony orchestras to maintain and present the finest and most demanding classical repertory; the remaining 550 can do something else—perform works by composers in the state university music school, or commission pieces memorializing landmark community events. We've seen that the Arts Endowment Millennium Project, Continental Harmony, was just this kind of program, placing composers in residence and reshaping the traditional relationship between communities and nonprofit art making. If we need to nurture amateurism and build institutional support for art as a public good, our nonprofits can help make it happen. In the process, many will make themselves more secure.

The commercial and nonprofit parts of America's arts system existed a century ago; they were "green industries" unformed, undeveloped, presenting an essentially benign face to consumers. Over the past hundred years, and especially the past three decades, our cultural system has taken shape but also moved away from the public interest. Copyright bloat, narrowed opportunities for artists and citizen art makers, limited choice, incoherent cultural exchange, and consolidation have conspired to sabotage our expressive life. America's arts organizations have lost much of their

capacity to effectively link creativity, heritage, and consumption; our expressive lives have been diminished. In for-profit distribution, giant consolidated companies driven by the bottom line and directed by research have found it increasingly attractive to reduce risk, thereby narrowing choice for citizens. Our cultural rights have been undermined.

This is a time for new leadership, or for old leaders to think in new ways. The foundation community that invented the matching grant, the urban arts center, and national tours of dance and theater, creating a half century of growth in the nonprofit arts, should revisit cultural policy and develop new interventions that will nurture a healthy twenty-first-century arts system. Given a commitment of time, intelligence, and money, a new model is within reach. Working with a range of nonprofit and commercial partners and dedicated to advancing an open arts system that serves the public interest, this new approach can galvanize government and the private sector to build strong, responsible organizations capable of risk and open to creativity and innovation.

The Failure of Government

Congressman Obey thought we had a chance. "Now that we've balanced the budget," he explained, "we can begin to pay for some of the 'grace notes' in life." David Obey, a fire-breathing fourteen-term Democrat representing central Wisconsin, had been a staunch advocate of the NEA and was enthusiastic about a budget increase for the agency; I was delighted to have his support. It was spring 1999, and we were hard at work trying to secure a small budget increase to fund the NEA's new Challenge America initiative, and even though Obey was then in the minority party (in 2007 he became committee chairman), as ranking member on the powerful House Appropriations Committee he could make plenty of noise.

But maybe noise was what it was all about.

"We'll offer a floor amendment for an additional $50 million," Obey exclaimed. "That'll show 'em!"

That'll show 'em, all right. We were hoping for a $5 million or $10 million increase—something significant enough to get the NEA budget growing again but nothing approaching the full amount requested by the White House. In fact, only a few years after the agency was nearly eliminated, a big "ask" was certain to attract intense opposition from House conservatives. We wanted to stay under the radar, but Obey had more in mind. Sure, he supported the Endowment and wanted to see its budget grow, but he also knew that a high-priced floor amendment was likely to fail and that failure would provide yet another opportunity for a prominent Democrat to twist the ear of the majority by standing proudly in defeat, decrying the philistine parochialism of Republican conservatives who had once again proven themselves too narrow-minded and mean-spirited to support America's tiny cultural agency. And I'd been given a valuable lesson in the politics of culture: members of Congress don't go to the mat over "grace note" issues, but they will—angling in from the left and the right—speak out if there's an opportunity to score political points. As we've seen, from the presidency of John Kennedy forward, culture hasn't been on the domestic or foreign policy agenda of any administration; it's no different with Congress. But that doesn't mean politicians haven't *used* culture to stir up constituents or pummel the opposition.

And what about today? Late in 2007, with a Democratic majority in both houses of Congress, the future of NEA funding was an open question. The Interior bill, making its way through Congress in summer 2007, exhibited disparate approaches to advancing the agency's budget. The House version was aggressive—a $35 million increase that would restore funds cut during the culture wars of the 1990s. The Senate bill included an increase of $9 million, a figure more likely to remain under the radar of agency critics. Would congressional conservatives resist any significant new appropriation, once again loudly highlighting the NEA as a symbol of government excess? The omnibus spending bill, passed just before the holiday recess in December 2007, split the difference with an increase of $20.3 million—a figure approved without rancorous floor debate.

However, our leaders should be talking about culture right now. After all, one thing should be clear from our exploration of the impact of an unfettered marketplace, light-touch regulation, and an expanding web of

intellectual property constraints: our cultural system has become detached from the interests of the American people. And, at the end of the day, our loss of cultural rights reflects a failure of leadership—a failure to define and secure the public interest in art and art making, compounded by the repeated cave-in of government to the market-driven carving up of our collective expressive life. As media scholar Philip Napoli observes, cultural policy "has never resonated or developed in the policymaking sector as an explicitly defined and institutionalized field of governmental activity." We've paid a price: public policy in matters of culture has been poorly aimed, limited in scope, and astoundingly tolerant of incoherence and unintended consequences. And the absence of public-interest priorities in intellectual property law, trade in cultural goods, creative education, and access to heritage has allowed an unrestrained marketplace to cobble together an arts scene that serves narrow commercial interests. And to be blunt, over the decades things have gotten worse, not better; the quality of life—even the safety and security— of American citizens has been put at risk.

Even though the biggest part of our cultural system has been abandoned to corporate interests, government *has* dabbled in culture and the arts. But instead of a coherent, centralized approach to a policy process that might actually connect our arts system with public purposes, the biggest voices in and around government have decided that *content*— what we hear on CDs, read in books, watch on television, or view on an art museum wall—is the most meaningful target against which to deploy laws, regulation, or plain old political jawboning in order to improve the arts in America. It's a simple idea: if TV, radio, movies, and CDs are scrubbed free of sex and profanity, if government funding never lands on sex or political protest, we'll be a happier, healthier nation. From comic books to NEA grants to hip-hop CDs, cultural content has been exploited by our leadership for political purposes.

In his 2004 State of the Union message, President Bush encouraged parents, educators, and government leaders to "work together to counter the negative influence of the culture." We've already seen that around the world American music, movies, and television shows are both avidly consumed and soundly condemned; anti-American ideologues have

made the hedonism and reach of American popular culture a centerpiece of radical resistance. But that's not the "negative influence" the president was lamenting. It's here at home that parents of all political stripes have at times reacted with dismay to what television brings into their living rooms. Online, or on satellite or cable TV services, objectionable content sometimes shows up unexpectedly—even rising up as a sidebar to a family-friendly sporting event. As one father noted in an interview on the NPR program *All Things Considered*, "I don't know if you've tried to explain to a twelve-year-old a Viagra ad. I mean, it's not the most fun thing you ever did on a Sunday afternoon."

But America's generalized dissatisfaction with the way our cultural system works as it is reconfigured by politicians and pundits stops right here. It's all about *content*—the one component of art making protected from government interference by the First Amendment. It seems fair to assume that if Congress were to acknowledge any citizen "right" in relation to culture, it would probably be our right to protection from violence and sex in print, in movies, and over the airwaves. Of course, congressional meddling has mostly stopped short of legislation and regulation likely to be ruled out of bounds under the First Amendment, but elected leaders nonetheless found ways to "improve" the character of U.S. society by flexing government influence to counteract perceived harmful elements of art—usually depictions of violence or sex on television, movies, or in print. In 2004 Ken Paulson (then director of the Freedom Forum's First Amendment Center, later *USA Today* editor) argued that despite First Amendment protection, Congress has had a "significant say in the content of America's entertainment media and popular culture, particularly programs and products directed toward young people."

Remember, First Amendment protections are powerful but limited in scope. As sociologist Bruce Barry explains in *Speechless*, "The great thing about our constitutional system of free speech is that personal expression is presumptively safe from government interference. But the flip side is that personal expression is safe *only* from government interference." The intervention model fancied by legislators is simple and politically irresistible; even though the U.S. Constitution prevents Congress from dictating the content of films, books, or popular music through legislation,

members can use public hearings convened on Capitol Hill to browbeat arts companies into significant self-regulation. The political appeal of hearings on the content of culture is undeniable: they provide members of Congress with a perfect political moment—an opportunity to posture on issues that push the buttons of our body politic even as the Constitution prevents legislators from actually *doing* much of anything about them. However, companies feel the heat, often scrambling to come up with various mechanisms of self-regulation shortly after perspiring CEOs exit Capitol Hill hearing rooms.

The movies are a case in point: because the U.S. film industry can deliver graphic moving images and because its stock in trade is adventure and romance (read *violence* and *sex*), from its earliest days the business has been dogged by Congress and state and community officials concerned with the portrayal of values. By 1930 the infamous Hays Code had been set in place by studios that had, somewhat uncharacteristically, in the industry's early years, banded together in self-regulation in order to prevent legislation intended to restrict content.

The Hays censors lost their vise grip on movies in the early 1950s when the Supreme Court extended First Amendment protection to films, a move that paved the way for motion-picture lobbyist Jack Valenti's masterwork—an industry-generated age-based rating system that warned parents about content while freeing producers to pump up language, violence, and sexual content. But movie ratings didn't actually have the effect of removing constraints on content; just as Hollywood's creative leadership had chafed under the thumb of arbitrary Hays Code restrictions, some critics argued that the Motion Picture Association of America rating system continued de facto censorship—noting, among other things, that guidelines on sexual content, violence, or language were applied inconsistently. The threat of an X or, today, an NC-17 rating still encourages many writers and directors to excise explicit scenes or language even before the start of production, a form of self-restraint that ends up placing film in a more restrictive creative environment than literature.

And the written word—bastion of First Amendment freedoms—has not escaped the attention of elected officials. One form of literature, the comic book, came in for congressional scrutiny in the early 1950s. Fueled

by an exposé—*Seduction of the Innocent*, written by Dr. Fredric Wertham, the former senior psychiatrist for New York City's Department of Hospitals—the Senate Subcommittee on Juvenile Delinquency took up the notion that comic books exposed young people to criminal and sexually abnormal ideas (including the now-notorious allegation that Batman and Robin modeled male homosexuality). The subcommittee's top Democrat, Estes Kefauver, laying groundwork for his 1956 presidential bid, pursued the comic book industry with vigor. The 1954 "Kefauver Committee" hearings led the industry to create the Comics Magazine Association, quickly followed by the establishment of a code of conduct modeled on the one already established by the film industry. But the hearings and the "Comics Code" alarmed parents and chilled the industry; by the late 1950s two-thirds of crime comic-book publishers had gone out of business.

In 1985 the cause du jour was once again the corruption of youth, and Congress was again the landing place for public outrage. This time the culprit was rock 'n' roll lyrics, with the PTA and then the Parents Music Resource Center pressuring Congress to pressure record companies to label those CDs that contained violent, profane, or sexually explicit lyrics. Senator John Danforth, chairman of the Committee on Commerce, Science, and Transportation, convened hearings on rock lyrics in fall 1985. Like other congressional investigations into the content of art produced by U.S. cultural industries, the hearings disavowed any interest in regulating the music business and instead sought to use "moral suasion" aimed at "encouraging restraint." But the threat was more than implied; committee members were frank in asserting that if the industry didn't clean up its act, "there is likely to be legislation." Favorable publicity afforded the hearings made it all but impossible for the record industry to resist its critics, and the RIAA signed an agreement with the Parents Music Resource Center in 1989; by 1990 record companies were using stickers on CD packages to warn parents about "Explicit Content" within.

With the comic book, film, and recording industries sufficiently intimidated to create ratings systems, Congress turned its attention to violence on television. Although 1993 hearings produced conciliatory words, there was no immediate industry policy response aimed at self-regulation. But this time around legislators departed slightly from established patterns of

intimidation, shifting their attention away from ratings or self-imposed industry content constraints toward technology, and in 1995 passed legislation requiring every newly manufactured TV set to build in an electronic chip, enabling parents to selectively block programs based on a not yet developed rating system. The same law encouraged the industry to design and implement a rating system in a manner that would interface with the new V-chip, making certain that programming with violent or sexual content would automatically produce a parental alert. The V-chip mandate was bundled into the very 1996 Telecommunications Act that cleared the path to radio, television, and newspaper consolidation.

The ultimate impact of congressional inquiry aimed at encouraging arts industries to protect young citizens from the content of popular cultural has been uneven—comic books were transformed, CDs were "stickered," and TV didn't change much at all. But the *process* by which issues are brought forward, addressed in hearings, and sold to the public has been remarkably consistent.

There's an established pattern. Calls for government intervention are inevitably voiced in the language of concern—concern for the well-being of the American public and, specifically, for the safety and health of the nation's children. No matter whether sex or violence in movies, comic books, television, or popular music constitutes the subject of congressional indignation, the inquiry sets sail by fanning fears that the behavior and values of American youth are being undermined by the content of popular entertainment. Sometimes Congress is alerted by a book or statistical survey that purports to show "youth in crisis"; sometimes an event (the exposure of a pop singer's breast during a Super Bowl halftime show) moves Congress to action. And, once scheduled, hearings inevitably proceed formulaically—a rhetorical nod memorializing everyone's respect for the First Amendment, followed by an immediate shift to questions challenging the purveyors of objectionable content, berating the producers of offensive arts products for their role in subverting morality. A predictable cast of characters is trotted out; competing claims of authority are advanced; experts armed with thin research portfolios who nonetheless claim confidently that movie, TV, or video games cause violent or sexually irresponsible behavior are treated with every courtesy; researchers

who challenge the assumptions or conclusions underlying criticism of media are given short shrift or not consulted at all. Heaven help those artists or industry executives whose testimony challenges congressional authority in matters of cultural content: they are consigned to verbal duels with overbearing committee members perched at the high table. Throughout the process, the press serves as willing handmaiden to congressional investigators, headlining the sensational claims of doom-and-gloom experts predicting the decline of American youth while failing to challenge the most obvious causal assumptions that attempt to connect misbehavior with things that students watch, read, or listen to. And, once things get rolling, testimony frequently feeds the bottomless appetite for publicity that is the hallmark of modern-day national politics. As in the attacks on artists and the NEA that rumbled across both houses of Congress in the mid-1990s, hearings on the content of entertainment offer congressional blowhards an irresistible two-for-one value: they can attack the evil of big arts companies without expending much political capital, and they can generate gobs of press on hot-button issues that don't actually allow members to *do* anything. After all, no matter how belligerent the rhetoric, the Constitution shortstops most attempts to legislate content. Attacking the media offers Congress a rare opportunity to score public service points without having to engage in the hard work of actually passing laws.

Enter the FCC. No government agency is charged with oversight of movies and CDs, but the Federal Communications Commission possesses a specific mandate to serve citizens by ensuring that the broadcasting spectrum is used in ways that serve the public interest. Part of that mandate involves content; the FCC has had a say not only in things like the amount of advertising that can air in an hour or how political speech should be balanced on the airwaves but also in what kind of words and images are appropriate in broadcasts—especially in those TV programs that appear in time periods of likely family viewing. Congress can indirectly influence broadcasting by delivering mandates to the FCC, for example, by passing legislation that sets high fines for offensive speech.

As in comic books and rock and rap lyrics, at the beginning of the day it's sex and violence; at the end of the day it's violence and sex. In the past

five years Congress has significantly increased penalties for stations that air offensive content and has expanded the scope of legal responsibility. In late spring 2006 Majority Leader Bill Frist stood in the well of the Senate and argued on behalf of the imposition of tough new fines on broadcasters that air "indecent" language or images. "When families are watching Sunday night football games," he said, "they should not have to brace themselves for a televised striptease." Frist was referring, of course, to the infamous "wardrobe malfunction" that briefly exposed singer Janet Jackson's bare breast during the 2004 Super Bowl. The senator's colleagues concurred; in June 2006 President Bush signed legislation increasing fines for indecency in broadcasting tenfold—from $32,500 to $325,000 per incident.

Today FCC fines not only affect the broadcasting company that allowed sex or violence to show up on the air; they can also be levied on individual performers who utter offending words and phrases. It goes without saying that a $50 million contract helped inspire Howard Stern to move his "shock-jock" morning show to the Sirius satellite radio system. It's also clear that Stern was seeking an environment in which the free-form sexual exchanges that are the hallmark of his show would not continuously subject his on-air team to government scrutiny and potentially devastating fines. Stern's confidence in a satellite broadcasting system free of content restriction may have been overly optimistic. Although nothing has happened yet, within days of occupying his Twelfth Street office in Southwest Washington in spring 2005, new FCC chairman Kevin Martin expressed agreement with Congress's desire to assert greater authority over the content of broadcasting, even indicating enthusiasm for extending agency regulatory powers into cable television and satellite radio, fee-based services that to date have not been regulated as "broadcasters."

But recent experience has shown just how difficult it is to apply an even hand in enforcing rules that target indecency. When Bono mouthed the "f-word" in a spontaneous awards show acceptance speech, the FCC first declared the word incidental—a "fleeting expletive"—but later cited the show for a violation. Despite chest-thumping by Congress and the FCC, our courts have been dismissive of efforts to punish the fleeting

appearance of obscenity. In 2007 the U.S. Court of Appeals for the Second Circuit in New York struck down new regulations fining broadcasters for incidental outbursts. As Stephen Labaton reported in the *New York Times*, the court determined that "if President Bush and Vice President Cheney can blurt out vulgar language, then the government cannot punish broadcast television stations for broadcasting the same words in similarly fleeting contexts."

Early in 2006 the FCC fined a public broadcasting station for airing the Martin Scorsese–produced documentary *The Blues: Godfathers and Sons.* Why? The film contained numerous obscenities—exactly the kind of language to be expected in an intimate look at grassroots musicians in a casual offstage setting. However, in an earlier decision the commission had ruled that the film *Saving Private Ryan* would *not* trigger fines when it was the subject of a network broadcast, because profane language is allowed "where it is demonstrably essential to the nature of an artistic or educational work." Commissioner Jonathan Adelstein dissented in the public broadcasting decision, arguing that fines targeting legitimate documentary films "could chill the future expression of constitutionally protected speech." In papers filed with the FCC in 2006 four major networks agreed with Adelstein: "To avoid exposure to enormous indecency penalties, creative personnel censor themselves because of the risk that they will misjudge what the current commissioners find offensive."

Congress has remained undaunted by judicial skepticism and media confusion about suppressing passing expletives. In July 2007 Senator Daniel Inouye (D-Hawaii) was "aggressively preparing" legislation that would regulate foul language and violence on television, including things like "fleeting instances" of the f-word. But do Americans possess, or even desire, a *right* to government-regulated content in entertainment media?

Perhaps. But public outrage in response to offensive radio and television has never been especially broad-based. In fact, the impressive total number of e-mails and blast-faxes on most media issues doesn't represent the work of a random assortment of citizens but rather the support base of one organization—the conservative Parents Television Council. And what are we to make of attempts by policy makers to intervene in the content of American popular art and entertainment? Congress has been

flexing its power in order to pressure America's arts industries toward self-regulation for seventy-five years; clearly, tweaking the content of popular culture in order to improve society has become a kind of cottage industry for U.S. politicians.

Have any of these inquiries and excursions into self-regulation produced the desired results? Have youthful values and behaviors improved because Congress intimidated our arts industries? As novelist Jim Harrison observed, "Sexual content on TV is avidly discussed in Congress as if there were no sexual content in life"—a contradiction that makes it unlikely that reforms dreamed up on Capitol Hill will succeed in reconfiguring reality.

Evaluated as a means of producing change in the well-being or behavior of America's youth, the results of these efforts appear spotty at best; some interventions don't seem to have acquired much support from the citizens they purportedly protect. Clearly, both the early Hays Code and the more recent rating system have had an impact on the content of motion pictures; producers and directors go to great length to avoid the dreaded NC-17 rating. But how hard is it for a fifteen-year-old to sneak into (or rent) an R-rated picture? TV content control seems to have been greeted by American parents with a collective yawn; a 2001 Kaiser Family Foundation study found that of those families who owned a set with the V-chip installed, less than 20 percent made use of the system. In a similar fashion, parental advisory stickers attached to CD packages have obviously not affected the popularity of many youth-oriented releases that contain violent or sexually explicit language. In fact, some observers have suggested that R movie ratings and cautionary stickers affixed to CDs are, in effect, advertisements that actually draw young people to content that may be more alluring, more sensational, or just plain more fun than a PG- or (heaven forbid) G-rated alternative.

It's one thing for regulation by intimidation to be ineffective—no harm, no foul. But the unintended consequences of legislative badgering raise troubling questions about the relationship between public policy and the U.S. arts system. At the very least, the threat of a congressional tongue-lashing creates an atmosphere supportive of self-censorship.

When the *Imus in the Morning* program was canceled in spring 2007 because the host uttered objectionable sexist and racist comments during

voiceovered improvised banter describing the talented Rutgers University women's basketball team, it was not because making racist or sexist comments is illegal—our First Amendment won't permit such legislation—or because it's regulated by the FCC. The FCC enforces rules prohibiting obscene comments but not those that are politically incorrect. It wasn't government that took Imus down but the loud voices of pundits like Al Sharpton and Jesse Jackson, amplified by Internet blogs and cable news services and reinforced by corporations that quickly threatened to pull advertising from the offending networks. By the time the Rutgers team "forgave" Imus for his offensive comments, he was long gone—the victim not of government censorship, but of media influence and corporate power deployed to enforce unwritten standards dictating correct political speech. What does the First Amendment really mean if media and advertising cán be so easily prodded to shut down constitutionally protected content?

In response to this unlegislated censorial mood, Ken Burns's documentary *The War*, aired in fall 2007, was offered to PBS stations in two versions—one with obscene words (scattered throughout the fourteen-and-a-half-hour program) bleeped out. Burns's company also promised to indemnify stations against FCC fines. A few days after the Burns announcement, the ugly confusion surrounding offensive language developed into a series of stunning examples of excessive self-censorship. On the night of August 16, 2007, the Fox network used a tape-delay on the live Emmy Awards telecast to excise an antiwar statement by actress Sally Field, ostensibly because her rant included a fleeting profanity: "goddamn." The next morning CNN reported that basketball coach Isaiah Thomas, in a court deposition, stated that the term *bitch* applied to a black woman by a white man was more offensive than if it were uttered by someone black. CNN, in reporting the story, repeatedly bleeped the offensive word. The next evening host Chris Matthews of MSNBC's *Hardball* program, reported both stories and used the words *goddamn* and *bitch*, after noting that each was "offensive." (Note that, to date, the FCC has not indicated that either *bitch* or *goddamn* is obscene. They are, in fact, nothing but words that some find offensive.) Threats of FCC fines and corporate timidity have empowered unelected, unknown network employees

to arbitrarily edit the speech of citizens. You don't need a CSI technician to find the fingerprints: this *is* government censorship.

More than a decade ago the Blockbuster video rental chain announced that it would not stock any movies that had earned an NC-17 rating; we've seen that Wal-Mart has employed similar shorthand in determining which CDs to include in its vast distribution system—it won't stock anything with a parental guidance sticker. This is all legal. Although it may look like censorship, retailers are free to sell or ignore any product they please, for any reason. But in an arts system in which success demands tapping multiple revenue streams controlled by a shrinking number of outlets, decisions at retail level flow upstream into headwaters of the creative process. Movies, TV shows, and musical recordings require significant upfront investment; what company would knowingly put that investment at risk by producing art products that would almost certainly be excluded from big-box retail and multiplex theater chains?

Congress and compliant industry watchdogs may strive to preserve or improve values by regulating art, but in reality the depiction of "values" is nuanced and inevitably vague. In contrast, a ratings system must be consistent and clear, so a few bare buttocks in a shower room scene can earn a film an R, while a story line that exploits female sexuality in the workplace ends up rated PG. Don't get me wrong, the character of America's music and drama is an appropriate object of public attention, and it is fine for any society to come together, for example, to develop policies that would limit contact between young citizens and age-inappropriate movies and music, but is it really our intent to chill creativity by manipulating our system in ways that not only prevent young people from *consuming* challenging content but also inadvertently prohibit America's creative community from *producing* it in the first place? Of course, there is no actionable offense to our First Amendment rights when some corporation decides on its own *not* to produce or distribute an arts product, but Foucault-style self-regulation in broadcasting, the movie multiplex, or in retail gets awfully close to censorship, especially when creative caution is set in place by fear of congressional or federal agency retribution. Most Americans view our society as a bastion of free speech. But with media and corporate power poised to limit expression, the reality of free speech in the United States may be a conceit mostly honored in the breach.

And there exist troubling undercurrents in congressional excursions that might otherwise constitute little more than entertaining sidebars in the legislative process. For one thing, once we move thirty or forty years past these congressionally imposed industry regulations, both the issues they address and the solutions imposed almost always appear trivial.

Were comic books really a threat to youth? Viewed from the perspective of the twenty-first century, such a notion seems, well, comical. And what about married couples forced to appear on screen in twin beds, or the idea that a movie should never depict a criminal character in a sympathetic light? These interventions in the creative process, once advanced with chin-stroking solemnity, today seem laughable.

Meanwhile, through the decades, measurements of crime rates, teen pregnancy, drug and alcohol abuse, and other indicators of values-in-action among young citizens have gone up and come down without any apparent linkage to mass culture trends. Should we be surprised that, after the fact, punditry never seems to tie a measured uptick in positive youth behavior (a decline in teen use of street drugs, for example) to the collapse of comic-book publishers or the installation of V-chips. Instead, post facto explanations gravitate toward the economy, educational policy, and law enforcement—the standard ingredients of social change that are the currency of legitimate public policy.

Actually, real expertise has almost never endorsed the view that entertainment dictates behavior. In fall 2000, in a long opinion piece in the Sunday *New York Times*, author Richard Rhodes debunked the TV-violence myth. "In fact," Rhodes writes, "no direct, causal link between exposure to mock violence in the media and subsequent violent behavior has ever been demonstrated, and the few claims of modest correlation have been contradicted by other findings, sometimes in the same studies."

The FCC's own 2007 report on "Violent Programming and Its Impact on Children," after presenting a predictably sensational overview of the "problem," offers the following nearly buried disclaimer: "Most researchers and investigators agree that exposure to media violence alone does not cause a child to commit a violent act, and that it is not the sole, or even necessarily the most important, factor contributing to youth aggression, anti-social attitudes, and violence."

If "most researchers and investigators" don't see a serious problem, what are we up to? Perhaps these popular congressional and regulatory excursions, which can seem compelling when initiated, are nothing but frivolous meddling—a fleeting pseudo–news moment that makes it more difficult for American filmmakers, record executives, and TV producers to do their jobs. But the allure of content restriction must be taken seriously; anyone who cares about our right to a vibrant U.S. arts system must remain aware that tinkering with content has been, for the past century, the most favored cultural policy exercise in America. It is the responsibility of all of us who care about culture to point out, again and again, that congressional intimidation of arts industries has produced few demonstrably good results and many bad ones, not the least of which is the capacity of a congressional sideshow about comic books, fake violence, or a momentary flash of nudity to distract us from the very real problems that tilt America's cultural landscape away from public purposes.

· · · · ·

Nonprofit arts have come in for their share of congressional tomfoolery, but for the fine arts community, government involvement in culture has come to be almost only about money—federal funds appropriated for cultural institutions and tax policy favoring tax-exempt organizations. But funding agencies have also been subjected to political attention more intense and no less cynical than attacks on comic books, sex on television, and rock lyrics.

Our federal government established the Fine Arts Commission to review and approve the design of buildings and monuments in Washington, and the Roosevelt administration made artists part of Works Progress Administration worker relief programs, but the most visible connection between culture and the federal government is the National Endowment for the Arts. Established in 1965, the NEA first gave matching grants to cultural nonprofits late in the decade. In an acknowledgment of the NEA's impact, by the 1980s a national fine arts sector had been motivated to organize as an interest group in order to lobby both the agency and Congress. Through the efforts of "service organizations" like the American Symphony Orchestra League (now the League of

American Orchestras), Dance/USA, or the more inclusive Americans for the Arts, elected officials and public agencies were encouraged to sustain the NEA, fund arts education, and support cultural organizations. In a sense the presence of the Arts Endowment as a hub of public engagement with art narrowed the focus of cultural policy work, keeping the nonprofit community to the side of debates over intellectual property rights, media regulation, or issues affecting the content of movies, television, records, and radio. It's true that art museum directors have lobbied on behalf of tax breaks for artists who might donate collections to museums, and nonprofit groups have complained when changes in immigration policy made it difficult for visiting artists to enter the United States, but these are exceptions that underline the rule: there's been little arts-community interest in much beyond funding programs. It's been all about grants, and advocacy efforts aimed at increasing federal grant support have been replicated at the state and local levels.

Arts advocates have always argued that the federal government does too little for culture—a position that's often supported by one of the biggest red herrings in policy work: the comparison of national per-capita funding in a country with a ministry of culture—like Germany or Finland—with annual per-citizen expenditures by the National Endowment for the Arts. Cultural ministries often spend the equivalent of $60, $70, or even $80 per year for each citizen; in contrast, the NEA budget (about $130 million) by itself yields less than 50 cents for each American.

What a travesty! How can we allow such a condition to persist?

The comparison, of course, is classic apples-to-oranges. As I learned firsthand in my occasional role as our nation's slightly ersatz cultural minister, full-blown government cultural agencies in most countries exercise mandates far broader than does the NEA, often footing the bill for the operation of national and regional museums and performing arts centers while also financing the kind of trade and regulatory programs that lie totally outside the Endowment's portfolio. We've already seen the way the U.S. divides authority in heritage, trade, media regulation, and arts education among many federal agencies and congressional offices: we do the same thing with public support. If we pull back for a long view, we can see that the United States invests plenty of taxpayer dollars in culture;

it's just not coherently organized, nor is most of it channeled through the grant-making programs most familiar to the arts community.

A January 2007 report assembled by the NEA, *How the United States Funds the Arts,* sketches the beginning of a more complete story by adding non-Endowment sources of federal support into the government total. These figures, combined with the contributions of state and municipal governments, reveal a more robust investment of public money in cultural work. Here's how the 2006 appropriations played out (in millions of dollars):

Local arts agencies	$778
Smithsonian Institution	517
Corporation for Public Broadcasting	460
State arts councils and commissions	328
Institute of Museum and Library Services	247
National Endowment for the Humanities	142
National Endowment for the Arts	124
National Gallery of Art	95
Department of the Interior	28
Kennedy Center for the Performing Arts	18
Department of Education	13
Advisory Council on Historic Preservation	5
Department of State	5
Commission of Fine Arts	2

These annual federal appropriations total almost $2.8 billion, *without* including funds provided to agencies like the Voice of America or other radio and TV outlets of the Broadcasting Board of Governors, substantial arts programs in the Departments of Defense (our military spends about $100 million) and Transportation, or more modest cultural projects like the commissioning of artwork by NASA, the U.S. space agency. Even without tracking down every government cultural dollar, our almost $2.8 billion total provides Americans with government arts spending of more

than $9 per citizen—not the equal of some European systems, but nothing like the pitiful 50-cent figure decried by some nonprofit arts leaders.

True, France, with a population of 64 million, funds its Ministry of Culture and Communication at a significant level—nearly 3 billion Euros annually. At current levels of exchange, that translates to about $80 per citizen. But the total is deceptive because, as the name of the agency implies, the French ministry does far more than pay for performances and exhibitions; it regulates broadcasting, like our FCC, manages 38,000 historic sites, far more than our Interior Department, and promotes global trade in French cultural goods, like the Office of the U.S. Trade Representative. Carve away the multiple "divisions" and "administrative boards" that bloat the French ministry, and the annual amount actually dedicated to art and art making lands well below the $80-per-citizen figure that U.S. arts advocates trot out in alarmist comparisons.

And remember, unlike most European and Asian governments, the United States has used the power of government not just to spend money, but to implement tax policy that uses deductions to redirect potential tax revenue toward charitable purposes, including cultural philanthropy. Because of the tax code, the U.S. has been able to secure one positive result from the otherwise problematic link between fine arts and social and financial elites: a highly evolved tradition of private giving to arts organizations. Although we have seen that the arts have not maintained their "market share" of total giving in the U.S., it remains impressive to citizens of other nations that individuals, corporations, and foundations gave more than $13.5 billion to "Arts, Culture, and Humanities" in 2005.

By taking a closer look at the numbers, and at the massive expenditures required by the broad mandates of most cultural ministries, it's clear that the disparity between government funding here and in other countries has often been exaggerated. However, it *is* fair to emphasize that, like legislation and regulation that shape arts policy, government funding is parceled out among many agencies possessing distinct and even conflicting mandates. So, while dollar totals may be impressive, money available for a specific agency or single purpose might be inadequate. Witness the Smithsonian Institution: it receives more than $500 million in annual appropriations but still must raise private money for major capital

improvements and most special programs. Thus, inevitably, coordinated efforts are all but impossible; the overall spending may be in place, but in our system it would be unthinkable to plan a major initiative that depended on different agencies giving up control to pool resources around an exhibition, tour, or facility. Again, we could do a better job if arts work and cultural regulation were the responsibility of a department of cultural affairs, for although total U.S. government funding is significant, the division of authority among many policy actors seems to perpetuate a bleak reality—the government-funding whole appears something less than the sum of its various parts.

Although direct support of nonprofits is modest, government grants to culture have overachieved as a source of controversy. Despite the fact that the nonprofit world has concentrated political advocacy on securing government support for arts organizations and their projects, it has found itself caught up in the same kind of political posturing that periodically swirls around movies, broadcasting, and the record business.

Some of my progressive friends claim that Republicans don't actually want the U.S. Supreme Court to overturn *Roe* v. *Wade*. "They don't want their core constituents to be satisfied," they say. "They want to stir people up by keeping the issue alive." Back in the 1990s the same thing could have been said of the National Endowment for the Arts; our cultural agency was threatened with elimination, but many who criticized it would have been disappointed had it really gone away.

I saw it firsthand.

As NEA chairman working to restore good relations with the Hill, I met one-on-one with well over two hundred members of Congress. One afternoon I'd taken a meeting with the chief of staff serving John Shadegg, a conservative Republican from Arizona who was then head of the "CATs"—the secretive Conservative Action Team (now called the Conservative Study Group) that set the informal agenda for far-right Republican members of the House. I patiently explained the changes that had been made at the agency, how we were helping communities realize their dreams through the arts with our Challenge America initiative. He was nodding his head in agreement as I made my points and seemed to be getting the message. About fifteen minutes into the meeting I asked what he

thought; would his boss support us? As I remember it, he said: "You're doing a great job, but we're still going to oppose you: *you're just too good an issue for us.*"

So I shouldn't have been surprised when John Podesta, President Clinton's chief of staff, called me at home on a cold night in January 2000. "We just couldn't get it done," he said. The president had tried, he indicated, but the NEA was the last issue that wasn't agreed on in the whole federal budget. Congress knew Clinton wasn't going to shut down the government over the little arts agency. John had gotten the message; three years after the NEA had had its budget trimmed, more than two years after Jane Alexander had exited the chairmanship, the Endowment remained such a signature issue for congressional conservatives that they wouldn't budge on a $5 million or $10 million increase for a small agency, even when it was the final point of disagreement between the White House and Congress on the 2001 budget.

It took another year before the hard work on Challenge America paid off, and the NEA earned its first budget increase in a decade. But early in 2000 we were still under a dark cloud of congressional suspicion.

"You're just too good an issue for us."

True enough. We were a perfect punching bag for congressional conservatives. Like comic books, dirty words on radio, and violence in computer games, NEA grants could serve as tinder fueling the passions of constituents on both the left and the right. But, for the NEA, no First Amendment protections stand between arts grants and Hill critics; because the NEA is a federal agency dependent on Congress for its budget and for its very existence, what happens on the Hill can make a real and direct difference. The rhetoric might echo decades-old attacks on rock 'n' roll or sex on television, but when the target is federal funding for the arts, congressional displeasure can have real-world consequences.

The NEA does outstanding work. I was proud to serve as chairman and found both the career professionals and political appointees who staffed the Endowment to be smart, hard-working, patriotic, and deeply committed to the agency's mission. But by the time I arrived both the staff and outside arts advocates were demoralized, beaten down by congressional critics and rabble-rousing right-wing pundits. Artist groups had

also turned hostile; for a time the Endowment received far more negative attention than a small federal agency deserved. It's important to recall that NEA skirmishes during the "culture wars" (1989–96) were sufficiently intense to, for a time, turn the letters *N-E-A* into a household phrase. (Today the NEA initials have been restored to the National Education Association, but in the mid-1990s teachers were shoved aside; when anyone said the letters *NEA*, they actually *meant* "National Endowment for the Arts.")

The bill first authorizing the agency was on President John Kennedy's desk awaiting his signature in November 1963, when he left Washington on his fateful trip to Dallas. After years of lobbying and much compromise, the NEA launch was a successful "handoff" of funding from nonprofit grant makers to the government, transferring key components of programs pioneered by the Ford and Rockefeller Foundations. Not unexpectedly, many of the same arts leaders who shaped the character of foundation support for the arts had lobbied Congress on behalf of the new arts agency. So it should be no surprise that the Arts Endowment came out of the gate charged first with nurturing the same icons of America's inherited tradition of refined European art—opera and dance companies, orchestras, art museums—that had received attention from the big New York–based foundations. After exploring a number of alternatives (including ministry-of-culture concepts like a national theater company) the new agency settled on two approaches to nurturing the arts: matching grants to an arts organization (the Ford model) and individual artist fellowships, both awarded on the basis of expert panel review. (By its fortieth anniversary, in 2005, the NEA had awarded more than 124,000 grants.) Over the years, because of predictable political pressure applied by artists' interest groups, the Endowment's personality became more "American" and more attuned to grassroots art making. Programs in jazz, folk arts, design, musical theater, and media moved in from the margins, broadening the mandate of the agency.

The NEA was never very big as government agencies go. At its peak in the early 1990s, its budget totaled $176 million; of that total about $135 million was available for grants. For fiscal year 1996 the entire annual appropriation was reduced by more than a third, to just over $99 million.

The low point of the culture wars was in fiscal 2000, when the budget fell to just over 97.5 million. (With a lot of effort, during my tenure as NEA chairman, we turned things around; we hit $115 million for fiscal 2002, and the agency worked with over $124 million in fiscal 2007.)

Defended by lawyers, represented by lobbyists, and protected by the First Amendment, broadcasters and movie studios could stand up to Congress and controversy. The situation of the Arts Endowment was different. One of the "grace notes" of public policy, the NEA made the mistake of acting as though it was a player in the Washington political game. It was actually the ball. How did our terrific arts agency get itself into so much trouble?

Culture war issues were familiar to agency staff long before things got really bad in the 1990s; controversy surfaced before the NEA was a decade old. In the 1970s Congress was outraged when a "thank you" to the Endowment appeared in Erica Jong's *Fear of Flying;* the work of poet Aram Saroyan (his one-word poem "lighght") was ridiculed on the Senate floor; a visual arts crepe paper project earned the agency Senator William Proxmire's notorious Golden Fleece Award. The Erica Jong controversy typified tension between some members of Congress and the small arts agency. Not only did it foreshadow a more consequential conflict twenty years ahead, but it also introduced one of the NEA's most tenacious antagonists: Jesse Helms, the North Carolina senator at the center of the 1974 attack and later challenges to the Endowment. Helms strongly objected to the NEA's fellowship support for work on Jong's blockbuster novel and wrote to NEA chair Nancy Hanks positing two possible explanations for Jong's fellowship. "You either 1) deny that it is filthy and obscene," Helms wrote, "or 2) consider it a manifestation of 'art' which the taxpayers should support. . . . In any event, would you please be good enough to supply me with an explanation of the mentality in your agency which prompted the disbursement of funds for such a purpose—in the name of art?"

Hanks responded to Senator Helms's questions about the Erica Jong grant this way: "It was on the basis of [previous] work that the fellowship was awarded to her. In this case, as in all fellowship awards, the Endowment exerts no control over the work the artist does after receiving the

grant. . . . It is the Endowment's position that excellence should be supported without restrictions, in order to prevent Federal assistance from becoming Federal control of the arts."

Helms's reaction was prickly: "Why did you not answer the questions in my letter of June 12?"

Hanks attempted to deflect Helms's strident second letter by explaining in her reply the panel system through which "outside experts" selected fellowship recipients, concluding her response by quoting one of her own speeches: "Nurturing the broad range of the Nation's creativity is far more important than the few tempests that arise."

The early Helms/Hanks back-and-forth is revealing and established a pattern for both the manner in which congressional critics addressed the agency and the tone of future NEA responses. Helms was polite, direct, tendentious, and a bit testy; Hanks took refuge in procedure while waxing poetic about the Endowment mission; her tone was that of a knowledgeable expert gently instructing the unwashed. Neither side in the early dust-ups seemed interested in compromise, and that underlying approach never changed. Back then, Hanks could afford to be condescending. She had solid support in a solidly Democratic Congress. Given the firm backing of a few key congressional Democrats, Helms's early complaints couldn't affect NEA appropriations, but the seeds of more damaging future conflict were well planted during the skirmishes of the 1970s. Congressional critics viewed the agency as self-absorbed and unresponsive to oversight by the legislative branch; the NEA saw critical voices as those of unsophisticated philistines incapable of comprehending the essential character of its work on behalf of creativity and artistic innovation. These positions only hardened over the years, taking on new significance decades later when congressional criticism acquired a new partisan bite.

When the NEA was attacked in the mid-1990s, its budget cut by more than one-third, agency staff and supporters felt blindsided by right-wing critics. However, its near-death experience was no sudden tsunami but a kind of perfect storm in which politics, congressional policy, history, ideology, and long-standing NEA practices came together in a mash-up that very nearly blew the arts agency away. In the 1970s and 1980s, rail as they

might, conservatives like Jesse Helms were stopped cold when it came to disciplining the NEA for a simple reason: for nearly two decades after the creation of the NEA, powerful supporters in the Democratic congressional majority and the seniority system that assigned power and autonomy to committee chairs combined to keep agency critics at bay.

When Republicans lost control of Congress late in 2006, their twelve-year run in the majority had made Democratic control a distant memory. In addition to reassigning oversight of rules, appropriations, and confirmations, Congress reconfigured long-standing practices established in the era of secure Democratic majorities. For one thing, in the earlier era Democrats held committee chairmanships on the basis of seniority. Thus, chairs were remarkably independent of the "whips" and leaders of their own party. Opinions of the minority party, no matter how stridently conveyed, could pretty much be ignored. The seniority system enabled committee chairs to assemble their own agendas, fund favorite programs, and protect or advance policies and agencies that they favored.

Then, as now, NEA appropriations (and funding of the Humanities Endowment) were part of the Interior Appropriations Bill—the same legislation that funds national parks, Native American education and health care, the Smithsonian Institution, and Smokey the Bear. Through its first twenty years of operation Sidney Yates chaired the subcommittee in the House that set the level of Interior appropriations. In the Senate Claiborne Pell chaired the committee charged with authorizing the agency itself. Although both leaders gently questioned agency practices from time to time, each was an ardent supporter of both endowments, and each was capable of ensuring regular budget increases, no matter what.

The two endowments were always something of an anomaly in the array of federal agencies. In addition to supporting nonprofits, both gave government grants directly to individuals—few government agencies disburse funds this way—and the grants process was not implemented by elected or appointed officials but by professionals skilled in often-arcane academic disciplines and artistic practices. Further, NEA fellowships recognized an individual's past achievements; there was no telling what an honored artist might do in the future with agency funds. Protected from outside interference by seemingly unshakable congressional

support and tasked with developing its own systems for the disbursement of funds, the NEA developed a distinct internal culture. One part of that culture comes through in the aloof, slightly disdainful tone of the Helms/Hanks exchange. A second and related component of the agency's self-image arose in funding visual artists—the conviction that it was the agency's job to invest in "cutting-edge" art making, in the most inventive, most contemporary, and most advanced work going on in the multiple art forms supported by the NEA.

In most arts fields agency commitment to the avant-garde was folded into programs that supported a range of artistic practice; contemporary classical composition was funded, but so were projects involving works by established European masters. Likewise, in literature, the NEA supported experimental poetry, but many of its fiction fellowships went to writers of solid, conventional novels and short stories.

However, things were different in the visual arts. Here the agency's dedication to contemporary, modern, evolved, cutting-edge work legitimated a relatively narrow band of artistic practice—art making closely intertwined with the views of influential critics and artists associated with the gallery and museum establishment of Lower Manhattan. The cutting edge became the Endowment's visual arts mainstream.

Early in the Clinton-Gore administration, Claiborne Pell asked the NEA staff to assemble slides of "representational painting" that had been supported through NEA visual arts fellowships. A senior agency staffer found that there basically weren't any: no plein air landscapes, no marine painting, no portraits, and certainly no wildlife art. A glance through the NEA's 2001 listing of the Visual Arts Fellowship Program confirms the impression: with the exception of photography, few reproduced examples of fellows' work are straightforward representational paintings.

It shouldn't have been surprising: the NEA's Visual Arts Program had been, from the outset, pretty much hijacked by a three-pronged curatorial vision that wanted nothing to do with realism. This version of modernism combined Duchamp's "art-is-what-the-artist-says-it-is" with bohemian antagonism toward the bourgeoisie, both bundled into a commitment to abstraction, especially the kind of work that moved beyond abstract expressionism to honor, as Tom Wolfe puts it in *The Painted Word*,

l'art pour l'art, form for the sake of form, color for the sake of color." This stuff came directly from the New York gallery scene and was carried to the NEA by the agency's first two Visual Arts directors, Henry Geldzahler and Brian O'Doherty.

Geldzahler was a curator at the Metropolitan Museum of Art, pioneering the museum's Department of Twentieth-Century Art. Carter Ratcliff, writing in *Art in America* in 1965, noted that Geldzahler subscribed to "Clement Greenberg's argument that modernist painting progresses by clarifying its own, purely pictorial concerns." Never completely severing his ties to the Met, Geldzahler remained yoked to the New York art scene after he became director of the Visual Arts Program in 1967, injecting the agency's vision with modernism's dedication to pure color and flat canvases.

It was Geldzahler who developed the early mechanism for disbursing funds to visual artists, settling on an approach that divided the country into regions, soliciting nominations from each. But as journalist and critic Michael Brenson points out, despite regional distribution, Geldzahler's view was narrow: "There really was essentially one standard of artistic quality and the number of artists who met it was limited. . . . Geldzahler . . . took for granted that New York was the center of American art and culture. That is where he lived. That is where his heart was." Geldzahler's approach to grant making was casual to a fault: he solicited recommendations from curators, artists, and collectors, for the most part people who thought just like him. These were heady, improvisatory times, and despite the deficiencies of process, Geldzahler gave the new program, in Brenson's words, "visibility and flair." "Because of his museum affiliation and his reputation as a devotee of the new, he helped give the NEA a reputation for adventurousness." That "reputation for adventurousness" would be reinforced by his successors and agency leaders, only to place the agency in hot water in 1994, the year Geldzahler died and the Republican Party finally took control of Congress.

Geldzahler was followed in the visual arts position by Brian O'Doherty, a trained physician, *New York Times* art critic, editor of *Art in America*, and conceptual artist who showed his own work under the pseudonym Patrick Ireland. O'Doherty brought intelligence, dedication, and

versatility to the agency and introduced a peer-panel grant review process that was a distinct improvement on the informal, old-boy approach favored by Geldzahler. O'Doherty also shifted fellowship criteria from the recognition of artistic achievement to the encouragement of talent and artistic promise, thereby focusing grants on future work and opening the door to greater support for younger, experimental, "emerging" artists. Further, O'Doherty was masterful at advancing core ideas within the NEA bureaucracy, and his devotion to formalism over amateur practice and craft and to the importance of individual artists within the larger society grafted these concepts to the agency's DNA.

But O'Doherty could seem arrogant and dismissive, tightly focused on ensuring that the agency responded to the "most inventive and adventurous artists." Where Geldzahler emphasized purity of line and color, O'Doherty valued message. His own artworks were conceptual and highly political, a combination that became another hallmark of Endowment-supported work. Like his predecessor, O'Doherty was convinced that the values of the New York art scene represented the ultimate evolutionary stage in visual art. (When Geldzahler held the NEA post, he continued to reside in Manhattan; O'Doherty stayed in Washington during the week but returned to New York City on weekends, presumably to refill his tank from the rivers of creativity freely flowing through SoHo.)

O'Doherty joined the Arts Endowment staff in spring 1969, a few months before the agency's legendary chair, Nancy Hanks, came on board. Hanks, like her predecessor, Roger Stevens, knew very little about visual art, and O'Doherty, focused, charming, and versed in highbrow arts theory, quickly made himself one of her favorites. His views on art soon became Arts Endowment dogma.

What Nancy Hanks brought to the Arts Endowment were remarkable political skills honed during her decades-long personal and professional connection with Nelson Rockefeller. Working for Rockefeller philanthropic interests in the early 1960s, just as the Ford and Rockefeller approaches to increasing the supply of fine arts were being developed, Hanks internalized the priorities of big-city philanthropy that fueled investment in major cultural institutions. She lacked an understanding of the unique dynamics of American culture and never had an intellectual's

grasp of how an agency might best serve our cultural scene. Instead, Hanks attacked her new government post with a classic southern belle's mixture of finishing-school polish and steel resolve perfectly suited to backroom politics, budget tussles, and black-tie opening nights. She focused on growing the agency's budget, making annual increases a marker of Endowment success. Poorly equipped to challenge O'Doherty's priorities intellectually, Hanks enabled his commitment to experimental, political, cutting-edge visual art and his conviction that "the essential decisions about art should be made by arts professionals." Both ideas became tenets of NEA ideology. If the NEA's ability to charm and disarm critics in a congressional hearing was pure Hanks, a dismissive letter to an outraged senator was Brian O'Doherty—all the way.

The NEA flourished through the 1970s and 1980s: budgets increased, the staff grew, and programs in jazz, folk arts, and design gradually democratized the agency's portfolio. But the NEA's success depended on a delicate arrangement of forces that could easily be undone. Changes affecting the political landscape—some big and others insignificant in their own right—combined to make the crisis of 1995 virtually inevitable. As we've seen, the end of the cold war quietly eliminated an important justification for government support for the arts—especially direct support to individual artists. American visual art, abstract expressionism in particular, had been a terrific metaphor for our democratic freedoms, standing as a pointed rebuke to the stilted, message-driven imagery of Soviet socialist realism. However, once the battle with Russian Communism had been won, establishment discomfort with modernism and artistic lifestyles that had been set aside during the cold war gradually resurfaced.

There were other changes in the NEA's political stage set. By the early 1990s issue-driven cable news channels had emerged, and Congress itself was on television—the quiet backroom negotiations that allowed small, nonessential government programs to navigate the political landscape were now out in the open. And the demise of the FCC's "fairness doctrine" made it possible for new TV networks to take sides in a debate and run with a slanted story ad nauseum. The fax machine, unheard of only a few years earlier, had by the mid-nineties driven New York and DC bicycle

messengers out of business, but, more important, this technology made it possible for advocacy groups all over the country to flood congressional offices with thousands of position letters in a matter of hours. During the same period, the Christian right emerged as an aggressive conservative voice on the national political scene; Christian conservatives were trolling for signature issues. Gay and lesbian artists had always maintained a visible role in the U.S. cultural scene, a drumbeat affront to the "family-values" crowd. Adding volatile energy to our perfect storm, the emerging AIDS epidemic had begun to spin off vast quantities of free-floating anger, distrust, and fear within the arts community and on Capitol Hill. Finally, the Endowment drifted into the greatest sin of all—spending too much of its money in one place. By 1992, complacently honoring its fine arts, big-institution heritage, the Endowment made 25 percent of its grants and sent 24 percent of its grant money to one state: New York.

But key Democratic committee chairmen still blunted the effect of criticism, and the budget remained robust; through the 1980s arts advocates had little apparent reason to worry. However, the NEA's ability to maintain and increase appropriations despite a low-level buzz of congressional criticism was dependent on support that was a mile deep but only an inch wide. It was support that could be sustained only by a healthy Democratic majority and by the seniority system of committee chairmanship that enabled long-serving members like Yates and Pell to protect the NEA and grow its budget even though conservative members of the minority party attacked agency work. In retrospect, it's easy to see that because the NEA had done little to placate congressional critics, the agency was poised for political freefall once the tent-pole support provided by Democratic committee chairmen was knocked away.

The storm, or at least some preliminary showers, actually rolled in as early as spring 1989, when the Reverend Donald Wildmon of the conservative, Mississippi-based American Family Association activated Senator Helms (and others), first, on the subject of Andres Serrano's *Piss Christ*, a glowing amber photograph of a crucifix submerged in what the artist claimed was his own urine, and, second, on the homoerotic content of the posthumous Robert Mapplethorpe exhibition *The Perfect Moment*. The retrospective of Mapplethorpe's work, including homoerotic nudes, had

opened free of controversy at the University of Pennsylvania's Institute of Contemporary Art. But when it hit Washington's Corcoran Gallery, a noisy internal debate led the museum's management to cancel the show, generating an entirely unproductive brouhaha that quickly found its way a couple of miles west to Capitol Hill. On July 25, 1989, Reverend Wildmon issued a press release calling for the elimination of the NEA, asking that "the government end their $171 million support for pornography and anti-Christian bigotry." "We hope," Wildmon continued, "that taxpaying voters will hold accountable Senators who vote to fund such 'art.'" The very next evening Senator Helms introduced his infamous amendment to the Interior Appropriations Bill, requiring that no NEA funds be applied to "obscene or indecent materials."

We were off and running.

And, remember, Congress was now on TV—the House since 1979, the Senate since 1986. (Alphonse D'Amato was inspired to actually tear up an NEA grant catalog in the well of the Senate, an event duly transmitted by C-SPAN.) The mixed blessing of a televised Congress fed an increasingly voracious, visually oriented, TV-trained journalism industry—a journalism shot through with post-Watergate "gotcha" and "follow-the-money" values. And, of course, we had the "Gingrich revolution" and the Contract with America, which, toward the bottom of its wish list, targeted the Arts Endowment.

To make things worse, the small agency in the conservatives' gunsights was, in the late 1980s and early 1990s, experiencing an especially weak moment. When the Mapplethorpe and Serrano controversies first flared, the NEA was between Senate-confirmed chairmen. A presidentially appointed agency head simply has more standing with which to push back against Congress and greater access to help from the White House than does an interim, acting official. Hugh Southern, then acting chairman, was a charming fellow with a distinguished manner, but he wasn't outfitted to counteract the Helms-Wildmon-Buchanan-D'Amato onslaught when it first showed up.

Unfortunately, the introduction of a new, Senate-confirmed agency head didn't make things better. John Frohnmayer, the Oregon lawyer and arts patron who was confirmed as the Bush White House NEA chair in

late 1989, failed to take a firm and consistent position on controversial grants. He first supported congressional limitations on the activities of Arts Endowment grantees, then supported artists' rights, while along the way allowing the debate over grant making to be reframed as a free speech issue. An especially vocal arts community was more than willing to argue the position that a grant rejection constituted censorship and a denial of free speech, and the debate over the work of the NEA took on a highly ideological, left/right, Christian/heathen, no-shade-of-gray tone. The "freedom of expression, First Amendment" formulation was ultimately unhelpful—it brought far too many nonarts voices into the fray and measured out a playing field and rules of engagement within which it was virtually impossible for antagonists to follow or even uncover any path to compromise.

So the rhetoric raged on, the perfect storm spread over the landscape, and, with the press, Congress, and an activist art community eager to frame controversy as inflammably as possible, the real story of what the NEA was trying to accomplish couldn't surmount the rising heights of passion and prejudice. To sustain arguments against the NEA, combatants eagerly traced any penny of federal support that had, by whatever route, found its way to a controversial project—failing to note that many grants were for general operating support or were subgranted from one agency to another. For example, the flow of money to Annie Sprinkle (the performance artist who, notoriously, invited her live audience to look at her vagina) was actually from the NEA to the New York State Council on the Arts through a block grant and then to New York City's Kitchen theater, which booked Sprinkle in its performance series. Nobody at the NEA had heard anything about the performance artist when NYSCA's routine annual funding was approved, but that didn't prevent the entire matter from being hashed out as "an NEA grant."

It got worse. Early in 1992 perceived Arts Endowment abuses became a regular feature of the campaign rhetoric of conservative Republican presidential candidate Pat Buchanan. George H. W. Bush, facing the former Nixon speechwriter in a tough primary race at the start of his reelection campaign, saw the Arts Endowment problem as a small matter that was, nonetheless, giving him political heartburn. Chairman Frohnmayer,

deploying his lawyering skills in an effort to mollify all parties, had ended up alienating just about everyone. In February 1992, having lost the confidence of not only the White House, Congress, and a campaigning George H. W. Bush, but also the arts community, John Frohnmayer was forced to resign his chairmanship.

. Surprisingly, even while the NEA was at the center of controversy from 1989 forward and after Frohnmayer lost his job because of the presidential campaign of 1991, powerful Democratic supporters still kept congressional adversaries at bay. It took five more years and a transformation of Washington's Capitol Hill landscape for the dismay of Republican members of Congress to find its way to the NEA's bottom line.

But the ax finally fell. When Democrats lost the House in 1994, Sidney Yates, longtime NEA advocate, was reduced to the role of ranking minority member on the House Interior Appropriations subcommittee he had chaired for decades. Yates's ability to short-circuit any and all efforts to convert rhetorical attacks on the NEA into significant budget cuts was gone. No doubt Yates's effective but sometimes high-handed and uncompromising guardianship of the agency fueled deep resentment among its critics, especially conservative Republicans. It quickly became obvious that, absent Yates's power, the agency was operating without a safety net.

The mile-deep, inch-wide support base of the Arts Endowment had vanished, and the agency took a pretty hard tumble: a one-third reduction in budget, significant staffing cuts, and, following a study by an independent commission, the elimination of both general operating grants and almost all direct grants to individual artists. The NEA's core commitment to cutting-edge individual artists was taken down; it was left demoralized, its Clinton administration chair Jane Alexander, "weary and cynical," Congress wary, and the arts community disheartened. Many factors combined to cripple the NEA early in the Republican revolution, but attacks on the agency by congressional conservatives were irresponsibly harsh. Alexander recalls a "battle to the death," both "unprecedented and mean to the core."

When I became chairman, the White House charged me with rebuilding relations with Congress and improving the morale of Arts Endowment

staff and the arts community. With our senior deputy chairman, Scott Pe-
terson, and a team made up of political appointees and career profession-
als, we developed a new strategic plan and introduced the community arts
initiative—Challenge America—that became the basis for a fresh start
with both Congress and a White House that feared the arts had become
politically radioactive. I met face-to-face with more members of Congress
than any other Senate-confirmed official of my era, and we were able to get
the budget growing again. It was a great team effort that really brought to-
gether the NEA's political appointees and its talented and dedicated career
staff; all of us who worked on Challenge America are proud that the ini-
tiative is still part of the agency's programming.

In the game of government you need to know if you're a player, and
what team you're on. But the arts aren't a team, or even a player. Whether
we're talking about comic books, hip-hop CDs, Janet Jackson's bared
breast on Super Bowl Sunday, or the NEA in a four-way tussle among
Democrats, Republicans, activist-artists, and the Christian right, "art"
ends up as a pawn to be positioned on the game board as players ma-
neuver for advantage. Thus, during the 1991 presidential campaign,
when actor Christopher Reeve debated Pat Buchanan on *Crossfire,* no ex-
change of ideas about government arts funding emerged, just a fresh op-
portunity for Buchanan to cynically position himself against a poorly de-
fended target. (He took on immigration in much the same inflammatory
fashion in the run-up to the 2006 midterm election.) From *Piss Christ* to a
few curse words in *Saving Private Ryan,* cultural content has become a
cynically manipulated political football.

In the end, the perfect storm was instructive. Dick Woodruff, who
served as congressional and White House liaison when I was with the
NEA, says there are two types of issues in Washington, *career* issues and
do-the-right-thing issues. Career issues are those that a member of Con-
gress will take a stand on, and maybe lose a seat over—think gun control
or abortion rights. These overarching issues are fought over, tooth and
nail, in political campaigns, in the press, and in the halls of Congress. Do-
the-right-thing issues, on the other hand, don't generate sufficient com-
mitment to cause an elected official to expend quantities of political cap-
ital to produce an outcome. It's OK to do the right thing, but nobody's
going to resign or lose an election over it. If a do-the-right-thing issue such

as arts funding starts to exhibit the profile of a career issue—opinion pieces in newspapers, congressional speeches, he-said/she-said's on talk TV—then you're in trouble; in trouble because you've got passion without deep commitment; you've got the thunder and lightning of the perfect storm without a harbor of refuge. To the extent that my NEA team turned things around, it was in large part because we were able to return the agency to the realm of backroom conversation where do-the-right-thing issues can be quietly resolved, as they ultimately were in 2008.

It's an important lesson: For a while the NEA was surrounded by the same rhetoric Congress brings to bear on movie studios or TV networks. But in our political world culture is "East Wing": no one holds the arts as a career issue, the agency was unprotected, and the NEA almost went away.

It would be unfair to argue that there's *no* serious legislative work on culture; some members of Congress have begun to act on their unsettling intuition that the public interest isn't being served in debates about intellectual property and media regulation. Senators Patrick Leahy, Democrat, and John McCain, Republican, have both questioned the impact of consolidated ownership on the content of radio and television, and Senator Orrin Hatch, a Republican from Utah, supported copyright protection for songwriters while simultaneously challenging the reasonableness of similar protection for the rights of record companies.

Our federal agencies have also shown signs of acknowledging the public interest dimension of arts industry regulation. In a 2006 op-ed in the *Financial Times*, FCC commissioner Michael Copps called the fight against media consolidation "a grassroots, all-American campaign to preserve the very democracy that de Tocqueville saw in America." The Bureau of Competition within the Federal Trade Commission, charged with ensuring that Americans can "choose goods and services within an open marketplace," has begun to consider whether the impact on consumer *choice* should be added to price concerns when the FTC considers mergers among cultural industries. There exists an increasing understanding on Capitol Hill and within key agencies that far too much legislation and regulation affecting the U.S. cultural scene is defined by contending interested parties—radio against songwriters, record companies against publishers, record companies against file sharing. The American public

interest just isn't in the room. But to date growing sensitivity to nonmarket public purposes by a few members of Congress, career FTC lawyers, and a minority-party FCC commissioner is not enough to offset the lobbying power of global conglomerates.

It's not as though policy leaders never see art and artists; they just don't place America's expressive life anywhere on the public interest agenda. Over the years the arts crowd· has enjoyed easy access to the halls of power, at least when it's time for a concert, reading, the screening of a new movie, or sometimes making the case for protective legislation. But from a public policy perspective, the arts arrive at the party preceded by an unhelpful assumption: art is the "grace note" to be engaged only when other priorities have been fulfilled; it is "women's work" that now and then finds itself dragged into the political mainstream to be poked at with partisan intensity. Artists and advocates for the arts can find a way to be present in most political arenas, but ease of *access* belies the absence of *credibility.* By viewing America's expressive life as a mere "entertainment" (that can now and then throw off political shrapnel), West Wing–style power brokers have, well in advance of any encounter, placed cultural concerns firmly on the sidelines of public policy.

And, to be fair once again, with the exception of content controversy, the kind of public outrage that can move policy has been absent from the cultural sphere. It's been easy for politicians to use art as a political plaything in part because they don't hear much from the public about copyright, heritage, fair use, or even media consolidation. After all, for the average citizen going about her business, it seems culture is plentiful and everywhere: pictures hang on walls, music plays in restaurants and elevators, and Wal-Mart shelves seem fully stocked with DVDs. But in matters of our arts system, to paraphrase Donald Rumsfeld, Americans don't know what they don't know about heritage, art making, and cultural vibrancy. Several years ago the *New York Times* Sunday Arts and Leisure section featured a convincing argument that there existed no single U.S. visual art work—no painting, sculpture, or photograph—that would create an uproar should it be sold to a collector in another country. Apathy to heritage owned by arts companies is just as pronounced; the merger of the Sony and BMG music companies that consolidated two-thirds of

America's recorded musical heritage in the hands of a single, non-U.S. company did not generate the slightest tremor of public outrage. No one seems especially concerned that the global distribution of many of our arts products supplies terrorist recruiters with an inventory of salacious talking points, and citizens seem unaware that copyright restrictions often stop contemporary artists in their tracks when they attempt to create new works out of old. Despite the proliferation of cable television and bargain CDs at Best Buy, the broad individual and public benefits of a healthy arts system remain beyond the reach of too many Americans. Not knowing what we don't have, the American public hasn't forced politicians to really dig in.

But just because the American people and government leaders haven't engaged culture on its own terms, that doesn't mean government doesn't invest in, touch, or sometimes even shape America's expressive life—it's just that around most issues, the points of contact are narrow, the marketplace rules, interventions are uncoordinated; individual laws and regulations too often lead to troubling unintended outcomes. As Slate.com points out, "A bunch of federal agencies perform the functions given to ministries of culture in other countries." The FCC engages (or, more accurately today, *disengages*) broadcasting and media; the Office of the U.S. Trade Representative promotes arts products in international trade negotiations; Homeland Security decides which artists from other nations can tour the Midwest; the Library of Congress is a kind of keeper of copyright while simultaneously advocating cultural preservation; the Department of Justice and the Federal Trade Commission approve mergers among media companies; and the State Department tries to manage public relations and official media efforts abroad. And the list could go on. But, as we've seen, divided authority and responsibility produce uneven outcomes and unintended consequences: no one at the FCC dreamed that changes in radio ownership rules would unhinge the record industry; no one with the FTC worried that the Sony-BMG merger might disrupt access to heritage. The public interest is hidden behind a blur of small decisions that although scattered among many agencies and committees of Congress accumulate to diminish the quality of our expressive life.

The FCC's changing approach to broadcast regulation over the past quarter century stands as a cautionary example of the way established public purposes can be set aside to serve the marketplace. The Reagan administration was the launching pad for what turned out to be a lasting, bipartisan commitment to deregulation—a commitment that has played out with special intensity during the Bush-Cheney years. A backward glance at the 1980s reveals numerous deregulatory actions, some mandated by the FCC and some by Congress. In 1981 the term of broadcast licenses was lengthened from three to five years, and by 1985 the number of TV stations that could be owned by one company grew from seven to twelve. Also in 1985, guidelines that required stations to air nonentertainment programming were eliminated, as were guidelines on how much advertising could be carried. Two years later, in 1987, the fairness doctrine was eliminated—ending the requirement that stations broadcast opposing political points of view and laying the foundation for the establishment of today's nonstop, ideologically tilted cable services. The drive to deregulate—initiated in the Reagan era—carried forward into the 1990s. The 1996 Telecommunications Act virtually eliminated station ownership restrictions—the result was Clear Channel, Cumulus, and consolidated media. Despite continuous repetition of lofty public-interest language by the FCC, throughout the twentieth century, and especially in the past few decades, broadcasters were ushered into a wide-open entrepreneurial playing field by scaled-back regulations, some of which dated to the dawn of radio. Simultaneously, copyright protections were expanded, helping music publishers increase the reach and value of protected revenue streams attached to the intellectual property that is performed on radio and television. This is not regulation and legislation completed to serve citizens but to serve business. Over the past three decades, our arts industries have been unabashedly successful in parlaying what sociologist Eric Klinenberg calls "the federal government's blind faith in the power of markets and technology" into critical concessions in law and regulation.

• • • • •

It has been conventional wisdom in the United States that a department of cultural affairs charged with coordinating policy affecting the arts

system would somehow damage America's arts scene. Critics contend, "A cultural agency would be trying to dictate content; it would just follow political fashion; it wouldn't serve artists or the public." And for years I agreed; in the past I've made the argument myself.

But how much worse could things be if government interventions in cultural life were coordinated in a single agency?

After all, Congress and the FCC attempt to interfere with artistic content all the time, advertisers and media companies are de facto censors, and our for-profit arts industries have been free to go their own way; regulation of media and reasonable public interest restraints on copyright have become *less* attuned to public purposes while corporations have grown in size and global influence. If we Americans are dissatisfied with the vibrancy of our arts system and our inability to engage art to advance quality of life, much of our distress derives from the simple fact that a society that does not protect its cultural system through serious legislation and regulation is certain to end up with a cultural landscape bulldozed by political cynicism, mindless confidence in market efficiencies, and obeisance to maximized shareholder value. Today we simply do not engage art and artists through a system that honors the public interest assertions of our Cultural Bill of Rights. Today we must push policy leaders and pundits to relocate the public interest within our arts system. A U.S. department of cultural affairs, or a White House cultural council, managing a portfolio including international trade, intellectual property, mergers of cultural industries, arts education, and support for art of lasting cultural significance, can be the place where the forces of politics and the marketplace can be continuously balanced against the cultural rights of Americans.

Conclusion

BRIDGING THE CULTURAL DIVIDE

Early in 2006, at the Las Vegas International Consumer Electronics Show, Microsoft Corporation chairman Bill Gates painted his vision for future consumer technology. "He demonstrated a computerized wall easel for the home that can show television images, keep track of family members and interact with an office computer," the *Washington Post* reported. Gates also showed off a phone that could make calls on conventional land lines or over the Internet. A year later Steve Jobs did him one better, auditioning the iPhone mobile entertainment center for an audience of worshipful Apple fans. On top of satellite radio, camera phones, Blackberrys, digital cameras and radios, MP3 players, and MySpace home videos, our technology leaders planted yet another mile marker on the highway of twenty-first-century cultural consumption.

But who is really able to pay for all these connective devices? Can pricey hardware and an Internet connection help secure our cultural rights?

Participation is the hallmark of a vibrant cultural scene, not just participation for the trained and well-heeled but participation that's available to just about everybody. And access to computers alone doesn't make someone a player; it's one thing to participate on a shared library computer using dial-up Internet service, quite another to work the Net at home with high-end hardware, current software, and a high-speed cable modem. And in many ways hardware is the least of it. Artists and nonartists alike need software, access to content, and the time and skill that full participation in art and art making require. Ironically, the reach of copyright and tight-fisted, litigious corporate practice is handing us a high-priced permission culture at the very moment when the public interest demands open access to artistry and artists in support of our emerging creative economy. As intellectual property expert James Boyle observes, "In the name of authorial and inventive genius, we are creating a bureaucratic system that only a tax collector or monopolist could love." But corporate moguls and the IRS don't care about heritage, the work of artists, our cultural organizations, American artistry abroad, or the expressive lives of citizens. We need to make certain government and business honor our cultural rights, and because cultural rights precede and supersede legislation and legal precedent—"a bureaucratic system"—they offer a chance at a new beginning: a new cultural playing field that average citizens can navigate.

THE GOOD NEWS

Well, not *good news*, exactly; it's what might better be labeled the *not so bad news*.

Although nowhere near the fundamental change we need—reform is mostly seeping in gradually from the margins—the march of events seems to be grinding away at some of the hard edges of the damaged U.S. arts system. There's good news, for example, in education: not *arts education* as in "band and chorus" but in higher education's tentative embrace of creativity as an emerging economic driver. According to *Wired* editor-at-large Daniel Pink, author of *A Whole New Mind*, we are entering a new age—a new economy—that not only supplants the industrial age but also

supersedes the decades-old age of tech-enabled information. Because older economic drivers like industrial production and information processing migrate easily to emerging nations, Pink argues that economies, and societies, will no longer succeed though high tech but through "high concept" and "high touch." High concept, the toolkit of Pink's Conceptual Age, is characterized by "the ability to create artistic and emotional beauty, to detect patterns and opportunities, to craft a satisfying narrative, and to combine seemingly unrelated ideas into a novel invention." Its complement, high touch, is described by Pink as "the ability to empathize, to understand the subtleties of human interaction, to find joy in one's self and to elicit it in others." In an interview in *Executive Travel Magazine*, Pink predicts "the rise of the right-brain qualities as the most important in business: inventiveness, visual thinking, empathy and meaning."

Bill Gates, the preeminent leader of our twenty-first-century digital economy, has repeatedly cited the need to nurture American innovation, arguing that more training in math and science will give us the creative skills required by postindustrial entrepreneurship.

But are math, science, and engineering really the whole answer?

Pete Buck, a senior engineer with the famed Lockheed Martin "skunkworks," thinks otherwise. For Buck, "math, science, and engineering are just tools to implement creative ideas." Walter Isaacson, author of a recent biography of Albert Einstein, seems to agree. In a *USA Today* opinion essay, Isaacson describes the great physicist as "a wonderfully visual, creative and imaginative thinker [who] used vivid mental pictures that make his theories come alive." Isaacson argues that Einstein's thought experiments can be used, "with no math necessary, to give a glimpse of the creativity at the heart of true genius." Did Einstein's brilliance derive from training in math and science or, just as likely, from his lifelong devotion to music and the violin?

In the 2006 edition of *The World Is Flat, New York Times* columnist Thomas Friedman agrees with Pink, offering his personal list of required global-worker attributes in the new world economy: "to be a good collaborator, leverager, adapter, explainer, synthesizer, model builder, localizer, or personalizer, . . . to learn how to learn, to bring curiosity and passion to your work, to play well with others, and to nurture your right-brain

skills." A vibrant expressive life is both an incubator and a reservoir for these skills, and educators have begun to respond by pressing training in art and cross-discipline studies as a key to producing twenty-first-century workers equipped with a portfolio geared to a conceptual age. Pink and Friedman argue that storytelling, creativity, model building, curiosity, and right-brain skills—an active and rich expressive life—are keys to success, personal and professional, in a post-information age. Even Ellen Winner and Lois Hetland of Harvard's Project Zero, skeptics when it comes to the secondary effects of arts learning, see promising links between art and creativity; their recent research suggests broad indirect benefits: "Students who study the arts seriously are taught to see better, to envision, to persist, to be playful and learn from mistakes." And there is some evidence that college students, on their own initiative, are tilting toward art. In 2002 the comparative Survey of College Freshmen found that compared to 1990 a larger percentage of first-year students set life goals around art making—creating work or original writing or becoming accomplished in a performing art.

A vibrant expressive life is more than simply the key building block of a creative economy. Observers like Pink are ultimately interested in individual human development; in the search for authenticity and meaning in life in an era dominated by images of affluence and consumption. Pink's notion of a "new mind" builds on and incorporates the work of Robert Fogel, Martin Seligman, and other big thinkers who link culture, creativity, spirituality, positive psychology, and happiness. For these scholars, happiness is not the "Good Life" or even the "Pleasant Life" but, as Seligman says, "the pursuit of meaning . . . knowing what your highest strengths are and deploying them in the service of something larger than you are." Our argument advancing America's cultural rights gains importance as creativity emerges as a source of economic vitality; it is becoming clear that one of the benefits of advancing our cultural rights by implementing a more coherent, public-purpose approach to the U.S. cultural system will be a strong economy grounded in the skills of a creative citizenry. But our goal is a high quality of life for all.

It is also helpful that today the most countercreative practices of conglomerated cultural industries are increasingly being challenged, and

their impact softened, just a bit. For one thing, it's not all about shareholder value anymore. Observers have begun to remind business leaders that the notion that corporations exist *only* to serve the interests of investors is not a long-standing given of corporate philosophy but instead dates to a 1919 ruling by the Michigan State Supreme Court stating that a corporation is organized "primarily for the profit of the stockholders" and that "the powers of the directors are to be employed to that end." However widespread this view is today, both older and more recent court decisions have taken a different view, providing corporate boards and managers considerable latitude in basing business decisions on multiple factors—not only shareholder profits, but also long-term benefits to corporations themselves and the impact of decisions on employees and communities. In a lecture delivered in the early 1990s, New York University professor William Allen identified two distinct, conflicting ways to conceptualize a corporation; he described one as "the property conception," the second "the social entity conception." There is little doubt that the property conception, with its emphasis on short-term, bottom-line results and shareholder value (expressed as stock price), has been dominant for the past few decades. But the alternative view that honors the interests of other stakeholders is quietly ascending; to the extent that corporate social responsibility and the interests of multiple stakeholders find their way to boardrooms and top-floor management offices, the arts system will be better served.

In a related trend, the value of short-term performance as the primary measure of corporate success also seems to be losing ground. Obviously, it's common for artists' careers and creative projects to mature over years, even decades, so the laserlike focus on quarterly performance that characterizes contemporary corporate practice is especially disabling to the steady pace at which arts companies properly work. We've heard from the senior executive with a Nashville branch of a major record label when repeatedly pressed to deliver predictions of quarterly profits for his division: "I just had to make up numbers." Apparently others have begun to agree; late in 2006 the Business Roundtable Institute for Corporate Ethics issued a report calling for the end to quarterly earnings predictions, indicating that the emphasis on short-term performance "does not create value for shareholders and in many cases destroys value."

That conclusion wouldn't surprise arts industry leaders. Successful arts companies are often small and nimble; they don't flourish operating by the rules of global parents. Today there is a nascent but encouraging tendency for merged media giants to divest individual businesses once the entertainment or book publishing divisions prove incapable of hitting imposed revenue and net earnings targets. We've seen that when Edgar Bronfman purchased Warner Music from Time Warner in 2004, the takeover produced a predictable round of firings and cutbacks—the usual stuff of mergers and acquisitions—but the move can also be viewed as an acknowledgment that recording and music publishing businesses had *not* flourished in the AOL–Time Warner conglomerate. Bronfman has also been experimenting with a new business model. Faced with plummeting CD sales in mid-2007, the Warner CEO expressed his intent to redefine the company's "role in the music value chain," in part by getting more involved in artist management. Publisher Jason Epstein believes that media conglomerates will begin to spit out backlist-driven publishing houses once parent companies figure out that they can't profitably execute a "blockbuster-hit" strategy. And even if entertainment giants manage to avoid being spun off, Warner-style, the lumbering pace of highly consolidated businesses inevitably stimulates the creation of small, owner-managed companies capable of serving niche customers left behind by big-company strategy.

But let's not get too excited; none of these modest reworkings of conventional corporate wisdom are being driven by concern for culture, the vibrancy of the arts system, or our culture rights. There has been no revolution in the way companies treat art; practices that assume culture is a commodity remain the norm.

The nonprofit sector is also revisiting long-standing conventional wisdom. A 2006 Rand Corporation study, *Gifts of the Muse: Reframing the Debate about the Benefits of the Arts,* sent shock waves through the nonprofit cultural community. The report concluded that claims made by the arts world about the secondary effects of investments in arts education and the work of cultural organizations, in general, lacked "empirical rigor as well as a comprehensive theoretical explanation for the claimed benefits." Or, as critic John Carey put it in *What Good Are the Arts?* "The widely

shared belief that art can instruct the public, and help to attain a better state of affairs, lacks any factual backing."

Such emperor's-new-clothes revelations have sent some arts advocates back to the drawing board. "We need new language; new arguments to make our case . . ." But, of course, that's not really what's required at all. The challenge facing all who care about the vitality of our cultural scene is not answered by coming up with new assertions about how music helps little Jenny get better math scores, or how free housing for artists will set off a boom in the construction of downtown apartments—such arguments don't hold up. Instead, the sober conclusions conveyed in Rand's literature review should force the sector to acknowledge that we can't advance art without linking it to broad public purposes or the right of citizens to lead vibrant expressive lives. We don't need new "instrumental" arguments for investment in the arts education or the nonprofit arts but an understanding of what kind of arts system serves public purposes and the importance of art to a high quality of life.

There are signs that this reassessment is beginning. The University of Chicago's Cultural Policy Center held a 2006 conference on the critical question facing the nonprofit sector: Is it simply too big? Do we have too many cultural institutions; is the sector "overbuilt"? Organizations with long histories of support for the arts are beginning to rethink their role. The Utah State Arts Commission is reconstituting itself as a kind of department of cultural affairs, developing ways to help film production houses and other for-profit cultural industries. Commission chairman Newell Daley noted that the Utah commission had assessed revenue sources for the state's nonprofits and determined that "the sector is doing quite well," enabling the funding body to "expand its view." As we've seen, even the League of American Orchestras, a bastion of conservative nonprofit policy and practice, has determined that orchestras must take new directions.

These trends are encouraging, but, as in the commercial cultural sector, innovation mostly consists of efforts to sustain the old model, not transform it. How can public policy take us beyond these incremental changes in nonprofit and commercial arts companies? What, as citizens,

should we encourage government to do in order to align corporate prac-
tice in culture with the interests of the U.S. public?

First, the commercial sector. Absent a department of cultural affairs,
our federal government does not directly attempt to shape the cultural
system but *does* regulate corporate mergers and acquisitions. Regulatory
systems are already in place, and if we allow agencies like the Federal
Trade Commission and the Department of Justice Antitrust Division to
take *cultural impact* into account, existing regulatory mechanisms can pro-
vide points of intervention, enabling the public to push back against
merged arts industries, thereby securing key cultural rights. In fact, par-
ties engaged in any government approval process can be forced to pro-
vide assurances that artistic heritage and artistic practice will not be put
at risk by changes in ownership, management, or geographic location.
One senior attorney with the Judiciary Committee of the U.S. Senate,
when asked about historical films and recordings, made this suggestion:
"Maybe we should use FTC approval as a kind of backstop to make sure
historical material gets preserved?" A requirement that companies file a
"cultural impact analysis" or "heritage preservation plan" (or, as has been
discussed, that they take account of "consumer choice") in advance of a
merger or acquisition would help ensure that artistic practice and histor-
ical performances and texts will not end up as roadkill on the path to busi-
ness efficiencies and that the public interest will be embedded in forms
filed for approval with regulatory agencies.

Similarly, by working community heritage and homegrown art mak-
ing into the agency's definition of *localism*, the FCC can make cultural im-
pact a component of station ownership criteria. Even local challenges to
the hegemony of Wal-Mart could benefit from a critical assessment of the
retailer's effect on artistic variety and choice. Corporations will undoubt-
edly resist such an expansion of regulatory authority, for the recent over-
all regulatory trend has been toward less, rather than more, public inter-
est intervention in corporate practice. But it's clearly disengenuous for
cultural industries to claim they're incapable of advancing public pur-
poses. After all, large corporations have learned that when embarking on
activities that affect the natural environment they must accommodate a
range of laws and regulations designed to serve citizens by ensuring that

corporate practice protects land, water, air, and wildlife; some energy companies have actually internalized sound environmental practice. Pressured by public commitment to our cultural rights, our arts industries can also learn to conduct art business within the parameters of public purposes. And remember, we need healthy arts companies. Absent the connoisseurship and commitment that enable leaders to select, finance, and advance the best art and artists, our cultural landscape devolves into a YouTube free-for-all.

Immune to mergers and acquisitions, with few connections with agencies that regulate business, nonprofits are actually less susceptible to government intervention than are for-profit arts industries. Although the NEA, the NEH, and the Institute of Museum and Library Services provide grants to nonprofits, the most important point of contact between government and nonprofits is the tax code enforced by the IRS, the agency that secures both the benefits and the responsibilities of nonprofit status by making certain museums, orchestras, and the like operate within the limits of their corporate charters and the law. But the IRS doesn't have a mandate to examine the financial health of cultural organizations, even though nonprofits today exhibit many symptoms of bumping the upper limits of their philanthropic business model—a model that lacks both regulatory oversight and marketplace flexibility. Generally unable to consolidate or engage in hostile takeovers and prohibited by their charters from acquiring subsidiaries or engaging in unrelated business activities, nonprofits have drifted into a dysfunctional state of perpetual competition for the aggregated philanthropic and public revenue streams that have traditionally fed the sector. At the very least, a multiyear business plan demonstrating adequate financing should be part of the application process for new nonprofits. But right now our federal and state governments lack financial and regulatory tools flexible enough to help sort out the problems facing an overbuilt nonprofit sector.

The failure of many midsized nonprofits appears inevitable, but in a sector that claims a moral right to community resources, failure doesn't go down easily. A couple of years ago, when a funded project was not executed according to its grant application, the NEA's inspector general, in

a rare move, attempted to secure the repayment of $75,000 from the Connecticut-based National Theater of the Deaf. But the grantee fought back, ascending to moral high ground. The *New York Times* reported that the company's director, Dr. Paul Winters, claimed to be, among other things, "working without pay much of the time." In an e-mail message to the NEA, Winter complained, "It would be very disappointing to me personally and professionally if the NEA was the one that drove the final nail in the NTD coffin." Posturing of this sort makes it hard for funders to respond to failure; cultural nonprofits, even those with long histories of financial problems, do not exit the stage quietly. But at some point public policy must take on the challenge of leveling out or even turning back the relentless growth in the size of the nonprofit sector; a healthy twenty-first-century nonprofit arts system may require some culling, especially among unendowed midsized organizations. Today the challenge for nonprofits is not to expand seasonal offerings or build new arts centers but rather to facilitate the downsizing or even the graceful demise of some institutions on the edge of survival in order to free up resources to allow stronger museums, orchestras, and dance companies to exercise greater creativity. The nonprofit sector has begun to acknowledge the challenges of downsizing and demise—step one of a multistep recovery program aimed at securing a community of cultural organizations strong enough to serve the public.

U.S. foundations can help, but to date they have shown little interest in the overall vitality of our cultural system and its connection with public purposes and quality of life. Ford and others have engaged media policy and issues of political speech, but larger questions of cultural vitality have so far failed to capture the interest of grant makers.

THE BAD NEWS: COPYRIGHT AND
THE CULTURAL DIVIDE

Paul Goldstein's vision of a celestial jukebox conjures up the charming image of a giant, neon-ringed, bubble-tubed music machine floating somewhere above the Big Dipper, sprinkling hit tunes on Earth from a soft summer sky. But don't be fooled: the jukebox-in-space may look

pretty, but it's a down-and-dirty copyright engine that runs on fees collected for even the most trivial use of any creative product. Creativity may be on the rise on campus and arts companies may be tweaking their business models to better honor long-term performance and new business realities, but copyright and its cousins, trademark, patent, and name-and-likeness rights, show no signs of receding on their own. In fact, the intellectual property universe has steadily expanded its reach over the past century, and today intellectual property law constitutes a constellation of constraint that locks up heritage, ties the hands of creativity, and assigns a price to an ever-widening spectrum of our expressive life.

When the J. M. Smucker Company asks a federal judge to provide patent protection for Uncrustables, the firm's frozen, disc-shaped peanut butter and jelly sandwiches, or when Cleveland's Rock and Roll Hall of Fame seeks an injunction preventing two journalists and a disc jockey from putting up a Web site called the "Jewish Rock and Roll Hall of Fame"; when court battles over the rights to original choreography prevent the Martha Graham Dance Company from dancing its founder's work, and when a *New York Times* reporter chides the city's police and fire departments for failing to bird-dog rights to their trademarks and logos, we know that claims of ownership in the U.S. arts system have begun to undermine the creative process.

In 2002 Michael Perelman's *Steal This Idea* argued that "the ever-tightening grip of intellectual property rights threatens to undermine science, economic progress, personal liberty, and democracy." Perelman's overwrought message is a counterpoint to Goldstein's image of a "technology-packed satellite orbiting thousands of miles above earth, awaiting a subscriber's order . . . to connect him to a vast storehouse of entertainment and information."

Who is right? Are we living in a world blessed by a cosmic nickel-in-the-slot art machine, or one in which copyright, trademark, and patent threaten our democratic way of life?

Both Perelman and Goldstein are "right," but their divergent views are grounded in very different assumptions about the meaning of a rigorously enforced copyright regime. Perelman, like Lawrence Lessig and

Siva Vaidhyanathan, favors a "light" copyright environment with expansive fair use and a relaxed system of licenses; Goldstein's celestial jukebox is a wide-open pipeline, but it's one that can only function within a "heavy" copyright system in which every tidbit of entertainment or information that flows to consumers triggers some form of payment. The twentieth-century trend in the character of intellectual property rights has given us a system that would please Goldstein: today we navigate a heavy copyright system. Policy analyst David Bollier compares our current intellectual property burden to a medieval economy in which travelers were taxed at every castle: "Now we are on the cusp of a similar regime in the information economy, where market tribute must be paid at every tollgate that someone manages to erect."

Back in the late stages of the dot-com boom, a TV commercial posited a fictional dilapidated desert motel in which a tired traveler, checking in on a hot afternoon, is informed that his room lacks "free HBO"; the guest can choose instead among "every movie ever made in every language ever spoken." The grizzled traveler, confronting the desk clerk's description of an ultimate in-room TV, gasps, "How is that possible?"

Well, today such a system *is* possible, or nearly so, but at a price. "Ultimate HBO" works only if film studios are willing to invest enormous sums to locate archived originals, clear rights, digitize the works, and create additional content such as subtitles, and only if the seedy motel is able to purchase some fancy equipment and periodic upgrades in high-end software. And the entertainment fees attached to this pipeline (think *jukebox*) would probably cost the weary traveler more than the room itself. Of course, all this makes sense only if the guest is willing to find his way around what would undoubtedly be the most complex on-screen menu ever compiled.

True, the Internet offers the potential of ultimate contact between consumers and creativity, but, brought close to the ground, it requires a familiar mixture of old-fashioned ingredients—time, knowledge, and regular infusions of cash. Because of what it takes to connect with culture through technology, the distribution of arts assets and art making in America is increasingly unfair. Time, knowledge, and money are the markers of a real-world divide that today gives the United States new

clusters of haves and have-nots, a divide sufficiently marked to hint that the promise of digital plenty, when translated into real-world costs and habits of consumption, will fail to secure cultural rights for all.

Just think how things have changed.

When I was a student at the University of Michigan in the 1960s, I was hooked up to America's expressive life through the modest array of media gadgets available to almost every citizen. I owned a hand-me-down black-and-white TV set, and a blond, tabletop, one-speaker record player. Four channels of televised news and entertainment arrived over the air through pointy chromed rabbit ears attached to the set. I had an AM/FM radio in my apartment, but my older car was still AM-only, so I could tune in local news and deejays during the day and if I was driving at night hear the long-distance power of old clear-channel AM stations, like WWL in New Orleans or WJR in Detroit. It's hard to recall that jazz was truly pop mainstream music back then, but it was, and I paid $5 to see the Dave Brubeck Quartet in a sold-out concert in the university's Hill Auditorium. In pop music, the folk revival had, by the 1960s, produced Bob Dylan, who competed head-to-head with the upstart British rockers, the Beatles. Arguments about the relative merits of each act fueled impassioned late-night bull sessions, and fans divided up into "Dylan people" and "Beatles people." If my interest shifted to the visual arts, I could view paintings at the university museum or drive east along the relatively new Interstate 94 for a couple of hours and check out the Detroit Institute of Arts: still "free," although donations were encouraged.

I was a pretty typical student. I made some money teaching at an Ann Arbor guitar studio, and my parents supplemented my earnings from music. But back then, for someone ten times richer or for somebody with half my income, the opportunities to engage culture would not have varied much. Sure, a newfangled color TV would have been nice (although only a handful of programs were then shown in color), and maybe a phonograph with two speakers would have encouraged me to spend an extra buck for the stereo version of the latest LP, but even without up-to-date technology I still had a chance to hear and see pretty much the same things as anybody else, and, had we gathered around a water cooler to

talk about art—rich, poor, educated or not—we would've easily been able to cite shared experiences in movies, music, and TV programming. It didn't demand much money, or much specialized knowledge, to navigate the cultural system in the mid-1960s.

My apartment was on Detroit Street, northwest of campus; up the hill from the train station. Although he took in rent from three apartments, my landlord, who lived with his family on the first floor, seemed to operate in a perpetual state of financial turmoil. But despite money problems and an absence of shared interests, education, and income, my landlord's crowded apartment contained cultural gear pretty much like mine: a TV set, a radio/phonograph, and a telephone. Apart from programs like *The Tonight Show* or *The Ed Sullivan Show*, we probably watched and listened to very different things, but the slice of our nation's expressive life *available* in the two apartments was virtually identical.

My cultural consumption budget, back in Ann Arbor, rarely reached $20 a month. Now, as then, culture gets paid for in three ways; you can buy a product, a book, compact disc, or painting; you can rent it (a Netflix DVD, a music download, or a seat at a performance or a museum tour); or culture shows up "free," by way of a television or radio broadcast supported by advertising. Today, though, more and more of our experiences are rented, neither bought in a store nor delivered through advertiser largesse. Think about it: my satellite radios, maxed-out cable TV service, high-speed Internet, and online subscription Web sites, the possibility of a Netflix DVD or music-streaming service—all rental. This rental-culture trend isn't a problem if your cash flow is (and remains) good, but it represents a growing burden for citizens with limited incomes. And remember, culture we acquire through new technology just doesn't belong to us quite the way it used to.

But don't I own the music I purchase legally, just as in the old days, when I cough up ninety-nine cents to download selections onto my iPod?

Not exactly.

It may be true, in a manner of speaking, that you "own" the new Neil Diamond or Emmylou Harris track stored in your Apple MP3 player, but something came along that you didn't pay for and didn't even want. Apple bundles a "digital rights program" (ironically dubbed *FairPlay*)

that constrains your ownership rights; you can make only five copies of the cut before you're forced back to iTunes and billed another ninety-nine cents; only then are you freed to make another five copies for friends or family. But, according to Slate.com, "you can't e-mail a song to a friend, you can't distribute it over the Web, and you can't play it on anything but iTunes and an iPod."

This is a trend. Without telling us, arts companies have bought into Paul Goldstein's vision of a metered entertainment pipeline that triggers a debit on a customer's bank account every time a song is played, a movie shown, a book read, or a photograph copied. In this dream everything becomes a short-term rental, the model that best serves the bottom lines of entertainment companies. After all, copyright-dependent industries learned long ago that you maximize profits not by selling your rights but by renting intellectual property over and over and over again.

The process of digital rights management was enabled by the Clinton-era Digital Millennium Copyright Act that, first, authorizes the installation of technology that can constrain use and, second, makes it illegal to circumvent those same protective technologies. When Sony was outed for concealing secret XCP anticopying software in regular CDs ("root kit" software that basically gave Sony control of host computer hard drives), the company had only been caught trying to inch a few steps forward toward its ideal business model, nudging a CD purchase toward rental by preventing you, the customer, from making copies.

The extent to which digital rights management constrains the rights of consumers to engage in copying or circulating media purchased in electronic form will have an impact on the character of the U.S. arts scene through the rest of the twenty-first century. In spring 2007 Apple wizard Steve Jobs challenged the record industry to abandon limits on the use of music purchased online, arguing that restrictions on copying downloaded music had, in effect, made online product inferior to the old CD— a medium that allows fans to duplicate and distribute content pretty much at will. Universal went along with Jobs, creating a new product that, although priced thirty cents higher than the standard ninety-nine-cent iTunes download, was free of DRM restrictions. But other record companies remained committed to limits on duplication.

.

A couple of years ago a student in my senior seminar, freshly set up in her first off-campus apartment, exclaimed to her fellow students, "Do you have *any idea* how much it costs to live out there?!" She was talking, of course, about land-line and cellular telephone service, high-speed Internet connections, and cable television. As I've argued, there is simply no comparison between the cost of reasonably full participation in the cultural delivery system today and the almost-free arts experiences available to almost everyone forty years ago.

Today my home boasts a high-speed wireless Internet connection, a digital cable box offering more than two hundred channels, a high-definition TV set, a DVD player, two additional TV sets (one with cable access and another featuring a built-in VCR), a stereo system with both an iPod and an XM satellite radio receiver attached, and, in my car, in addition to AM and FM radios and CD systems, a built-in satellite receiver. The high-speed Internet and digital cable connection cost more than $150 per month; add four satellite radio subscriptions (don't ask why) and an AOL account (so I can check my e-mail while traveling), and I'm paying at least $2,500 per year to watch television, listen to news and entertainment in my car, download music, and search the Internet for books or DVDs. And that total doesn't include purchasing CDs (which, after adjusting for inflation, actually cost less than LPs of the 1960s), or, heaven forbid, the cost of state-of-the-art video games, legal iTunes downloads, DVDs, downloaded books for my new Sony Reader, or periodic upgrades of hardware and software, to say nothing of attendance at live performances and exhibitions, or phone service (two land lines and a cell phone: the cell is emerging as a key technology for delivering arts products). And please observe: I'm not one of those characters living on the even more costly "bleeding edge" of technology. Notice the things I didn't list: digital still or moving-image photography, Blackberry e-mail gear, a Netflix subscription (about $18 per month), streaming music service (about $10), a Tivo or another time-shifting hardware, or a setup for CD burning. Add these devices and services into my whole package, and it's easy to imagine a $4,000 or $5,000 annual "cultural consumption" bill.

The idea, of course, is that all of this culture delivered by telephone, cable television, satellite radio, and endless downloads is making things better: Americans have access to more art, in more ways, than ever before. But there's a destructive irony in all this digital choice. Not only does participation require money, time, and training, but an arts system that serves up so many niche programming choices—endless options feeding the curiosity of the well-to-do and well trained—threatens the integrity of our cultural commons. Think, for a moment, about public television. Twenty-five years ago the service offered up a mixture of local fare, highbrow imported drama, and an assortment of news and special programming in the fields of history, nature, and social science. Scroll forward a quarter century, and cable television has, in the words of one commentator, "eaten public television's lunch." Take the History Channel, add in A&E and the Discovery Channel, CNN and Fox News, and sprinkle a dash of HBO and Showtime, and you've completely overrun territory homesteaded by public television thirty years ago. Cable choice has replaced our commons, but that's not necessarily good. Sociologist Barry Schwartz has argued convincingly that too much choice can have an almost paralyzing effect on consumers. At the very least, options online or on the phone or on television force us to curate our own inventory of art. As media critic Andrew Keen points out, "Democratized media will eventually force all of us to become amateur critics and editors ourselves."

We miss those intelligent gatekeepers—think Ed Sullivan—who have been supplanted by an unedited cacophony of creative voices that we have to sort out ourselves. If we develop the ability navigate the complexities of choice, cable offerings are terrific, but that's not the only issue. After all, public television is there for everybody, not just those able to pay a hefty fee for top-tiered cable subscriptions. I've never stepped inside my local Comcast office without seeing a long line of less affluent cable users waiting to make a monthly cash payment to keep the cable pipeline flowing, or perhaps, to get it turned back on, and I regularly observe young people in the AT&T cellular store down the street, paying in advance for a week's worth of "minutes" to keep their phones active, their ringtones current, their digital images flying from phone to phone. Can our democracy

really tolerate a system that makes culture, art, and communication this difficult and expensive?

Much has been made of the "digital divide," and certainly the availability of digital technology in less affluent communities or families is a legitimate public policy issue; but America's digital divide is just a part of the story. As the price of access goes up, as rental replaces purchase, and as copyright owners deploy invisible programs to lock up content, we're challenged by a *cultural divide* that has shattered shared, egalitarian linkages to art and heritage that would have been a given only a few decades ago. This cultural divide results in part from the scope of our current technological revolution, but it has been exacerbated by business practices that shape both the production and the distribution of art products and by the introduction of high-end software programs that greatly expand the horizons of those affluent consumers who can buy in at the highest level.

Poverty and geography still figure in—they're the main culprits behind the digital divide. Equipment and access are expensive, and providers have few incentives to deliver cable, Internet, or communications services to poor or sparsely populated areas. And even when libraries or community centers offer online access to poor neighborhoods or rural communities, dial-up or DSL service doesn't compare to the broadband connection enjoyed by the kid with a megacapacity computer waiting in her bedroom in an upscale suburban home.

But today we've moved beyond the superficial challenge of the digital divide to a deep cultural divide that involves more than mere access to computers and the Internet. The cultural divide is a new division of American society, with haves and have-nots in the world of culture and communication. It is a fence down the middle of our cultural commons, separating the fully engaged from those left in the dust by lack of knowledge, money, or the time required to gain access to new digital tools and new creative choices. After all, to exercise our cultural rights in a digital world we must have the money, knowledge, and time required by culture online.

Think about the knowledge needed today. Our arts system wasn't always complicated, and learning new technologies was pretty straight-

The Hewlett-Packard HP xw9300 Workstation. In both her Ringling School of Art and Design studio and in her apartment, student Bevin Carnes used this HP unit and gobs of high-end software and additional memory to create her regional Student Academy Award–winning film, *A Leg Up*. Carnes notes that a technically competitive studio needs to upgrade equipment and software every two years, while "for college students most places can get away with upgrading every four years." More young people than ever can produce films and animation, but while you can do it at home, this kind of participation is only for those who operate on the right side of the cultural divide. (Photo: © AMD/epa/CORBIS. Fee: $260.)

forward. Recall the scene of a few decades ago: Americans reared on dial telephones and vinyl records had little trouble transitioning to push-buttons and CDs; color TV worked pretty much like black-and-white; and everybody with any sense was quick to shout "Hallelujah!" when cassettes replaced eight-track tape. But the digital age is different; from cell phones to Napster, movies-on-demand, iTunes, Amazon .com, Tivo, and HDTV, cultural consumers face a daunting array of setup procedures, password-protected gateways, and pop-up commercials—a point-and-click maze. Anybody lacking special knowledge gets less.

Choice and participation are markedly different on opposite sides of the cultural divide. Armed with state-of-the-art equipment, adequate time, and an ability to pay through the nose for high-speed access, the savvy few can find their way to more and more choice (although they

often land variations of what a search engine thinks it knows they already like). But for those who get their television over the air, who shop at Wal-Mart (not online), see blockbuster films at the multiplex, and listen to Clear Channel–owned radio in the car, the options are increasingly bleak and seem to be getting worse. HBO gives subscribers *Angels in America, The Sopranos,* and Spike Lee's take on the Katrina disaster, but today's free network TV exhibits a tilt toward cheap-to-produce fare—game shows, "reality" contests, and endless "makeovers"—altering homes, parenting styles, and even faces.

Who's in and who's out in our new arts system? Plenty of kids with limited means would be master navigators on the digital sea; plenty of well-heeled professionals can't reconfigure the ringtone on their high-tech cell phones; plenty of smart, well-to-do stay-at-home moms just don't have the time to be creative online. As I said, it's not just about the money.

So the demography of our cultural divide hasn't been patched together yet, but certainly the poor are out, as are many older citizens. Even with 51 million households wired for broadband by the end of 2005, only 17 percent of rural homes are in the broadband game. A Corporation for Public Broadcasting study predicts that by 2010 broadband service will have expanded to only 69 million households. (When thinking of media penetration, remember that there are 110 million "TV households" in the United States today.) And government has made the divide worse. In early 2009, when analog TV broadcasting is ended, 30 million Americans who still receive programming via an antenna will find their sets suddenly dark.

Expertise is one factor in defining the two sides of our cultural divide, but the absence of free time also limits the ability of even affluent professionals to get maximum utility from the digital realm, just as lack of training (which itself may result from a lack of money) will also shortstop full access for others. If mapped, the cohort of citizens on the wrong side of the cultural divide would probably be the sociological equivalent of a gerrymandered congressional district—a class not grounded just in race, or income, or geography, or age, or employment but defined by a hybrid combination of elements powerful enough to keep many citizens on the bottom of a two-tier cultural participation system. And today we seem to

be heading in the wrong direction. In mid-2007 the United States ranked fifteenth in high-speed broadband adoption, down from ninth at the end of 2006. In the percentage of homes connected to broadband service, the United States was twenty-fourth, with 60 million subscriptions. And, unfortunately even when connected, our system is slow. Finland, Sweden, and Canada all have broadband service faster than the United States; Japan's is thirty times faster than the U.S. average.

At the end of 2006 a mirror-covered *Time* magazine declared "YOU" its "Person of the Year." Citing MySpace, YouTube, and LiveJournal, *Time* argued that the modern Internet is made up of "ordinary people" who are "adding their voice" to the Web. But, as Andrew Keen reminds us, this "cult of the amateur has made it increasingly difficult to determine the difference between reader and writer, between artist and spin doctor, between art and advertisement, between amateur and expert." Keen sees an all-me, "flattened, editor-free world" as ultimately "corrupting." Besides, who's producing all this online creative content, anyway? *Time* seems to suggest that it's everyone, but the Pew Internet and American Life Project reports that 57 percent of teenagers are active online and 12 million are involved in creating their own work. That's quite a few young people, but it remains obvious that many—if not most—remain on the dark side of the cultural divide.

.

The exclusionary character of U.S. cultural participation is the direct result of a bloated intellectual property regime; our cultural divide exists because copyright has enabled a growing, high-priced permission culture. The copyright-fueled marketplace is the biggest single obstacle separating Americans from the full exercise of our cultural rights. For the past half century, our copyright-dependent arts industries have continuously "come back to the well," lobbying Congress for term extensions or additional enforcement tools that protect their revenue streams. Last time around, when the "Sonny Bono Act" extended copyright to a term equal to the life of the artist plus seventy years, the cultural community was not at the table. Americans who claim an interest in arts policy have so far been uninterested in critical legislative and regulatory actions. But

our media industries will be back, and every time they ask for an extension of the copyright monopoly or insist on the ramping up of penalties for perceived infringement, we need to fight hard for specific public-interest give-backs in exchange.

First, old movies, books, and music that have remained out of print for decades, orphaned copyrights that are not claimed by any owner, millions of music, movie, and photographic holdings deemed of no contemporary commercial value should all immediately enter the public domain. Our cultural commons will be enriched when legislation removes copyright constraints from many thousands of works that can't be connected with owners or that completely lack commercial potential. There are recordings, films, books, and photographs that possess historical and cultural significance even though they can't generate revenue. When our arts industries ask for more, let's bargain for free access to material that shouldn't be locked away.

Second, the principle of statutory license fees and compulsory licenses—a system that works extraordinarily well in facilitating access to compositions in the recording industry—must be expanded to other classes of copyrighted material, thereby making it easier for contemporary artists to incorporate existing music, film, visual art, and television into new work. Remember, if I agree to pay the writer and publisher the "statutory rate," currently 9.1 cents for every CD sold, I can record anything I want. That means Bill Ivey, mediocre singer, can record the same Lennon-McCartney classic that might be cut by Whitney Houston or Harry Connick Jr. The U.S. recording scene is enriched by compulsory licensing, because singers don't have to ask permission or, even worse, negotiate a what-the-traffic-will-bear price for the use of a song. But the way recording artists license compositions stands alone in our system; the rights to every other use—music in film soundtracks, use of old film clips, photographs, even quotations from books—must be negotiated, bird by bird. Why shouldn't a contemporary filmmaker be able to license film footage from originals that are more than twenty-five years old at some fair preestablished rate? Older newsreel footage should also have a preset per-foot license fee. But today, if anything, movement in Congress is in the *opposite* direction; copyright-dependent companies hate the compulsory license and would love to secure legislation that would end it and its

related statutory rate. A concern for the public interest, as opposed to the interests of contending copyright-dependent companies, should be moving exactly the other way: we need *more* standardized rates for the use of more types of copyrighted materials, not less.

Third, let's bring back copyright registration, for heaven's sake. A hundred-year protected right that places no burden on the owner to let us know who owns what will inevitably break down. We don't need the kind of self-serving registration that helps publishers mount lawsuits, but meaningful registration that regularly updates key information about copyright holders. If those who manage copyrights are determined to collect a fee for every imaginable use of creative work under their control, we at least should be provided with a central registry that lets citizens know who must be paid, with whom we must negotiate a price, and where owners can be found.

Fourth, citizens must be especially alert as copyright-interested industries manipulate our courts to expand intellectual property protections. As Congress has grown tired of crafting narrow laws to protect media from the impact of new technologies, entertainment companies have turned to the courts to secure expanded copyright protections. Lessig noted that companies have become uncomfortable with some provisions of the Digital Millennium Copyright Act. Sensing little political support for a change in the legislation, the arts industries have successfully pursued their agenda in court, where, as Lessig points out, fewer votes are needed. Court action and precedent have emerged as an alternative route to expanded intellectual property rights—one that obviates the need to engage the uncertainties of the legislative process. Thus, concerned citizens must pay attention to both Congress and the courts. Fair use, for example, has mostly been shaped by courts; citizens must work to define boundaries of fair use broad enough to enable any citizen who desires to make noncommercial use of copyrighted material to know, in *advance* of embarking on a project, exactly what the law allows. In recent years copyright-dependent industries have undermined perfectly legitimate fair use through litigation or the intimidating threat of a lawsuit. And because fair use is only a defense, not a specified procedure that, if followed, will ensure compliance, companies get away with strong-arming legitimate fair users into backing down. The threat

of corporate lawsuits too often chills perfectly reasonable noncommercial exploitation of music, print, and moving-image originals.

In advancing a public interest approach to intellectual property protection, the Creative Commons stands as an especially interesting attempt to carve out a regime in which fair use, free use, and a nuanced assortment of fees for different applications of copyright can encourage a lively cultural commons. Music publishers and copyright attorneys *hate* Lessig's Creative Commons—a good sign. If interests dependent on copyright hate the concept, the Commons' layered approach to rights protection probably hews close to the public interest.

Sadly, absent any strong assertion of a counterbalancing public interest, copyright-dependent industries have to date met little resistance to the expansion of their intellectual property domain. In fact, in December 2007, with the support of industry groups, some leading Democratic and Republican representatives proposed the sweeping Prioritizing Resources and Organization for Intellectual Property (PRO IP) Act, which would increase penalties for copyright infringement, make Justice Department criminal prosecution easier, and create a new Executive Office agency to coordinate and initiate enforcement programs. It's as if transportation policy were being crafted by road pavers, or environmental legislation and regulation were being written by oil well drillers. Take the Internet, for example. Once a freewheeling Wild West of ideas and creativity, it has, with considerable dispatch, been redefined as a fenced-in minefield on which one false step can bring take-down notices or lawsuits.

EXPRESSIVE LIFE AND THE PUBLIC INTEREST

A movement to secure our cultural rights, the creation of a U.S. department of cultural affairs, and the reorientation of our arts system to serve public purposes makes sense because a vibrant expressive life is a key to a high quality of life for all Americans in the twenty-first century. My Cultural Bill of Rights speech, delivered over lunch at the National Press Club in fall 2000, was originally inspired by a book, not about art, but about quality of life. Economist Robert William Fogel's *The Fourth Great Awakening and the Future of Egalitarianism* argues that equity in the distribution of *spiritual resources* constitutes the greatest challenge facing Western de-

mocracies in the twenty-first century. In defining a balanced spiritual life, Fogel lists attributes like a sense of purpose, a vision of opportunity, a sense of community, the ability to engage diversity, a thirst for knowledge, an appreciation for quality, and self-discipline (he lists fourteen "spiritual resources" in all). I was convinced by his argument (which is not about culture but instead addresses the evolution of egalitarian values in America's democracy), but I was especially struck by the obvious links between Fogel's "spiritual assets" and the elements that make up a vibrant expressive life. Remember, our expressive life is made up of two equally important components: the history, community connections, and shared knowledge that give us a sense of belonging, permanence, and place—our cultural heritage—and the counterbalancing arena of accomplishment, autonomy, and influence: our individual voice. Fogel's spiritual resources are a perfect inventory of the building blocks of expressive life. It requires little imagination to advance art and art making as a route to a high quality of life. Should we move beyond analysis to develop policies and corporate practices designed to help citizens acquire a balanced spiritual life, nothing will work more effectively and efficiently than an elevated connection for citizens with heritage, artistry, and art making. If we take our Cultural Bill of Rights to heart, we'll automatically craft policies that enhance the nation's spiritual life.

At first glance, it might seem surprising that an important work on the distribution of the *spiritual* good life would be penned by a recipient of the Nobel Prize in economics, or that economists are the researchers most interested in connecting happiness with democracy. But first-in, first-out, it is economists who long ago linked material well-being and happiness. It's only right that they're now among the first to argue that pure material self-interest has limits as an explanation for human behavior. Economists, ever the purveyors of selfishness-as-motivation (I once heard an economist argue that suicide was in the economic self-interest of the victim!), have ended up forced out onto the frontier of behavior, seeking conditions of happiness that aren't just about wealth or material possessions. For these thinkers, it is family, friendships, religion, and work (not income but the quality of the work experience) that determine happiness once absolute material scarcity is overcome.

On January 1, 2006, the first baby boomer hit the age of sixty, and since

that date a new boomer has entered his or her seventh decade every 7.7 seconds. Many will live to be ninety, and, beyond access to health care, the problem of sustaining a high quality of life from limited retirement income will constitute a major public policy challenge. Forced by circumstance to abandon the treadmill of consumerism, our aging population can be steered by public policy toward a deep connection with art. After all, of all our cultural rights, the "Right to a Creative Life" comes closest to encapsulating the essential value of an arts system that serves the public interest and is the "right" that can best promote individual happiness and well-being. The idea of a sustained expressive life, both grounded in tradition and heritage and supportive of autonomy and individual voice, is an attractive democratic policy destination.

In addition to the looming demand to sustain quality of life for an aging, less-than-affluent population, the quest for a postconsumerist definition of happiness is emerging as a related but distinct public policy question facing Western democracies. As we've seen, since World War II perceived happiness has not tracked increased wealth in the United States and other Western democracies. If happiness has not been advanced by prosperity, it's clearly time to accept the possibility that once absolute material scarcity is alleviated, *immaterial* factors take over as the most important determiners of happiness. To date, reformers have tended to recycle arguments for more jobs, greater income, and better housing. But while progressives may be pained to shift focus away from interventions targeting material well-being, projects that enhance quality of life by nurturing a vibrant expressive life may constitute effective and efficient policy alternatives in the twenty-first century.

For example, if we begin by accepting the notion, as Richard Layard puts it, that "the greatest happiness is the right guide to public policy," programs that provide access to heritage and artistry, combined with the opportunity to express individuality and autonomy through art, may be the key to postindustrial democratic achievement. This sense of happiness, of course, is not about some search for an endless beach holiday— umbrellas, burbling surf, and creamy tropical drinks (most would be bored after a few weeks)—but instead seeks out the capacity to derive continuous satisfaction from work, family, and friendships. It's also about

stepping away from the perpetual yearning of consumerism. Happiness, for Layard, is about *feeling*, not about *having*: "People are happier if they are able to appreciate what they have, whatever it is; if they do not always compare themselves with others; and if they can school their own moods." Martin Seligman, father of the positive psychology movement, identifies three levels of happiness. One is "pleasantness," having good feelings; the second is engagement, maximizing your talents; the third is "the meaningful life," serving "something bigger than you are." These are buildable attributes that can be nurtured by public policy.

Art works because it's never really about ease; it's hard to paint reasonably well, to think through the meaning of a poem, or even to play the guitar or piano well enough to lead a family singing session. As Robert Fogel, Richard Layard, Robert Lane, and, for that matter, John Dewey would agree, happiness is instead about life lived on a higher plane: what Michael Hughes calls "meaningfulness" and Michael Kimmelman describes as "an artistic life."

For progressives throughout the twentieth century, improving quality of life meant crafting policy to improve the material circumstances of the poor. Concurrently, political conservatives drilled away with the contrary message that government is incapable of advancing society, that it is venal and corrupt, that it is "the problem, not the solution." In our push-pull partisan policy machine, it's difficult for Americans to imagine that a broad-based effort to reshape society for the better—especially a movement that talks about "expressive life," "autonomous voice," or even "spiritual resources"—could emerge and gain any traction.

But only one hundred years ago, at about the time our arts system was fixed in its modern form, the United States was caught up in a movement of exactly this sort. The Arts and Crafts movement advanced from the belief that art, labor, design, and natural materials could evoke the spiritual dimension embedded in everyday objects and ordinary work. Begun in England and generally viewed as a reaction to the dehumanizing effects of early industrial production, Arts and Crafts thinking spread around the world, ultimately influencing many aspects of daily life as well as public policy targeting immigrants and the poor. As historian Eileen Boris puts it, "What began as a critique of art and labor under industrial

capitalism turned into a style of arts, leisure activities, and personal and social therapy." Reaching its peak of U.S. influence around 1910, the Arts and Crafts movement linked aesthetics with humanitarian sensibilities—Prairie architecture, settlement houses, and a revival of folk arts and crafts. A rekindled respect for the handmade object and the notion of "reforming society through craftsmanship" were both elements of Arts and Crafts thinking.

Although the movement's values were centered in aesthetics and the moral dimension of handwork, Arts and Crafts leaders also criticized the impact of industrialization on both the natural environment and the lifestyles of workers. The movement meshed with early environmental reforms and vigorous outdoor lifestyles advanced by Theodore Roosevelt and by government-sponsored youth programs implemented by Herbert Hoover during the 1920s. These initiatives, like the Arts and Crafts movement generally, represented an effort to recapture a high, preindustrial quality of life by reconnecting with nature and pushing back against the excesses of modernism. Similarly, aspects of the Arts and Crafts movement were embraced by Social Gospel reformers, and also became part of American social anthropology's reworking of cultural studies, a process that ultimately debunked the nineteenth-century notion that societies were differentiated by inherent racial attributes.

Today our digital age presents challenges to community and family life every bit as daunting as those that arose with the industrial revolution. When present-day cultural critics decry American materialism, the selfish isolation of our online "me" society, or the hollowness of a search for life meaning in fitness, adventure, drugs, or psychoanalysis, they echo Arts and Crafts thinkers who one hundred years ago bemoaned the growing gulf between rich and poor, industrial pollution, and the glorification of profit above basic human needs. And, like the late nineteenth century, our new American millennium exhibits its unique, debilitating pathology. Today *depression* undermines the family and work lives of millions, just as *neurasthenia* drove many of America's best and brightest to months of bedrest around the turn of the twentieth century.

Today the Arts and Crafts movement is not much talked about; its commitments to everyday art, handmade objects, and Progressive reform

were gradually absorbed by other movements—strands can be found in ideologies as disparate as socialism and twentieth-century fascism. Of course, the movement lives in the efforts of collectors and art historians, for whom Stickley furniture, Frank Lloyd Wright houses, the notion of the fireplace as the emotional center of a home, and the use of rough structures like old barns, factory lofts, and log houses as residences survive from the era that ushered in a new level of comfort and practicality in architecture and the decorative arts. But it's also conventional wisdom: as a critical response to the elements of modernity that undermined individual and community development, the Arts and Crafts movement has left a legacy so embedded in modern thought that its sometimes-radical notions are taken for granted. The idea that small, intimate communities are better and more humane than impersonal suburbs; the idea that antiques, folk art, crafts, and traditional music are worthy of study, preservation, and emulation—all derive from Arts and Crafts thinking. In fact, the entire rhetoric of "authenticity" owes its existence to John Ruskin and William Morris and their followers. The idea that a unique, well-designed, handmade object, built to traditional standards using natural materials, offers a valuable alternative to mass-produced products remains powerful—strong enough to have found its way into advertising for everything from Target cookware to Ralph Lauren fashion.

Pioneers of the Arts and Crafts movement not only promoted the special value of handmade art but also argued that for individuals a well-configured expressive life was an antidote to the deadening influence of industrial production. Were these thinkers among us today, they would, in the same spirit, challenge consumerism, the isolating chill of cell phones and the Internet, and the dulling influence of television, promoting instead a revitalized connection with heritage, creativity, and art making to secure a new spiritual, economic, and social order.

But if our claim to cultural rights is to take the shape of a new Arts and Crafts movement, framing a new investment in national identity, community and family connectedness, and personal accomplishment, we must give up some long-standing assumptions that have shaped the way we think about our expressive life. We can't take it for granted that fine art is good art and popular art is bad; we can't assume that a nonprofit

organization automatically makes better art than a Hollywood studio; we can't act as though amateur art making is less important, or even less good, than what's accomplished by a professional. Larry Shiner, in *The Invention of Art*, demonstrates convincingly that the separation of *art* from *craft* is both recent and of questionable legitimacy. We need to bring industrial design, video gaming, poetry slams, book clubs, family sing-alongs, and fashion back into the container labeled "art," so we can engage art the way Americans really live it.

Giving up old assumptions might be the easy part. The critical task—the part requiring heavy lifting—is to begin the journey that will convince the leaders of an affluent democracy that the best way to improve the quality of life of citizens is to meaningfully integrate art into the heart and soul of every citizen. To secure our Cultural Bill of Rights, to push back against copyright or regulate business so as to ensure openness in media and access to heritage, requires little more than the transfer of a healthy suspicion of corporate practice into public policy. But to advance art as an antidote to twenty-first-century malaise, we must risk a leap of faith.

· · · · ·

Today it's hard for Americans to imagine that government can accomplish anything big. As essayist Josie Appleton put it, "Politics today is about fiddling, making a tweak here and there but not changing anything much. We can't conceive of a future much better than the present." But to realize our Cultural Bill of Rights we must reacquaint ourselves with the notion that government can lead the way to a better life. It's a daunting task that doesn't fit the formula of twenty-first-century leadership. If we are to decide, first of all, that happiness apart from material well-being is a goal of good democratic government, and, second, that a vibrant cultural system nurturing artists—professional and amateur—is the best mechanism for creating the conditions of a happy life, we must move beyond "tweaking" to enact policy that can really make life different. Further, we have to get past the burdensome assumption that progress through public policy is always about bringing needy citizens from the basement to the ground floor, acknowledging instead that progressive leadership can also be about moving beyond dead level by creating the

conditions of a high quality of life. We can generate real change only if we believe that we as citizens have both the need and the capacity to seize control of the levers of power in order to make things better. Plenty of pundits express our profound discomfort with consumerism as a gateway to satisfaction, and the outsourcing of technological expertise has underlined the need for a new engine of economic growth, but we lack confidence that by reorienting shared priorities we can choose a different course.

A new approach to cultural questions will be required if Americans are to reshape our arts system so it honors our cultural rights. Changes in the way we secure and police the ownership rights to intellectual property, regulatory reform that encourages companies to free up heritage, an educational system that builds creativity and lifelong art making for all, and a coordinated system of international arts exchange can together restore America's cultural mainstream as an anchor for the elevated quality of life we claim as the benefit of democracy.

If there exists a single underlying policy reason why our arts system has become detached from the public interest, it is the fact that what passes for cultural policy is parceled out among dozens of government agencies, none of which has as its primary responsibility the care of America's expressive life. The absence of a single agency, a policy hub, around which issues of trade, diplomacy, arts education, and heritage can be debated and resolved, has made it all too easy for the marketplace to shape the rules. There's no entity with sufficient authority to balance the demands of arts industries and cultural nonprofits against what's best for the American public. The policy void, the lack of a credible cultural authority, has kept cultural issues out of the domestic and international agendas of the White House West Wing—in Republican and Democratic administrations alike. But opportunity exists: partisan disinterest in the cultural dimension of public policy has spun off an important benefit: issues involving art, intellectual property, and cultural diplomacy have not yet divided along party lines.

We must approach the idea of a department of cultural affairs with plenty of caution—eyes wide open. There's a demonstrated chance for mischief when government gets its nose under the cultural tent,

especially when matters of content are in play. Art is especially suscep-
tible to Foucault's notion of "governmentality": invisible, sometimes-
internalized mechanisms of control that extend the reach of official au-
thority and limit individual autonomy. Foucault would likely (and
correctly) see entities like Wal-Mart, Clear Channel, and major founda-
tions like the Smithsonian Institution and the J. Paul Getty Trust as
sources of quasi-governmental authority in the U.S. arts system. Viewed
through Foucault's skeptical lens, the introduction of a central cultural
authority in the United States could backfire, opening new opportunities
for control that might make it more difficult, not easier, for Americans to
achieve rich expressive lives. But, as we've seen, there's plenty of poorly
directed cultural interference going on right now.

Truth be told, the path of cultural rights outside the United States
has been sufficiently fraught to at least introduce a measure of caution.
UNESCO conventions covering cultural rights, the ownership and repa-
triation of cultural properties, and rights to intangible heritage constitute
the most dramatic efforts to date to improve the quality of cultural sys-
tems by the application of abstract principles through government policy.
Such well-intentioned international agreements have generated more
than their share of unintended consequences. Put into practice, these
principles have conflated "cultural rights" with protectionist trade prac-
tices and the identification of worthy "indigenous" communities. In
short, the global cultural rights movement has enabled governments to
define an official culture and then enact sometimes-oppressive measures
to preserve and protect it. Our starting point helps; the broad acceptance
of cultural diversity in the United States will likely help our policy lead-
ers avoid rigid notions of national identity or cultural purity that have
snared emerging former colonies as well as countries like France.

But whether we examine heritage, learning in the arts, the careers of
artists, our arts organizations, or cultural diplomacy, the U.S. arts sys-
tem today is in disarray, far removed from the mark set by our Cultural
Bill of Rights. Wherever we look, government is doing too little, or too
much of the wrong things, or allowing fragmented cultural policy to
generate unhelpful quantities of unintended consequences. Yes, a cen-
tral cultural authority might make mistakes, but it's hard to imagine

that a well-organized government department charged with maintaining public purposes in our cultural system could make the current situation worse.

And even though Foucault was adept at pointing out arenas in which government exercises unseen control to stifle freedom and stunt human development, he was never a complete pessimist about interventions in culture and art. Foucault understood that his intellectual critique of invisible controls imposed by government action could simply freeze policy in its tracks. Instead he explained, "My point is not that everything is bad, but that everything is dangerous." In other words, be careful, but proceed. Despite the possibility of a few false steps down blind alleys, we must begin the task of humanizing our arts system by pulling cultural work into an agency devoted to cultural affairs—one that would tune the system, not the content, of our expressive lives; one that would not upset the balance between identity and freedom that is the essence of heritage and creativity.

As I have argued, a U.S. department of cultural affairs would be hard-pressed to make things worse than they are right now. Intellectual property law and media regulation don't track public purposes but instead mediate the demands of various interested parties. No one is addressing America's growing cultural divide. Today, to say that the FCC, the Office of the U.S. Trade Representative, the NEA, the Department of Homeland Security, Patents and Trademarks, the Department of Justice, the Internal Revenue Service, and the Copyright Office all regulate culture in the public interest is to say, in effect, that no one really regulates it. And, with responsibility for "soft diplomacy" apportioned among the Department of State, the Office of the U.S. Trade Representative, the Department of Defense, and the Broadcasting Board of Governors, our global cultural message is, to say the least, inconsistent. Over time a high-level authority addressing cultural affairs will begin to pull the pieces together, and even if resulting arts policy isn't perfect, it will at least be something it almost never is today—coherent.

And a new Cabinet department isn't the only way to bring citizen rights and policy coordination to cultural work; a multiagency White House office like the National Security Council might be just as effective.

The place to begin is with the appointment of a presidential commission charged with studying these issues, bringing the public interest forward, and making recommendations. Hearings conducted by the Judiciary and Commerce committees can also be a good start.

If the notion of a government agency devoted to the openness of the arts system and the vitality of the nation's expressive life turns out to be a bridge too far, there remain other opportunities to reverse the pattern of marketplace domination, unintended consequences, and policy incoherence that have, to date, undermined our cultural rights. After all, although arts industries are motivated by profit, their interests don't automatically run counter to citizen interests in a cultural system that reflects the rich diversity of our society. Movie studios, record companies, and broadcasters have themselves suffered mightily from the staccato rhythm of policy in international trade, media regulation, and intellectual property legislation. An Aspen Institute–style consortium of leading for-profit cultural industries and public interest organizations could no doubt craft corporate practices in heritage preservation and educational access to media that could improve the arts system without recourse to new legislation or regulation.

Whether we address the challenges of our Cultural Bill of Rights through collegial negotiation with arts companies or through new government legislation or regulation, the task of bending our arts system to the public interest raises important questions that will be with us for decades. If we are committed to a vibrant expressive life for all Americans, what are the indicators that will tell us how we are doing or how effective some new program might be? Who are the key partners in this effort? Fifty years ago the Ford and Rockefeller Foundations defined the U.S. cultural intervention model, then handed that model off to government. It was that successful effort that gave us our Arts and Humanities Endowments. Will these venerable sources of leadership and philanthropy, and new players like the Bill and Melinda Gates Foundation, move beyond interventions related to material well-being—poverty, health care, and education—to also address creativity, identity, independent voice: the spiritual resources, and our cultural rights, that ultimately determine happiness and quality of life? Can the NEA, or a redirected nonprofit arts

community, provide leadership essential to a fresh connection between art and the public interest?

And what about the Internet and digital technology?

A few years back my cultural rights argument would have probably viewed the Internet as an agent of massive cultural transformation; today the Internet's bright promise of individual creativity and citizen access has dimmed. At first the Internet looked all wild and wooly: new people, new ideas, no rules. But today it looks less like a freewheeling frontier and more like the Upper West Side of Manhattan—all high-priced rentals and out-of-reach condos featuring spectacular views. Three issues, all up in the air as this volume goes to press, will determine the character of art on the Internet for the foreseeable future. First, "Net neutrality"—the notion that an Internet search should be not be directed to the highest-paying, advertiser-supported site—should be a major object of congressional action. Second, the Copyright Royalty Board has announced dramatic increases in per-listener payments for the broadcast of music through streaming services on the Internet. Third, media giant Viacom sued the video-sharing Internet site YouTube (and the company's new parent, Google) for $1 billion, alleging massive copyright infringement. If these pending issues resolve the wrong way, if high Internet music fees survive public comment, if Net neutrality yields to advertiser priority, and if Viacom succeeded in making YouTube responsible for the infringing activities of millions of individual site users, big corporations will have taken a major step toward converting the Internet into something that resembles regular radio or television broadcasting—you'll either be watching an ad, paying a fee, or finding your way to only those sites that have paid to draw you in. There's a desperate need right now for leaders to look hard at how the Internet intersects with expressive life and where the public interest lies.

Sadly, if forced to place a bet, I'd side with the media giants. After all, for the past century weak laws shaped to suit the marketplace have enabled them to ultimately lock up every emerging technology in a web of revenue streams, payments, and permissions. A recent article in *CNET News* declared Net neutrality "dead," and, with annual revenues of $21.7 billion, Internet advertising has surpassed terrestrial radio. These are not good signs.

So for today America's Cultural Bill of Rights remains a distant dream, and each day silent forces erode the quality of our expressive life. The dream has nearly drifted beyond our reach. Each cultural right—to heritage, an artistic life, great art, and artistry abroad—presents unique value that can only be realized by taking on unique challenges. There are weaknesses in the way we teach art, in the interplay of international relations and culture, and in the priorities of our funding agencies and nonprofits. Our artists too often do not live and work in circumstances that enable originality, synthesis, and respect. We seem unable to gather up and care for the system that sustains creativity and artistic identity.

It has been a long time since Americans have transformed society by working together to align our future with a set of important ideas. It has been at least since the civil rights revolution of the 1960s, and cynics might well be right to argue that we've lost the spirit of idealism, uplift, and human progress that can bring about change. After all, the prices at Home Depot are still low, most Americans have jobs, and *Lost* has just gone into syndication. Why worry?

But we're also caught up in a global spiritual struggle that pits the core values of modernity against resurgent theocracy; and here at home we will soon be forced to consider the quality of life for older citizens, as well as for a cohort of younger Americans who find they are unable to duplicate the financial feats of their parents' generation. At the same inconvenient time, some of the smartest people around tell us we need a new definition of happiness to suit a postconsumerist age, while educators and public intellectuals point beyond information, technology, and industrial production to envision an economy with global reach built on high-concept creativity.

Today Americans are uniquely poised to seize and make real the "street bazaar" view of cultural democracy—everyone participates, many people sell, prices are low, and social interaction is high. But that dream is threatened by new costs, new restrictions, new tolls, and bad public policy. An assertion of cultural rights can help save the day. Taken to heart, our Cultural Bill of Rights can bring an essential focus to the challenge we face: not reworking problems of the last century, but addressing those of the hundred years to come.

Acknowledgments

This volume would not exist but for the work of many who have thought seriously about culture, creativity, intellectual property, and the public interest. I am especially indebted to those writers who have challenged the U.S. intellectual property regime and those who have questioned our addiction to consumerism, encouraging us to think more deeply about happiness, quality of life, and spiritual resources; among these leaders are Lawrence Lessig, Siva Vaidhyanathan, Robert Fogel, Tim Kasser, Sir Richard Layard, and Richard Sennett.

Malcolm Knapp's encouragement helped keep the idea of the Cultural Bill of Rights alive. Victoria Hutter and my Vanderbilt colleague Steven J. Tepper read early drafts of the manuscript and made valuable suggestions; Steven returned at the end of the project to help top things off. From the start, Nicole Pietrantoni and Heather Lefkowitz provided invaluable

research and assistance with licensing issues, and our Curb Center Associates—Neala Swaminatha, Brielle Bryan, Ania Lipowska, and Chethana Biliyar—were always willing to deploy their Internet skills to check obscure facts or track down quotations. Paula Cleggett and Kira Florita collected up-to-date facts on short notice. Critical assessments of the manuscript by John Kreidler and Andrew Taylor were most helpful, as were the ideas of former NEA chairs Jane Alexander and Frank Hodsoll. My English teacher mother, Grace Ivey, at age eighty-nine, emerged from a long retirement to proofread and critique the entire volume, and Nan Zierden brought both perspective and editorial expertise to bear as we prepared a final draft. My agent, Kristen Auclair, and Naomi Schneider at the University of California Press maintained enthusiasm during a long process and were understanding when the scope and character of my work were reshaped in midstream. Susan Keffer provided support and a real understanding of the challenges facing the author. Finally, I am grateful to Mike Curb and the Mike Curb Family Foundation for their enthusiastic backing of new approaches to cultural policy work.

I hope that this volume triggers a new conversation about culture and the public interest, because for those who have helped so much, that fresh conversation, and my gratitude, will be the only compensation received.

Notes

PREFACE

p. xv *Steven Pearlstein, writing in the* Washington Post: Steven Pearlstein, "A Sound Marketplace for Recorded Music," *Washington Post,* July 19, 2006. *George Lesser, in the* Washington Times: George H. Lesser, "Bring Back the USIA," *Washington Times,* June 22, 2006. *National Public Radio reports:* Celeste Headlee, "Detroit Symphony Finds an Audience," *All Things Considered,* National Public Radio, July 8, 2006. New York Times *art critic Michael Kimmelman laments:* Michael Kimmelman, "The Art of Drawing, When Amateurs Roamed the Earth," *New York Times,* July 19, 2006.

p. xviii *In a speech to the American Folklore Society . . . Barry Lopez identified:* Barry Lopez, "A Conversation with Barry Lopez," Annual Meeting of the American Folklore Society, October 18, 2006.

p. xix *An old southern farmer:* From an address by Adrian King, then head of GAS programming for the Coca-Cola Foundation, June 7, 1999. King was

speaking at the Hilton Hotel in Atlanta at the annual membership meeting of Americans for the Arts.

INTRODUCTION

p. 1 *Salonen's answer contained an accurate assessment:* Interview with Esa-Pekka Salonen, reported by Jeffrey Brown, "Musical Mission," *News-Hour,* PBS, June 30, 2004.

p. 2 *As cultural historian Lawrence Levine puts it:* Lawrence W. Levine, *Highbrow/Lowbrow: The Emergence of the Cultural Hierarchy in America* (Cambridge, MA: Harvard University Press, 1988).

p. 3 *This entry from the June 9, 1805, journal: The Journals of the Lewis and Clark Expedition,* http://lewisandclarkjournals.unl.edu/index.html.

p. 5 *As Leon Wynter observes in* American Skin: Leon Wynter, *American Skin: Pop Culture, Big Business and the End of White America* (New York: Crown, 2002).

p. 6 *. . . what critic Gilbert Seldes labeled the "7 Lively Arts":* Gilbert Seldes, *The 7 Lively Arts* (New York: Harper and Brothers, 1924). New edition, with an introduction by Michael Kammen (New York: Dover Publications, 2001).

p. 7 *Music of all kinds:* Russell Sanjek and David Sanjek, *Pennies from Heaven: The American Popular Business in the Twentieth Century* (New York: Da Capo Press, 1996).

 In 1920 . . . fifteen film studios. In 1927 . . . 6,000 moviegoers: www.filmsite.com.

 KDKA . . . went on the air in 1920: www.kdkaradio.com.

 . . . according to Wynter: Wynter, *American Skin.*

p. 10 *. . . piano factories built:* www.pianonet.com.

 As critic Michael Kimmelman points out: Michael Kimmelman, "Prodigy's Return," *New York Times,* August 8, 1999.

 . . . during a period when the U.S. population grew: www.demographia.com.

p. 14 *Today, as copyright guru Lawrence Lessig explains:* Lawrence Lessig, *Free Culture: How Big Media Uses Technology and the Law to Lock Down Culture and Control Creativity* (New York: Penguin, 2004).

p. 15 *As sociologist Pierre Bourdieu observed:* Pierre Bourdieu, *Distinction: A Social Critique of Judgment of Taste,* translated by Richard Nice (Cambridge, MA: Harrold Press, 1984).

 In his landmark study: Paul DiMaggio, "Cultural Entrepreneurship in Nineteenth-Century Boston: The Creation of an Organizational Base for High Culture in America," *Media, Culture, and Society* 44, no. 1 (1982): 33–50.

p. 16 *As Seattle journalist Matthew Richter correctly observes:* Matthew Richter, "The Nonprofit Motive," *The Stranger,* April 27–May 3, 2006. www.thestranger.com/seattle/content?oid=31920.

 As Levine wryly observes: Levine, *Highbrow/Lowbrow.*

p. 22 *Lawrence Harrison and Samuel Huntington, writing in* Culture Matters: Lawrence E. Harrison and Samuel P. Huntington, eds., *Culture Matters: How Values Shape Human Progress* (New York: Basic Books, 2000).

p. 24 *The notion of a space . . . contained in Thomas Friedman's notion:* Thomas Friedman, *The Lexus and the Olive Tree* (New York: Anchor Books, 2000).
. . . *it underlies philosopher Kwame Anthony Appiah's conviction:* Kwame Anthony Appiah, "The Case for Contamination," *New York Times,* January 1, 2006. Essay adapted from *Cosmopolitanism: Ethics in a World of Strangers* (New York: W. W. Norton, 2007).
As Toby Miller observes: Toby Miller, "Hullo Television Studies, Bye-Bye Television?" *Television & New Media* 1 (2000): 308.

ONE: HERITAGE

p. 29 *As historian Kevin Starr observed:* Kevin Starr, *Americans and the California Dream, 1850–1915* (New York: Oxford University Press, 1973).
Bonnie Raitt put it more succinctly: Bonnie Raitt, quoted in documentary *Make It Funky* (Michael Murphy Productions, 2005).

p. 30 *As record historian Tim Brooks put it:* Tim Brooks, in "Comments for the National Recording Preservation Board Study on the Current State of Recorded Sound Preservation," Harry Ransom Center at the University of Texas at Austin, January 30, 2007.

p. 32 *"I got $25 . . . ," Stearns said:* Sarah Boxer, "A Century's Photo History Destined for Life in a Mine," *New York Times,* April 15, 2001.

p. 34 *As Gates recently observed:* Steve Hamm, "Bill Gates' Photo Op," *BusinessWeek Online,* January 21, 2005 (see www.businessweek.com).

p. 35 *In an NPR interview he recalled scouring the alleyways:* Frank Driggs, interview by Renee Montagne, *Morning Edition,* National Public Radio, March 15, 2000.

p. 37 *. . . with total holdings having surpassed the 100 million mark:* See www.corbis.com.
Initially, in 1996, Corbis estimated: Boxer, "A Century's Photo History Destined for Life in a Mine."

p. 38 *"What's gotten to me over the years":* Orrin Keepnews, telephone interview with author, March 17, 2004.

p. 39 *In 1980 CBS staff producer Michael Brooks:* Bill Holland, "Labels Strive to Rectify Past Archival Problems," *Billboard,* July 12, 1997.

p. 41 *As an award-winning investigative series by* Billboard *correspondent Bill Holland:* Bill Holland, "The Alarming Deterioration of Master Tapes in U.S. Record Company Vaults," *Billboard,* June 5, July 17, and November 6, 1999.
According to Holland, RCA demolished an entire warehouse: Holland, "The Alarming Deterioration of Master Tapes."

p. 43 *DVD sales totaled $2.3 billion in 2004:* Mike Snider, "Record Year for DVDs," *USA Today,* January 1, 2005.
 The MGM film library generated $440 million: "DVD a Major Driver in Film Revenue," August 12, 2004, www.dvdforum.org; also in *DVD News Digest,* August 17, 2004.

p. 44 *Patrick Loughney . . . cites a conclusion:* Patrick Loughney, "On the Trail of Television's Lost Treasures," *New York Times,* April 29, 2001.
 A 2004 New York state court decision: Meredith Amdur, "Sony and Its Backers Looking to Punch Lion's Library Card," *Variety,* April 26–May 2, 2004, pp. 7, 22.
 Legal scholar Joseph Sax, in Playing Darts with a Rembrandt: Joseph L. Sax, *Playing Darts with a Rembrandt: Public and Private Rights in Cultural Treasures* (Ann Arbor: University of Michigan Press, 1999).

p. 45 *As record executive Dan Sheehy notes:* Dan Sheehy, public hearing of Recorded Sound Preservation Foundation, Library of Congress, at Princeton Club, New York City, December 19, 2006.

p. 46 *In 2005 Heritage Preservation . . . surveyed 30,000 collections:* "A Public Trust at Risk: The Heritage Health Index Report on the State of America's Collections," December 2005, www.heritagepreservation.org/HHI/summary .html.
 New York Times *art critic Michael Kimmelman pummeled the New York Public Library:* Michael Kimmelman, "A City's Heart Misses a Beat," *New York Times,* May 16, 2005.

p. 48 *Hillary Rosen, then RIAA CEO, claimed:* Bill Holland, "NARAS Aims for National Discography, but Labels Wary," *Billboard,* February 7, 1998.

p. 49 *Paul Goldstein imagines a "celestial jukebox":* Paul Goldstein, *Copyright's Highway: From Gutenberg to the Celestial Jukebox* (Stanford, CA: Stanford University Press, 2003).
 Chris Anderson envisions a "long tail": Chris Anderson, *The Long Tail: Why the Future of Business Is Selling Less of More* (New York: Hyperion, 2006).
 For Anderson: Chris Anderson, "The Long Tail," *Wired,* October 1, 2004.

p. 50 *Farhad Manjoo, writing in Salon.com:* Farhad Manjoo, "Throwing Google at the Book," November 9, 2005, http://dir.salon.com/story/tech/feature/ 2005/11/09/google/index.html.

p. 51 *As Librarian of Congress James Billington observed:* James Billington, remarks at an event at the American Folk Life Center, Washington, DC, March 15, 2007.

p. 53 *As Tim Brooks discovered:* Tim Brooks, Survey of Reissues of U.S. Recordings, commissioned for and by the National Recording Preservation Board, Library of Congress, August 2005.
 Kimmelman has suggested: Kimmelman, "A City's Heart Misses a Beat."

p. 54 *FTC attorney Neil Averitt has argued:* Neil Averitt and Robert H. Lande, "Using the 'Consumer Choice' Approach to Antitrust Law," 74 Antitrust LJ 175 (2007).

TWO: ARTISTS

p. 58 *In a cut from his 2005 album:* "Beautiful Despair" © 2005 Sony/ATV Music
Publishing LLC and J Only Publishing. All rights administered by
Sony/ATV Music Publishing LLC, 8 Music Square West, Nashville, TN
37203. All Rights Reserved. Used by Permission.
Sony/ATV Music Publishing, administering rights for Rodney Crowell,
originally asked for $600 to license these twenty-three words from "Beau-
tiful Despair," reducing the fee to $500 when I objected to the cost. The
Sony/ATV licensing agreement also required the submission of several
pages of the *Arts, Inc.* manuscript to show "context." This excerpt, which
almost certainly would be fair use, is the most expensive single item of in-
tellectual property licensed for this volume.

p. 60 *One album into his contract, Dylan had sold:* John Hammond, quoted in
Dunstan Prial, *The Producer: John Hammond and the Soul of American Music*
(New York: Farrar, Straus and Giroux, 2006).
Author David Hajdu went further: David Hajdu, quoted in Prial, *The Pro-
ducer.*
"You had to respect John . . ." Miller explained: Mitch Miller, in *Don't Look
Back,* documentary on Bob Dylan, dir: D. A. Pennebaker (1967).
The singer-songwriter remembers Hammond: Bob Dylan, *Chronicles, Volume
I* (New York: Simon and Schuster, 2004).
"Too much rides on the success or failure": John Hammond, in John Ham-
mond and Irving Townsend, *John Hammond on Record* (New York: Pen-
guin, 1977).

p. 62 *. . . in 2000 more than 66 percent of jazz artists:* Joan Jeffri, "Changing the
Beat: A Study of the Worklife of Jazz Musicians," NEA Research Division
Report #43, National Endowment for the Arts, Washington, DC, 2003.
As a recent study by the NEA makes clear: Neil O. Alper and Gregory H.
Wassell, *More than Once in a Blue Moon: Multiple Jobholdings by American
Artists* (Santa Ana, CA: Steven Locke Press, 2000).
A 2001 Rand research brief reported: Kevin F. McCarthy, Elizabeth Ondaatje,
Arthur Brooks, and Andras Szanto, "A Portrait of the Visual Arts: Meeting
the Challenges of a New Era," Rand Corporation, Santa Monica, CA, 2005.

p. 63 *In Hollywood:* Bridget Johnson, "Is Hollywood Too Discriminating?" *Wall
Street Journal,* October 25, 2005.
Nathan Holstein, writing in the Chronicle of Higher Education: Nathan
Holstein, "Pushing the Big Red Button," *Chronicle of Higher Education,*
May 20, 2005.
In a 1998 report . . . Joan Jeffri tracked: Joan Jeffri, "The Artist as Citizen,"
paper presented at the conference "Social Theory, Politics, and the Arts,"
Philadelphia, October 1998.

p. 65 *Writing in the* New York Times: Paul Theroux, "Aid to Africa, from a Rock
Star" (op-ed), *New York Times,* December 15, 2005.
. . . he boasted a background as "a Peace Corps volunteer": Peter Carlson, "But

Seriously, Folks: Heard the One about Friedman Running for Texas Governor?" *Washington Post*, July 18, 2006.

p. 66 *As Walter Capps observed:* Walter H. Capps, "Interpreting Václav Havel," *Cross Currents* 47, no. 3 (fall 1997).

In a 1993 essay: Václav Havel, "The Role of the Czech President," *Mlada Fronta Dnes*, January 19, 1993.

"Reagan was always a Hollywood creature": David Gergen, *Eyewitness to Power: The Essence of Leadership, Nixon to Clinton* (New York: Simon and Schuster, 2004).

p. 67 *Kevin Phillips, reviewing* The Reagan Diaries: Kevin Phillips, review of Douglas Brinkley, ed., *The Reagan Diaries, New York Times Book Review*, June 17, 2007, pp. 11–12.

In the title of his respected biography: Lou Cannon, *President Reagan: The Role of a Lifetime* (New York: Simon and Schuster, 1991).

p. 68 *But eighteenth-century philosopher:* Denis Diderot, *Diderot on Art*, edited and translated by John Goodman (New Haven, CT: Yale University Press, 1995).

In his characterization of Reagan's letters: Douglas Brinkley, *The Boys of Pointe du Hoc: Ronald Reagan, D-Day, and the U.S. Army 2nd Ranger Battalion* (New York: William Morrow, 2005).

Lou Cannon credits Reagan: Cannon, *President Reagan*.

p. 69 *Without ever connecting the dots . . . Gergen seems to agree:* Gergen, *Eyewitness to Power*.

Editor Mort Zuckerman: Zuckerman, as quoted in Nick Paumgarten, "The Tycoon: The Making of Mort Zuckerman," *New Yorker*, July 23, 2007, p. 47.

As Diderot makes clear: Diderot, *Diderot on Art*.

p. 71 *. . . a study by American University's Center for Social Media determined:* Patricia Aufderheide and Peter Jaszi, "Untold Stories: Creative Consequences of the Rights Clearance Culture for Documentary Filmmakers," Center for Social Media, American University, Washington, DC, 2004, www.centerforsocialmedia.ort/rock/index.htm.

p. 72 *"I wanted to see it get out there . . .":* Derek Webb, quoted in Russ Breimeier, "Sing Your Peace," *Christian Music Today*, May 21, 2007.

Jonathan Lethem, in his brilliant article: Jonathan Lethem, "The Ecstasy of Influence: A Plagiarism," *Harper's Magazine*, February 2007, pp. 59–68.

But, as the LA Times *editorialized:* "Fashion Copyrights Cut Creativity," *LA Times*, August 15, 2007.

p. 73 *. . . "creative copyright infringement . . . is thriving online":* Joshua Ostroff, "Music's Copyright Defenders Face an Upstoppable Force," *Globe and Mail*, May 25, 2005.

For an artist, piracy *means something bigger:* Quotation at www.cbc.ca/story/arts/national/2005/06/09/Arts/warhollawsuit050609.html.

. . . Mary Gaitskill's novel Veronica: Mary Gaitskill, *Veronica* (New York: Pantheon, 2005).

p. 74 *... the Country Music Foundation:* Dorothy Horstman, *Sing Your Heart Out, Country Boy* (Nashville: Country Music Foundation, 1975, 1986). This compilation of annotated lyrics was first assembled in 1975; the revised edition in 1986 included a number of new titles acquired with gratis licenses.

Author Peter Guralnick noted: The Curb Center conference (on music writing) was held on March 30, 2005. For an excellent discussion of the application of fair use in real-world art making, see "Documentary Filmmakers' Statement of the Best Practices in Fair Use," Center for Social Media, School of Communication, American University, Washington, DC, issued November 18, 2005.

Policy analyst Timothy Lee writes: Timothy B. Lee, "Circumventing Competition: The Perverse Consequences of the Digital Millennium Copyright Act," *Policy Analysis* (Cato Institute), no. 564, March 21, 2006.

p. 76 *... think of Alice Randall's reshaping of characters:* Alice Randall, *The Wind Done Gone* (Boston: Houghton Mifflin, 2001).

p. 77 *... HR 683, the Trademark Dilution Revision Act:* For discussion of this legislation, see, for example, Edward Greenberg's "Important New Legislation Proposal," *Stock Photographer,* January 2006.

p. 78 *... as the* New York Times *reported:* Adam Liptank, "Sports Artist Sued for Mixing Crimson and Tide," *New York Times,* November 12, 2006.

As one New York Times *reporter put it:* Roberta Smith, "Critic's Notebook: When One Man's Video Art Is Another's Copyright Crime," *New York Times,* October 22, 2007.

p. 87 *As a Web site passionately devoted to the integrity of* WKRP *observed:* http://members.allstream.net/~jacjud/wkrpmusic.html. See also www.deathby copyright.ca.

Other series ... are in the same boat, at least in the United States: Although you can get only a few episodes of *Ally McBeal* on DVD in the United States, the complete series has been released in England and other European countries.

p. 88 *... but a copyright system ... is an equal-opportunity villain:* An amusing and absolutely authoritative look at the daunting intellectual property/fair use playing field that must be navigated by filmmakers is given in the comic-book-style *Bound by Law?* written by Keith Aoiki, James Boyle, and Jennifer Jenkins, and published by the Duke University Center for the Study of the Public Domain in 2006 (see www.law.duke.edu/cspd/comics).

p. 90 *However, a small but growing cohort of artists and educators:* BCOME, the Brevard Conference on Music Entrepreneurship, was initiated in 2006 as a program of the Brevard Music Center, Brevard, North Carolina. According to its March 28, 2006, press release, BCOME encourages graduates of conservatories and schools of music to "explore career tracks beyond traditional pathways" and works to make courses in entrepreneurship part of university-level programs in instrumental and vocal music.

In The Future of Ideas: Lawrence Lessig, *The Future of Ideas: The Fate of the Commons in a Connected World* (New York: Random House, 2001).

p. 91 *In a* New York Times *interview . . . Gil called for "a new culture of sharing":* Larry Rohter, "Gilberto Gil Hears the Future, Some Rights Reserved," *New York Times,* March 11, 2007.

"*Fair Use Network":* See http://fairusenetwork.org.

p. 92 *Redford notes:* These remarks and those below were made by Redford at the Americans for the Arts National Arts Policy Roundtable, Sundance Preserve, October 5, 2007.

THREE: A CREATIVE LIFE

p. 94 *The year was 2000, and I was visiting:* For more on Raw Art Works, see www.rawart.org.

p. 95 Back *in 1961, at the first White House Conference on Aging:* John F. Kennedy, "Special Message to Congress on the Needs of the Nation's Senior Citizens," February 21, 1963, www.presidency.ucsb.edu/ws/index.php?pid =9572.

p. 96 *. . . I joined forty guests . . . to celebrate:* Isaac Stern with Chaim Potok, *My First 79 Years* (New York: Alfred A. Knopf, 1999).

p. 97 *When veteran pianist Earl Wild performed:* Bernard Holland, "A Veteran Pianist Sticks with the Things He Knows Best," *New York Times,* December 1, 2005.

Michael Kimmelman, in The Accidental Masterpiece: Michael Kimmelman, *The Accidental Masterpiece: On the Art of Life and Vice Versa* (New York: Penguin, 2005).

Yo-Yo Ma . . . with the violinist and pianist he performed with: Evan Eisenberg, "Through College and Life, in Harmony," *New York Times,* July 15, 2001.

p. 99 *The photograph accompanying a* New York Times *profile:* Teri Karush Rogers, "A Leader Who Values Harmony over Aggression," *New York Times,* July 17, 2005.

The sports pages of the same edition: Judy Battista, "Classic Rock, Perfect Team, and a Mellow Colts Owner," *New York Times,* December 18, 2005.

A few months later . . . Condoleezza Rice: Anthony Tommasini, "Condoleezza Rice on Piano," *New York Times,* April 6, 2006.

p. 100 *As psychologist Tim Kasser writes:* Tim Kasser, *The High Price of Materialism* (Cambridge, MA: MIT Press, 2002), pp. ix–x.

Some scholars, such as economic historian Avner Offer: Avner Offer, *Challenge of Affluence: Self-Control and Well-Being in the United States and Britain since 1950* (Oxford: Oxford University Press, 2006).

p. 101 *As economist Robert Lane observes:* Robert E. Lane, *The Loss of Happiness in Market Democracies* (New Haven, CT: Yale University Press, 2000).

Or, in the words of psychiatrist Peter Whybrow: Peter C. Whybrow, *American Mania: When More Is Not Enough* (New York: W. W. Norton, 2005).

Sociologist Richard Sennett argues: Richard Sennett, *The Corrosion of Char-*

acter: The Personal Consequences of Work in the New Capitalism (New York: W. W. Norton, 1998).

Americans spent $750 million: Sanjay Gupta projected this amount in a CNN program on "Happiness and Your Health" aired on November 26, 2006 (see www.cnn.com).

Psychologist Jonathan Freedman characterizes the first realm: Jonathan L. Freedman, quoted in Richard Layard, *Happiness: Lessons from a New Science* (London: Allen Lane, 2005).

Economist Richard Layard defines happiness: P. R. G. Layard, *Happiness: Lessons from a New Science* (London: Allen Lane, 2005).

p. 104 *Layard argues:* Ibid.

Nobel laureate Robert Fogel: Robert William Fogel, *The Fourth Great Awakening and the Future of Egalitarianism* (Chicago: University of Chicago Press, 2000).

For political scientist Robert Putnam: Robert D. Putnam, *Bowling Alone: The Collapse and Revival of American Community* (New York: Simon and Schuster, 2001).

Sociologists Michael Hughes and Carolyn Kroehler expand the definition: Michael Hughes and Carolyn Kroehler, *Sociology: The Core* (Boston: McGraw-Hill, 2004).

Kasser uses "autonomy": Kasser, *The High Price of Materialism.*

. . . an avenue . . . that, according to Whybrow: Whybrow, *American Mania.*

p. 105 *I concur with . . . Kimmelman:* Michael Kimmelman, "Prodigy's Return," *New York Times,* August 8, 1999.

p. 106 *. . . what Layard calls one of those "treasured skills . . .":* Layard, *Happiness.*

p. 107 *It's not that we don't have art in schools:* Fast Response Survey System report on arts education in 1999–2000, http://nces.ed.gov/surveys/frss/.

p. 110 *In New York, the "Blueprint for Teaching and Learning in the Arts":* Robin Pogrebin, "Renewed Push for the Artistic ABC's in N.Y.," *New York Times,* June 26, 2006. For a copy of this plan, see http://schools.nyc.gov/projectarts/PAGES/a-blueprint.htm.

p. 111 *There are 250,000 choruses:* Chorus America, "America's Performing Art: A Study of Choruses, Choral Singers, and Their Impact," Washington, DC, 2003.

p. 113 *I visited the Old Town School of Folk Music:* Old Town School of Folk Music, 4544 North Lincoln Ave., Chicago, www.oldtownschool.org.

p. 116 *Today Scott "The Piano Guy" Houston:* Scott Houston, *Scott The Piano Guy's Favorite Piano Fake Book* (Milwaukee: Hal Leonard Corporation, 2006).

p. 117 *Betty Edwards's* Drawing on the Right Side of the Brain: Betty Edwards, *Drawing on the Right Side of the Brain: A Course in Enhancing Creativity and Artistic Confidence* (New York: Simon and Schuster, 1986).

Michael Kimmelman has written: Kimmelman, *The Accidental Masterpiece.*

p. 118 *An era, as Kimmelman writes:* Michael Kimmelman, "The Art of Drawing, When Amateurs Roamed the Earth," *New York Times,* July 19, 2006.

p. 119 *. . . we're participating in art:* The changing character of participation in art is explored in Steven J. Tepper and Bill Ivey, eds., *Engaging Art: The*

Next Great Transformation in America's Cultural Life (New York: Routledge, 2007).

As Kimmelman observes: Kimmelman, "The Art of Drawing."

p. 120 *Already in 2000:* Ellen Wimmer and Lois Hetland, "Does Studying the Arts Enhance Academic Achievement?" *Education Week* 20, no. 9 (November 1, 2000): 46, 64.

p. 121 *But, as Kimmelman notes:* Kimmelman, "The Art of Drawing."

p. 122 *But, as Mary Flannery . . . argues:* Mary Flannery, conversation with author, 2000.

p. 123 *In 2002 the Higher Education Research Institute's Survey:* L. J. Sax, J. A, Lindholm, A. W. Astin, W. S. Korn, and K. M. Mahoney, *The American Freshman: National Norms for Fall 2002* (Los Angeles: Higher Education Research Institute, UCLA, 2002). See also www.gseis.ucla.edu/heri/index.php.

For Isaac Stern, in his seventy-ninth year: Stern with Potok, *My First 79 Years.*

Feminist author Brenda Ueland: Brenda Ueland, *If You Want to Write: A Book about Art, Independence and Spirit* (St. Paul, MN: Graywolf Press, [1938] 1987).

FOUR: AMERICA, ART, AND THE WORLD

p. 124 *Late in his October 2001 press conference:* "President Holds Prime Time News Conference," October 11, 2001, www.whitehouse.gov/news/releases/2001/10/20011011-7.html.

"President Bush," Roberts observed: Interview with Cokie Roberts, *This Week with George Stephanopoulous*, ABC, October 11, 2001.

p. 125 *. . . what the* New York Times *called:* Elizabeth Becker and contributors Edmund L. Andrews, Felicity Barringer, Barry Bearak, and John F. Burns, "In the War on Terrorism, a Battle to Shape Opinion," *New York Times*, November 11, 2001.

First, we engage in "cultural diplomacy": Richard T. Arndt, *The First Resort of Kings: American Cultural Diplomacy in the Twentieth Century* (Washington, DC: Potomac Books, 2005).

p. 126 *Bill Clinton accurately observed:* Bill Clinton, *My Life* (New York: Random House, 2004).

As William J. Holstein wrote: William J. Holstein, "Erasing the Image of the Ugly American," *New York Times*, October 23, 2005.

p. 127 *. . . the National Science Board reported:* Martha Bayles, "Now Showing: The Good, the Bad and the Ugly Americans, Exporting the Wrong Picture," *Washington Post*, August 28, 2005.

As media critic Martha Bayles points out: Bayles, "Now Showing."

. . . Tutwiler employed an anecdote: Margaret Tutwiler, impromptu speech, Nashville Cumberland Club Committee on Foreign Relations, Nashville, Tennessee, December 20, 2003.

p. 128 *"A show like* Baywatch *. . .":* Margaret Tutwiler, remarks at "Culture Diplomacy," Arts Industry Policy Forum, Curb Center, Vanderbilt University, September 23, 2005.

According to . . . Syd Vinnedge: "History of Baywatch: Beach Syndie Bingo," http://members.tripod.com/~baywatchun/history/index.html.

p. 130 *A student at South Africa's Rhodes College described:* Larry Strelitz, "Against Cultural Essentialism: Media Reception among South African Youth," *Media, Culture, and Society* 26, no. 5 (2004): 635.

p. 131 *When the 9/11 Commission's report laments: The 9/11 Commission Report: Final Report of the National Commission on Terrorist Attacks upon the United States* (New York: W. W. Norton, 2004).

p. 132 *As historian Milton Cummings has noted:* Milton Cummings, "Cultural Diplomacy and the United States: A Survey," Center of Arts and Culture, Washington, DC, 2003, www.culturalpolicy.org/pdf/MCCpaper.pdf. Other useful sources include Arndt, *The First Resort of Kings;* Joseph S. Nye, *Soft Power: The Means to Success in World Politics* (New York: Public Affairs, 2004); Cynthia P. Schneider, "Diplomacy That Works: 'Best Practices' in Cultural Diplomacy," Center of Arts and Culture, Washington, DC, 2003, www.culturalpolicy.org/pdf/Schneider.pdf); and *Cultural Diplomacy: The Linchpin of Public Diplomacy,* report of the Advisory Committee on Cultural Diplomacy, U.S. Department of State, September 2005, www.state.gov/documents/organization/54374.pdf.

p. 133 *As Louis Menand observed in the* New Yorker: Louis Menand, "American Art and the Cold War," *New Yorker,* October 17, 2005.

p. 136 *However, from the 1950s through the 1980s:* Frances Stoner Saunders, *Who Paid the Piper? The CIA and the Cultural Cold War* (London: Granta Books, 1999).

 In spring 2005 the General Accountability Office: Al Kamen, "Dear GAO: OGC Is DOA," *Washington Post,* April 6, 2005.

p. 137 *In mid-2006 . . .* U.S. News & World Report *concluded:* Linda Robinson, "The Propaganda War: The Pentagon's Brand-New Plan for Winning the Battle of Ideas against Terrorists," *U.S. News & World Report* 140, no. 20 (May 29, 2006): 29–31.

p. 139 *Joseph Nye . . . coined the phrase:* Nye, *Soft Power.*

p. 140 *. . . a practice Martha Bayles dismisses:* Bayles, "Now Showing."

 In fact, congressional critics of Alhurra learned: Helene Cooper, "Unfriendly Views on U.S.-Backed Arabic TV," *New York Times,* May 17, 2007.

 And the GAO still found: U.S. Government Accountability Office, "U.S. Diplomacy: State Department and Broadcasting Board of Governors Expand Post 9/11 Efforts but Challenges Remain," testimony before the House Subcommittee on National Security, Emerging Threats, and International Relations, statement of Jess T. Ford, August 23, 2004 (http://www.gao.gov/new.items/d041061t.pdf).

p. 141 *Richard Arndt . . . offers a blunt assessment:* Arndt, *The First Resort of Kings.*

p. 147 *But Copps and her allies . . . used the attractive notion of* diversity: George Will, "Dimwitted Nod to 'Diversity,' " *Washington Post,* October 12, 2005.

p. 148 *David Rieff frames the question:* David Rieff, "Their Hearts and Minds?" *New York Times,* September 4, 2005.

According to the Pew Global Attitudes Project: Testimony of Andrew Kohut, "America's Image in the World: Findings from the Pew Global Attitudes Project," Subcommittee on International Organizations, Human Rights, and Oversight, Committee on Foreign Affairs, U.S. House of Representatives, March 14, 2007.

p. 150 *The exhibition . . . was given five stars:* "Terracotta Army Conquers British Museum," *Times Online,* September 11, 2007, http://entertainment .timesonline.co.uk/tol/arts_and_entertainment/visual_arts/article 2423601.ece.

As an opinion piece in the Financial Times *observed:* Peter Aspden, "Culture's Swagger Is Back," *Financial Times,* December 28, 2006.

According to the New York Times: Jeff Leeds, "The New Ambassadors," *New York Times,* November 12, 2006, Arts and Leisure section.

p. 151 *Journalist George Lesser, writing in the* Washington Post: George Lesser, "Bring Back the USIA," *Washington Post,* June 22, 2006.

When the long-anticipated "National Strategy . . ." emerged: Strategic Communication and Public Diplomacy Policy Coordinating Committee (PCC), "U.S. National Strategy for Public Diplomacy and Strategic Communication," June 2007, www.cfr.org/publication/13601/.

p.152 *Available only as a draft:* Richard L. Armitage and Joseph S. Nye Jr., *CSIS Commission on Smart Power: A Smarter, More Secure America* (Washington, DC: Center for Strategic and International Studies, 2007–8). See also Cynthia P. Schneider, *Diplomacy That Works: "Best Practices" in Cultural Policy* (Washington, DC: Center for Arts and Culture, 2003).

p. 153 *Trade negotiator Carol Balassa . . . has argued:* Carol Balassa, at "Federal Regulation and the Cultural Landscape" conference, Curb Center for Art, Enterprise, and Public Policy, Vanderbilt University, Nashville, March 19, 2004. Balassa has since retired from the USTR's Office and become a senior fellow at the Curb Center.

p. 154 *Two months after the terrorist attacks:* President George W. Bush, Address to National Homeland Security, World Congress Center, Atlanta, Georgia, November 8, 2001.

FIVE: ART OF LASTING VALUE

p. 155 Black Orpheus . . . *retells the Greek legend:* Bosley Crowther, "Screen: Legend Retold; 'Black Orpheus' Bows at the Plaza" [film review], *New York Times,* December 22, 1959.

p. 157 *. . . as movie critic David Denby puts it:* David Denby, *Great Books: My Adventures with Homer, Rousseau, Woolf, and Other Indestructible Writers of the Western World* (New York: Simon and Schuster, 1996).

p. 158 *Bill C. Malone, in* Southern Music/American Music: Bill C. Malone, *Southern Music/American Music* (Lexington: University Press of Kentucky; London: Eurospan, 2003).

p. 161 *Each year, something like 2,000 feature-length films are released:* Patrick
Robertson, *Film Facts* (New York: Billboard Books, 2001).
In the late 1990s Film Comment *magazine polled:* Gavin Smith, "Top 150
Unreleased Foreign Language Films of the Nineties," *Film Comment,*
July–August 1997, www.filmlinc.com/fcm/7-8-97/poll.htm.

p. 162 *Eckart Runge . . . was kept from entering the United States:* Anthony Tom-
masini, "No Laws Broken, Artemis Quartet Goes on Tour," *New York
Times,* February 12, 2004.
Artists have never had an especially easy time: Martha Hostetter, "Artists'
Visas," *Gotham Gazette,* November 11, 2002.

p. 163 *. . . his bass player, Alain Pérez, was initially denied a temporary visa:* Larry
Katz, "Visa Blues: Post 9/11 Security Hard on International Musicians,"
Boston Herald, February 13, 2004.
Five Cuban musicians were denied visas: Yvonne Wong, "World Music
Artists Shut Out of U.S. Borders," *Wiretap,* March 31, 2003.
In August of 2006 musicologist Nalini Ghuman: Nina Bernstein, "Music
Scholar Banned from U.S., but No One Will Tell Her Why," *New York
Times,* September 19, 2007.

p. 164 *As Boston concert promoter Maure Aronson says:* Tommasini, "No Laws
Broken."
In 2005 overseas travel to the United States: The statistics in this paragraph
come from David Armstrong, "Travel Industry Fears Tougher Security,"
San Francisco Chronicle, July 3, 2005. Although the number of foreign vis-
itors has increased since 2005, the number of travelers coming from
countries other than Canada and Mexico was still down 17 percent in
2007 from the high of 2000. See Samantha Gross, "NYC to Improve First
Impressions for Foreign Visitors," *USA Today,* August 30, 2007.
As Mahatma Gandhi wrote: Mahatma Gandhi, in *Young India,* June 1, 1921,
170.

p. 165 *In fall 1991 David Denby reentered Columbia University:* Denby, *Great Books.*

p. 166 *But until the last three decades of the twentieth century:* Joseph Horowitz,
Classical Music in America: A History of Its Rise and Fall (New York: W. W.
Norton, 2005).

p. 167 *Critic Alex Ross makes it clear:* Alex Ross, "Listen to This," *New Yorker,* Feb-
ruary 16, 2004.
Juilliard president Joseph Pelosi . . . laments: Claudia Parsons, "Juilliard
Toasts 100 Years as Bastion of Arts," Reuters, October 7, 2005, http://
music.yahoo.com/read/news/24558487.
This notion . . . goes straight back to Matthew Arnold: Matthew Arnold, *Cul-
ture and Anarchy and Other Writings (1822–88)* (Cambridge: Cambridge
University Press, 1993).

p. 168 *Or, as in Allan Bloom's more contemporary formulation:* Allan Bloom,
Shakespeare on Love and Friendship (Chicago: University of Chicago Press,
2000).

Larry Shiner, in The Invention of Art: Larry Shiner, *The Invention of Art: A Cultural History* (Chicago: University of Chicago Press, 2001).

It was in Boston: Paul DiMaggio, "Cultural Entrepreneurship in Nineteenth-Century Boston: The Creation of an Organizational Base for High Culture in America," in *Rethinking Popular Culture: Contemporary Perspectives in Cultural Studies,* ed. Chandra Mukerji and Michael Schudson (Berkeley: University of California Press, 1991).

Joseph Horowitz, in his expansive history: Horowitz, *Classical Music in America.*

p. 169 . . . *Harold Bloom first observes:* Harold Bloom, *Shakespeare: The Invention of the Human* (New York: Riverhead Books, 1998).

Susan Sontag, in "Against Interpretation": Susan Sontag, *Against Interpretation, and Other Essays* (New York: Dell, 1996).

Julian Johnson, in Who Needs Classical Music?: Julian Johnson, *Who Needs Classical Music? Cultural Choice and Musical Value* (Oxford: Oxford University Press, 2002).

. . . *by assembling what Ross skewers as "a cult of mediocre elitism":* Ross, "Listen to This."

p. 170 *Ross imagines this depressing entry:* Ross, "Listen to This."

"On the one hand [classical music]": Johnson, *Who Needs Classical Music?*

p. 171 *Writing in the* New York Times: Edward Rothstein, "Classical Music Imperiled: Can You Hear the Shrug?" *New York Times,* July 2, 2007.

As NPR reported: "Detroit Symphony Finds an Audience," *All Things Considered,* National Public Radio, July 8, 2006.

The number of commercial classical radio stations: NEA, "Airing Questions of Access: Classical Music Radio Programming and Listening Trends," September 2006.

Allan Kozinn, writing in the New York Times: Allan Kozinn, "Check the Numbers: Rumors of Classical Music's Demise Are Dead Wrong," *New York Times,* May 28, 2006.

And . . . Kozinn admits: Kozinn, "Check the Numbers."

p. 172 *As Johnson points out:* Johnson, *Who Needs Classical Music?*

p. 173 . . . *what British event producer Andrew Missingham describes:* Andrew Missingham and Piers Hellawell, "Beethoven Who?" *New Statesman,* October 31, 2005.

p. 174 *As critic Bernard Holland put it:* Bernard Holland, "A Veteran Pianist Sticks with the Things He Knows Best," *New York Times,* December 1, 2005.

p. 175 *But suddenly, there it was:* Imus in the Morning, MSNBC Studio in Secaucus, New Jersey, September 14, 2006.

In the old days . . . The Ed Sullivan Show: *The Ed Sullivan Show,* Museum of Broadcast Communications, www.museum.tv.

p. 177 *Folklorist Henry Glassie accomplished this:* Henry Glassie, *Turkish Traditional Art Today,* Turkish Studies Series 11 (Bloomington: Indiana University

Press; Ankara: Ministry of Culture of the Turkish Republic, 1993). New edition: Directorate of Publications, Art Book Series 375 (Ankara: Ministry of Culture of the Turkish Republic, 2002).

In 1966 the average ticket: Wynne Delacoma, "Music: Opportunity Turns Up the Volume," *Chicago Sun-Times,* August 28, 2005.

p. 178 . . . *ticket to the 2006 Barbra Streisand tour:* "Rolling Stones among Biggest 2006 Tours: Barbra Streisand, Tim McGraw, Faith Hill Also among Top Grossers," Associated Press release, December 28, 2006, www.msnbc .msn.com/id/16385870.

. . . *early in 2006 NASCAR signed an agreement with Harlequin:* Charles McGrath, "In Harlequin-NASCAR Romance, Engines Roar and Hearts Race," *New York Times,* February 19, 2007.

But there was always an alternative: Jere T. Humphreys, "Strike Up the Band! The Legacy of Patrick S. Gilmore," *Music Educators Journal* 74, no. 2 (October 1987).

p. 179 *Julian Johnson accurately observes:* Johnson, *Who Needs Classical Music?*

p. 180 *A. O. Scott, writing in the* New York Times: A. O. Scott, "The Whole World Is Watching, Why Aren't Americans?" *New York Times,* January 21, 2007.

For Alex Ross: Ross, "Listen to This."

Anthony Tommasini, writing in the New York Times: Anthony Tommasini, "Passing the Baton: Be Bold, New York," *New York Times,* April 15, 2007.

A draft of a new strategic plan: "Supporting Orchestras in a New Era: A Strategic Direction for the American Symphony Orchestra League: Executive Summary," June 2006, htpp://2006.leagueconference.org.

SIX: STRONG, RESPONSIBLE INSTITUTIONS

p. 185 *"Yellow bird, up high in banana tree":* "Yellow Bird." Words by Alan and Marilyn Bergman. Music by Norman Luboff. © 1957, 1958 (Renewed) Threesome Music Co. and Walton Music. All Rights Reserved. Used by Permission.

p. 187 *In a revealing experiment:* Gene Weingarten, "Pearls before Breakfast; Can One of the Nation's Great Musicians Cut Through the Fog of a D.C. Rush Hour? Let's Find Out," *Washington Post,* April 8, 2007, p. W10.

p. 190 ·*As Lon Helton . . . points out:* Lon Helton, conversation with author, August 2, 2007.

p. 192 *But by 2002 the FCC:* "Joint Statement on Current Issues in Radio," issued May 24, 2002, by American Federation of Musicians, American Federation of American Federation of Television and Radio, Association for Independent Music, Future of Music Coalition, Just Plain Folks, Nashville Songwriters Association International, National Association of Recording Merchandisers, National Federation of Community Broadcasters, Recording Academy, and Recording Industry Association of America.

In 2005 Clear Channel alone owned: Bob Tedeschi, "As Clear Channel Enters the Fray, Online Radio Looks to Be Coming of Age," *New York Times,* July 18, 2005.

p. 193 *Senator Barbara Boxer called the ban:* Anne Hull, "Uncowed Cowgirls," *Washington Post,* August 8, 2003, p. C1. McCain's comments were reported by the *LA Times* ("Radio Consolidation Could Hurt Free Expression, Senators Say," Associated Press bulletin, July 9, 2003).

p. 194 *. . . recording artists, record companies, and concert producers began to complain:* "Is Clear Channel Hogging the Airwaves?" *BusinessWeek,* October 1, 2001.

By 2002 *Clear Channel dominated:* See "Radio Deregulation and Consolidation: What Is in the Public Interest?" AIPF [Arts Industries Policy Forum] Background Report, Curb Center for Art, Enterprise, and Public Policy, Vanderbilt University, Nashville, July 12, 2004.

A 2001 lawsuit: Alexei Barrionuevo and Jeff Leeds, "Clear Channel Loses Case with Rival," *New York Times,* March 22, 2005.

p. 195 *Late in 2006 Clear Channel agreed to a . . . buyout offer:* Andrew Ross Sorkin, "Buyout Bid Becomes Proxy Fight," *New York Times,* March 7, 2007. By fall of 2007 the sale of Clear Channel to two private equity firms was complete, and the company began spinning off blocks of its stations. Retaining 750 of the nation's biggest stations in the most important markets, the media conglomerate remained a broadcasting powerhouse. See Erik Sass, "Clear Channel Closes Deal to Sell More Radio Stations," *Media Daily News,* October 4, 2007, http://publications.mediapost.com/index.cfm?fuseaction=Articles.showArticle&art_aid=68608.

p. 196 *Lon Helton asked:* Helton, conversation with author, August 2, 2007.

. . . Andre Schiffrin indicates: Andre Schiffrin, *The Business of Books: How the International Conglomerates Took over Publishing and Changing the Way We Read* (London: Verso, 2000).

As Sheelah Kolhatkar wrote: Sheelah Kolhatkar, "Freyed Tomato," *New York Observer,* February 6, 2006, p. 1.

p. 198 *Each year nearly 130 million customers:* Jerry Useem, "One Nation under Wal-Mart," *Fortune,* March 3, 2003, p. 64.

The chain accounts for 40 percent of all DVD purchases: David Lieberman, "Wal-Mart to Launch Video Downloads," *USA Today,* February 6, 2007.

p. 199 *As one music executive explained:* Warren Cohen, "Wal-Mart Wants $10 CDs," *Rolling Stone,* October 12, 2004.

As Variety *noted:* Meredith Amdur, "Wal-Mart DVDs: The Price Is Might," *Variety,* July 19–25, 2004, p. 6.

p. 200 *As public television's* NewsHour *reported:* Liz Harper, "Wal-Mart: Impact of Retail Giant," *Online NewsHour,* August 20, 2004.

p. 201 *The Pew Research Center reports:* Kim Parker, senior researcher, "How Young People View Their Lives, Futures, and Politics: A Portrait of 'Generation Next,'" Pew Research Center, Washington, DC, January 9, 2007.

p. 202 ... *at a seminar for midlevel managers in the music business:* Quotations here and below attributed to "an executive" or "a music industry leader" are from panel discussants in the Leadership Music Program, a yearlong series of executive training and networking sessions for midlevel managers in Nashville's entertainment industry. To ensure candid discussion of industry issues, Leadership Music maintains a strict nonattribution policy.

... *as Jason Epstein puts it:* Jason Epstein, *Book Business: Publishing Past, Present, and Future* (New York: W. W. Norton, 2001).

p. 203 ... *in 2006 just over 34,000 CDs were released into distribution:* When digital-only product is included, nearly 76,000 titles were released in 2006. Exact sales figures are surprisingly difficult to pin down, but see "Retail Track: New Release Numbers," *Billboard.biz,* www.billboard.biz/bbbiz/search/article_display.jsp?vnu_content_id=1003580716. See also "Nielsen Trends: Soundscan: State of the Industry, 2006," www.narm.com/2007Convention/Nielsen.pps. For a critique of record industry use of statistics on illegal downloads, see George Zeimann, "RIAA's Statistics Don't Add Up to Piracy," December 11, 2002, www.azoz.com/music/features/0008.html.

The book business is similarly top-heavy: A. N. Greco, *The Book Publishing Industry* (London: Allyn and Bacon, 1997).

p. 204 *"I tried to make enough to pay salaries":* Mike Curb, conversation with author, August 1, 2007.

When Edgar Bronfman ... acquired Warner Music: Jeff Leeds, "Wipe Egg Off Face, Try Again. Voila!" *New York Times,* April 17, 2005.

p. 205 *A friend told me:* Author's conversation with CFO friend at Leadership Music seminar.

p. 206 The Da Vinci Code ... *sold more than 60 million copies:* Alan Riding, "Mystery of the 'Da Vinci Code' Film: Will We Love It?" *New York Times,* May 13, 2006.

In late 2005 the Associated Press reported: Hillel Italie, " 'Da Vinci Code' Has Sparked A Whole New Genre," *Chicago Tribune,* December 17, 2005.

p. 207 *A. O. Scott, writing in the* New York Times: A. O. Scott, "Where Have All the Howlers Gone?" *New York Times,* December 18, 2005.

p. 211 *John Kreidler, writing a decade ago:* John Kreidler, "Leverage Lost: The Nonprofit Arts in the Post-Ford Era," *In Motion Magazine,* February 16, 1996.

p. 212 *Because the fine arts are mostly organized as nonprofits:* Bill Ivey, "America Needs a New System of Supporting the Arts," *Chronicle of Higher Education,* February 4, 2005.

p. 213 *Finally, as Americans for the Arts recently reported:* Randy Cohen and Margaret Jane Wyszomirski, "National and Local Profiles of Cultural Support: Executive Summary," Americans for the Arts, Arts Policy and Administrative Program, Ohio State University, Columbus, November 2002.

The old approach to enhancing the cultural landscape: Ivey, "America Needs a New System."

p. 214 . . . *twenty-four important art museum directorships were vacant:* Jori Finkel, "Impossible Job: Here's What You Need for It," *New York Times,* July 29, 2007, Arts and Leisure section.

"Because it's beloved," according to the Times: John Rockwell, "Where Dreams and Snowflakes Dance," *New York Times,* November 28, 2005, p. B1.

p. 215 *But, as Michael Kimmelman has observed:* Michael Kimmelman, "Art, Money and Power," *New York Times,* May 11, 2005.

According to the Observer: Tyler Green, "Krens Relinquishes the Ramps! Ms. Dennison to Feed Starved Gugg," *New York Observer,* October 2, 2005.

p. 216 . . . *Richard Florida's "bohemian index":* Richard Florida, *The Rise of the Creative Class and How It's Transforming Work, Leisure, Community and Everyday Life* (New York: Basic Books, 2002).

Doug McLennan . . . concludes: in Matthew Richter, "The Nonprofit Motive," *The Stranger,* April 27–May 3, 2006, www.thestranger.com/seattle/content?oid=31920.

p. 219 *As the* Financial Times *reminds us:* Michael Skapinker, "When Companies Put Shareholders Second," *Financial Times,* February 27, 2005.

SEVEN: THE FAILURE OF GOVERNMENT

p. 222 *"Now that we've balanced the budget":* David Obey, conversation with author, May 12, 1999.

p. 224 *As media scholar Philip Napoli observes:* Philip Napoli, "Bridging Cultural Policy and Media Policy in the U.S.: Challenges and Opportunities," working paper, Donald McGannon Communication Research Center, Fordham University, Bronx, New York, September 2006.

In his 2004 State of the Union message: President George W. Bush, State of the Union Address, Washington, DC, January 20, 2004, www.whitehouse.gov/news/releases/2004/01/20040120-7.html.

p. 225 *As one father noted:* Melissa Block, host, "Rising Concerns about Television Indecency Cutting across Political Issues," *All Things Considered,* National Public Radio, January 11, 2005.

In 2004 Ken Paulson: Kenneth Paulson, "Regulation through Intimidation: Congressional Hearings and Political Pressure on America's Entertainment Media," paper presented at the Curb Center Conference on Federal Regulation and Cultural Landscape, Curb Center for Art, Enterprise, and Public Policy, Vanderbilt University, Nashville, March 19, 2004.

As sociologist Bruce Barry explains in Speechless: Bruce Barry, *Speechless: The Erosion of Free Expression in the American Workplace* (San Francisco: Berrett-Koehler, 2007).

p. 226 *Fueled by an exposé:* Fredric Wertham, *Seduction of the Innocent* (New York: Rinehart, 1954).

p. 230 *In late spring 2006 Majority Leader Bill Frist:* Broadcast Decency Enforcement Act, *Congressional Record,* May 19, 2006, S4819, http://thomas.loc.gov/cgi-bin/query/z?r109:S19MY6-0005.

It goes without saying: Bill Carter and Jeff Leeds, "Howard Stern Signs Rich Deal in Jump to Satellite Radio," *New York Times,* October 7, 2004.

p. 231 *As Stephen Labaton reported in the* New York Times: Stephen Labaton, "Decency Ruling Thwarts F.C.C. on Vulgarities," *New York Times,* June 5, 2007.

Early in 2006 the FCC fined a public broadcasting station: Jeremy Egner, "PBS Doc Brings San Mateo, Station Viewer Acclaim, FCC Fine," *Current Magazine,* March 20, 2006.

Commissioner Jonathan Adelstein dissented: "Statement of Commissioner Jonathan S. Adelstein . . . Re: Complaints Regarding Various Television Broadcasts between February 2, 2002 and March 8, 2005," www.fcc.gov/commissioners/adelstein/statements2006.html.

In papers filed with the FCC: Reuters, "Networks Say Indecency Policy Imperils Live TV," September 21, 2006.

Congress has remained undaunted: Ted Hearn, "Inouye 'Aggressively Preparing' TV Content Bill," *Multichannel News,* July 11, 2007, www.multichannel.com/article/CA6459510.html?q=inouye.

p. 232 *As novelist Jim Harrison observed:* Jim Harrison, *Off to the Side: A Memoir* (New York: Atlantic Monthly Press, 2002).

 . . . a 2001 Kaiser Family Foundation study found: "New V-Chip and TV Ratings Study Release," *Parents and the V-Chip, 2001: A Kaiser Family Foundation Survey,* July 2001, www.kff.org/entmedia/3158-index.cfm.

When the Imus in the Morning *program was canceled:* Bill Carter, Jacques Steinberg, and Tina Kelley, "Off the Air: The Light Goes out for Don Imus," *New York Times,* April 13, 2007.

p. 233 *. . . with obscene words . . . bleeped out:* Paul Farhi, "Fearing Fines, PBS to Offer Bleeped Version of 'War,'" *Washington Post,* August 31, 2007.

p. 235 *In fall 2000 . . . Richard Rhodes debunked the TV-violence myth:* Richard Rhodes, "Hollow Claims about Fantasy Violence," *New York Times,* September 17, 2000.

The FCC's own 2007 report: "Violent Programming and Its Impact on Children," report released April 25, 2007, http://fjallfoss.fcc.gov/edocs_public/attachmatch/FCC-07-50A1.pdf

p. 236 *Our federal government established the Fine Arts Commission:* National Endowment for the Arts, *A Brief Chronology of Federal Support for the Arts, 1965–2000,* rev. ed. (Washington, DC: NEA, Office of Communications, 2000); www.nea.gov/about/Chronology/Chronology.html.

p. 238 *A January 2007 report assembled by the NEA:* National Endowment for the Arts, *How the United States Funds the Arts,* 2nd ed. (Washington, DC: NEA, 2007), 10; www.nea.gov/pub/how.pdf.

p. 239 *True, France . . . funds its Ministry of Culture and Communication:* For information on the French government's arts budget, see www.culture.gouv.fr.

 . . . tradition of private giving to arts organizations: French critic Frédéric Martel documents the decentralized, public-private character of U.S. arts funding for a European audience, debunking the myth that the American

system necessarily shortchanges culture (Martel, *De la culture en Amérique* [Paris: Gallimard, 2006]).

Although . . . the arts have not maintained their "market share": "The Future of Private Giving to the Arts in America," National Arts Policy Roundtable briefing, Americans for the Arts, Washington, DC, October 26, 2006.

p. 242 *By its fortieth anniversary:* "Fortieth Anniversary Facts," www.nea.gov/about/Facts/40.html.

At its peak in the early 1990s: "National Endowment for the Arts Appropriations History," www.nea.gov/about/Facts/AppropriationsHistory.html.

p. 243 *Helms strongly objected to the NEA's fellowship support:* Helms's letter appears in full in Michael Straight, *Twigs for an Eagle's Nest: Government and the Arts, 1965–1978* (New York: Devon Press, 1979), which also includes Hanks's response.

p. 246 *A glance through the NEA's 2001 listing:* National Endowment for the Arts, *A Creative Legacy: A History of the National Endowment for the Arts Visual Artists' Fellowship Program* (New York: Harry N. Abrams, 2001).

This version of modernism . . . as Tom Wolfe puts it: Tom Wolfe, *The Painted Word* (New York: Farrar, Straus and Giroux, 1975).

p. 247 *Carter Ratcliff, writing in* Art in America: Carter Ratcliff, quoted in Michael Brenson, *Visionaries and Outcasts: The NEA, Congress, and the Place of the Visual Arts in America* (New York: New Press, 2001).

But as journalist and critic Michael Brenson points out: Brenson, *Visionaries and Outcasts.*

p. 250 *. . . the homoerotic content of the posthumous Robert Mapplethorpe exhibition:* The Mapplethorpe project is an example of the way a grant can go awry. The artist died of AIDS-related illness between the time the project was approved and the exhibit opened. Janet Kardon, director of the University of Pennsylvania's Institute of Contemporary Art, expanded the show to include the soon-to-be notorious, homoerotic Portfolio X series. As then-NEA chairman Frank Hodsoll explained in an email exchange with the author in August 2007, "Had [this] series been part of the original project, I would have denied the grant."

p. 251 *On July 25, 1989, Reverend Wildmon:* Press release, American Family Association, July 25, 1989, in Richard Bolton, ed., *Culture Wars: Documents from the Recent Controversies in the Arts* (New York: New Press, 1992).

p. 253 *Alexander recalls:* Email correspondence from Jane Alexander to the author, May 31, 2007.

p. 255 *In a 2006 op-ed in the* Financial Times: Michael Copps, "Media Mergers Are Damaging American Democracy," *Financial Times,* June 21, 2006.

p. 256 *Several years ago the* New York Times *. . . featured a convincing argument:* Michael Kimmelman, "A Century of Art: Just How American Was It?" *New York Times,* April 18, 1999.

p. 257 *As Slate.com points out:* Christopher Beam, "What Do Ministers of Culture Do?" June 29, 2007, www.slate.com/id/2169233/nav/ais.

p. 258 . . . *what sociologist Eric Klinenberg calls:* Eric Klinenberg, *Fighting for Air: The Battle to Control America's Media* (New York: Metropolitan Books, 2007).

CONCLUSION: BRIDGING THE CULTURAL DIVIDE

p. 261 *"He demonstrated a computerized wall easel":* Mike Musgrove and Arshad Mohammed, "Gates Sees 2006 as the Year for 'The Digital Lifestyle,'" *Washington Post,* January 5, 2006, p. D5.

p. 262 *As intellectual property expert James Boyle observes:* James Boyle, "A Manifesto on WIPO and the Future of Intellectual Property," *Duke Law and Technology Review,* Rev. 0009, September 8, 2004.

According to Wired *editor-at-large Daniel Pink:* Daniel H. Pink, *A Whole New Mind: Moving from the Information Age to the Conceptual Age* (New York: Riverhead Books, 2005).

p. 263 *In an interview in* Executive Travel Magazine: Karlin Sloan, "The Rise of the Right Brain Executive Coach," *Executive Travel Magazine,* September 2006.

For Buck, "math, science, and engineering are just tools . . .": Peter Buck, conversation with author, Oshkosh, WI, March 25, 2007.

Walter Isaacson . . . seems to agree: Walter Isaacson, *Einstein: His Life and Universe* (New York: Simon and Schuster, 2007).

In a USA Today *opinion essay, Isaacson describes:* Walter Isaacson, "A New Way to View Science," *USA Today,* April 9, 2007, www.usatoday.com/news/opinion/2007-04-09-oplede_N.htm.

In the 2006 edition: Thomas Friedman, *The World Is Flat* (New York: Farrar, Straus and Giroux, 2006).

p. 264 *"Students who study the arts seriously . . .":* Quoted in Robin Pogrebin, "Book Tackles Old Debate: Role of Art in Schools," *New York Times,* August 7, 2007.

In 2002 the comparative Survey of College Freshmen found: "Four-Year Freshmen at Four-Year Colleges: A Statistical Profile. Survey of College Freshmen—Life Goals," *Chronicle of Higher Education,* February 4, 2005.

. . . but, as Seligman says: Martin E. P. Seligman, *Authentic Happiness: Using the New Positive Psychology to Realize Your Potential for Lasting Fulfillment* (New York: Free Press, 2002).

p. 265 *. . . a 1919 ruling by the Michigan State Supreme Court:* Dodge v. Ford Motor Co. 204 Mich. 49, 170 N.W. 668 (1919).

In a lecture delivered in the early 1990s: Reported in Michael Skapinker, "Measures of Success Must Go beyond Financial Results, *Financial Times,* March 2, 2005.

"I just had to make up numbers": Author's conversation with Nashville music executive, January 19, 2007.

. . . late in 2006 the Business Roundtable Institute for Corporate Ethics: R. Edward Freeman, S. Ramakrishna Velamuri, and Brian Moriarty, "Company Stakeholder Responsibility: A New Approach to CSR," *Bridge*

Paper, Business Roundtable Institute for Corporate Ethics, 2006, www
.corporate-ethics.org/pdf/csr.pdf.

p. 266 *Faced with plummeting CD sales:* Audre Edgecliff Johnson, "Warner Poised
to Change Its Tune on Digital Links," *Financial Times,* August 8, 2007, p. 14.

Publisher Jason Epstein believes: Jason Epstein, *Book Business: Publishing
Past, Present, and Future* (New York: W. W. Norton, 2001).

A 2006 Rand Corporation study: Kevin F. McCarthy, Elizabeth Heneghan
Ondaatje, Laura Zakaras, and Arthur Brooks, *Gifts of the Muse: Reframing
the Debate about the Benefits of the Arts,* 2006, www.rand.org. [Available
only through Rand Web site.]

Or, as critic John Carey put it: John Carey, *What Good Are the Arts?* (London:
Faber and Faber, 2005).

p. 267 *Commission chairman Newell Daley noted:* Newell Daley, conversation with
author, Nashville, March 18, 2006.

p. 268 *One senior attorney with the Judiciary Committee . . . made this suggestion:*
Comments of unnamed staff members of congressional offices and regu-
latory agencies originate in meetings of the Arts Industries Policy Forum,
a bipartisan, policy-neutral, off-the-record seminar program created and
managed by the Washington, DC, office of Vanderbilt University's Curb
Center for Art, Enterprise, and Public Policy. The Forum engages issues in
U.S. cultural policy, is supported by a grant from the Ford Foundation, and
currently has fifty-five members drawn from such agencies as the FCC, the
USTR, and the FTC, as well as staffs of the Judiciary and Commerce Com-
mittees and the offices of a number of individual members of Congress.

p. 270 *The* New York Times *reported:* Alison Leigh Cowan, "Money Woes
Threaten National Theater of the Deaf," *New York Times,* August 10, 2006.

Paul Goldstein's vision of a celestial jukebox: Paul Goldstein, *Copyright's
Highway: From Gutenberg to the Celestial Jukebox* (Stanford, CA: Stanford
University Press, 2003).

p. 271 *When the J. M. Smucker Company asks a federal judge:* Sara Schaefer Muñoz,
"Patent No. 6,004,596: Peanut Butter and Jelly Sandwich," *Wall Street
Journal,* April 5, 2005.

. . . . *or when Cleveland's Rock and Roll Hall of Fame seeks an injunction:* Liel
Leibovitz, "Rockin' the Tribe," *Jewish Week,* July 1, 2005.

. . . *when court battles . . . prevent the Martha Graham Dance Company:* Jen-
nifer Dunning, "Martha Graham Center Wins Rights to Dances," *New
York Times,* August 24, 2002.

. . . *and when a* New York Times *reporter chides:* Clyde Haberman, "Bad
Taste in New York? Alert the Media," *New York Times,* January 16, 2002.

In 2002 Michael Perelman's Steal This Idea argued: Michael Perelman, *Steal
This Idea: Intellectual Property Rights and the Corporate Confiscation of Cre-
ativity* (New York: Palgrave, 2002); cf. Goldstein, *Copyright's Highway.*

p. 272 *Policy analyst David Bollier compares:* David Bollier, *Silent Theft: The Private
Plunder of our Common Wealth* (New York: Routledge, 2002).

p. 275 *But . . . "you can't e-mail a song":* Adam L. Penenberg, "Digital Rights Mismanagement: How Apple, Microsoft, and Sony Cash In on Piracy Prevention," November 14, 2005, http://slate.com/id/2130300.

p. 277 *Sociologist Barry Schwartz has argued:* Barry Schwartz, *The Paradox of Choice: Why More Is Less* (New York: Ecco, 2004).
 As media critic Andrew Keen points out: Andrew Keen, *The Cult of the Antenna: How Today's Internet is Killing Our Culture* (New York: Doubleday, 2007).

p. 280 *. . . only 17 percent of rural homes are in the broadband game:* Robert Mitchell, "ISPs to Rural America: Live with Dial-up," August 27, 2007, www.computerworld.com/action/article.do?command=viewArticleBasic&articleId=299844&pageNumber=1.
 A Corporation for Public Broadcasting study predicts: Corporation for Public Broadcasting, "A Survey of Recent Innovations in the Production and Distribution of Video," August 2005.
 In early 2009, when analog TV broadcasting is ended: Mike Snider, "TV's Digital Switchover Has a Downside," *USA Today,* August 7, 2007, p. 10.

p. 281 *In mid-2007 the United States ranked fifteenth:* Steven Levy, "Tech's Partying Like 1999. Uh-Oh," *Newsweek,* July 2, 2007.
 And . . . even when connected, our system is slow: "Speed Matters: A Report on Internet Speeds in All Fifty States," Communication Workers of America, Washington, DC, July 2007.
 At the end of 2006 a mirror-covered Time *magazine:* Lev Grossman, "Person of the Year: You," *Time,* December 13, 2006.

p. 281 *But, as Andrew Keen reminds us:* Keen, *The Cult of the Amateur,* pp. 19, 27.
 . . . but the Pew Internet and American Life Project reports: Amanda Lenhart and Mary Madden, "Teens, Privacy and Online Social Networks: How Teens Manage Their Online Identities and Personal Information in the Age of MySpace," Pew Internet and American Life Project, April 18, 2007, www.pewinternet.org/pdfs/PIP_Teens_Privacy_SNS_Report_Final.pdf.

p. 283 *Lessig noted that companies have become uncomfortable:* Lawrence Lessig, "Make Way for Copyright Chaos," *New York Times,* March 18, 2007.

p. 284 *Economist Robert William Fogel's* The Fourth Great Awakening and the Future of Egalitarianism: Robert William Fogel, *The Fourth Great Awakening and the Future of Egalitarianism* (Chicago: University of Chicago Press, 1999).

p. 286 *For example, . . . as Richard Layard puts it:* Richard Layard, *Happiness: Lessons from a New Science* (New York: Penguin, 2005).

p. 287 *Martin Seligman . . . identifies three levels of happiness:* Martin Seligman, remarks at "Happiness and a High Quality of Life: The Role of Art and Art Making," Curb Center conference hosted by the Pocantico Conference Center of the Rockefeller Brothers Fund, supported by a grant from the Rockefeller Foundation, May 31–June 2, 2007.
 . . . what Michael Hughes calls . . . and Michael Kimmelman describes: Michael Hughes and Carolyn Kroehler, *Sociology: The Core* (Boston: McGraw-Hill,

2004); Michael Kimmelman, *The Accidental Masterpiece: On the Art of Life and Vice Versa* (New York: Penguin, 2005).

As historian Eileen Boris puts it: Eileen Boris, quoted in Wendy Kaplan, *"The Art That Is Life": The Arts and Craft Movement in America, 1875–1920* (Boston: Bullfinch, 1987).

p. 290 *Larry Shiner, in* The Invention of Art, *demonstrates:* Larry Shiner, *The Invention of Art: A Cultural History* (Chicago: University of Chicago Press, 2001). *As essayist Josie Appleton put it:* Josie Appleton, "In Search of Utopia," *Spiked Online,* December 22, 2005. www.spiked-online.com/articles/0000000CAEE7.htm.

p. 293 *Instead he explained, "My point is not that everything is bad":* Michel Foucault, *The Foucault Reader,* ed. Paul Rabinow (New York: Pantheon, 1984).

p. 295 *Third, media giant Viacom sued . . . YouTube:* Jeremy W. Peters, "Viacom Sues Google over YouTube Video Clips," *New York Times,* March 14, 2007. *A recent article in* CNET News: Declan McCullagh, "Ten Things That Finally Killed Net Neutrality," *C/Net News,* September 6, 2007, www.news .com/8301-13578_3-9773538-38.html.

. . . *with annual revenues of $21.7 billion:* Eric Sass, "Internet Displaces Radio as Fourth Biggest Ad Medium," *Media Daily News,* August 31, 2007, publications.mediapost.com/index.cfm?fuseaction=Articles.print Edition&art_send_date=2007-8-31&art_type=10.

PHOTOGRAPHS

p. 279 *The Hewlett-Packard HP xw9300 Workstation.* Art student Bevin Carnes uses the following gear: HP xw9300 Workstation, Microsoft Windows XP Professional 32-bit, AMD Opteron 250/2.4 GHz 1GHz HT, AMD Opteron 250/2.4 GHz 1GHz HT (2nd), NVIDIA Quadro FX3400, Memory–Dual Processor–4GB (8x512MB) DDR-400 ECC reg for Dual Processor, 146 GB U320 SCSI 10K (1st), and 16X DVD-R. And the following software: Autodesk Maya 7.0.1; Pixar-Renderman for Maya 1.2; Adobe Photoshop CS2, Premiere Pro 1.5, Encore 1.5; Corel Painter 9; Apple-Shake 2.4; and Tsunami.

Carnes notes that she acquired some hardware on eBay and assembled parts of her system herself. "You could make a perfectly good CG animated short with a cheap laptop and a copy of Maya, but you would have to be a little more resourceful with your files . . ." Her observation sets a baseline for participation in digital animation: not as hard to achieve as a full-blown professional setup, but still, obviously, expensive and dependent on high-speed Internet access.

Bibliography

Alderman, John. *Sonic Boom: Napster, MP3, and the New Pioneers of Music.* Cambridge: Perseus Publishing, 2001.

Alexander, Jane. *Command Performance: An Actress in the Theater of Politics.* New York: Public Affairs, 2000.

Arndt, Richard T. *The First Resort of Kings: American Cultural Diplomacy in the Twentieth Century.* Washington, DC: Potomac Books, 2005.

Association of Independent Video and Filmmakers, Independent Feature Project, International Documentary Association, National Alliance for Media Arts and Culture, Women in Film and Video, Washington, DC, Chapter. *Documentary Filmmakers' Statement of Best Practices in Fair Use.* Washington, DC: Center for Social Media, American University, 2005. See www.centerforsocialmedia.org/resources/fair_use.

Baker, Nicholson. *Double Fold: Libraries and the Assault on Paper.* New York: Random House, 2001.

Baker, Wayne E. *America's Crisis of Values: Reality and Perception.* Princeton, NJ: Princeton University Press, 2005.

Barry, Bruce. *Speechless: The Erosion of Free Expression in the American Workplace.* New York: Berrett-Koehler, 2007.

Berns, Gregory. *Satisfaction: The Science of Finding True Fulfillment.* New York: Henry Holt, 2005.

Besek, June M. *Copyright Issues Relevant to Digital Preservation and Dissemination of Pre-1972 Commercial Sound Recordings by Libraries and Archives.* Washington, DC: Council on Library and Information Resources and Library of Congress, 2005.

Binkiewicz, Donna M. *Federalizing the Muse: United States Arts Policy and the National Endowment for the Arts, 1965–1980.* Chapel Hill: University of North Carolina Press, 2004.

Bloom, Allan. *Shakespeare on Love and Friendship.* Chicago: University of Chicago Press, 2000.

Bollier, David. *Silent Theft: The Private Plunder of Our Common Wealth.* New York: Routledge, 2002.

Bolton, Richard, ed. *Culture Wars: Documents from the Recent Controversies in the Arts.* New York: New Press, 1992.

Booth, Eric. *The Everyday Work of Art: How Artistic Experience Can Change Your Life.* Naperville, IL: Sourcebooks, 1997.

Brenson, Michael. *Visionaries and Outcasts: The NEA, Congress, and the Place of the Visual Artist in America.* New York: New Press, 2001.

Brooks, Tim. Survey of Reissues of U.S. Recordings. Washington, DC: Council on Library and Information Resources and Library of Congress, 2005.

Brown, Michael F. *Who Owns Native Culture?* Cambridge, MA: Harvard University Press, 2003.

Cameron, Julia. *The Artist's Way: A Spiritual Path to Higher Creativity.* New York: G. P. Putnam's Sons, 1992.

Cannon, Lou. *President Reagan: The Role of a Lifetime.* New York: Public Affairs, 1991, 2000.

Carey, John. *What Good Are the Arts?* London: Faber and Faber, 2005.

Carson, Rachel. *Silent Spring.* New York: Houghton Mifflin, [1962] 1994.

Clements, Kendrick A. *Hoover, Conservation, and Consumerism: Engineering the Good Life.* Lawrence: University of Kansas Press, 2000.

Cornwell, Terri Lynn. *Democracy and the Arts: The Role of Participation.* New York: Praeger, 1990.

Dalrymple, Theodore. *Our Culture, What's Left of It: The Mandarins and the Masses.* Chicago: Ivan R. Dee, 2005.

DiMaggio, Paul J. *Nonprofit Enterprise in the Arts: Studies in Mission and Constraint.* New York: Oxford University Press, 1986.

Dissanayake, Ellen. *Art and Intimacy: How the Arts Began.* Seattle: University of Washington Press, 2000.

————. *Homo Aestheticus: Where Art Comes From and Why*. Seattle: University of Washington Press, 1992.

————. *What Is Art For?* Seattle: University of Washington Press, 1988.

Dylan, Bob. *Chronicles, Volume I*. New York: Simon and Schuster, 2004.

Easterbrook, Gregg. *The Progress Paradox: How Life Gets Better While People Feel Worse*. Toronto: Random House, 2003.

Edwards, Betty. *Drawing on the Right Side of the Brain: A Course in Enhancing Creativity and Artistic Confidence*. New York: Simon and Schuster, 1986.

Epstein, Jason. *Book Business: Publishing Past, Present, and Future*. New York: W.W. Norton, 2001.

Florida, Richard. *The Rise of the Creative Class and How It's Transforming Work, Leisure, Community and Everyday Life*. New York: Basic Books, 2002.

Fogel, Robert William. *The Fourth Great Awakening and the Future of Egalitarianism*. Chicago: University of Chicago Press, 2000.

Frohnmayer, John. *Leaving Town Alive: Confessions of an Arts Warrior*. New York: Houghton Mifflin, 1993.

Gaitskill, Mary. *Veronica*. New York: Pantheon Books, 2005.

Geneen, Harold. *The Synergy Myth and Other Ailments of Business Today*. New York: St. Martin's Press, 1997.

Gergen, David. *Eyewitness to Power: The Essence of Leadership, Nixon to Clinton*. New York: Simon and Schuster, 2004.

Goldstein, Paul. *Copyright's Highway: From Gutenberg to the Celestial Jukebox*. Stanford, CA: Stanford University Press, 2003.

Goleman, Daniel. *Emotional Intelligence: Why It Can Matter More than IQ*. New York: Bantam Books, 1995.

Graves, James Bau. *Cultural Democracy: The Arts, Community and the Public Purpose*. Chicago: University of Illinois Press, 2005.

Hajdu, David. *Positively 4th Street: The Lives and Times of Joan Baez, Bob Dylan, Mimi Baez Farina and Richard Farina*. New York: Farrar, Straus and Giroux, 2001.

Hall, Donald, and Pat Corrington Wykes. *Anecdotes of Modern Art: From Rousseau to Warhol*. New York: Oxford University Press, 1990.

Hammond, John, and Irving Townsend. *John Hammond on Record*. New York: Penguin, 1977.

Harrington, Lawrence E., and Samuel P. Huntington, eds. *Culture Matters: How Values Shape Human Progress*. New York: Basic Books, 2000.

Heins, Marjorie, and Tricia Beckles. *Will Fair Use Survive? Free Expression in the Age of Copyright Control*. New York: Brennan Center for Justice, 2005.

Hurlburt, Heather, and Bill Ivey. *Cultural Diplomacy and the National Interest: In Search of a 21st-Century Perspective*. Nashville: Curb Center for Art, Enterprise, and Public Policy at Vanderbilt University, 2005.

Johnson, Steven. *Everything Bad Is Good for You*. New York: Riverhead, 2005.

Jones, Bill T. *Last Night on Earth*. New York: Pantheon Books, 1995.

Kaplan, Wendy. *The Arts and Crafts Movement in Europe and America: Design for the Modern World*. Los Angeles and New York: Los Angeles County Museum of Art and Thames and Hudson, 2004.

———. *"The Art That Is Life": The Arts & Crafts Movement in America, 1875–1920*. New York and Boston: Little, Brown, and Museum of Fine Arts, Boston, 1987.

Katz, Mark. *Capturing Sound: How Technology Has Changed Music*. Berkeley: University of California Press, 2005.

Kimmelman, Michael. *The Accidental Masterpiece: On the Art of Life and Vice Versa*. New York: Penguin, 2005.

Klinenberg, Eric. *Fighting for Air: The Battle to Control America's Media*. New York: Metropolitan Books, 2007.

Kren, Michael J. *Fall-Out Shelters for the Human Spirit: American Art and the Cold War*. Chapel Hill: University of North Carolina Press, 2005.

Kunstler, James Howard. *The Long Emergency: Surviving the Converging Catastrophes of the Twenty-first Century*. New York: Atlantic Monthly Press, 2005.

Lane, Robert E. *The Loss of Happiness in Market Democracies*. New Haven: Yale University Press, 2000.

Layard, Richard. *Happiness: Lessons from a New Science*. New York: Penguin, 2005.

Lessig, Lawrence. *Free Culture: How Big Media Uses Technology and the Law to Lock Down Culture and Control Creativity*. New York: Penguin, 2004.

———. *The Future of Ideas: The Fate of the Commons in a Connected World*. New York: Random House, 2001.

Levine, Lawrence W. *Highbrow/Lowbrow: The Emergence of Cultural Hierarchy in America*. Cambridge, MA: Harvard University Press, 1988.

Levy, Alan Howard. *Government and the Arts: Debates over Federal Support of the Arts in America from George Washington to Jesse Helms*. New York: University Press of America, 1997.

Lewis, Justin, and Toby Miller. *Critical Cultural Policy Studies: A Reader*. Malden, MA: Blackwell, 2003.

McCarthy, Kevin F., Elizabeth Ondaatje, Laura Zakaras, and Arthur Brooks. *Gifts of the Muse: Reframing the Debate about the Benefits of the Arts*. Santa Monica, CA: Rand Corporation, 2004.

Miller, Toby, and George Yudice. *Cultural Policy*. Thousand Oaks, CA: Sage, 2002.

Morris, Edmund. *Dutch: A Memoir of Ronald Reagan*. New York: Modern Library Paperbacks, 1999.

Munson, Lynne. *Exhibitionism: Art in an Era of Intolerance*. Chicago: Ivan R. Dee, 2000.

Murray, Albert. *The Blue Devils of Nada: A Contemporary American Approach to Aesthetic Statement*. New York: Random House, 1996.

Nye, Joseph S. *Soft Power: The Means to Success in World Politics*. New York: Public Affairs, 2004.

Perelman, Michael. *Steal This Idea: Intellectual Property Rights and the Corporate Confiscation of Creativity*. New York: Palgrave, 2002.

Pink, Daniel H. *A Whole New Mind: Moving from the Information Age to the Conceptual Age*. New York: Riverhead Books, 2005.

Pope, Denise Clark. *"Doing School": How We Are Creating a Generation of Stressed Out, Materialistic and Miseducated Students*. New Haven, CT: Yale University Press, 2001.

Putnam, Robert D. *Bowling Alone: The Collapse and Revival of American Community*. New York: Simon and Schuster, 2000.

Said, Edward W. *On Late Style: Music and Literature against the Grain*. New York: Random House, 2006.

Salamon, Julie. *The Devil's Candy: The Bonfire of the Vanities Goes to Hollywood*. Boston: Houghton Mifflin, 1991.

Sanjek, Russell. *American Popular Music and Its Business: The First Four Hundred Years*. Vol. 1, *From 1790–1909*. New York: Oxford University Press, 1988.

Saunders, Frances Stonor. *The Cultural Cold War*. New York: New Press, 1999.

Sax, Joseph L. *Playing Darts with a Rembrandt: Public and Private Rights in Cultural Treasures*. Ann Arbor: University of Michigan Press, 1999.

Schiffrin, Andre. *The Business of Books: How International Conglomerates Took over Publishing and Changed the Way We Read*. London: Verso, 2000.

Schwartz, Barry. *The Paradox of Choice: Why More Is Less*. New York: Ecco, 2005.

Seabrook, John. *Nobrow: The Culture of Marketing—The Marketing of Culture*. New York: Alfred A. Knopf, 2000.

Seldes, Gilbert. *The 7 Lively Arts*. New York: Harper and Brothers, 1924. New edition, with an introduction by Michael Kammen. New York: Dover Publications, 2001.

Seligman, Martin E. E. *Authentic Happiness: Using the New Positive Psychology to Realize Your Potential for Lasting Fulfillment*. New York: Free Press, 2002.

Shiner, Larry. *The Invention of Art: A Cultural History*. Chicago: University of Chicago Press, 2001.

Stern, Isaac, with Chaim Potok. *Isaac Stern: My First 79 Years*. New York: Alfred A. Knopf, 1999.

Tepper, Steven J., and Bill Ivey, eds. *Engaging Art: The Next Great Transformation in America's Cultural Life*. New York: Routledge, 2007.

Thierer, Adam, and Wayne Crews. *Copy Fights: The Future of Intellectual Property in the Information Age*. Washington, DC: Cato Institute, 2002.

Traub, Charles H., and Jonathan Lipkin. *In the Realm of the Circuit: Computers, Art, and Culture*. Upper Saddle River, NJ: Pearson Prentice Hall, 2004.

Vaidhyanathan, Siva. *Copyrights and Copywrongs: The Rise of Intellectual Property and How It Threatens Creativity*. New York: New York University Press, 2001.

Vaughn, Stephen. *Ronald Reagan in Hollywood: Movies and Politics*. Cambridge: Cambridge University Press. 1994.

Venturelli, Shalini. *From the Information Economy to the Creative Economy: Moving Culture to the Center of International Public Policy*. Washington, DC: Center for Arts and Culture, 2002.

Warshaw, Robert. *The Immediate Experience: Movies, Comics, Theatre and Other Aspects of Popular Culture*. Cambridge, MA: Harvard University Press, 2001.

Whybrow, Peter C. *American Mania: When More Is Not Enough*. New York: W. W. Norton, 2005.

Wolfe, Tom. *The Painted Word*. New York: Farrar, Straus and Giroux, 1975.

Zeigler, Joseph Wesley. *Arts in Crisis: The National Endowment for the Arts versus America*. Chicago: A Cappella Books, 1994.

Index

Page numbers in italics refer to illustrations.

Text: 10/14 Palatino
Display: Univers Condensed, Bauer Bodoni
Compositor: Binghamton Valley Composition
Printer and binder: Maple-Vail Book Manufacturing Group